LOVE IN WESTERN FILM AND TELEVISION

Love in Western Film and Television
Lonely Hearts and Happy Trails

Edited by

Sue Matheson

First published in 2013 by
PALGRAVE MACMILLAN®
in the United States—a division of St. Martin's Press LLC,
175 Fifth Avenue, New York, NY 10010.

Where this book is distributed in the UK, Europe and the rest of the
World, this is by Palgrave Macmillan, a division of Macmillan Publishers
Limited, registered in England, company number 785998, of
Houndmills, Basingstoke, Hampshire RG21 6XS.

Palgrave Macmillan is the global academic imprint of the above
companies and has companies and representatives throughout the world.

Palgrave® and Macmillan® are registered trademarks in the United
States, the United Kingdom, Europe and other countries.

ISBN: 978–1–137–27293–5

Library of Congress Cataloging-in-Publication Data is available from
the Library of Congress.

A catalogue record of the book is available from the British Library.

Design by Integra Software Services

First edition: January 2013

10 9 8 7 6 5 4 3 2 1

Dedicated to the memory of Sam Matheson,
who loved a good horse opera

CONTENTS

FIGURES

ACKNOWLEDGMENTS

I would like to acknowledge the generosity of the writers represented in this book and Dr. Kathryn McNaughton, vice-president, Academic and Research, University College of the North, for her funding and support of this project. I would also like to thank my saddle pals at *PCA* and *Film & History* conferences over the years—particularly, Helen, Debbie, and Cynthia. Their enthusiasm, insights, and interest in Westerns helped make this book a reality.

INTRODUCTION

Sue Matheson

Since the publication of John Cawelti's *The Six-Gun Mystique* in 1971, the Western has been read as a platform for exploring America's social, political, and cultural concerns. As John E. O'Connor and Peter C. Rollins point out in *Hollywood's West: The American Frontier in Film, Television & History*, the Western is a complex genre that expresses a myriad of dramatic relations and situations characteristic of the American experience and values (6). And when one considers the 9/11 attacks, American involvement in the Korean War, the Vietnam War, the Gulf War, the Iraq crisis, and the ongoing conflict in Afghanistan, it is not surprising that many Westerns produced during the latter half of the twentieth and the early twenty-first centuries have been concerned with questions of violence. As O'Connor and Rollins note, Richard Slotkin's very popular *Gunfighter Nation: The Myth of the Frontier in Twentieth-Century America*, a compelling American studies approach to the "myth" of the West, has proven to be an excellent jumping-off point for many scholars of the Western (12). However, one only need consult Gary R. Edgerton and Michael T. Marsden's *Westerns: The Essential Journal of Popular Film & Television Collection* to see that the last 40 years of scholarship concerning this genre demonstrates that the history of the American West and the West in the Western, as O'Connor and Rollins point out, is a far more complex reality than *Gunfighter Nation* suggests (12).

Although Western scholarship is no longer in its infancy, there are still wide open spaces left for scholars to explore. To date, scant attention has been paid to another important staple of the Western: love. Whether or not the cowboy rides off alone into the sunset at his movie's end, intense caring and affectionate interpersonal relations are found at the heart of this genre, from its early beginnings to its most recent releases. When I think of the Westerns that I have watched, it is not their misogyny or miscegenation, but their love stories that I remember holding my interest. Be it platonic or erotic, narcissistic

or patriotic, in the American West, love is a prime mover, driving characters and action forward. Take for example that early, formula-establishing dramatic Western *Riders of the Purple Sage*, founded on the difficulties of two couples, released in 1918, and subsequently remade and re-released in 1925, 1931, 1941, and 1996. Love also creates the dramatic tension of the revenge Western. The hugely popular *Nevada* (1927) and its remake in 1944, the powerful *Searchers* (1956), and the Coen brothers' highly acclaimed remake of Henry Hathaway's *True Grit* in 2010 are just three examples of the Western's interest in the power of familial love. Indeed, love is such a powerful force in the Western that whether or not the beloved is physically present seems to matter little. Absence does seem to make the heart grow stronger in the case of characters like Lucy Mallory in *Stagecoach* (1939), Judge Roy Bean in *The Westerner* (1940), Tom Dunson and Matt Garth in *Red River* (1948), Amy Fowler Kane in *High Noon* (1952), Mattie Ross in *True Grit* (1969), and Hallie Stoddard in *The Man Who Shot Liberty Valance* (1962). The presence of the beloved, on the other hand, is equally powerful and is the focus of Westerns dealing with the transgressive nature of unrequited love, as in *Calamity Jane* (1953) and *Legends of the Fall* (2000).

One need only remember the importance of Ruth Cameron and Breck Coleman's romance in *The Big Trail* (1930), the budding relationship between Ringo and Dallas in *Stagecoach* (1939), Custer's tender familial relationships in *They Died with Their Boots On* (1941), Ethan Edwards' obsessive attachment to the memory of his brother's wife in *The Searchers* (1956), Elsa's curious attachment to Heck in *Ride the High Country* (1962), John McCabe's longing for a most unsuitable partner in *McCabe and Mrs. Miller* (1971), John Dunbar's attraction to Stands With A Fist in *Dances with Wolves* (1990), and William Munny's paternal love for his children in *Unforgiven* (1992) to begin tracing the important influence of love and its part in creating both conflict and resolution in the Western. *Brokeback Mountain* (2005) has been lauded for breaking new territory by queering the Western, but much earlier Westerns like *Red River* (1948), *Calamity Jane* (1953), *The Wild Bunch* (1969), and *The Ballad of Little Jo* (1993) have depicted homosexual and lesbian flirting and relationships.

Erotic love is not the only way in which intense caring is examined in the Western. Homosocial bonding is an important characteristic of cowboy culture. Love expressed as loyalty to one's comrades is a recurrent theme in the Western and the basis of the action in movies like *Fort Apache* (1948), *El Dorado* (1966), *The Wild Bunch* (1969),

and *The Cowboys* (1972). Even loyalty to and love for one's animal companions is a quality expected of and displayed by the frontiersman, evidenced in movies like *Lonely Are the Brave* (1962), *The Electric Horseman* (1979), and *Dances with Wolves* (1990).

In short, Westerns embody the whole human experience in America, not just a part of it. As Edgerton and Marsden point out, the Western has evolved dramatically since World War II, responding to massive paradigm shifts in American culture and the advent of television (3–5). But however the genre's celluloid settlers and Native Americans, outrageous outlaws and straight-laced lawmen, reflect the times in which they were made and address the social and cultural issues of the1950s through the 2000s, love remains a constant feature in the Western, underpinning these characters' acts of social transgression and personal transformation. Love forms the crux of the American character in the Western, be it found in Westerns set during the Civil War like *The Horse Soldiers* (1959), which depicts concerns similar to those of Americans experiencing the Cold War; *The Big Trail* (1930), which presents early Americans' resourcefulness for audiences at the beginning of the Great Depression; *Red River* (1948), which reflects generational conflict during a cattle drive; or *The Magnificent Seven* (1966) and *Tombstone* (1993), which convey the importance of personal redemption. The action of ship-of-fools Westerns like *Stagecoach* (1939); revenge tales like *My Darling Clementine* (1946) and *True Grit* (1969); and contact stories like *A Man Called Horse* (1970), *Little Big Man* (1970), and *Geronimo: An American Legend* (1993) all pivot on intense relationships forged between individuals, their families, and their communities.

Looking back, it is fascinating to note how love situates this genre in the broader social, political, and cultural concerns of the United States. Love is one of the means by which writers and directors of movies like *The Horse Soldiers* (1959), *Sergeant Rutledge* (1960), *Cheyenne Autumn* (1964), and *Geronimo: An American Legend* (1993) challenged racial and cultural barriers. Mediating conflicts between genders, as well as clashes between cultures and races, portrayals of love in the Western have reflected the changing nature of relationships between men and women. Edgerton and Marsden attribute the often noted decline of the Western to America's sexual revolution (2–3), yet it must also be noted that movies like *Once upon a Time in the West* (1968) and *McCabe and Mrs. Miller* (1971) sympathetically embodied and supported that revolution in their depictions of the single working woman—the saloon girls—as well as independent woman ranchers of the Western.

Throughout the latter half of the twentieth century, love in television Westerns has also reflected and critiqued America's social, political, and cultural concerns. Since episodes of *The Roy Rogers Show* (1951) depicted Roy Rogers and Dale Evans' traditional relationship as a pathway to personal transformation and social transcendence, interpersonal relationships have morphed on the small screen: the affectionate friendship between men and women evidenced by *Gunsmoke's* Matt Dillon and Miss Kitty in the Sixties has been replaced in the late twentieth century by a darker, transgressive *eros*, evident in *Deadwood's* Seth Bullock and Alma Garrett's hook-up. The nature of familial love in the television Western has also responded to the changing social fabric of the United States. *The Rifleman* (1958–1963) and *Bonanza*'s (1959–1973) investigation of the single-parent family re-contextualized familial dynamics during a time when Americans experienced an exodus of women from hearth and home to the workplace. A wistful response to the changing nature of the American family from 1974 to 1983, *Little House on the Prairie* offered a nostalgic and idealized version of the pioneer family to its viewers.

Whether the Western's concern falls within America's broader social concerns or cultural crisis, matters of the heart always meant trouble—enough conflict to drive men to drink and women to marry...enough trouble to create this timely and groundbreaking collection about the nature of love in America's favorite genre. Containing 14 essays concerned with depictions of love in Westerns produced after World War II, *Love in Western Film and Television: Lonely Hearts and Happy Trails* examines the complicated (and often conflicted) nature of love in masterpieces and cult classics of Western film and television. *Love in Western Film and Television* does not attempt or claim to be a comprehensive work but offers original perspectives on a largely disregarded topic by a wide range of contributors from four countries, both genders, and a variety of disciplines. The book begins by discussing the issues of social transcendence and personal transformation. Helen Lewis' comparison of the historical realities of the Wild West's bride pool with that found in John Wayne movies prepares readers for Andrew Patrick Nelson's and Debra Cutshaw's discussions of gender dynamics, Andrea Gazziniga's insights into female subjectivity in the Spaghetti Western, and Cynthia Miller's groundbreaking exploration of interracial romance in the genre. The socially transgressive nature of love is then examined in Erin Lee Mock's examination of the "erotic domestic" in 1950s television, Vincent Piturro's discussion of reverse transvestitism, Peter Falconer's discussion of love and melancholy, Frances Pheasant-Kelly's reading of

sexual politics in the Western, Stella Hockenhull's consideration of the relationship between the cowboy and his horse, and Lara Cox's rehabilitation of Michael Cimino's *Heaven's Gate* (1980). Homosocial bonding in the Western is the focus of this collection's final chapters: filmmaker Zhenya Kiperman's sensitive close reading of Ratso and Jo's relationship in *Midnight Cowboy* (1969), Robert Spindler's examination of the protagonists and sidekicks in Karl May's Westerns, and my own examination of *philia* in Sam Peckinpah's *The Wild Bunch* (1969). However different our approaches and subjects may seem, all these chapters celebrate the Western's capacity to communicate America's pressing social, political, and ethical concerns to its audiences and encourage further research. Because the Western transmits the very heart of American culture, its triumphs and its transgressions, I am looking forward to the conversations that the book will generate, and hope that such opportunities for further study continue as long as Western movies are made and enjoyed.

Works Cited

Rollins, Peter C. "Introduction." *Hollywood's West: The American Frontier in Film, Television & History.* Lexington: U of Kentucky P, 2005: 1–34.

Edgerton, Gary R. and Marsden, Michael T. "Introduction." *Westerns: The Essential Journal of Popular Film & Television Collection.* New York: Rutledge, 2012: 1–4.

VIRGINS, WIDOWS, AND WHORES: THE BRIDE POOL OF THE JOHN WAYNE WESTERNS

Helen M. Lewis

The topic of cowboy love in the Old West requires consideration of how the increasing male population obtained women to court and marry because the shortage of marriageable young women on the frontier led to the further competition among hundreds of bachelors to make the available virgins, including aging spinsters, as well as widows, widows with children, divorcees, and prostitutes, all part of the wifely domain. Figures vary regarding "the ratio of males to females in the nineteenth-century West [. . . from] ten to one" (Lackman 120) to "from three to thirty times as many unmarried men as unmarried women" (Dick 232). And an 1870 census cites a ratio of 172,000 women to 385,000 men west of the Mississippi (Poling-Kempes 49). Thus, the women in the West became "more concerned about male suitability than availability [. . .]" (Luchetti, "*I Do*" 5). Indeed, the westering women often enjoyed the numerous choices placed before them as prospective marriage partners.

From the perspective of cowboy courtship, then, one can see historical influences in Westerns featuring women choosing their men, in Westerns showing men competing for a woman's hand in marriage, in Westerns revealing a woman determined to leave the hostile West to return to the civilized East, and in Westerns treating a woman's leaving her husband or partner of cohabitation for someone with improved

economic prospects. When exploring cowboy love relationships, historical or otherwise, no single Westerns star offers as many opportunities as John Wayne for examining on the screen successful and unsuccessful romances of the itinerant cowboy, rodeo rider, rancher, cavalry man, lawman, miner, gunman, ex-con, and even bank robber.

The John Wayne characters in Westerns assume a number of typical roles for men in the historical West. However, the many love situations and sources of the love interests for the Wayne characters prove to be less historical. Exploring the John Wayne Westerns against real Western stories offers the advantage of studying an actor who ranked in the top ten box office draws from 1949 to 1973 (except 1958). Wayne did not always star in Westerns during this period. His Westerns consist of 84 films to examine, and in the majority most of these films, the John Wayne character wins and often keeps the girl. Wayne's Westerns span from the 1930 *The Big Trail* to the 1976 *The Shootist*. When John Wayne died on June 11, 1979, he left a cinema legacy that for many remains their understanding of the Old West. Although the John Wayne Westerns often do depict a credible bride pool, they also omit significant populations of women marrying, divorcing, mourning, and remarrying on the Western frontier.

In *Building and Breaking Families in the American West*, Glenda Riley proposes that the very nature of life on the frontier, that is, the skewed ratios of men to women, affected the traditional stages of courtship that had led to enduring marriages in previous decades in the Eastern United States. Recognizing one's "motivation for courting, meeting potential mates, following courtship rituals, dealing with opinions of parents and others, and bringing courtship to resolution [. . .]" (7) by marrying or cohabiting fell to the wayside in boom or bust makeshift societies, among independent youths without parental supervision, as well as in territories that readily granted divorce when one or both parties experienced dissatisfaction in the union. To this latter Western experience of divorce, women in the territories could obtain divorce for a variety of reasons. For example, Maude Davis wed and later divorced Elzy Lay, a member of the Wild Bunch because he refused to give up his outlaw life; she remarried, this time a "respectable farmer" with whom she had children (Lackmann 44); Belle Francis Allen divorced her lawyer husband, Samuel Allen, when he criticized her for wearing pink tights to a charity fundraiser event. She then wed Tom Noyes, son of the wealthy John Noyes, who objected to the marriage by cutting his son out of his will not because Belle Allen was a divorcee but because she had worn the pink tights(Chartier and Enss 97–107). In the John Wayne

Westerns, however, the Wayne character does not divorce: although he can have his wife separated from him, but later in the film she returns to reconcile, as in *McLintock!* and *Rio Grande*. Or the Wayne character can leave, like in *Big Jake*. Either she travels East fascinated by the culture or he leaves to seek freedom and adventure outside the home. But the wife of the Wayne character never divorces him. Nor does the Wayne character wed divorcees, unlike what commonly happened in the historical West.

Despite the real West's population of thousands of bachelors competing for the sparse female supply, the John Wayne character seldom seems to wait long for the women to seek him. Yet many men in the historical West did resort to a variety of means to recruit potential wives: they write letters or even visit East to entice former sweethearts or past acquaintances to marry them and move West, request relatives and friends back in the East to select a prospective wife— some courtship by correspondence to follow, and post newspaper ads, including in the specialized *Matrimonial News,* which had brought the widowed Elinor Pruitt to Clyde Stewart, resulting in their marriage after six weeks on the Wyoming frontier after she had claimed her independent homestead (Enss x). The want ads placed by men and women seeking suitable matches to marry became popular in the last half of the nineteenth century; often these proved quite blunt, indicating age, weight, and personal disposition to money, land, and even fun. Catherine Beecher, sister of Harriet Beecher Stowe, published in 1845 *The Duty of American Women to Their Country,* urging women to travel West "to supply bachelors with wives" (Poling-Kempes 50). Advocates also urged the American Women's Educational Association to send teachers West, but not for lifetime careers in the classroom. Even the matrimonial services of business entrepreneurs like Asa Mercer and the widowed Eliza W. Farnham became a lucrative trade in the 1850s and 1860s (Chartier and Enss 47). Farnham and Mercer advertised and then charged to transport respectable single women by ship to San Francisco and to Oregon Territory, respectively. With the arriving women usually marrying within one year, the men waiting on the docks demanded even more women as bridal candidates (Luchetti, "*I Do,*" 5). The John Wayne character, however, never employs these means to obtain a marriage partner; he never advertises, checks the ads, nor sends for a bride.

Women journalists, dentists, writers, artists, and scientists populated the West, but they do not form the bride pool of the John Wayne characters. Occasionally, a college graduate marries the John Wayne character, but then she replaces her career potential with cooking

and keeping house happily on the ranch, like Betty Benson in *The Lucky Texan*. Real women in the West worked as cooks and laundresses, milliners and seamstresses, midwives and restaurant owners. Although women miners and prospectors appear in the 1870s and 1880s from the Western mines to Alaska, they often choose not to marry. In fact, one prospector left her husband because he wanted her to cook and clean while she wanted to mine in the hills (Zanjani 8). While the Wayne character occasionally wins the daughter of a miner or saves the mine of a town, he does not seek the actual prospecting woman as a wife. Nor does the John Wayne character find romance with waitresses, not even among the Harvey Girls. From 1883 to the 1950s, Fred Harvey and his restaurant chain with the Santa Fe Railroad brought 100,000 single white women ages 18 to 30 to the Southwest. Suspected at first of prostitution, the Harvey Girls proved their virtue through their adherence to their strict code of conduct while under contract and through their high standards of customer service. At the expiration of their twelve-, nine-, or six-month contracts, half of the Harvey Girls stayed in the Southwest to marry cowboys or railroad men (Poling-Kempses xii-xiii). Another kind of professional woman, the attorney, also journeyed West, but in much smaller numbers than professional food servers. In 1892, when Henri J. Haskell was reelected the Montana State attorney general, he named Ella Knowles, a law graduate of Bates College, Lewiston, Maine, and first woman lawyer in Montana, as his assistant attorney general. Eventually, they married, but the John Wayne character weds no woman lawyer. Women doctors, like Nebraska's Suzanne la Flesch and Oregon's Bethune Owens, likewise do not attract the attention of the John Wayne character. Indeed, no intellectual professional woman wins the hand of the John Wayne characters.

The unmarried John Wayne character typically associates with the following female archetypes: nonprofessional virgins; widows, often with children; and soiled doves, or women of "professional experience." Regarding the virgins, the Wayne character sometimes pursues and sometimes competes for a particular woman—true to the situation in Western frontier—but he also sometimes experiences women competing for him, unlikely in the historical West with so many men vying for each woman. In Wayne's early Westerns career, the virgin supply consists of the daughters of ranchers and other wealthy landowners, such as Delores in *Man from Monterey,* Fay Winters in *West of the Divide*, and Celia in *New Frontier.* The virgin daughters of professional men also become acceptable bridal candidates for the youthful Wayne characters: judge's daughter Maxine Carter in *Man from Utah,*

doctor's daughter Barbara Forsythe in *Winds of the Wasteland*, newspaper editor's daughter Janet Carter in *The Lawless Nineties*, banker's daughter Miss Florie in *Three Godfathers*, and store owner's daughter Felece Newsome in *The Trail Beyond*.

Occasionally, the young prospective brides themselves have employment, but not all careers attract the John Wayne character. Postmistress Eleanor Hale in *Rainbow Valley* received her job through the corrupt Morgan, but John Mailin rescues her from Morgan and the post office. Ann in *Desert Trail* attracts the romantic interest of John Scott from the moment he sees her behind the counter of the general store, but by the film's end, one doubts that the beautiful Ann will continue serving customers in the store. While the Wayne character might not court a domestic, a hairdresser, or a professional woman with a college degree, he does not dismiss all working women from the bride pool any more than he prefers the daughters of one professional man over another.

In a number of the early Westerns, the John Wayne character must overcome obstacles presented by family members of the young virgin. The Quaker farm family of Penny Worth, in *Angel and the Badman,* supports their daughter's growing affection for the gunman but they ban Quirt Evans' loaded guns from their house. Often these young virgins have no mothers; they either have just fathers or have no parents at all; sometimes the young woman has become recently orphaned through the murder of her father for whom the Wayne character will seek justice through vengeance. Several of the eligible virgins have undesirable family members whom the Wayne character dispatches by the film's end. These sisters of the villains remain oblivious to the robberies and the murders committed by their beloved brothers, as in the cases of Clara Moore of *'Neath Arizona Skies*, Ann of *Desert Trail*, and Alice Gordon of *The Dawn Rider*. Of course, each of these films contains the last confession scene of the lawless brother, pleading to the Wayne figure, "Please, don't tell my sister what I've done. It will break her heart." Naturally, the Wayne character preserves that trust! In all cases, courtship occurs swiftly, thus mirroring the conditions on the Western frontier when the wedding trip often equaled the move to the homestead.

True to many historical anecdotes of marrying in the West, stories abound of women who married and then divorced or just abandoned their husbands in pursuit of someone wealthier, more honest, or less abusive. Women in the West also broke engagements or understandings in favor of the seemingly more educated, more civilized, more promising candidate for marriage. The John Wayne character does

experience these setbacks. In *The Dark Command*, Mary McCloud weds the teacher/aspiring politician for his sophisticated ideas of bringing civilization to town, but her choice of the infamous Cantrell leads her to reject Bob Seton, the itinerant worker who becomes literate and eligible to run for sheriff just to win her attention and affection. Hallie in *The Man Who Shot Liberty Valance* actually asks rancher Tom Doniphan to protect tenderfoot lawyer Ranse Stoddard from Liberty Valance's threats. Doniphan's protection of Stoddard, however, costs Doniphan the girl. These films gain interest because the women never seem to realize the tremendous pain that their rejection causes the John Wayne figure.

As John Wayne gained more experience on screen, his characters likewise gained more diversity in love interests—not racial diversity, despite the presence and practice of marrying tribal women in the early West—but the Wayne hero figure no longer needed the virgin heroine; an experienced woman could prove acceptable as a prospective wife. Thus begin the Wayne roles that involve relationships with widows. According to Cathy Luchetti's *"I Do": Love and Marriage on the American Frontier*, "in the Frontier west, widows were often in demand, not only for the properties they might own, but [also] for their expertise in domestic economy; they often remarried quickly [...]" (11). The older Wayne character, himself conveniently widowed before the film begins, has the maturity to make a suitable match with a widow. In *Comancheros*, Paul Regret advises widower Jake Cutter, captain of the Texas Rangers, to marry "that widow," the attractive Mrs. Melinda Marshall who has always fed the visiting Jake Cutter well and who seems to have had an attraction to Cutter before both of their marriages. More memorable, in *Hondo*, the relationship between Mrs. Angie Lowe, abandoned wife, and Hondo Lane, ex-gunfighter-turned-US-cavalry-dispatcher, shows more complexity. When Hondo, afoot in the desert, comes upon the neglected ranch of Ed Lowe, Hondo helps Mrs. Lowe and her son make needed repairs to her husband's ranch. Hondo's surprisingly tender poetic recollection of the meaning of the name of his dead Apache wife increases Mrs. Lowe's obvious attraction to this manly, self-sufficient widower; her many protests of her married state seem more for her benefit than for Hondo's.

Later, when Ed Lowe ambushes Hondo, Hondo has no choice but to kill Lowe in self-defense. Hondo then returns to explain to Mrs. Lowe that he has unintentionally made her a widow, yet Mrs. Lowe does not play the grieving widow; unlike many other unhappy wives in the West, Mrs. Lowe had stayed with the abusive, unfaithful Ed. Now she can surrender to her love for Hondo.

Likewise, Hondo has affection for her and the boy, and apparently Ed Lowe had never romanced Angie the way Hondo does. Eventually, Hondo in rapid historical Western-style courtship takes Mrs. Lowe and the boy to become Hondo's family on Hondo's ranch in California. The Wayne character will not live off his future wife's property. The maturing Wayne character can form successful attachments to widows, including assuming the full responsibilities of fatherhood, too. Of course, the prostitutes proved to be the most colorful and alluring bride source; from many nations and past experiences, teenage girls and experienced women came West to make quick money by selling their time and bodies to men weary of male company. In *Women of the West*, Cathy Luchetti and Carol Olwell indicate that "[...] prostitution existed as an art, a social service, and a thriving industry in nearly every major city in the West. [...] In 1860, [for example], 2,379 men and only 147 women [inhabited] the Comstock Lode [...] no doubt many of these women were prostitutes" (*Women* 31).

Prostitutes proved to be eligible to be wives for the Earp brothers, and, like many other prostitutes in the West, continued their profession to support their families after marriage. The Wayne characters, though, suggest a new life for each former prostitute-now-wife. Dallas in *Stagecoach* has suffered banishment and scorn by the "good women" in town, but the Ringo Kidd proposes to her after a short acquaintance by telling her of his ranch across the border: "A man could live there...and a woman.... Will you go?" In *The Spoilers*, Cherry Malotte, gambler queen, wins the hand of miner Roy Glennister once the judge's niece Helen Chester, whom Glennister had wanted to marry, decides to leave Nome, Alaska, for a calmer life back East. The two women had vied for Glennister, not an expected situation historically. Dancehall singer Lacey, in *Old California*, eventually joins Tom Miller, pharmacist, to fight an epidemic; Lacey had become engaged to a corrupt politician while Miller gave attention to the respectable Ellen Sanford, whom he leaves in order to save the town with Lacey. The competition for the showgirl/saloon girl/prostitute proves a common theme. Saloon singer Flaxen Terry inspires cowboy Duke Fergus to learn gambling to buy a gambling house to woo her from the corrupt gambling hall owner in *Flame of the Barbary Coast*. An earthquake allows Fergus to leave San Francisco, taking the injured Flaxen to the purity of Montana to heal. *Rio Bravo*'s cardsharp/saloon girl Feathers not only courts sheriff John T. Chance but actually helps save his life a few times. However, she could force Chance's hand to wed her only when she dons her scanty new dancehall outfit and threatens to let other men

see her can. Similarly, in *North to Alaska*, classic and classy "companion" Michelle Bonet, or Angel, also has to pressure Wayne character Sam McCord, wealthy miner, to declare his love even though he had brought her to Alaska to marry his broken-hearted partner George Pratt. Historically, many a prostitute, many a Western madam, eventually entered the respectable sector through marriage and generosity to the growing community.

While sometimes the Wayne character pursues the prostitute, choosing the saloon girl over the lady; sometimes he gives up the good-time girl for the town girl, for instance leaving Juanita, the girl of any man with money, for Anne in *Desert Trail*; and sometimes he himself is chosen by the saloon gambling woman, like Feathers, at the latter part of his career, the older John Wayne portrays characters who evolve into platonic roles with the women they encounter, appropriately in keeping with Wayne's age. In *Train Robbers* released in 1973, when the beautiful young widow Mrs. Lowe, played by Ann-Margret, offers herself to the aging Lane (yes, the same names as in *Hondo*) hired by her to recover a lost treasure, the 66-year-old Wayne responds to this woman of questionable virtue, "I've got a saddle that's older than you are." The Wayne figure has become "comfortable" with his age, with his wider body, and with his weathered face. He can resist the woman of easy virtue, preferring instead a quiet sleep.

However, *True Grit*, *Rooster Cogburn*, and *The Shootist* reveal a John Wayne character who can accept his age, his health, and his physical limitations, yet still establish meaningful relationships with women, even though platonic. Like Mrs. Lowe in *Train Robbers*, the 14-year-old Mattie Ross in *True Grit* has formed an employer–employee connection with the irascible, one-eyed, cussing US deputy marshal Reuben J. "Rooster" Cogburn. But during the trek to capture Tom Chaney, her father's killer, Mattie and Rooster form a solid bond of loyalty and affection. Rooster tries to maintain an older brother/kid sister tone, but Mattie wants more. She offers Rooster a place by her side in death—not marriage for her, but a union of sorts after death. Rooster's words "Come see a fat old man sometime" when he rides his horse hard to leap over a fence suggest the youthful lover showing off for his girl. Mattie and Rooster seem well aware of the difference in their ages; they can accept what they have without becoming another frontier statistic of older man wedding teenage bride. Thus, the aging John Wayne character can feel satisfied even without a sexual relationship with a younger woman.

The maturing of the hero proves to be significant in the latter films in which the obviously old Wayne character can light sparks with a

woman of his own age, yet preserve the platonic nature of their relationship. *Rooster Cogburn* pairs an even older, crustier Rooster than in *True Grit* with the spinster Eula Goodnight, a missionary seeking justice on those who murdered her father. This time the stubborn Rooster and the equally hard-headed Eula engage in clashes that result in an unstated chemistry between them on the screen. Despite Eula's role as the old crone, perhaps Rooster's observation that "She's a fine filly" implies romance possibilities if they both could shed about 20 years and their set ways. However, of all the many loves and lost loves in the span of John Wayne Westerns, perhaps none stirs audiences quite so much as the respectful, unspoken weeklong platonic "courtship" of gunfighter John Bernard Books and widow Bond Rogers in *The Shootist*. Although Bond Rogers at first is upset by the gunman in her home, in her boardinghouse business, and in her family life influencing her teenage son, by January 29, 1901, one feels regret that this gunman and this lady do not have time for more than one carriage ride together. Even though the older Wayne does not seek a bride to care for him in his last years, the later Wayne Westerns still populate the West with the same "bride pool" of virgins and spinsters, widows, and whores (represented by Mrs. Lowe in *Train Robbers*).

In conclusion, the youthful John Wayne—once declared as the handsomest man by girls in his high school—who portrayed characters attractive to women and smitten by women of all social ranks definitely developed into the aged hero who could still appreciate the prostitute, the virgin, and the widow even without physical romance on screen. And while Wayne's Westerns do not encompass all the sources of women in the historical Western bride pool, the Wayne characters' winning and losing potential brides does fit some of the historical practices of the Old West: rapid courtships and quick marriages, estranged marriages when the bride seeks the cultured East, and marriages to widows and prostitutes. While the John Wayne Western character faces a restricted bride pool, he certainly never lacks for female companionship on the frontier, unlike his historical counterparts who struggled because of the scarcity of women.

FILMOGRAPHY

Angel and the Badman. Dir. James Edward Grant. 1947. Alpha Video, 2003. DVD.

Big Jake. Dirs. John Wayne and George Sherman. 1971. Paramount, 2003. DVD.

The Comancheros. Dir. John Wayne. 1961. 20th Century Fox, 2003. DVD.

Dark Command. Dir. Raoul Walsh. 1940. Lions Gate, 2010. DVD.
The Dawn Rider. Dir. Robert N. Bradbury. 1935. Synergy Ent, 2007. DVD.
The Desert Trail. Dir. Lewis D. Collins. 1935. Synergy Ent, 2007. DVD.
Flame of Barbary Coast. Dir. Joseph Kane. 1945. Lions Gate, 2010. DVD.
Hondo. Dir. John Farrow. 1953. Paramount, 2005. DVD.
In Old California. Dir. William C. McGann. 1942. Lions gate, 2010. DVD.
John Wayne: American Legend. Dir. Kerry Jensen-Iszak. New Video. 2007. DVD.
The Lawless Nineties. Dir. Joseph kane. 1936. Republic Pictures, 1998. VHS.
The Lucky Texan. Dir. Robert N. Bradbury. 1934. Front Row Video, Inc., 2001. VHS.
McClintock! Dir. Andrew V. McLaglen. 1963. Paramount, 2005. DVD.
The Man from Monterey. Dir. Mack V. Wright. 1933. Warner Home Video, 2006. DVD.
Man from Utah. Dir. Robert [N.] Bradbury. 1934. Good Times Video, 2001. DVD.
The Man Who Shot Liberty Valance. Dir. John Ford. 1962. Paramount, 2009. DVD.
'Neath Arizona Skies. Dir. Robert N. Bradbury. 1935. Synergy Ent, 2007. DVD.
New Frontier [as *Frontier Horizon*]. Dir. George Sherman. 1939. Republic Pictures, 1998. VHS.
North to Alaska. Dir. Henry Hathaway. 1960. 20th Century Fox, 2003. DVD.
Rainbow Valley. Dir. Robert N. Bradbury. 1935. Westlake Entertainment, 2003. DVD.
Rio Bravo. Dir. Howard Hawks. 1959. Warner Home Video, 2001. DVD.
Rio Grande. Dir. John Ford. 1950. Republic Pictures, 1999. VHS.
Rooster Cogburn. Dir. Stuart Millar. 1975. Universal Studios, 2010. DVD.

BIBLIOGRAPHY

Armitage, Susan, and Elizabeth Jameson. *The Woman's West.* Norman: U of Oklahoma P, 1987.
Butler, Anne M. *"Prostitution."* In *Encyclopedia of Women in the American West.* Ed. Gordon Morris Bakken and Brenda Farrington. Thousand Oaks, CA: Sage Publications, 2003: 234–241.
Chartier, JoAnn, and Chris Enss. *Love Untamed: Romances of the Old West.* Two Dot, MT: TwoDot, 2002.
Dick, Everett. *The Sod-House Frontier, 1854–1890: A Social History of the Northern Plains from the Creation of Kansas & Nebraska to the Admission of the Dakotas.* 1937. Lincoln: U of Nebraska P, 1979.
Ellet, Mrs. Elizabeth F. *The Pioneer Women of the West.* 1873. Bowie, MD: Heritage Books, Inc., 2002.

Enss, Chris. *Hearts West: True Stories of Mail-Order Brides on the Frontier.* Two Dot, MT: TwoDot, 2005.

Eyles, Allen. *John Wayne.* South Brunswick, NJ: A.S. Barnes, 1979.

Fagen, Herb. *Duke, We're Glad We Knew You: John Wayne's Friends and Colleagues Remember His Remarkable Life.* NY: Citadel P, 2009.

Grierson, Alice Kirk. *The Colonel's Lady on the Western Frontier: The Correspondence of Alice Kirk Grierson.* Ed. Shirley Anne Leckie. Lincoln: U of Nebraska P, 1989.

Kinsella, Steven R. *900 Miles from Nowhere: Voices from the Homestead Frontier.* St. Paul: Minnesota Historical Society P, 2006.

Lackmann, Ron. *Women of the Western Frontier in Fact, Fiction and Film.* Jefferson, NC: McFarland & Co., Inc., 1997.

Luchetti, Cathy. *"I Do": Courtship, Love and Marriage on the American Frontier: A Glimpse of America's Romantic Past Through Photographs, Diaries and Journals, 1715–1915.* NY: Crown Trade Paperbacks, 1996.

Luchetti, Cathy and Carol Olwell. *Women of the West.* NY: W.W. Norton & Co., 1982.

Peavy, Linda, and Ursula Smith. *Pioneer Women: The Lives of Women on the Frontier.* NY: Smithmark Publishers, 1995.

Poling-Kempes, Lesley. *The Harvey Girls: Women Who Opened the West.* NY: Paragon P, 1989.

Riler, Glenda. *Building and Breaking Families in the American West.* Albuquerque: U of New Mexico P, 1996.

Zanjani, Sally Springmeyer. *A Mine of Her Own: Woman Prospectors in the American West, 1850–1950.* Lincoln: U of Nebraska P, 1997.

ONLY A WOMAN AFTER ALL? GENDER DYNAMICS IN THE WESTERNS OF BARBARA STANWYCK

A. P. Nelson

"BARBARA STANWYCK AS A LAND BARON? NOT INTERESTING"

Following the critical and commercial success of *Dances with Wolves* (Kevin Costner, 1990) and *Unforgiven* (Clint Eastwood, 1992), the mid-1990s witnessed a small resurgence in the production of big screen Westerns. Between 1993 and 1996, over a dozen Westerns were released theatrically in the United States, a level of output not experienced since the 1970s, and, to date, certainly not experienced again at any point thereafter. This 1990s cycle of Western production is notable for its diversity, with films ranging from updated takes on mythical Western heroes like Wyatt Earp, Jesse James, and Wild Bill Hickok to narratives that privileged groups the genre had historically been inclined to marginalize, including American Indians, blacks, and women.

Notably, gun-toting female protagonists came to the fore in three pictures: *The Ballad of Little Jo* (Maggie Greenwald, 1993), *Bad Girls* (Jonathan Kaplan, 1994), and *The Quick and the Dead* (Sam Raimi, 1995). Of these movies, it is *The Ballad of Little Jo*—director Maggie Greenwald's saga of an Eastern society woman who, to avoid disgrace after bearing a child out of wedlock, heads West disguised as a man— that has garnered the most attention. Although not as high profile

a movie as *Bad Girls* or *The Quick and the Dead*, upon release the picture garnered positive notices from mainstream critics including Roger Ebert and Leonard Maltin, and has received critical consideration from scholars ranging from B. Ruby Rich to Jim Kitses, whose monograph *Horizons West* remains the most influential study of the Western genre.[1]

Examinations of the representation of women in the Western genre have largely limited themselves to analyses of the stereotypes prevalent in classical Hollywood filmmaking. Indeed, the conventional woman characters found in the Western are so well known that they were invoked by the advertising for *The Ballad of Little Jo* as a point of product differentiation. To quote the movie's tagline: *In 1866, a woman had two choices . . . she could be a wife or she could be a whore. Josephine Monaghan made the boldest choice of all. She chose to be a man.*

Yet not all Western women were maternal schoolmarms or deviant saloon girls, and gun-toting female screen heroes appeared long before the 1990s. Greenwald acknowledged this in a 1995 interview with Tania Modleski, which was published in *Film Quarterly*. Questioned about what motivated her to make a Western, Greenwald said that the "few [Western] stories that have women as main characters were not interesting" to her. When asked which films she's referring to, Greenwald responds: "The woman in *High Noon*—not very interesting Barbara Stanwyck as a land baron—not interesting."[2]

As is often the case with filmmakers who set out to offer a critique of the Western, attention is directed not at what are perceived to be the exceptions—in this case, the "few stories that have women as main characters"—but instead toward more general notions about the genre's conventions, especially with respect to their ideological subtext and historical inaccuracy. Greenwald's disinterest in revisiting the way in which women were portrayed in the earlier Westerns is evident in *The Ballad of Little Jo*. The narrative of the picture is not one common to the Western. Instead, conventional iconographic elements from the genre, like settings and character types, are grafted onto the kind of "passing" narrative more common to the melodrama or women's film: a female protagonist is forced to conceal her true status—be it racial, cultural, or economic—in order to "pass" for a member of another social group. Moreover, the film's premise is drawn from the work of new Western historians who discovered, among other things, that cross-dressing and homosexuality were more prevalent in the "Old West" than earlier scholars could have imagined (or were willing to admit).

This concern with history is not a new one. As Edward Buscombe notes, the genre has always been "constrained by its need to retain a certain bedrock historical plausibility." This constraint has frequently precluded the possibility of females being anything but domestic in deed and demeanor. The genre requires action in order to dramatize its central conflict between civilization and savagery, but, as Buscombe writes, "in the 19th century women did not, on the whole, go rushing around on horseback shooting at Indians." In the same article, however, Buscombe does acknowledge that there have always been "honorable exceptions" to the Western's conventional wives and working girls, including "Barbara Stanwyck's various incarnations of the western woman with more balls than the men around her."[3]

CATTLE QUEEN OF THE SILVER SCREEN

With all due respect to Greenwald, Stanwyck's association with the Western genre is significant and, indeed, interesting. Although perhaps best remembered as a *femme fatale* or screwball comedienne, Stanwyck's involvement in the Western equaled that of many of the genre's well-known male stars. Over the course of her career, Stanwyck starred in eleven Western features.

After making two Westerns in the 1930s and two in the 1940s, Stanwyck starred in seven between 1950 and 1957, after which her work was largely confined to television, where she filmed Western-themed episodes of her anthology program *The Barbara Stanwyck Show* in 1960 and 1961, and took a lead role on the Western series *The Big Valley* from 1965 to 1969.[4] In the context of Stanwyck's career, then, most of her Westerns came after her better-known movies from the 1930s and 1940s, like *Stella Dallas* (1937), *The Lady Eve* (1941), *Double Indemnity* (1944), and *Sorry, Wrong Number* (1948). I'll turn to Stanwyck's own stated motivations for making Westerns shortly, but at this point it is worth mentioning that it was not uncommon for male stars of Hollywood's Golden Age to favor the Western as they aged, as was the case with John Wayne, Randolph Scott, Joel McCrae, Gregory Peck, Burt Lancaster, and others. Similarly, many of Stanwyck's female contemporaries, including Joan Crawford and Bette Davis, were relegated to making (often-mediocre) genre films in the 1950s and 1960s.

As her biography in the *BFI Companion to the Western* states, Stanwyck was "virtually without peer in her portrayal of tough, fearsome women of the West."[5] Significantly, many of these women defy the genre's conventional wife/whore dichotomy. This is particularly

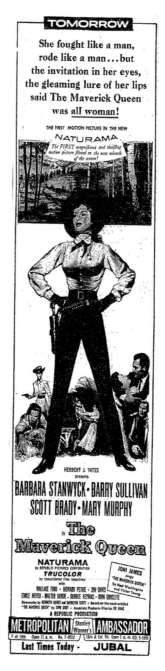

Figure 2.1 From *The Washington Post and Times Herald,* May 13, 1956.
Source: Courtesy of Republic Pictures.

true in the latter half of Stanwyck's screen career, during which a particular Western screen persona emerges: the "cattle queen." The description of Jessica Drummond, Stanwyck's character in *Forty Guns* (Samuel Fuller, 1957), offered by singing bathhouse owner Barney (Jidge Carroll) conveys the essence of this persona:

> *She's a high-ridin' woman with a whip*
> *She's a woman that all men desire*
> *But there's no man can tame her*
> *That's why they name her*
> *The high-ridin' woman with a whip*
> *She commands and men obey*
> *They're just putty in her hands so they say*

The cattle queen is a strong-willed woman of independent means, riding tall in the saddle, ready to crack her whip at horse and man alike. While there are elements of this persona in all of Stanwyck's Western characters, from the sharp-shooting title character of *Annie Oakley* (George Stevens, 1935) to the strong-willed rancher's daughter Vance Jeffords in *The Furies* (Anthony Mann, 1950), it is over three 1950s Westerns—*Cattle Queen of Montana* (Alan Dwan, 1954), *The Maverick Queen* (Joe Kane, 1955), and *Forty Guns*—that the character of the strong-willed, financially independent woman crystallizes, helping to lay the foundation for her starring role as frontier matriarch Victoria Barkley in *The Big Valley*.

Cattle Queen of Montana pits pioneer Sierra Nevada Jones (Stanwyck) against the villainous landowner Tom McCord (Gene Evans), who, with the help of a tribe of renegade Indians led by Natchakoa (Anthony Caruso), had killed her father and stolen her land and cattle. Jones is helped in her fight by the "educated" Indian Colorados (Lance Fuller), who has attended the white man's college in the East, and the mysterious Farrell (Ronald Reagan), a hired gun working for Evans, who is revealed to be an undercover agent working to bring down McCord from the inside. Unlike the heroic Sierra Nevada, Stanwyck's characters in the other two pictures are more ambiguous. In *The Maverick Queen*, she stars as Kit Banion, a saloon proprietor, cattle dealer, and town boss who is secretly in league with the Wild Bunch, an outlaw gang led by Butch Cassidy (Howard Petrie) and Sundance (Scott Brady). Kit determines to leave town after falling in love with the new gang member Jeff Younger (Barry Sullivan), who, as in *Cattle Queen of Montana*, is really an undercover agent working to bring down the Wild Bunch. Kit's decision to leave

24 A. P. NELSON

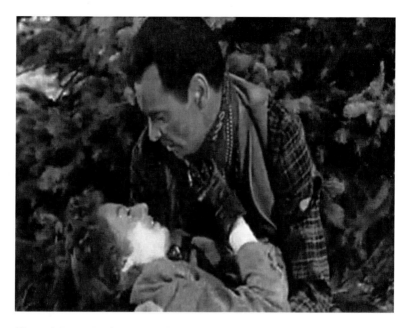

Figure 2.2 Kit (Barbara Stanwyck) dies in the arms of Jeff Younger (Barry Sullivan) in *The Maverick Queen* (1956).
Source: Courtesy of Republic Pictures.

puts her at odds with her former partners, and in particular the jealous Sundance, precipitating a climactic shoot-out in which Kit is shot and dies in Jeff's arms. Stanwyck again takes up the role of town boss in *Forty Guns*. Backed up by a cadre of 40 armed riders, cattle baroness Jessica Drummond rules over Tombstone, Arizona. The arrival of Griff Bonnell (Barry Sullivan) and his two brothers, working for the US attorney general, disrupts this order, as Jessica falls for the famed lawman—much to the displeasure of those accustomed to having the run of the town, including Jessica's petulant brother Brockie (John Ericson) and ineffectual sheriff Ned Logan (Dean Jagger). Unlike Kit, Jessica survives the final shoot-out, and leaves town with Bonnell as the credits roll.

Regarding Western heroines, Pam Cook has observed thus: "Over and over again, the woman relinquishes her desire to be active and independent, ceding power to the hero and accepting secondary status as mother figure, educator, social mediator. If she is allowed to be active, it is in the hero's cause rather than her own."[6] Although each cattle queen picture, in its own way, draws upon conventional Western themes and narratives—from the "undercover" lawman, a carryover from the B-Western, to the Wyatt Earp-inspired Bonnell

and his brothers—they all flout the traditional scenario that has strong women characters nonetheless defined by their relationships with heroic cowboys. Stanwyck's heroines, even after choosing love (dependence) over money and power (independence), always remain the agitating force that drives the narrative forward and brings about resolution. When Jeff is congratulated for bringing down the Wild Bunch, he replies, "No, the Wild Bunch came to its end because of the Maverick Queen." The films feature heroines who display agency and, as we shall see, a barely contained physicality that threatens to both overcome their male counterparts and subvert the patriarchal order characteristic of classical Hollywood filmmaking.

Here it is important to note that anyone expecting these movies to somehow *not* be from the 1950s will be disappointed. Expectedly, Stanwyck's characters all ultimately do pay a price, as it were, for their agency and independence: death in the case of *The Maverick Queen*, and being relegated to one half of the good heterosexual couple in *Cattle Queen of Montana* and *Forty Guns*. But that these movies in the end conform to societal and industrial norms should not dissuade investigators from examining how Stanwyck's characters were able to stand up to and alongside their male counterparts.

Women and the Western

While the Western may be, on balance, a "masculine" genre, we should not underestimate its longstanding appeal to female viewers. The initial resurgence of Western production in the 1930s was partly an attempt by the Hollywood studios to exploit the drawing power of their male stars to what was then a majority female audience. Also, Peter Williams Evans has argued that Western heroines of the late 1930s, like those in many other genres, often reflect significant advances in women's emancipation. Yet Evans also says that, by the late 1940s and 1950s, the genre restores women to their more traditional roles of "decent and long-suffering matron or sexually-aggressive adventuress."[7] The corollary to this purported change in the representation of women is the idea that, in the classic Western that coalesces around the same time, women are ultimately a civilizing—and therefore destructive—influence on the independent cowboy hero, and so he must reject them if he wishes to maintain his special status as mediator between the competing forces of the wilderness and civilization. The iconic ending of John Ford's 1946 Western *My Darling Clementine* comes to mind, where Wyatt Earp (Henry Fonda) rides out of Tombstone, telling his love Clementine that he

might be back that way, some day—a doubtful proposition, if there ever was one. Never mind that Fonda's lawman character in *The Tin Star*, directed by Anthony Mann and released in 1957, rides away *with* the woman in the end, as did John Wayne's hero at the conclusion of *Stagecoach* (John Ford, 1939), or that the majority of Westerns, like most classical Hollywood film, actually do end with the formation of the romantic couple.

Perhaps the most problematic tendency in scholarship on the Western is the continued use of reductive interpretive models based on a select canon of films. That canon is largely defined by the work of important filmmakers like John Ford, Anthony Mann, and Sam Peckinpah, and continues to be investigated using variants of structuralist models developed in the late 1960s and 1970s that conceive of the genre as offering imaginary resolutions to the eternal American conflict between garden and desert, civilization and wilderness, first articulated by historian Frederick Jackson Turner in 1893.[8] As a result, some Westerns are homogenized in order to have them conform to this overarching framework, while many others—including the Westerns of Barbara Stanwyck—are usually neglected altogether. Whether saloon girl or schoolmarm, women characters fall squarely on the side of "civilization," always subordinate to the frontier hero (and, in many cases, his antagonist).[9]

In truth, Westerns continued to be aggressively marketed toward women throughout the 1950s. The trailer for the 1950 Western *Two Flags West* (Robert Wise) featured star Linda Darnell extolling the movie's "exciting and spectacular" New Mexico setting, then adding, "But, as a women, I'm just as interested in the picture's unusual love story and human conflict." She concludes the promo by describing the film as "Every man's, and especially every woman's, idea of a great, romantic adventure." In fact, one of the most striking aspects of the advertising for Westerns of the 1940s and 1950s is the prevalence of the word "romance." Promotional materials for *Cattle Queen of Montana* described the film as a "romantic action drama" and "romantic adventure story." In this way, Stanwyck's heroines appear in a genre that had an imperative to attract woman viewers, and was thus quite receptive to strong female characters. This is not to say that "Cattle Queen" characters were at all common—they weren't, a fact acknowledged both in the promotion of these pictures as well as in the movies themselves. As Jeff Younger says of Kit in *The Maverick Queen*, "[She's] supposed to be a big wheel in this town. That's unusual . . . for a lady." The question then becomes how Stanwyck was able to pull off these kinds of roles while other actresses could not.

Acting Like a Man

The most prominent element of the promotional poster for *Cattle Queen of Montana* is, expectedly, Sierra Nevada Jones. Wearing a cowboy hat, Western shirt, and slacks, with her holster slung low to the right, she stands confidently, hands on hips, a look of steely determination in her eyes. Above reads the tagline: "SHE STRIPS OFF HER PETTICOATS . . . and straps on her guns!" Two years later, the artwork promoting *The Maverick Queen* depicted Kit Banion standing almost exactly the same way—clothing, gun, posture, countenance—below the words "She fought like a man, rode like a man . . . but the invitation in her eyes, the gleaming lure of her lips said The Maverick Queen was *all woman*!" With their emphasis on shooting, fighting, and riding (like a man), both posters ascribe masculine characteristics to Stanwyck's heroines. The ballad of Jessica Drummond in *Forty Guns* does much the same: the cattle baroness is a "high-ridin' woman" who carries a whip. These ladies both dress and act like men—indeed, dressing and acting like a man go hand-in-hand. Yet they are still, ultimately, distinct. As the poster for *The Maverick Queen* tells us, Kit, though adept in the masculine arts, was still—invitingly, alluringly—"all woman." Likewise, Jessica is admired and obeyed by men, who are "putty in her hands," and Sierra must "strip off" a feminine accouterment, her petticoats, before she can don a masculine one, her guns—the prospect of which is made all the more tantalizing by the curious omission of the intermediary step of putting on her trousers.

That gender identity or actions are tied to particular kinds of dress brings to mind notions of gender performativity: that gender, rather than a natural classification, is socially constructed through the repetition of coded, stylized appearances and acts.[10] These ideas have been productively applied to other Westerns, most notably *Johnny Guitar* (Nicholas Ray, 1954), which features not one but two strong-willed women of independent means. Jennifer Peterson has shown how the gendered identity of the protagonist, Vienna (Joan Crawford), changes over the course of the film.[11] These changes, denoted by costume, are often as much strategic as symbolic. In a scene that requires her to appear unthreatening and innocent in the face of an angry mob, she wears a white dress and positions herself at the piano, whereas earlier in the film, when the stakes were lower, she wears "masculine" clothing and takes care to strap on her gun to confront the same group. For Peterson, Vienna's "gender mobility" is a "radical critique of the binary gender construction itself, demonstrating that

a full character is inadequately pigeonholed by rigid identities. These identities are the only framework available, however, thus the method of subverting them is to demonstrate their constructedness."[12] Could a similar "radical critique" be found in Stanwyck's Westerns?

Of the three cattle queen pictures, the most striking change in Stanwyck's costume, so far as it relates to gendered performance, occurs in *Forty Guns*. The first time we see Jessica, she is dressed entirely in black, astride a white stallion, cracking her whip as she leads her 40 guns galloping across the barren Arizona landscape, past the Bonnell brothers who are riding their buckboard into town—literally leaving Bonnell in her dust. The last time we see Jessica she is wearing a white dress, chasing after Bonnell as he rides out of Tombstone on the same buckboard. As the camera cranes upward and the credits roll, she catches and joins him. If anything, this appears to be the opposite of a critique of rigid gender roles. Jessica's transformation—where love has led her to relinquish independence—is patently represented on screen. Both her behavior and costume, and the implications thereof, are inverted at the end of the film.

The film's gender dynamics are not as straightforward as this example suggests, however. Jessica's outfit changes at other points in the movie, and these changes do not symbolize a loss of agency. In scenes set at her mansion in the evenings, Jessica wears a dress—black, but still feminine—and she retains control over the men around her—conveyed most emphatically in a scene where she sits at the head of a massive dining table, around which sit all of her 40 guns. Indeed, regardless of how she is attired or what she is doing, Jessica rides roughshod over all of the men around her—with one exception. Griff Bonnell, though not immune to her womanly charms, rebuffs Jessica's attempts to get him to join her stable, thus fulfilling the second half of Barney's ballad:

> *When she rides and the wind is in her hair*
> *She has eyes full of life, full of fire*
> *But if someone could break her*
> *And take her whip away*
> *Someone big, someone strong, someone tall*
> *You may find that the woman with a whip*
> *Is only a woman after all*

That the Western hero should prove himself better than all other men in this regard is to be expected, but we should question whether Jessica—as well as Sierra and Kit, who are comparably

empowered, though more cooperative than authoritative—is really "only a woman" if she is better than all men but one. Leading ladies in Westerns often occupy the moral high ground, but this seldom correlates to influence or authority, let alone agency of the kind demonstrated by "manly" actions like shooting and riding. In *Johnny Guitar*, masculine masquerade fails to translate to ability. The final shoot-out between Vienna and her nemesis Emma Small (Mercedes McCambridge) is a brief, awkward affair in which both women miss their first shots, despite being at close range. By contrast, Sierra is able to stand shoulder-to-shoulder with Farrell as they shoot it out with Natchakoa's braves, and shoots McCord herself at the end of the picture. When the vindictive Sundance confronts Kit on horseback and makes plain that he's going to kill her, she gallops away, navigating her horse down a steep slope of scree while dodging Sundance's bullets. When he jumps her, sending them both tumbling to the precipice of a cliff, Kit is able to climb back to the top and kick a large log down at Sundance, sending him over the edge.

Without discounting the movies' concessions to cultural norms of the 1950s through the ultimate containment of the Cattle Queen's agency, action scenes like these are noteworthy, on the one hand, for their rarity in the genre, and on the other, for their frequency in Stanwyck's Westerns. The latter cannot be attributed to gendered performance alone, which suggests that there is something centered on Stanwyck herself that facilitates their inclusion in her pictures.

THE FRUSTRATED STUNTWOMAN

Over the course of her long career, Stanwyck never shied away from physical stunts—in contrast, it must be said, to many of her contemporaries. Describing herself on several occasions as a "frustrated stuntwoman," Stanwyck grew up idolizing not Mary Pickford or Lillian Gish but Peal White, the stunt queen of early cinema best known as the star of the *Perils of Pauline* serial (1914). From 1931's *Night Nurse* (directed by William A. Wellman), where her character is pushed, shoved, punched, and knocked unconscious—all onscreen—by a young Clark Gable, right up to *The Big Valley*, where, though nearing 60 years of age, she continued to insist on doing many of her own stunts; Stanwyck's ability to take a lickin' and keep on tickin' is a hallmark of her career that has not received the attention it deserves. It is in her Cattle Queen roles that this ability comes to the fore, as her characters are required to ride, shoot, fight, and even be drug along the ground by a horse repeatedly until director

Sam Fuller was satisfied. In what may come as a disappointment to some, her characters' choices of clothing and accessories lack the subversive symbolism of *Johnny Guitar*, and are only strategic insofar as they are practical for the completing of the task at hand. With that said, Stanwyck's transtextual physicality still threatens to undermine the containment engineered by each film's narrative.

The flipside to sequences like those described above are physical scenes in which Stanwyck's characters are relegated to the background. Both *Cattle Queen of Montana* and *The Maverick Queen* feature somewhat cumbersome fight sequences between the male hero and a villain, where Stanwyck's characters are reduced to onlookers. In the former, after the shoot-out with the Indians, a remaining brave jumps Farrell. As they fight, rolling about on the ground, the scene cuts between a panning wide shot of the scene (that is partially obstructed by the trees in the foreground) and medium framings of the fight and Sierra watching. As the combatants struggle, Sierra, in a surprising intervention, draws her gun and fires, killing the Indian. "Jonesy, you're quite a gal," says Farrell, and the pair kiss. A lengthier fistfight near the end of *The Maverick Queen* pits Jeff against Sundance (who survived his fall from the cliff) inside a remote cabin, with members of the Wild Bunch stationed outside—which precludes Jeff and Kit's ability to use firearms, lest they draw attention to themselves. Kit initially knocks a knife from Sundance's hand, but is then relegated to the background as the men brawl clumsily back and forth from one side of the small cabin to the other. The scene cuts between medium-shots of the men fighting, close-ups of Kit watching, and wide shots of the entire scene. In the close-ups Stanwyck registers the requisite concern for the fate of the man she loves, but in the wide shots, amid the lowish production values and poor staging, we glimpse the frustrated stuntwomen, awkwardly confined to a corner, looking both unimpressed and ready to jump into the fray to show the men how it is done.

Hand-to-hand combat with men remained outside of Stanwyck's Western repertoire, but little else did. (Given her diminutive stature—5'5" and maybe 100 lbs.—besting men with her fists might have stretched credulity a bit too much.) She shot, rode, and tumbled with the best of them. Again, the physical dimension of Stanwyck's acting deserves a longer treatment than can be afforded here, but suffice it to say that her ability to lend physicality—and a kind of authenticity—to her performances without sacrificing her femininity made her particularly suited to the Western. Richard Dyer put it well when he wrote, "When I see Barbara Stanwyck, I know that women are strong."[13]

Strength, of course, is relative. As was noted earlier, Stanwyck's "Cattle Queen" characters differ from other strong female characters found in the genre in that, unlike those women, her heroines are not defined by their relationship with a cowboy hero. This begs the final question of just what kind of men she found herself up against.

Behind Every Good Woman

Extratextually speaking, in these pictures Stanwyck found herself matched with actors from the genre's second-tier. Barry Sullivan plays the male lead in both *The Maverick Queen* and *Forty Guns*, and Ronald Reagan is the cowboy hero in *Cattle Queen of Montana* (making that picture something of a right-winger's dream, given Stanwyck's own conservative political views).

While it is fair to wonder how the Cattle Queen would have fared if paired up with a higher caliber of male costar, the fact is we'll never know. Established Western stars like Gary Cooper and new ones like Robert Wagner were not making movies at the struggling Republic Pictures studio, which produced *The Maverick Queen*, or for maverick filmmaker Sam Fuller. And Stanwyck was working with both actors in projects at the major studios. Moreover, it would be wrong to simply equate actors of lower stature with weak or unbelievable performances. This is not a case of a female character only having strength in relation to weak males. Although Reagan's acting may leave something to be desired—the *New York Times* described his performance as "stalwart and obvious"[14]—Sullivan is particularly good in both *The Maverick Queen* and *Forty Guns*. In the case of the former, his history of playing Western villains works in the film's favor, as part of the intrigue is the question of where his character's loyalties lie.

Unlike other actresses who turned to genre pictures out of necessity, Stanwyck genuinely loved the Western. "I'm crazy about westerns," she said in a 1981 interview, "that's why I've made so many of them. My one big frustration is that Duke Wayne never asked me to co-star with him."[15] *The Big Valley* came about after Stanwyck worked for nearly a decade to get a Western television series off the ground.

Fittingly, Stanwyck's association with the Western—and awareness of this association—increased as time passes. In 1973, she was awarded the Wrangler Award for "Outstanding Contribution to the West Through Motion Pictures" from the National Cowboy Hall of Fame and Western Heritage Center and was the first woman inducted into its "Hall of Fame of Great Western Performers"—the only award, she

said, that she wasn't nervous to receive. Upon her death in 1990, obituaries referred to her as the "Queen of the Cowboys," "Hollywood's Queen of Westerns and Wisecracks," and the "Gorgeous Dame on the Horse." Many of the accompanying photos depicted her in cowboy dress.

The Western, then, may be a genre with room for many kings, but only one queen.

NOTES

1. See B. Ruby Rich, "At Home on the Range," *Sight and Sound* 3.11 (November 1993), 18–22, and Jim Kitses, "An Exemplary Post-Modern Western: *The Ballad of Little Jo*," *The Western Reader*, ed. Jim Kitses and Gregg Rickman (New York: Limelight Editions, 1998), 367–380.
2. Tania Modleski, "Our Heroes Have Sometimes Been Cowgirls," *Film Quarterly* 49.2 (Winter 1995–1996), 7.
3. Edward Buscombe, "Go West, Young Woman," *Sight and Sound* 21.5 (May 2011), 40.
4. For an overview of Stanwyck's Westerns that read her films biographically, see Sandra Schackel, "Barbara Stanwyck: Uncommon Heroine," *Back in the Saddle: Essays on Western Film and Television Actors*, ed. Gary A. Yoggy (Jefferson, NC: McFarland & Co., 1998), 113–128.
5. "Stanwyck, Barbara," *The BFI Companion to the Western*, ed. Edward Buscombe (London: André Deutsch Ltd, 1993), 385.
6. Pam Cook, "Women and the Western" [1988], rpt. in *The Western Reader*, 294–295.
7. Peter William Evans, "*Westward the Women*: Feminising the Wilderness," *The Book of Westerns*, ed. Ian Cameron and Douglas Pye (New York: Continuum Publishing Company, 1996), 211.
8. See, for example, Jim Kitses, *Horizons West* (London: BFI, 1969); Peter Wollen, *Signs and Meaning in the Cinema* (London: Secker and Warburg, 1969); John Cawelti, *The Six-Gun Mystique* (Bowling Green, OH: Bowling Green University Press, 1971); Will Wright, *Six-Guns and Society* (Berkeley and Los Angeles, CA: University of California Press, 1975).
9. For an examination of some of the complexities found *within* the genre's female archetypes, see Blake Lucas, "Saloon Girls and Ranchers' Daughters: The Women in the Western," *The Western Reader*, 301. Also see Evans, cited in Note 7 above.
10. See Judith Butler, *Gender Trouble: Feminism and the Subversion of Identity* (New York: Routledge, 1990).
11. Jennifer Peterson, "The Competing Tunes of *Johnny Guitar*: Liberalism, Sexuality, and Masquerade," *The Western Reader*, 321–340.

12. Peterson, 332.
13. Richard Dyer, *Stars* (London: British Film Institute, 1979), 184–185.
14. Review of *Cattle Queen of Montana*, *The New York Times* (January 26, 1955), 22.
15. Bernard Drew, "Stanwyck Speaks," *Film Comment* 17.2 (March/April 1981), 43. It could be that the duke held a grudge after *Baby Face* (Alfred E. Green, 1931), in which Stanwyck's character unceremoniously shoots down his offer of a date.

FILMOGRAPHY

Annie Oakley. Dir. George Stevens. Warner Bros., 1935.
The Barbara Stanwyck Show. National Broadcasting Company, 1960–61.
The Big Valley. American Broadcasting Company, 1965–69.
California. Dir. John Farrow. Paramount Pictures, 1946.
Cattle Queen of Montana. Dir. Alan Dwan. RKO Radio Pictures, 1954.
Forty Guns. Dir. Samuel Fuller. Twentieth Century Fox, 1957.
The Furies. Dir. Anthony Mann. Hal Wallis Productions, 1950.
The Great Man's Lady. Dir. William A. Wellman. Paramount Pictures, 1942.
The Maverick Queen. Dr. Joe Kane. Republic Pictures, 1956.
The Moonlighter. Dir. Roy Rowland. Warner Bros., 1953.
Union Pacific. Dir. Cecil B. DeMille. Paramount Pictures, 1939.
Trooper Hook. Dir. Charles Marquis Warren. United Artists, 1957.
The Violent Men. Dir. Rudolph Maté, Columbia Pictures, 1955.
The Washington Post and Times Herald (1954–1959); May 13, 1956; *ProQuest Historical Newspapers: The Washington Post* (1877–1995) pg. H2.

CHAPTER 3

VIOLENCE, VIXENS, AND VIRGINS:
NOIR-LIKE WOMEN IN THE
STEWART/MANN WESTERNS

Debra B. Cutshaw

James Stewart and Anthony Mann collaborated on five Westerns:
Winchester '73 (1950), *Bend of the River* (1952). *The Naked Spur*
(1953). *The Far Country* (1954), and *The Man from Laramie* (1955).
Although Stewart plays the prominent roles, the chapter examines
the significance of *seven* actresses, Ruth Roman, Corrine Calvet,
Shelly Winters, Janet Leigh, Julia Adams, Cathy O'Donnell, and Aline
MacMahon, in plot development, and the different roles they play.
As Pam Cook points out, women's roles in films have long been over-
looked not only because of their treatment in the male narrative but
also because close studies have not really "come to terms with the
dual, contradictory role of women. On the one hand, she is peripheral.
On the other hand she is central" (Tasker 51). In the Mann Stewart
Westerns, women, whether central or peripheral to each story, are
often bifurcated in this way as well adhering to stereotyped Western
roles while showing signs of being *noir*-like in character. This con-
flation of genres is not unusual. Westerns used *noir* themes because
directors employed more serious and pessimistic themes; for instance,
Pursued (1947) is considered to be the first *noir* Western, and *Devil's
Doorway* (1950) is Anthony Mann's first *noir* Western. Furthermore,
as Monaco has stated, " . . . it would be fascinating to read the western
and the science fiction films of the fifties in terms of *female subjectivity*

(my italics)" (Wager 79). Indeed, women's roles in Westerns have not been studied enough.

According to fiction writers of dime novels, twentieth-century periodicals, and makers of films, "the West's women were of three kinds: innocent and beautiful homesteaders' daughters, attractive, good natured, mischievous tomboys (or 'sports,' as the dime novels called them), or provocative saloon girls with hearts of gold..." (Lackman 1). The women in the aforementioned Westerns primarily adhere to these stereotypes, but can easily be forgotten in their relevance. Many of the females possess stock pioneer abilities: cooking, removing bullets, nursing, and, most importantly, making coffee. Others can ride, fight, run a ranch or saloon, pan for gold, shoot, or warn menfolk of danger. All of the women in the Stewart/Mann Westerns do have some or all of these skills. But, Mann's females also possess *noir* traits, perhaps due to his extensive collaboration with women writers of thrillers and *noir* scripts, many of these *noir* films centering on a female figure as noted by Elizabeth Cowie (Copjec 136). By comparison, John Ford presents his women traditionally, somewhat as a pretext or model for civilization, and always with strength, fortitude, integrity, and nobility (Cameron 175).

Of course, not all of the Stewart/Mann Westerns have Westernized *noir*-like settings or cinematography. Raging rivers, inaccessible mountains, and winding trails can distract audiences from seeing *noir* character traits. There are no dark, dirty, wet alleys with a spotlight on a killer tormenting his Moll. Instead, there are saloons with gunfights and fistfights by gold thieves or murderers. The women primarily fill a passenger-like role until required to help the male star or the secondary males (who usually die by the protagonist's hand). Certainly, the two films being the most *noir*-like are *The Naked Spur* and *Winchester '73,* coincidentally the most temporal to the director's prior detective/crime *Noirs.* Three actresses, Janet Leigh, Shelly Winters, and Ruth Roman, embrace the most *noir* qualities in their roles. However, all of the women, whether marginal or major, are necessary for the protagonist's return to the community or family. But, the *noir*-like females do more; they assist in building or destroying their relationships with the protagonist, while also influencing his decisions, moral development, and ultimate consequences.

Jim Kitses notes that Mann's style creates a punishing and hard world filled with moral disorder and unnatural, extreme behavior, all *noir* elements. In Mann's *B Noirs,* Robert E. Smith writes "the moral ambiguity of protagonists and *their lack of options* (my italics) in *mise en scène* of darkness and desperation-filled instability are Mann's

means, and simultaneously the tangible visual expression of his phi-losophy" (Silver 201). Of all the women in the five films, Ronda, in *The Far Country*, and Lola, in *Winchester '73*, lack *the most options,* not only because women in general had few options after the Civil War; for instance, they could not own property and thus Ronda partners with a man, and Lola works in a saloon. Their romantic options also suffer primarily because of their unfulfilled love for Stewart's charac-ters, hampered not only by their soiled woman images but also by his quests for vengeance for a murdered friend and father, respec-tively. Additionally, Mann shows the *noir* themes of desire, revenge, and obsession in these two films the most, the women embracing desire. The women try to manipulate the protagonist, a difficult task because Stewart's cowboys range from misanthropic to paranoid to misogynistic—flaws which hamper their relationships with *all* females, not only the *noir*-like ones.

Janey Place sees female characters in *film noir* as being in two cate-gories: the *femme fatale* and the *woman as redeemer.* The femme fatale combines aggressiveness and sexuality, which must be suppressed and controlled so as to not destroy the male. The redeemer offers the lost or alienated male a possible integration into a more stable world of secure values and roles. She gives him understanding, love, and for-giveness, asking for little (Wager 14). Of the three main actresses, Winters, Leigh, and Roman, Ruth Roman most closely aligns her character (Ronda Castle) to a femme fatale. As Nicholas Christopher states, the femme fatale is usually the "more intriguing and energetic figure ... imbued with intelligence, guile, charm and unambiguous sexual electricity" (ibid.). Ronda is the first woman seen in *The Far Country*; and most like Jeff Webster (Stewart), she is a somewhat reluctant misanthrope, but very adept at making money and surviv-ing. Ronda's *noir*-ness is also validated due to the "leading female's commitment to fulfilling her own desires, whatever they may be (sex-ual, capitalist, maternal), at any cost, that makes her cynosure, the compelling point of interest for men and women" (Grossman 3). The customers in her saloon do not question her business practices; even the more powerful, corrupt Mr. Gannon lets her be. Ronda's sexual needs are met in her first scene of the film, and she continues to earn money (and chase Jeff) in her dealings with Gannon, even though she is reminded of Gannon's immorality and killings. Similarly, Lola in *Winchester '73* fulfills her sexual and capitalist desires by letting Steve, her fiancé, be her unacknowledged pimp, which discomforts him more than her. He wants to temporarily leave her to earn his own money (implied gambling) to buy their house. Later, Lola reveals that she

worked in the saloon to only earn enough money for their pending marriage, thus clouding her virtue.

In *The Far Country*, after Jeff Webster and sidekick Ben (Walter Brennan) sell their cattle and board a riverboat to Alaska to try gold prospecting, Jeff is wrongly pursued by the law. Ronda welcomes him to hide in her cabin. To thwart the pursuers, she invites him to hide under the covers of her bed, so that when her door is opened, she will be seen in bed alone. She removes her top and is in her corset; Jeff, fully clothed, hesitates slightly, afraid to rip the sheets with his spurs. The ruse works, and seals her power in the relationship. Jeff questions her reasons; instead she jokes about needing a friend in Skagway, and orders him to just say "thank you." Power shifts again when he replies that *thank you* is a term he seldom uses. Sex is implied when she mentions that she will inform him when it is safe to leave. Afterwards, she glibly tells him that he would look better with a shave, her relaxed banter implying a stronger attraction. A subsequent interior scene shows Webster in his cabin shaving, dressed in his undershirt.

Ronda's importance grows; she is an adroit businesswoman in a vague partnership with a corrupt sheriff-judge Gannon (John McIntire). Gannon takes Webster's property, thus setting up Ronda's rescue of him with a grubstake, while also hiring him to take her to Canada, thereby escaping Gannon. Notably, she is dressed less seductively, and is also on horseback instead of riding in a wagon, perhaps to show her interest in remaining in his life.

Renee Vallon (Corrine Calvet) is the *other* woman, a young French Canadian; at first, she is seen as nonthreatening to Ronda. Renee dresses as a boy, complete with watch cap and pigtails. She boasts to Jeff that she sings at the saloon (Ronda runs/owns) to try to peak his interest. Webster calls her *Freckle Face*, showing his noninterest, which upsets her. However, Renee appears as resourceful as Ronda, but without enough money or sexual power. She also cleans the saloon floor so that she can sift the sawdust for gold to send her father to Vienna "to study stomachs." From her "sawdust concession" in which she nudges customers to drop gold dust, Renee funds Rube, a father figure, who inadvertently *traps* her. (She becomes partners with Rube to follow Jeff to Canada.) Notably, Renee also rides alone on horseback (a symbolic showing of equality with Ronda) to warn Jeff of Gannon's pursuit, even though he dissuades her interest by continuously calling her *Freckle Face*, to which she replies: "I'm not a Freckle Face; I'm a woman!" Control remains with Webster when he steals back his cattle from Gannon without Ronda's permission. That night, Ronda angrily tells Jeff that she was just his convenience

to travel to Canada, but she quickly regains power by kissing him (seen only by Renee). This time, he unhesitatingly thanks her. Ronda replies, "You're learning."

In Canada, Ronda's expertise is displayed again when she buys all of Jeff's cattle after outbidding another businesswoman, Hominy, who chastises her: "Skagway was a good town till you moved in—robbin' and cheating miners with bad women and fancy women. Made the place smell like high heaven but that weren't enough. No matter how hard a man worked in the gold field, you'd take it away from him in Skagway. Let me tell you woman, you ain't got Mr. Gannon backing you with his gun and his badge." Renee complains to Jeff that he should have sold the beef to Hominy, since she had been in the town first. Ronda never blinks. Later, after refusing a local miner credit, Ronda reveals to Webster that she does not trust any man, stating that she trusted a man once and it cost a home in San Francisco, carriages, and servants. Jeff replies, "That's quite a coincidence, I trusted a woman once." Ronda lets her guard down, stating, "Now ask me how a nice girl like me got into a bad trade like this." Jeff questions what is bad about it, but then Ronda does not expound. Her ruthlessness is foregrounded later when she underpays two miners for a claim. Renee tells them that they were robbed; the miner happily retorts, "But she's so pretty and we're so rich." They are ambushed and murdered as they leave town, although it is implied that Gannon gave the orders.

While sneaking out of the area, Ben is murdered and Jeff is seriously wounded, which allows Renee to remove a bullet and nurse him until Ronda arrives, an excuse to intrude on Renee's domesticity. Ronda gives him coffee, which lets him refuse Renee's soup and care. After Jeff permits Ronda to stay, Renee abandons him. This is expected; "the dangerous allure of the femme fatale threatens to infect or destroy the middle class home and family" (Wager 10). Thus, all the good townspeople also turn against Webster, who had previously refused to become a temporary sheriff and fight the evil Gannon for them.

So far, the night has enveloped Ronda's greatest decisions: her traveling with Webster to Canada and boldly kissing him. Since darkness is an element in *noir*, the final scene is set during the evening. Still seeing Jeff as her equal, Ronda desperately confesses her love for him, and states that she is planning to pull out of town, for which he gives no response. Webster realizes that he must avenge his friend, even though Ronda has denied involvement. He returns home, throws away his arm sling, and puts on his six-gun. Ronda, still working for the corrupt Gannon, warns Jeff and gets shot by Gannon before Jeff

Figure 3.1 Lola Manners (Shelly Winters) and Lin McAdam (James Stewart) embrace in *Winchester '73* (1950).
Source: Courtesy of Universal International Pictures.

can kill him. Her martyred death helps redeem Webster in order to rejoin the community, and, slightly wounded, he is again comforted by Renee, but now he welcomes her nurturing.

In *Winchester '73*, Shelly Winters plays Lola Manners, a saloon dancer who is escorted out of town by Marshall Wyatt Earp for the upcoming July 4th 1876 celebrations. He promises to give word to Steve, her implied fiancé, on her whereabouts. Lin McAdam (Stewart) tries to assist her when he mistakenly thinks she is being manhandled by Earp. Lola is attracted to his cavalier ways; of course, they meet later when cowardly Steve has almost deserted her to the marauding Indians. Helped by the US cavalry and McAdam, Lola subtly becomes the victim of the male gaze by all. Notably, Lola does not introduce Steve to the soldiers; later, a sergeant introduces him to McAdam. Lola and Lin further marginalize Steve when she thanks him for his blanket and saddle for sleep, thus not permitting her fiancé to address her needs. Afterwards, Lin gives Lola his gun for her protection before an imminent Indian battle. She does shoot, but fells no Indians. She is even protected by McAdam's friend, High Spade, who hides her under a wagon.

After Steve's cowardice becomes evident to her, and McAdam shows interest in her, Lola's power increases and her marginality decreases. Lola freely accepts Lin's dominant male gaze, which is symbolically seen in her asking him for the remaining bullet in the gun's cylinder, when returning his gun before he rides away. Lola becomes more interesting, and her past is never judged by Lin. She begins to question her implied marriage with Steve and wonders more about Steve's dealings with his outlaw friends. When Steve tells her that she must live alone temporarily in the house they are going to buy, she complains, telling him that she worked in the dance hall only to get them money to purchase it. He retorts, almost angrily, that he must obtain the money now, and so must leave. But, the control completely shifts to Lola when they arrive at the still occupied house. Steve states that he supposes that she will want kids too, a prompt for which Lola significantly does not respond.

When a band of outlaws arrives, led by Waco Johnny Dean (Dan Duryea), Lola realizes she has no protector. In fact, she has quit talking to Steve, thus gaining strength, as noted by Shere Hite, "... many men seem to be asserting superiority by their silences and testy conversational style with women" (Tompkins 59). Her sensed annoyance with Steve sets up Dean's humiliation of him, which she tries to stop, more than Steve himself. However, she controls *the testy* conversation with Dean during Steve's mistreatment. When she refuses Dean's cigarette, he asks, "No bad habits?" For which she bravely replies, "Just bad company." She fully cements her momentary control when she shames Dean, by holding a little girl in front of him and saying, "I want to tell my friends about Waco Johnny Dean, *another* brave man!" Afterwards, Lola is forced to flee with Dean, who has murdered Steve after provoking him to draw. Symbolically, she rides on the back of Dean's horse, and never alone, thus, sharing limited power with him. When she appears unhappy, Dean tells her that she did not love Steve and that he did her a favor, even though all that he wanted was Lola and the Winchester rifle that Steve accidently came to possess. When questioned later by Dean about Steve's "being yellow," Lola does admit to having loved him, despite of knowing of his cowardice.

Lola's place in the story does not materialize until its end. She becomes complacent for survival; being used to men like Dean, she could easily remain with him. However, when McAdam appears again and interrupts Dean and his friends' planned bank robbery, she warns him about Dean's gun hand, thus saving McAdam. Afterwards, she is accidentally wounded in street gunfire when she carries a young boy to safety. After McAdam ensures her safety, Lola's wound is tended

by High Spade, while Lin pursues his outlaw brother and then kills him. When Lola tries to interfere, High Spade tells her the reason for his friend's revenge: Lin must kill his brother because the brother murdered their father.

Lola completely discards her prior, soiled dance hall image; not only by her rescuing the child, but by her warning Lin of the danger and being wounded for him, a metaphorical baptism to a righteous womanhood. Her past erased, she can now be fully embraced by the community and wed, the change long anticipated by the audience. With Lin's successful return, the film ends as expected—an implied marriage; she and Lin are happy to see each other. But, of course, the last camera shot is of the prized rifle. Because of Lola's decision to shed her prior bad girl *noir* image, she can easily excuse McAdam's past violence. In a true *film noir*, she would have stayed with Dean, with a little reluctance, been mistreated, and ultimately used up by him and his outlaw gang.

The Naked Spur embraces the most *film noir* themes, character traits, and settings. Themes of desire, revenge, obsession, and greed are well defined for *all* the characters and could easily be inserted in a dark, wet city alley instead of jagged skyscraper-like cliffs and narrow riding paths. Stewart plays Howard Kemp, an untrusting pursuer of psychotic outlaw Ben Vandergroat (Robert Ryan). Kemp's only reason for the hunt is to capture or kill him for reward money so he can buy back his ranch that his fiancé had sold while he was fighting in the Civil War. Kemp receives assistance from Jesse, the luckless prospector, and Roy, a court-martialed cavalryman, all three being manipulated by Ben for a future escape.

Janet Leigh plays Lina Patch, a young naïve tomboy-like companion whom Ben "adopts" when her father (his friend) is killed. She is a trapped female; what Jans Wager defines as *femme attrapee*—the woman who accepts or resists her position in the *patriarchal family* (Wager 15). Lina first trusts Ben, whose treatment of her is like that of an abusive father or bullying brother. When Roy and Kemp try to capture Ben, Lina first bites Roy, and then jumps on him, which causes him to knock her out. She never tries to grab Roy's loose gun, but tells Ben to get it, showing implied weakness. However, her value is expressed early; she is given a horse to ride alone, while Ben must ride a burro. But, early loyalty to Ben remains firm. When ordered by Jesse to clean all the campfire dishes, she retorts without hesitation, "I'll do mine and Ben's." *Noir*-like, she aggressively resists Roy's sexual advances and innocent concerns, such as his offering her a wet handkerchief for her bruised cheek. She starts to see Kemp differently

when he tenderly covers her at night, thinking that she is asleep. But, Ben continues his abuse by having her wait on him and asking for frequent back massages: "Will you do me Lina, honey?"

Her marginality as *femme fatale* grows when she denies being Ben's girl to Kemp; this is the first sign of her rejecting her entrapment. But, Mann makes the audience question her role by continuing to let Ben have control of her. Ben promotes jealous behavior among his captors, therefore making Lina a total object of desire for the younger Kemp and Roy. As Kemp's interest in her grows the camera films Lina's softer face with more makeup. As Palmer notes, in *film noir* "women are victims of fate or circumstances who frustrate males' desires and act as obstacles in the hero's path to fulfillment" (Palmer 139). Thus, later in the cave night scene Lina realizes that she has been used and trapped by Ben. Reluctantly, she agrees to help Ben escape by distracting Kemp, who has warmed up to her after discovering that she had nursed him during his gunshot recovery and fever. Kemp wants to show her the ranch he plans to buy back with reward money. Lina replies, "It would be like walking on a grave." He tells her, "You know what I want." She replies, "I don't know how I feel." When Kemp roughly embraces and kisses her, Ben escapes. After Kemp recaptures him, a turning point is reached by all characters, who now see maniacal power shifting to Kemp. When Kemp and Roy almost murder Ben, there is a close-up shot of Lina's face, with one tear rolling down, when she implores them to stop. Lina has partially renegotiated control with Ben, but has also kept her destabilized role with Kemp, which is evident by his remarks: "You didn't keep me busy while he was making his break. It just happened that way—it just happened that way." Subsequently, Lina does not entirely reject Ben until she sees him murder the duped Jesse after a successful escape. Ben forces Lina along, and she rides his horse with him, thus sharing power, but power that has symbolically shifted to her by her sitting on the front part of the saddle.

Although the film embraces themes of romance after Lina has nursed Kemp, it does not entirely lose its *noir*-ness, which is evident in the violent killing of Ben and the retrieving of his body from the raging river. However, Lina discards her *femme attrape* and becomes a *redeemer*, as previously defined by Janey Place. She tries to convince Kemp not to collect the reward with Ben's body, calling it blood money, as it involved the killing of three men. When Kemp refuses, Lina relinquishes saying, "I'll go with you. I'll even live on your land." Thus, she has changed more than Kemp; she not only gives him love but also forgives, thus blindly enabling him to return

to his community. Her redemption forces him to *completely* change, shown by his digging a grave for Ben's body. Her acceptance of total domesticity is complete, when to ease their sorrow she states, "I'll make us some of Jesse's coffee." The parting shot ends with both of them riding off to California, a decision he has made with her needs in mind.

Mann's prior Western, *Bend of the River*, also includes *noir* settings of water and the themes of violence, greed, secrecy, and pursuit. Stewart plays Glyn McClintock, a man with a past and without a home. He is leading a group of farmers to Oregon, among which are Laura Baile (Julia Adams) and her father, Jeremy. Along the way, he saves Emerson Cole (Arthur Kennedy), a former Civil War raider like himself, from being lynched. Cole later expresses an interest in Laura, and asks McClintock if she is "his girl." Shortly after McClintock's denial, Laura is wounded during a small attack by Indians, which both men easily handle. Subsequently, after the farmers settle in Oregon, their winter supplies do not arrive; so Glyn and Jeremy return to Portland only to find the storekeeper running a corrupt Boomtown. When he and Jeremy take back their supplies and escape toward the settlement, they are stopped and betrayed by the greedy Cole and his friends. McClintock, with minor aid and luck, fights them off and then kills Cole, thus regaining the winter food for the settlement, and finally he is accepted as a good man by Jeremy and Laura.

Silvia Harvey states that the two most common types of women in *film noir* are the exciting, childless whores or the boring, potentially childbearing sweethearts (Kaplan 38). Laura is first shown as a capable woman, but somewhat boring to McClintock. When Laura softly argues with him about not being thought of domestically, he teases her much younger sister, Margie, into washing his shirts instead, thus ignoring Laura's sexual availability. He only begins to notice Laura when she gets wounded in the shoulder by an Indian arrow, which forces her to remain behind in Portland, while everyone else continues on. Laura, a good pioneer girl, with an overbearing father, who t*raps* her. It appears that her father wants her to marry McClintock instead of Cole. But, she resists Jeremy's control, first by staying behind in Portland. When she is able to leave, she shuns her father; instead choosing to be with Cole who has easily adapted to the exciting lifestyle of the newly corrupted gold-fevered town.

According to Janey Place, *film noir* shows the sexually expressive woman most dominantly in its movies (Kaplan 48). It is not unusual that Glyn begins to notice Laura when her role switches to an unclear exciting sexuality, although quite marginally *noir*. She works in a

gambling hall/saloon, and it is implied that she is engaged to marry the bad Cole. McClintock does show concern or possible regret that she and Cole are together and seemingly happy. But, he expresses no firm interest in Laura yet, even though she is more like the kind of woman in whom he was previously interested. She is more his equal now; being with the corrupt Cole and working in the gambling hall has soiled her somewhat. Does she have a past to hide now or is she merely a rebellious daughter? Her marginal *noir*-ness is further exhibited by her casino cage work as she cashes in a miner's gold dust. Cole tells McClintock, "She's the only one here everyone trusts." Cole insinuates that they are engaged and tells him that she likes to stay in Portland. Laura acquiesces, so Glyn suggests that she go tell her father at the boat docks. A bar fight ensues when it is discovered that McClintock is taking the settlers' delayed supplies. He and Cole escape by riverboat with Laura and her father, who is against her engagement to Cole, whose character he questions. But, Laura firmly believes that he will change. In fact, she had previously told Glyn, "A man can change when he meets the right woman." She has fully embraced the *noir* redeemer role, but not loosened her *femme attrape* identity. Laura believes that Cole will change and become a farmer up river, and Cole lets her believe it. Her new independence is seen when she rides horseback alone, dressed in borrowed menswear. Cole attends to her, sure that she will embrace his itinerant lifestyle. However, when Cole and his friends decide to steal the settlers' supplies from McClintock in order to sell to desperate miners, Laura rejects him. When her father and McClintock are injured and unable to fight back, she hides a gun to use. Later, after she tries to kill Cole and fails, he states, "I like a woman who's not afraid to kill." Realizing that she has been trapped by Cole, she crosses a liminal path to domesticity, having failed to achieve the full role of *femme fatale*, by her *failure* to kill Cole. But, she temporarily gains more power than her father and the beaten, abandoned McClintock, whom she later helps by leaving a horse on the trail. He succeeds in killing Cole and saving the needed supplies. Subsequently, they both accept their blossoming love, and ride together by wagon to the settlement. Thus, McClintock is given permission to rejoin the familial community even though his criminal past had been discovered by Laura and her father.

The last Stewart/Mann collaboration, *The Man from Laramie*, contains the most personal violence against the protagonist, Will Lockhart (Stewart). Lockhart has come to Coronado, New Mexico, to discover who sold rifles to the Apache that murdered his brother's entire army patrol unit. Not only does the town have a secret, but

its most powerful citizen, Alex Waggoman, tries to get Lockhart to immediately leave. Upon arrival, Lockhart is bullied, dragged, and tied up by Waggoman's psychotic son, Dave. He forbids Lockhart to take free salt from his father's land, and beats him, burns his wagons, and shoots most of his mules. Mann adroitly introduces the audience to cruelty and violence by *not showing* it completely. The shots are heard; the mules' screams are heard. There are no dead, mutilated animals; only the outraged Lockhart, who is being held back, is seen cursing his tormenter. However, Lockhart refuses to leave town, and later beats up Dave. He is saved from being shot by Dave by Kate Canady (Aline MacMahon), a competing rancher with Waggoman. Afterwards, Dave seeks revenge and tries to kill Lockhart for slightly wounding his hand. In retaliation, Dave shoots Lockhart's hand at point-blank range after making his men hold him. Again, violence is displayed by Lockhart's grimaced face after the gunshot tears up his hand. The beaten Lockhart is left to return to Kate, who tends his wound, assisted by Barbara.

Lockhart's helplessness is foregrounded by having only two people in town who help him: Barbara Waggoman (Cathy O'Donnell), a store owner, who had innocently told him about the free salt, and the older Kate, who hires him as a foreman, after seeing him fight Dave. Barbara (a cousin of Dave) is engaged to Vic Hansboro, Dave's appointed babysitter. Barbara fulfils the *femme attrape* mold; her dead father has left her his general store, which she dislikes running. When Lockhart delivers her supplies, she *forces* him to have tea with her, so craving outside companionship in the remote town. She has urged her fiancé, Vic, to move but he refuses, hoping to gain monetary control of the ranch through Dave when Alex retires. Barbara is indeed a marginal character, whose purpose in the story is to inform Lockhart of the drama of the town, and thus be on his side. She appears about ten to fifteen years younger than Lockhart, and begins to develop an interest in him when she realizes that she has other male options. For instance, she assists Kate in holding him during hand surgery; afterwards, when told to "entertain him" while Kate makes the inevitable coffee, she engages in schoolgirl nonsequitur conversation asking, "Did you know that Daniel Boone was 84 years old when he crossed the Rockies?" He replies, "Everybody knows that," not noticing her feeble flirtation. She leaves hurriedly, stating, "This wouldn't have happened if you hadn't come here How I feel about everything."

Barbara is both marginal redeemer and marginal *femme attrape*. She does help Lockhart regain his moral compass; for instance, he cannot kill Vic in cold-blooded murder after discovering that he was

responsible for killing his brother. Barbara's being engaged to Vic, and her sincere treatment of Lockhart, makes Vic appear more familiar, and thus harder to kill. After Vic's death by the Indians (who never receive their additional rifles), Barbara plans to leave town and travel East. During their last conversation, Lockhart invites her to ask for him in Laramie during her journey. She holds no animosity toward him for Vic's death. Therefore, he has released her from the trappings of a bad marriage and an unwelcome town and livelihood. Consequently, she cannot continue to see only what she has wanted to see.

However, the older Kate assists him more, as an equal. She posts bail for him when he is wrongfully accused of killing a man sent to murder him; she hires him as foreman, asking minimal questions and offering minimal information also. She is unmarried (having been left at the altar by Alex Waggoman) like Lockhart, and very outspoken. After Lockhart beats up Dave, she tells his father, "Dave got just what you should have given him a long time ago." Unknown to Alex, Kate still loves him. When Vic tries to kill Alex, and Lockhart rescues him, Alex tells Lockhart to hunt him down, realizing that Vic murdered Dave. Finally, Kate is together with Alex, now blinded from injuries, gladly letting Kate nurse him. For her years of unrequited love, and asking for little, she has redeemed Alex and been rewarded with his finally needing her. Of course, she downplays their pending marriage to Lockhart joking, "I just want to get my hands on the Barb Ranch."

Women in *noir* films are defined in their relation to men. More important, it is not that simple to define them. Perhaps, men need to control their sexuality in order not to be destroyed by it (Kaplan 49). Yet, Ronda and Lola are not classic *noir femme fatales* who entirely hurt men, and deserve to be hurt. Carl Richardson states thus: "...women connive, steal and murder. They are not fallen women, victimized by patriarchal exploitation. They are fully responsible for their actions. They are ambitious exploiters whose misdeeds merit punishment doled out in disappointment grief, and sometimes death" (Wagner 81). Ronda, in *The Far Country*, does indeed exploit others for personal gain, ignoring her immoral decisions until Jeff is robbed and shot and Ben is murdered without her being able to warn them. She later confesses to the recovering Jeff that she loves him and plans to leave town: "we make a good pair." But, the more aggressive Ronda gets, the less Jeff wants her, in effect, controlling *her sexuality and his*. As he does not reply to her invitation, her martyrdom is imminent; that is, 1940s *noir* themes of desire ended in destruction or death. Previously, Jeff chose *not* to see Ronda's fringed

corruption. And, as the leading female, she has been his guide, using her strength and resourcefulness to protect him (and make money) somewhat "perverse by conventional standards"; thus, according to Grossman, she keeps from submitting to the gendered social institutions that oppress women (3). In the West, there were very few corrupt female saloon owners; Ronda's expertise in a man's world has given her much alluring power, which she likes. She will not leave her corrupted wealth because she has lost wealth before, by "trusting a man once." Although, later, she decides to leave town only because she will emotionally lose Webster. So, at the end, her role reverses to *redeemer* by inadvertently helping Jeff bridge a higher moral ground of avenging his friend, and simultaneously saving the fledgling town.

Similarly, Lina, Renee, and Laura act as *redeemers* and help Howie, Jeff, and Glyn, respectively, achieve the greatest moral stability. Hiding in tomboy dress, Lina and Renee offer each protagonist their domesticity that he does not see or want at first. As Jane Tompkins writes, "What men are fleeing in westerns is not only the cluttered Victorian interior but also the domestic dramas that go on in that setting... men would rather die than talk" (67). However, both women get their misogynist man to talk and accept them. At the end of *The Far Country*, Jeff obediently tells Renee that she can tend his new but minor gunshot injury. After deciding not to collect the reward for the dead outlaw, a crying Kemp pleads with Lina for help and forgiveness. Lastly, the beautiful homesteader's daughter, Laura, remains a trapped female by her father, and then by the criminal Cole. But, later she is shown as failed *redeemer* to Cole and successful *redeemer* to McClintock by always believing and telling others that bad men can change; thus, domestication is implied.

Most of the actresses in these films renegotiate their roles, whether linked to *noir* traits or not. Their characters adapt when necessary: Ronda rides to Canada, Lola shoots Indians, and Lina warns Kemp of Ben's ambush. Most importantly, they all want to establish a relationship with Stewart's character, no matter how damaged the goods. Silvia Harvey notes that the representation of women in film "has always been linked to this nexus of the family" (Kaplan 36), so it is not unusual that Renee lives and Ronda dies in *The Far Country*. Although Ronda desires Jeff, she is too engrained as a minor *Mildred Pierce* of the West to settle down. In contrast, Renee expresses steadfast family values; she unquestionably saves money to give her father, and also to Rube, who treats her like his daughter. She lovingly nurses Jeff when no other good townspeople will help. Additionally, Laura leaves her exciting saloon job and accompanies her family, later trying

to protect her father and McClintock by attempting to shoot her fiancé-betrayer Cole. Furthermore, Lola shows more interest in the more stable McAdam than in her cowardly fiancé, Steve, and later, the rescuer-outlaw, Waco Johnny Dean. Lina Patch, the most naïve and vulnerable young woman, wants love and belonging, but must also come to terms with a man she barely knows, and who has just caused the death of her past rescuer. On the other hand, family values are broken for Barbara Waggoman, whose remaining family members are too dysfunctional or distant. Perhaps this gives her a reason to criticize her dead father as a lowly shopkeeper, which in turn has ironically become her livelihood.

None of Stewart's women drag him to the altar, but it is implied that the characters played by Shelly Winters and Corrine Calvet remain with him at the end. Douglas Pye argues that Renee's sexless adolescent crush makes marriage very unlikely, and the Lola character is not much stronger either. I disagree, mainly because both women still remain in their man's world. More important, they can regard him as a victim also, which similarly can tie any relationship. In contrast, it is clear that Laura, in *Bend of the River*, and Glyn do stay together and travel to Oregon to settle down. However, the firmest male/female bond occurs with Lina Patch and Howard Kemp of *The Naked Spur*. Lina moves from kicking, biting tomboy to loving woman. In the beginning, as a trapped female, she can only superficially react to Kemp's despair; later, she enables his recovery of health and partial trust in women. After the outlaw Ben Vandergroat's death, Lina is free to act as Kemp's redeemer. Yet, he remains a victim by letting Lina save him from his past identity of revenging, misogynist bounty hunter. She traps him emotionally when she convinces him not to collect the reward with Ben's dead body. Additionally, Douglas Pye sees Mann's Westerns as demolishing two fantasies central to resolutions in Westerns: fantasy of the ideal man and being happily settled (173). Lina and Kemp do ride off to California together, a place *she* desires to see, but the place where they will finally settle is unclear. Although both have changed, certain questions still remain: How long—months or years—will it take for them to achieve their happiness? Will Kemp still be an ideal man to her?

Finally, all of the women in these films are needed for plot development, but a concise discussion of their roles is necessary. Just as Elizabeth Cowie states that focus is mainly on seeing the male melodrama in *film noir*, she also recognizes that actresses should not be divided explicitly into types. A closer examination can change the sexual division, not just affirm it (Grossman 35). Furthermore, just

as there is a tendency to see women in *film noir* with subordinate roles per Janey Place, the women in the Stewart/Mann Westerns can be similarly overlooked, but are much more than secondary characters. Place further argues that *film noir* women are not subordinate: "Women are deadly but sexy, exciting and strong. If the women die as a result, they suffer a fate no different from that of the men" (Copjec 135). Thus, Ronda Castle, the most major female role, closely aligns with *noir*-ness. Her job lets her leak information to Gannon's ambushing thugs who rob and kill innocent prospectors, but Renee appears to be the only one who first notices Ronda's connection in all of this.

Although the Stewart/Mann women do fit the formulas of saloon girls with hearts of gold and mischievous tomboys, Shelly Winters, Ruth Roman, Janet Leigh, and Corrine Calvet were original enough to add much more to their respective roles. All of the characters also share certain traits: all are unmarried, all are self-reliant, all are trapped by their own choice or another's, and all have been or would become victims of men. Undoubtedly, Lola is a victim of her occupation; Lina is used by an outlaw surrogate-father; Cole mesmerizes Laura to forget her family; Barbara is unknowingly engaged to a murderous gun runner; Renee is ignored by Jeff until the end; Kate's broken engagement by Alex leaves her an old maid for years; and the sexy beautiful Ronda regains her wealth by dealing with the corrupt Gannon, who ultimately kills her. However, whether playing a weaker marginal female or a major *noir*-like role, each woman encourages Stewart's character to make right decisions, to achieve a higher moral standing, and to vaguely or explicitly rejoin the benevolent community at the end of each film.

FILMOGRAPHY

Bend of the River. Dir. Anthony Mann. Universal, 1952.
Devil's Doorway. Dir. Anthony Mann. Warner Bros., 1950.
The Far Country. Dir. Anthony Mann. Universal, 1954.
The Man from Laramie. Dir. Anthony Mann. Columbia, 1955.
The Naked Spur. Dir. Anthony Mann. Warner Bros., 1953.
Pursued. Dir. Raoul Walsh. Warner Bros., 1947.
Winchester '73. Dir. Anthony Mann. Universal, 1950.

WORKS CITED

Cameron, Ian and Pye, Douglas, eds. *The Book of Westerns*. New York: Continuum, 1996.

Grossman, Julie. *Rethinking the Femme Fatale in Film Noir*. New York: Palgrave Macmillan, 2009.

Kaplan, E. Ann. *Women in Film Noir*. London: BFI Publishing, 1998.

Lackman, Ron. *Women of the Western Frontier, in Fact, Fiction and Film*. Jefferson: McFarland Co. Inc., 1997.

Palmer, R. Barton, ed. *Hollywood's Dark Cinema: The American Film Noir*. New York: Twaine Pub., 1994.

Silver, Alain and Ursini, James, eds. *Film Noir Reader*. New York: Limelight Editions, 1998.

Tasker, Yvonne. *Working Girls, Gender and Sexuality in Popular Cinema*. London: Routledge, 1998.

Tompkins, Jane. *West of Everything, The Inner Life of Westerns*. New York: Oxford UP, 1993.

Wager, Jans B. *Dangerous Dames, Women and Representation in the Weimar Street Film and Film Noir*. Athens: Ohio UP, 1999.

FROM WHORE TO HERO: REASSESSING JILL IN *ONCE UPON A TIME IN THE WEST*

Andrea Gazzaniga

Sergio Leone's postmodern, revisionist Western *Once Upon a Time in the West* has typically been read as both a nostalgic farewell to cinema's classic Westerns and their male heroes and a pessimistic commentary on the consequences of social progress. In the film, Leone marks the end of the great Western, and thus the birth of the new West, with the arrival of the unstoppable train of capitalism. The iron horse brings industrial progress and Eastern civility to the old, wild West, severing Leone's ties to the American Western genre and its ideals of masculinity, honor, and the individual man seeking justice in a land where laws often fall short, and thus inaugurates a new symbolic order where the power of money replaces the power of the gun. Leone describes this shift in no uncertain terms when he says the "arrival of the railroad ushers in the beginning of a world without balls."[1] He marks a shift from the masculine to the feminine where a world without balls implies a world where women dominate, and so it is fitting that the central and surviving figure in the film is a woman. Ironically, his best intentions to revise traditional paradigms of the Western genre nonetheless reinforce the classic, patriarchal anxiety that views women as castrating agents. His mournful nostalgia for the machismo ideals of the old West would seem to necessitate

body of criticism on *Once Upon a Time in the West* and the Western genre in general.

While critics will concede that Jill's survival in the end confers a certain autonomy, that autonomy is nonetheless coded as less than ideal. Cumbrow is most dismissive of Jill in his assessment of the film's final outcome. He clearly glorifies Harmonica and Cheyenne as ideal heroes who perform the "supreme self-sacrifice because they help create a world that has no room for men like themselves." Because this new world has no room for heroic men like them, Cumbrow falls in step with Leone's pessimism. As he writes, "Those who inherit the West—and, implicitly, the earth—simply are not as interesting as the departing race of heroes." According to Cumbrow, Jill's survival at the end is truly a loss: "Jill is the only person with a name who survives; those who dig remain a faceless mass. The real personalities die or dissipate." Finally, Cumbrow concludes that "the 'new' world born at the close of *Once Upon a Time in the West* is neither very brave nor admirable."[4] Such an analysis refuses to acknowledge Jill's character as anything other than determined by her sex. Cumbrow illustrates the point that misreadings of female roles in the Western are the product of an inability to divorce heroics from gender.

Ironically, Jill as a receptacle of resentment requires critics to dismiss her agency in the film while at the same time acknowledging its very existence by fearing it. Discussion of Jill's role in the film usually reduces her to a passive figure who symbolizes the regrettable shift from a patriarchy to a matriarchy. Frayling reads Jill as merely a reactor in the film with no real agency. As he writes, "She [Jill] is

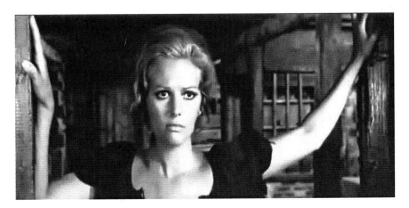

Figure 4.1 Jill (Claudia Cardinale) stops in the doorway before stepping out of the house and giving men water in *Once Upon a Time in the West* (1968).
Source: Courtesy of Paramount Pictures.

always being prompted or prepared by others," namely the men who surround her. The only agency she is permitted to have, according to Frayling, comes at the end of the film when she decides to step out of the house and give the men working on the railroad gang some water. Frayling argues that even this act of agency is not one she has chosen for herself because it is the men who have "groomed" her to assume the role she occupies at the end—that is, the role of matriarch and mother. She becomes for Frayling a symbolic Madonna of the West.

Jill does have agency in the film. Her role at the end is not restricted to a single, symbolic one, but rather amalgamates the multiple roles she shows a capacity to occupy throughout the film. Most importantly, and perhaps most radically, she occupies the role of a Western hero traditionally reserved for men, thereby declassifying the gendering of Western heroics. Wendy Chapman Peek's progressive reading of masculinity in the post-World War II Western is most helpful in understanding Jill's ability to embody both masculine and feminine traits and thus her ability to embody the role of hero. Peek writes thus:

Of ultimate important is not whether the hero is ideally masculine or ideally feminine but whether he is ideally successful. This success often demands that the Western hero negotiate between the poles of masculine and feminine performance to find the mean of behavior that will ultimately achieve that success... Although females in the Western are regularly dismissed, ridiculed, or reviled, it does not necessarily follow that effeminacy bears an irrevocable taint, for the assumption of feminine behavior by male heroes bespeaks strategy, not essence.[5]

Jill's success at the end of *Once Upon a Time in the West* rests on her competence and establishes her heroic status, not by being reduced to a symbol of nurturing femininity but by adopting both masculine and feminine characteristics. Just as it does not follow that effeminacy bears "an irrevocable taint" for male heroes, so it should not follow that characteristics considered masculine should convey a similar taint. For example, in order for women to participate in the public sphere and male-dominated economy, they were once required to bear the social taint of being a prostitute. In other words, women participated in the market economy only by way of being a commodity. As a former prostitute, Jill knows how to navigate within male territory. That she ends up owning that territory *without* being a commodity in it illustrates her successful ability to "negotiate between the poles of masculine and feminine performance."

Here it is important to note how feminist readings of the Western take into account women's roles not just as they play against men, but as they stand within a genre whose power dynamics have mistakenly been coded as masculine. Certain contradictions in the way male heroics and feminine influence have been classified by those writing about the genre reveal the way in which such criticism privileges the male figure over women's contributions. Will Wright, John Cawelti, and Jim Kitses all acknowledge the underlying tensions in Western films as being that between wilderness and civilization, and between the individual hero and the community. As Cawelti notes, the "function of the Western is to 'resolve' the conflict between key American values like progress and success and the lost virtues of individual honor and natural freedom." Westerns give us "an epic moment in which savagery and civilization stand against each other in a deadlock which is broken in favor of civilization through the intervention of the Western hero who possesses qualities of both the savage wilderness and civilization."[6] In this estimation, Shane, from George Stevens' eponymous film from 1953, would be the quintessential Western hero who intervenes to restore civilization back to a system of law and order and family values, even while he himself cannot function within it. As Cawelti continues his analysis, he likens Northrop Frye's classification of the Romance to the Western, arguing that both genres share a similar formula in which the movement of the hero "from alienation to commitment is an example of the 'recognition of the hero, who has clearly proved himself to be a hero even if he does not survive the conflict."[7] Canonical readings of the Western are centered upon a male hero who enables the transition from alienation to commitment and from wilderness to civilization.

The movement from savagery to civilization also characterizes how women's roles in Westerns have been perceived by critics of the genre. This is what Andre Bazin notes:

The myth of the western illustrates, and both initiates and confirms woman in her role as vestal of the social virtues, of which the chaotic world is so greatly in need. Within her is concealed the physical future, and, by way of the institution of the family to which she aspires as the root is drawn to the earth, its moral foundation.[8]

Bazin recycles old tropes—women serving as vestals of social virtues and earth mother of society's moral foundation—that are certainly not particular to the Western genre; the Victorians would call her the "angel in the house." According to Bazin, women represent the

"physical future," ostensibly one in which the town rids itself of villains and the streets are once again safe for womenfolk and children. The consequences of running off the villains often means running off the hero as well, for once a town is cleansed of its immoral forces the lonely male hero rarely stays to assume a place in that new social order. Donati admits to following this formula when he describes what he calls the "romantic element" of *Once Upon a Time in the West*: "the railroad which unites one ocean to the other one is the end of the frontier, the end of adventure, the end of the lonely hero and so on."[9] The end of the "lonely hero" means the end of men with balls. In other words, having balls requires a man to be alone. Donati's "and so on" includes the usurping of the male hero by women who survive to continue the work of suppressing the savagery. In this way, Leone's film would seem not to stretch too far from the classic Western formula in that Harmonica, the lonely male hero, leaves while Jill remains. Cawelti's formulation that the Western male hero intervenes to tame the wilderness contradicts Bazin's idea that it is the woman who brings civility. This kind of contradiction only underscores the privileging of male agency and heroics in writing about the Western.[10] If one considers the often noted assumption that men tame and women domesticate, then it must be acknowledged that while both actions result in the same outcome, only one of them can be called heroic. If a man negotiates the worlds of savagery and civilization eventually to restore peace, he is considered a "hero," but should a woman accomplish the same thing, she is a castrating matriarch.

The death of "frontier individualists" or lonely male heroes elicits a sense of loss and resentment toward the women who would domesticate them. But nowhere can we locate a sense of loss for the women who are consistently relegated to domestic roles or a sense of outrage for the fact that they become targets of male resentment even while performing the same heroic deeds.[11] While labeled a revisionist Western, *Once Upon a Time in the West* is a film that fits quite snugly into the genre. The film does not, in fact, demonstrate a departure from the traditions of its genre in order to signify, as critics would have it, a director's lament over the loss of patriarchal and masculine ideals, but rather it precisely follows the formulas of the Western genre. The most revisionary statement it makes concerns the way it liberates the figure of woman within that traditional system and reclassifies the gendered term of "hero."[12] Cawelti writes that the defining characteristic of the Western is the way in which it "presents for our renewed contemplation that epic moment when the frontier passed from the old way of life into social and cultural forms directly connected with

the present" and that "by dramatizing this moment, and associating it with the hero's agency, the Western reaffirms the act of foundation."[13] If one accepts Cawelti's definition then Leone's film situates itself within that tradition, for the film's ending marks that "epic moment" of transition. But if we are to associate that act of foundation with the "hero's agency" then who is the hero and who has agency in Leone's film? One could argue that the way in which Jill's agency reaffirms an act of foundation at the end of the film is also the resolution found in so many Westerns that Cawelti discusses. The difference, of course, is that, by being a woman, Jill cannot be called a hero nor can she be afforded the masculine hero's agency.

Jill asserts her agency not by what she chooses to do, but by what she chooses to ignore. Oddly, Frayling calls Jill merely a "reactor" in the film, and thus defines agency as action that is not reaction. If such is the case, then none of the characters in the film have any real agency since each one is prompted to act by the actions of another, and each one essentially reacts to events and affronts performed by others, either in the distant past or in the immediate present. Jill's decision to ignore acts that might otherwise prompt a reaction in a male protagonist would seem merely to reinstate the stereotypical idea of female passivity that has defined female roles in classic Westerns. For example, she does not take nor seek to take revenge against the man who slaughtered her husband and future step-children, and she does not want the money potentially hidden in Sweetwater. Though she looks for it in order to explain the killings, she ultimately tells Cheyenne, "if you find it you can have it." Jill's refusal to take possession of the money sets her apart from the other money-grubbing characters, Morton, Frank, and even Cheyenne.

Not having a gun also sets Jill apart from the other male characters. Often, agency in a Western means holding a gun, and it is this gunslinging agency that is privileged over other forms of negotiating and asserting power. Jill fires a gun once in the film when she shoots into the darkness at what she believes to be the murderer of the McBain family who has come to kill her, too. It turns out to be Harmonica staking the house for her own protection, though she cannot know who is friend or foe at this point. Once she fires the rifle, she promptly replaces it on the wall more like a decorative object than something she will depend upon in the future. Jill does not need a gun to maneuver her survival in the West; rather, she herself embodies her best weapon. Her wit, intelligence, sense of irony, and self-awareness arm her with the best ammunition against those who would destroy her. It would be too easy to classify Jill as the passive female who

stands in the margins while men engage in the real action of gunfighting. That Jill is the only character who survives in the end seems to be Leone's final statement on how such female passivity, winning out in the end, marks that pessimistic turn the Western must take in this new West "without balls." Passivity, however, is not an apt term by which Jill's character may be described. Rather, Jill is impervious to the external forces surrounding her, and, by being impervious, she embodies a more authentic kind of subjectivity than even what the typical Western male protagonist can possess. Whereas Jill resists succumbing to the masculine forces that try to manipulate her, the male protagonists submit themselves to those forces. The male protagonists in *Once Upon a Time in the West* are quite clearly stereotypical—the loner, Harmonica; the villain, Frank; and the desperado, Cheyenne. Each one stays within the bounds of their stereotypical roles, and when one does attempt to step outside that role, he ultimately fails. Frank exemplifies this point in his attempt to transform himself from the gunslinging villain into a venture capitalist; however, Frank's past haunts him to the point that he cannot shake one identity for another. His stereotype is too deeply rooted in past Westerns for him to occupy any other role, and he is ultimately killed by that past. The male stereotypes of the classic Western, those who hold grudges and are haunted by a past, find no useful place and have no ability to survive in this new West.

Jill, on the other hand, moves fluidly between the past and the present, and between the various roles she occupies in the film. She leaves her past life as a whore to begin a new life of virtuous domesticity, but when that new life is destroyed, even before she appears on the scene, she stays in Sweetwater not to seek revenge but to figure out the "why"—namely money—the McBain family has been killed. When she does not find the reason, she decides to leave again, but by this time, her own life is at stake, and she is thus drawn into this violent world of men with guns and grudges. She inherits the problems that confront her, and she is also enlisted as a servant to the problems of others. However, while she moves and works between the railroad plot and Harmonica's revenge plot, sometimes as an obstacle and sometimes as a pawn, she herself does not reside in either one nor is her identity determined by those plots. She resists being coopted and strictly defined by any one single plot. It is no accident that in being this kind of fluid character Jill is the one most closely associated with water. Her first word of the film is "sweetwater" and her first request is for a tub of water; she will eventually take a bath in that tub of water, she will fetch water for Harmonica, she will own the land with water, and, finally, she will offer water to the railroad gang.

While she inherits the problems that confront her and men enlist her to aid their own causes, she need do nothing more than take a bath to wash it away and restore her sense of self. For example, in one telling scene, she confronts the bandit Cheyenne, one of the "ancient race of men" the film will make extinct, who has come to sniff out any money that might have been the cause of the McBain massacre. At this point, Jill has no idea whether Cheyenne killed her husband and step-children. Cheyenne, in turn, thinks it might be possible that Harmonica is the one who massacred the family. Jill's life is in danger—as Cheyenne says, "when you've killed four it's easy to make it five." But Jill knows this is not about some chivalrous motivation to protect her life; it is about money. Up until this point Jill has said very little, but when she finally does talk, she asserts a command of the situation. She tells Cheyenne, "If you want to, you can lay me over the table and amuse yourself. And even call in your men. Well. No woman ever died from that. When you're finished, all I'll need will be a tub of boiling water, and I'll be exactly what I was before—with just another filthy memory." The close-up of Jill during this speech reinforces her command of the situation. Her ability to shift between inviting Cheyenne and his gang to have their way with her to preparing coffee marks her refusal to be classified or identified by men's expectations. Later in that scene, Cheyenne will liken Jill to his mother, "You know Jill, you remind me of my mother. She was the best whore in Alameda and the finest woman who ever lived." Even while Cheyenne can acknowledge that one role does not preclude the other, it is Jill's own sense of identity that stands out here. However these men classify her and however they may use her or have their way with her, they cannot penetrate her sense of self nor can they alter her identity. As she states, "all I'll need will be a tub of boiling water, and I'll be exactly what I was before—with just another filthy memory." Jill's ability to wash away the filthy encroachments of men and money give her the power to restore her identity no matter the circumstances percolating around her.

Even while the film attempts to identify Jill with the encroachments of the railroad, she stands for something singularly her own, apart from the corrupted ideals that the train represents. If, as Leone explains, "the arrival of the railroad ushers in the beginning of a world without balls," then the way in which the film ushers in Jill McBain would seem to associate her with that castrating agent. She first appears on screen emerging from the train in Flagstone, where she pauses at the threshold, framed within the doorway much in the way doorways will consistently frame her throughout the film. As she

surveys her new home, her gaze registers hope for a new future. Once she steps onto the platform, her displacement becomes more apparent as she searches for the man who is meant to claim her. She moves among the other exiting passengers in the station as one who is both alone, out of place, and abandoned, which she increasingly realizes. In this instance, the train signifies the displacement of people (a group of native Americans identified as "redskin warriors" are being shuffled off by a white man) and the intrusion of capitalism into the wild West (goods and livestock are being unloaded while two men discuss financial prospects and the economy). Jill enters this commercial world as a displaced and unclaimed outsider.

Jill's arrival by train contrasts sharply with Harmonica's arrival at the start of the film. The opposition set up between these two train scenes encodes Jill as being part of the new West while Harmonica occupies the old. Unlike the Flagstone station, the unnamed station where Frank's henchmen wait represent the still untamed West. Even the station manager appears ancient and powerless as the leader of Frank's gang quickly disposes of him by locking him in a closet. The closet's slamming door marks the appearance of the film's first title, a *nondiegetic* moment, to suggest that the film itself will signify a door slamming on the Western, itself. These old West gunslingers appropriate the train station and, as they bide their time waiting for Harmonica, their actions embody a more primitive, antiprogressive stance. Jack Elam's character, for example, rips apart the telegraph wires, a symbolic gesture of the old West refusing civilization's intrusion. He then proceeds to wield his gun as a weapon against a fly. Woody Strode's character is content to gather drips of water in the brim of his hat. In both of these instances, the film reminds us of the basic necessities for survival in this old West: guns and water.[14]

While Harmonica does arrive by train, he is entirely dissociated from it. Unlike Jill, who clearly emerges from the train and is framed in its threshold, Harmonica seems to materialize on screen out of nowhere. We do not see him exit the train, nor do we gain any clear sense that he was even on it. Fittingly, his mythic, almost mystical, status is reinforced by the harmonica playing that seems to blur the line between *diegetic* and *nondiegetic* sound. Harmonica's music differs from Jill's music precisely in this regard: Jill's music is unambiguously *nondiegetic* and, as if to reinforce her association with progress and commerce, swells to a glorious crescendo with the infamous crane shot over the station, looking onto the bustling town of Flagstone.

Like Jill, Harmonica arrives to find a missed connection. He too has been abandoned by the man meant to meet him. Harmonica arrives

hoping to meet Frank but instead finds the three men Frank sent to kill him. Assessing the situation, Harmonica asks them, "Did you bring a horse for me?" The response is ominous, as Jack Elam's character replies, "Looks like we're shy one horse." Harmonica slowly shakes his head and says, "No. You brought two too many." The exchange accomplishes two tasks. First, Harmonica's wit identifies him as the film's heroic gunslinger, for in Leone's West the only thing more important than being quick on the draw is having an even quicker wit. Second, it underscores the film's larger critique of a capitalist system usurping the place of the classic Western hero. Harmonica's quip, "You brought two too many," uses a capitalist's vocabulary of surplus to express the idea that supply has exceeded demand. Ultimately, considering the film's thematic scope, the horses are not in too abundant supply so much as the men (with balls) who represent the old West are. Indeed, Harmonica's symbolic exit from the film during which he ponies Cheyenne's corpse on horseback brings the economics lesson full circle, for here, instead of being "shy one horse," Harmonica is shy one man. Reading this opening sequence in conjunction with the ending of the film where Harmonica rides off with a dead Cheyenne frames the film with the idea that the old West's supply of men has exceeded a demand for them.

While Harmonica understands the new West's capitalist structure, he can only employ that understanding through metaphor. Indeed, he cannot function in the new West because he is too much an emblem of the past to be a fully embodied person. Oddly enough, Jill is the character who critics tend to reduce to symbol or emblem even though her physical presence, her ability to function in a complex world, makes her a much more fully realized subject than the lone male hero, Harmonica. Ultimately, saying good-bye to the lone male hero means that the lone female hero takes a privileged place in a new symbolic order that need not necessitate death and destruction.

Thus, in the final sequence of the film, Jill eschews gender classifications and becomes a much more complex, innovative model of a Western hero. While critics have read Leone's abundant allusions to classical Westerns both as a critique of traditional formulas and homage to the classic Western, the significance of the allusion in Jill's final scenes of the film usually gets short shrift. Frayling is meticulous about cataloguing the allusions to the great Westerns in *Once Upon a Time in the West*, but he makes only one reference to the way in which Jill's role alludes to a classic Western, and he does so in the most passive terms available: "Jill's preparation for her role as water-bearer resembles the equivalent scene in *Man of the West*." In fact, a

more fruitful reading of Jill's complex role in the film and its radical reinvention of the Western hero may be made by analyzing its allusion to John Ford's *The Searchers*. The film already encodes Jill, above all other characters in the film, as occupying what may be considered a Fordian landscape. After all, it is she who takes the buggy ride through Monument Valley. When we witness her bidding goodbye to Harmonica and Cheyenne, she more specifically steps into the familiar frame of Ford's final scene in *The Searchers*. In that iconic scene, Ethan, the lonely hero played by John Wayne, brings Debbie, the daughter kidnapped years earlier by the Comanche, home. The family awaits on the porch for Ethan to carry Debbie to them, and we witness the domestic unit—father and mother, and the soon-to-be wife and husband in Laurie and Martin—restored. The camera then shifts perspective as it occupies its place inside the home, and we watch the final reunion, framed by the front door, as insiders looking out. Mother and father usher an apprehensive Debbie back inside, and the others follow to take their place with us in this triumph of domesticity. Meanwhile, we watch Ethan, the lone hero, clearly standing as an outsider to this domestic space. Just then the soundtrack asks thus:

> What makes a man to wander?
> What makes a man to roam?
> What makes a man leave bed and board
> And turn his back on home?
> Ride away, ride away, ride away.

Ethan turns his back on the home to resume his role as lonely wanderer. As he walks away from civilization and returns into the wilderness, the front door shuts us in and shuts him out. Compared to the door slamming shut on the Western itself in the opening of *Once Upon a Time in the West*, Ford's door slams shut not on the genre but on the hero. While law and order and domesticity are restored, the Western lives on precisely because the lone man does not stay. In a way, his exit signals a chance for the wilderness to reemerge.

In contrast, *Once Upon a Time in the West* rejects all domestic unions and romantic connections. In the massacre of the McBain family, the film not only creates a cast of loners and outsiders but seems to privilege the status of the loner above notions of community and intimacy. In particular, the final scene between the three surviving characters refuses any intimate or romantic connections between man and woman. Just as in *The Searchers'* final scene, the makeshift family of Cheyenne and Jill await inside the home for the return

of the questing hero, Harmonica. Up until this point, Cheyenne's relationship to Jill is as a child to a mother—"you remind me of my mother," he tells her at one point—while Harmonica's relationship to Jill is as a potential partner. Jill makes a comment that Cheyenne is "sort of a handsome man," and Cheyenne tells Jill that he is not the right man for her and neither is Harmonica. Jill's face registers a brief sense of disappointment, but she quickly recovers to reply, "Maybe not. But it doesn't matter." Ultimately, love between a man and a woman is useless as a commodity in Leone's landscape as he believes it has been in the Western genre in general. Here, a woman recognizes just how useless it is. While love has so often defined the interest of women in traditional Westerns—the whore with a heart of gold, the devoted wife, the women who want men to stay and not wander—Jill can take it or leave it. As she says, love doesn't matter.

Jill represents a radical shift in thinking about women's roles in the Western and does something more than vilify women as destroyers of the "ancient race." As Harmonica and Cheyenne walk out the door, Jill stands at the threshold, framed within the doorway, and watches them leave. The camera is not an observer situated inside the house; rather, Jill appropriates the subjectivity awarded the camera in the last shot of *The Searchers*. She does not assume the stance of wife, mother, or pining woman, nor is she relegated to any normative female domestic role. She does not, like Debbie and all the women of Ford's West, become enfolded or trapped inside the expectations of her gender, whether that expectation is to become either whore or Madonna. Moreover, she claims a status for herself that is neither strictly coded feminine or strictly coded masculine. Jill, standing on the threshold in the film's final sequence, assumes a pose reminiscent of her first appearance on screen where she pauses within the train's doorway. Just as Jill steps off the train, she will step outside the house; and the door that was once slammed shut at the start of the film, marking the end of the Western itself, she will purposefully open and walk through.

The Searchers leaves us with Ethan walking away from domesticity and community, leaving its audience with a certain optimism that the lone hero may return some day, but *Once Upon a Time in the West* does end similarly with the male heroes, Harmonica and a dead Cheyenne, riding away. Rather, Jill becomes the Ethan-like character who walks away from domesticity. While she walks outside the confines of a domestic role, she does not walk away from the community. Jill's final act of exiting the house and walking into the community directly contrasts with that final moment in *The Searchers* when the door closes on the lone hero. Jill steps out of the house, a house that

never really could contain her, and takes her central place. Here, a woman's rejection of domesticity does not relegate her to the margins or underside of society as whore or saloon girl. The door does not shut her in, but rather she emerges to take a place within Sweetwater's new economy not as any man's commodity, whether that be as wife or whore, but as the owner and distributor of commodities.

In recounting the genesis of the story, Leone explains, "We placed these characters in an epic context, that of the first economic boom which was about to make the great romantic epoch of the West disappear."[15] Frayling annotates Leone's comment by saying, "So the story conferences started with debates about the confrontation between Western heroes ('an ancient race') and the new era of the railroad boom, and the survival through memorable images of childhood fairytales of cowboys and gunplay into the complex world of adults."[16] Cawelti reinforces the notion that the "Western heroes" of boyhood fantasies are replaced by a much more complex world in which those childish men and ideals cannot survive when he writes, "the Western expresses the conflict between the adolescent's desire to be an adult and his fear and hesitation about the nature of adulthood" and to be a lone hero "means to escape from the restrictiveness and helplessness of childhood without incurring any sense of guilt or adult responsibility."[17] Exiting the house to distribute water to a thirsty crew of railroad workers, Jill, however, does not alienate herself, nor is she alienated from the West—all are invited and fed. Rather than seeing Jill in terms of the normative gender role of matriarch, we can read her as representing a better version of capitalism: She does not hoard her resources; she distributes them. Jill joins the community as a proprietor and nurturer. Unlike the solitary hero in *Shane* (1953), who brings a community back together and then must leave, Jill stays to manage that community. Unlike the corrupt robber baron Morton whose hoarding is literally manifest in a body that is eating itself and who shelters himself from the community in his train (Frank calls him a tortoise in his shell), Jill demonstrates a healthier stance. Unlike Harmonica's radical romanticism that precludes him from participating in a social order that requires commitment and responsibility, Jill owns her responsibility and commitment to the community. Isolation may be the mythical ideal of the classic Western hero—the "lonely male hero"—but isolation has never been the providence of women. Thus, the new sense of heroics that women bring is not the isolated wild individual but the socially responsible one. Here it is important to note that a woman's heroics do not mean the death of the individual. A woman's independence need not imply man's demise.

In this final moment of the film, we see the ancient race of men exit the screen—oddly enough, if there is any lover or coupling in this film, it is the love between these two men—and we see Jill taking her place as the center of a new town, Sweetwater. This final scene is where critics say the film clearly encodes her as the mother figure and nurturer. Indeed she may be those things, but she is still the businesswoman, still the savvy whore, and still the proprietor of the land. Although some critics concede that centralizing Jill at the end is indicative of Leone's pessimist lament that men with balls have been replaced by a matriarchy, it is much more than that. Despite this lasting image of Jill at the end as a mother to men, she cannot be reduced to that single stereotype. She survives because her ability to occupy multiple roles, her fluidity, makes her more adaptable to flux and transition. Her complexity and self-consciousness, and her ability to recognize irony all mark this new kind of female subjectivity that is also heroic. Finally, the lone Western hero can be a woman.

Notes

1. Christopher Frayling, *Spaghetti Westerns: Cowboys and Europeans from Karl May to Sergio Leone* (London: I.B. Tauris, 2006), 201.
2. Christopher Frayling, *Sergio Leone: Something to Do with Death* (London: Faber and Faber, 2000), 252.
3. Mary Ann McDonald Carolan's article "Leone's Lone Lady: A New Perspective on Women in *Once Upon a Time in the West*," *The Romance Annual* 11 (1999), 261–268 is one of the only scholarly articles devoted entirely to a feminist reading of Jill's role in the film. Carolan credits Leone with presenting a subversive critique of women's stereotypical roles in Westerns, but I suggest that Leone does so in spite of himself. While I agree that the critic should "look beyond the traditions of machismo that have precluded a more egalitarian evaluation of this genre for too long," I would not agree that "Leone also appears to be constructing simultaneously a new paradigm for the future" in which women hold positions of authority. Rather, I would say that Jill continues the traditional formulas of the Western genre, but that it's the gender classifications of the genre that need revision.
4. Robert C. Cumbrow, *Once Upon a Time: The Films of Sergio Leone* (Metuchen, New Jersey: The Scarecrow Press, Inc. 1987), 72.
5. Wendy Chapman Peek, "The Romance of Competence: Rethinking Masculinity in the Western," *Journal of Popular Film and Culture* 30, 4 (Winter 2003), 208.
6. John G. Cawelti, *The Six-Gun Mystique* (Bowling Green, OH: Popular 1984), 26. Likewise, Jim Kitses calls the defining characteristic of a Western as the opposition between Wilderness and Civilization in

Horizons West (London: Thames and Hudson, Ltd., 1969). See also Will Wright, *Sixguns and Society* (Berkeley: University of California Press 1975) for a classification of the Western myth in terms of such basic oppositions.

7. Cawelti, 69.
8. Andrè Bazin, *What Is Cinema? Vol II* (Berkeley: University of California Press 1971), 145.
9. Frayling, *Something to Do with Death,* 265.
10. Cawelti acknowledges the inherent contradictions in thinking about which themes are more important than others in the Western: "For example, the Western commonly presents the pioneer as a good figure and seemingly reflects approval of the concept or theme of progress. At the same time, many Westerns suggest a basic incompatibility between heroic figures like the marshal and gunfighter and the social order being created by progress. Are we to say then that the theme of the Western is progress or anti-progress?" (5). Although women in Westerns are often placed on the side of "progress," they are not afforded the kind of "approval" reserved for pioneering men.
11. Tania Modleski acknowledges this insidious privileging of male loss and subsequent vilification of women in at least one supposedly revisionist Western, *Unforgiven.* Eastwood's film introduces us to the character of Will Munny, who Modleski calls "a caricature of the Western hero civilized through the love of a good woman." As she rightly points out, the film "presents the civilizing woman as part of the hero's past, not his future; he needs to find his way back to his old self." That is, he needs to find his way back to the gunslinging, male hero we have been accustomed to appreciate in Eastwood's more familiar incarnation as lonely male hero of Leone's spaghetti Westerns. In other words, the future that women represent necessitates a loss of masculine ideals. As usual, a woman is represented as the cause of our discomfort and dissatisfaction in seeing Eastwood's character domesticated into a poor pig farmer. Tania Modleski, "Clint Eastwood and Male Weepies," *American Literary History* 22, 1 (Spring 2010), 145.
12. John Fawell in *The Art of Sergio Leone's Once Upon a Time in the West* (Jefferson, North Carolina: McFarland & Company, Inc. 2005) seems to be the only one to use the word "hero" in conjunction with Jill. He calls her an "existential hero of sorts, not unrelated to certain masculine heroes of Hollywood, for example in film noir, who dream of a better life that they know they will never see and in the end persevere in the world given them" (89).
13. Cawelti, 73.
14. In his interview with Frayling in 1982, Leone admits that his films are concerned with "a simple world of adventure and uncomplicated men—a masculine world" (*Something to Do with Death,* 261) without much use for women. Women, Leone contends, "were an obstacle to survival" (*Something to Do With Death,* 261).

15. Quoted in Frayling, *Something to Do with Death*, 252.
16. Frayling, *Something to Do with Death*, 252.
17. Cawelti, 82–83.

FILMOGRAPHY

Once Upon A Time in the West. Dir. Sergio Leone. Paramount Pictures, 1968.
The Searchers. Dir. John Ford. Warner Bros., 1956.
Man of the West. Dir. Anthony Mann. Ashton Productions, 1958.

WORKS CITED

Bazin, Andrè. *What is Cinema? Vol II*. Berkeley: University of California Press, 1971.

Cawelti, John G. *The Six-Gun Mystique*. Bowling Green, Ohio: Bowling Green University Popular Press, 1970.

Carolan, Mary Ann McDonald. "Leone's Lone Lady: A New Perspective on Women in *Once Upon a Time in the West*," *The Romance Annual* 11 (1999): 261–268.

Cumbrow, Robert C. *Once Upon a Time: The Films of Sergio Leone*. London: The Scarecrow Press, Inc., 1987.

Fawell, John. *The Art of Sergio Leone's Once Upon a Time in the West*. Jefferson, North Carolina: McFarland & Company, Inc., 2005.

Frayling, Christopher. *Sergio Leone: Something to Do With Death*. London: Faber and Faber, 2000.

——. *Spaghetti Westerns: Cowboys and Europeans from Karl May to Sergio Leone*. London: I.B. Tauris, 2005.

Kitses, Jim. *Horizons West*. London: Thames and Hudson, Ltd., 1969.

Modleski, Tania. "Clint Eastwood and Male Weepies," *American Literary History*, 22 (1) (Spring 2010): 136–158.

Peek, Wendy Chapman. "The Romance of Competence: Rethinking Masculinity in the Western," *Journal of Popular Film and Television*, 30 (4) (Winter 2003): 206–219.

Wright, Will. *Six Guns and Society*. Berkeley: University of California Press, 1975.

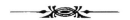

"Wild" Women: Interracial Romance on the Western Frontier

Cynthia J. Miller

Romance between races in the cinematic West is fraught with peril. Many a cowboy has lost his heart, his fortune, his friends, and even his life after succumbing to the charms of an exotic senorita or an alluring Indian maid. Volatile, passionate, and instinctual, they are, as one sadder-but-wiser suitor observed, "The sweetest poison that ever got into a man's blood."[1] Settlers' daughters fare even worse when their encounters with the "wild" West become intimate. Tainted in the eyes of their friends, neighbors, and communities, these unfortunates of the frontier lose their status as "clean," "moral," and "civilized" when their fates become intertwined with Mexican or Native American men bold enough to defy the boundaries of race or ethnicity. These liaisons, full of danger and despair, occur on dual frontiers—one geographic, and the other racial—where notions about civilization and savagery, morality and passion, collide.

From the silent era through the genre's Golden Age, and beyond, Western films such as *Scarlet Days* (1919), *North West Mounted Police* (1940), *My Darling Clementine* (1946), *Duel in the Sun* (1946), *High Noon* (1952), *The Searchers* (1956), *100 Rifles* (1969), *Little Big Man* (1970), *The Last of the Mohicans* (1992), and *All the Pretty Horses* (2000) illustrate the consequences of romance on the racial frontier, setting up morality tales about the common good that pit unfettered

emotion, wildness, and sexuality against order, control, and civiliza-
tion. While, as Angela Aleiss points out, filmmakers often "wrestled
with contradictory resolutions" to interracial romance, these narra-
tives typically reflect the codes of the eras from which they arise
(23). Time after time, lovers are beset by sorrow and destruction;
sirens, *bandidas*, and soiled doves meet violent ends; and the vic-
tims of captivity narratives are granted existence only at the margins of
their former worlds. The social message delivered by these films, as a
body of cultural work, is that miscegenation is dangerous, destructive,
and morally wrong. But even with all the consequences of interracial
romance on the classic Western frontier, these risky relationships con-
tinued to play a central part in many narratives, leaving us to ask, what
does this complex and dangerous love do for the story of the West?

This chapter will explore the workings of love across racial and eth-
nic boundaries in the cinematic West, with a particular eye toward
the roles of its "wild women"—the *bandidas*, saloon girls, traders,
and others of Native American, Latina, and mixed-race heritage who
are often aligned with the wildness of the untamed land and cast in
unruly opposition to the "civilized" frontier wife, rancher's daughter,
and schoolmarm—asking whether their relationships with the Western
genre's iconic cowboys, soldiers, lawmen, and ranchers might, in fact,
bring something *necessary* to the narrative history of the frontier.
In what ways might these women stand as a part of the frontier that
couldn't be tamed—a part that persists in the face of civilization?
Is their ability to speak to the wildness that exists in all civilized men
their real threat to society? Is their "taming" key to taming the West?

Regulating Romance

Concerns about cinematic depictions of relationships across
the boundaries of race and ethnicity—generally conceived as
miscegenation—have typically been focused on portrayals of romantic
or sexual encounters between blacks and whites.[2] Heavy-laden with
social, historical, and ideological freight, the term "miscegenation" is,
as Jane M. Gaines points out, far from neutral (199). Its very utterance
evokes images of "pollution," "corruption," and "trespass" (Lott,
"Love and Theft" 30). It carries a warning, not merely about sex
across the "color line," as Gaines notes, but of fear, inadequacy, loss
of control, and ultimately, of decline in social, political, and economic
status (199).[3] These concerns are part of a much larger constellation
of culturally situated notions about appropriate relationships, encom-
passing racial, ethnic, and class-based endogamy—a framework that

has informed cinematic portrayals of sexual and romantic couplings since the origins of the medium itself.

Portrayals of romantic or sexual pairings of whites with blacks, Asians, Latino/as, or Native Americans were increasingly suppressed during cinema's infancy, supporting and reflecting the proliferation of antimiscegenation legislation in the wider culture. In 1930, the intermittently enforced Motion Picture Production Code specifically prohibited the depiction of interracial sexuality or romance. In the surprisingly many films where portrayals of interracial coupling were present, they largely served to uphold "culturally accepted notions of nation, class, race, ethnicity, gender, and sexual orientation," typically functioning as a morality tale about the disastrous ends met by those who dared to cross racial or ethnic lines[4] (Marchetti 1; Mapp). While the production code specifically elaborated "sex relationships between the white and black races" in its edict against miscegenation, popular conceptualizations interpreted both "black" and the prohibition itself much more broadly, to include other non-Caucasian groups, as well (Chin and Karthikeyan 1; Fuller 168–169, 205). Even after the code's revision in 1956, when miscegenation became one of the several themes no longer banned in films, social resistance remained.

This resistance to, and resentment of, portrayals of interracial relationships in film echoes the fears embedded in its industry's origins, and the observations of scholars such as Eric Lott and Linda G. Tucker, who note that such resistance is informed by the "assumption that white women's bodies needed to be protected from what white men perceived as … superior sexual potency" (Lott 1993: 57; Tucker 50). These cultural responses to race and sexuality—as simultaneously threatening and fascinating—extended across genders, casting women of color as sexual aggressors or deviants, as well. As Jacqueline Bobo, Felly Nkweto Simmons, David J. Leonard, and others note, "the most resilient image has been that of the jezebel, the 'sexual siren' " (Leonard 48). These portrayals, then, have infused cinematic—as well as real-world—perceptions of relationships across racial and ethnic boundaries with a sense of physical, as well as social, danger.

In the first half of the twentieth century, the Western genre both confronted and reinforced taboos against interracial romance, perhaps more than any other genre of the time. As John Cawelti and others have observed, Westerns provide "archetypal stories that embody the organizing principles of the society we live in" (Stephens 61). Existing in dynamic tension with the prevailing social order, Westerns,

both the "A"s, with their high production values, and the low-budget "B"s were vehicles for tales of danger and adventure on the frontier—a land beyond law, beyond experience—where the moral order was continually renegotiated. As such, they were also suitable vehicles for explorations of the racial frontier, as well, as Stephens notes:

> Films about explorers of frontiers serve as morality plays. They can call into question the morality of the existing order ... Or they can affirm the existing order by using tragedies ... to warn of the dangers of going outside social norms into a "no man's land." (63)

These films—such as King Vidor's *Duel in the Sun* (1946)—were brought to life by narratives and characters that either subtly or overtly questioned, but ultimately reinforced social norms, mainstream values, and conventional gender roles of the times, and reassured audiences that despite changes in the world around them, the conventions on which their lives turned remained in force—creating tidy categories of "self" and "other," and making life, and its rewards and consequences, predictable. The preface to Vidor's film advises audiences that the film

> ... is a saga of Texas in the 1880s when primitive passions rode the raw frontier of an expanding nation. Here the forces of evil were in constant conflict with the deeper morality of the hardy pioneers. Here, as in the story we tell, a gray fate lay waiting for the transgressor upon the laws of god and man.
> (Beltran and Fojas 49)

A gray fate, indeed, awaited the film's "wild" woman, Pearl Chavez (Jennifer Jones), a mixed-race woman-child tormented by the consequences of her own sensuality. Unable to resist the desire that burns in her blood, she is torn between the passions of two brothers. Only a violent death ultimately frees her and her lovers from the battle of lust against love, flesh against faith.

Pearl and the other "wild" women of the frontier—Native Americans, Latinas, and women of mixed-race ancestry—played a significant role in both confirming and contesting mainstream social conventions, testing the boundaries of female gender roles, and adding dimension to audiences' understandings of "a woman's place" in the rugged, male-identified territory of the West. At the same time, they both challenged and succumbed to taken-for-granted notions about appropriate romantic and sexual relationships.

FROM PRINCESSES TO BANDIT QUEENS

As scholarship on race and sexuality in film has increased, volumes such as *Romance and the Yellow Peril* (1994), *Hollywood Fantasies of Miscegenation* (2005), and *Mixed Race Hollywood* (2008) have taken up these themes more broadly, but issues of interracial romance have informed discussions of the Western genre for decades, as early as volumes such as Fenin and Everson's *The Western: From the Silents to Cinerama* (1962), John Cawelti's *Six-Gun Mystique* (1971), and Pierre Berton's *Hollywood's Canada* (1975). Most recently, discussion of the social meanings that inform these narratives in Western films may be found in works such as Angela Aleiss's *Making the White Man's Indian* (2005) and M. Elsie Marubbio's *Killing the Indian Maiden* (2006).

While David Grimstead contends that "[t]he country in a sense began with the Pocahontas story, and never lost some enthusiasm for interracial romance between Indians and whites," the majority of scholarly work argues for much greater complexity and tension in those portrayals (322–323). In her considerations of the portrayals of Native American women, Marubbio identifies two primary archetypes: the Celluloid Princess and the Sexualized Maiden, which define characterizations of indigenous women in Western films. The Celluloid Princess, which is the more romantic of the two figures, is a critical figure in the mythic structure of the frontier—a symbol of the "wildness" of the West that is conquered by her willing union with a white hero—defined by

... her connection to nature and the American landscape, her innocence and purity, her link to nobility, her exotic culture and beauty, her attraction to the white hero, and her tragic death. (6)

Conversely, Marubbio's Sexualized Maiden is a character that retains her "wildness," combining "racial exoticism, sexual promiscuity, and physical threat to the hero" (7). She is a *femme fatale*—as Robert Lyons suggests, "explicitly erotic, sexually active, not above a little infidelity"—and a vivid reminder of the dangers of violating interracial sexual and romantic taboos (8). Although she shares these qualities, in various combinations, with other transgressive women of the West, one significant difference sets the Sexualized Maiden and her Latina and mixed-race sisters apart: Race. As Marubbio argues, the "inherently bad" qualities exhibited by these women are attributed to their racial and ethnic heritage—"bad blood"—making them inherently immoral and irredeemable (8).

76 CYNTHIA J. MILLER

The threat of miscegenation posed by these sexualized characters is significant. With their exotic beauty and cultural "otherness," they function as racialized sirens who threaten the core of civilization and community, by leading men—that is, civilized, white, Western men—astray. And when the "wild woman" in question is of mixed-race, she presents a double affront to civilization—combining the aforementioned threat with her role as the living, breathing, impossible-to-ignore embodiment of miscegenation, herself—making her both product of and player in a wild and savage West. She is also representative of the status Robert Park has termed "marginal man": "one whom fate has condemned to live in two societies and in two, not merely different but antagonistic cultures…an effect of imperialism, economic, political, and cultural" (xv, xviii). Tropes of savagery and ethnic stigmas of inferiority are heaped on the multiracial seductress, as the antitheses of white civilization.

Cinematic illustrations of these characterizations abound: Paulette Goddard's feisty Louvette in *North West Mounted Police* (1940); Carol Forman's portrayal of the silent and sinister spy in *Under the Tonto Rim* (1947); Barbara Britton's title role as the daring avenger in

Figure 5.1 Paulette Goddard's feisty Louvette in *North West Mounted Police* (1940) attempts to sell her furs to Dusty Rivers (Gary Cooper).
Source: Courtesy of The Samuel Goldwyn Company.

Bandit Queen (1950); and a host of infamous saloon girls and soiled doves, such as Katy Jurado in *High Noon* (1952), Margia Dean in *Ambush at Cimarron Pass* (1958), and, of course, Linda Darnell as the legendary Chihuahua in *My Darling Clementine*. Set in Tombstone in 1882, the film tells the story of Wyatt Earp's brief stint as marshal, his friendship with Doc Holliday, his revenge on the Clanton clan for killing his brother, and his love for Clementine Carter (Cathy Downs), Doc's ex-fiancée. Lovely, refined, jilted Clementine functions as the positive feminine pole in the narrative, and in her relationship with Earp, the promise of "harmonious community." Clementine's opposite, Chihuahua, a mixed-blood saloon girl, is the film's negative feminine pole, standing for immorality, the wild and savage West, and a threat to civilized order. Moral darkness surrounds Chihuahua, and in her passionate relationship with Doc Holliday, she serves as "a seductress—a deadly dame who will fascinate [him], drag him into deep waters, and then, as if by some eternal law, perish herself" (Jackson 96). And indeed, if not eternal law, constraints of the film industry and the social constructs of the day demanded that women who love across the racial or ethnic divide repent or suffer sanctions resulting in isolation, misery, or death. Their fate stands as a warning, and also acts as a preventative, assuring that the white men with whom they are entangled do not permanently abandon their own culture for the lure of passion and freedom.

In a West where the call of that freedom exists in constant tension with the mandate to dominate and control, racialized female characters, such as Chihuahua, are symbolically aligned with its chaos, savagery, and wildness. They defy the traditional Western binary opposition between men and women, in which gender shapes the moral and social norms of the characters, and typically pits female characters against the "male" propensity for violence and libidinal pursuits. John Cawelti observes that the racialized ("dark") Western "wild woman," like Chihuahua, is the "feminine embodiment of the hero's savage, spontaneous side. She understands his deep passions, his savage code of honor, and his need to use personal violence" (31). And in that understanding lies, as Richard Maltby notes, her downfall: "The dark heroine is doomed by her knowledge of the hero's sexuality" (43). This characterization of indigenous "darkness," and its opposition to light-skinned European-American women, is particularly relevant to the status of "wild" women entangled in interracial romance: Chihuahua and Clementine in *My Darling Clementine*; Cora and Alice in *The Last of the Mohicans*; Debbie and Lucy in *The Searchers*; Louvette and April in *North West Mounted Police* all

Figure 5.2 Louvette (Paulette Goddard) is contrasted with April Logan, Madeleine Carroll's Celluloid Princess in *North West Mounted Police* (1940).
Source: Courtesy of The Samuel Goldwyn Company.

function as poles of visible moral triangles in the struggle between passion and propriety.

TRANSGRESSIVE WOMEN, FORBIDDEN LOVE

Prior to the revisionist trend that began to shape the genre in the late 1960s—bringing a dark realism and more sympathetic treatment of Native Americans and Mexicans to the cinematic West—Western films were brought to life by characters who reinforced social norms, mainstream values, and conventional gender roles of the times (Stanfield). The classic Western emphasized the establishment of law and order, and presented an essential and a ritualistic conflict between civilization and savagery. These elements were constructed into various oppositions—East versus West; light versus dark; social order versus anarchy; community versus individual; town versus wilderness; cowboy versus Indian; schoolmarm versus dancehall girl—and were manifested externally, in the landscape, and internally, in the community. The boundaries that existed between these positive and negative poles were clearly marked off for all to see, with symbolic markers

clearly displayed in characters' dress, speech, and morals. Western heroes and heroines had a dual obligation—an allegiance to the frontier environment and the independence, ingenuity, and forthrightness that it symbolizes; as well as a moral commitment to civilization—embodying and defending the best of its values and beliefs, and taming the frontier's wildness so that it might be drawn into the civilized scope. Frontier romance was a significant component of that moral contract, with its emphasis on chastity, endogamy, and the promotion of family.

Heroes, hardworking men, and upstanding women—and their romances—reassured audiences that despite changes in the world around them, the conventions on which their lives turned remained in force—creating tidy categories of "insider" and "outsider," and making life, along with its rewards and consequences, predictable. Interracial and interethnic romance, however, eroded that certainty. The sexualized maiden, like the Latina *bandida*, the mixed-race soiled dove, and other transgressive racialized women of the West both confirmed and contested those conventions—challenging notions of chastity, fidelity, and moderation; testing the boundaries of female gender roles; and adding dimension to audiences' understandings of "a woman's place" in the rugged, male-identified territory of the West.

Tough, sinister, and sometimes shady, but also bold and daring, these racialized "wild" women helped and hurt heroic men and villains alike, and called into question the simplicity of the schoolteacher, the pioneer wife, and other mainstream female roles. These complicated women of the West were characters of great depth and breadth, frequently offering female actors a wider range of roles than was available in portrayals of the archetypal domesticated Western woman. Far from one-dimensional, they displayed an array of talents, motivations, and possibilities not often seen in Western women, and rivaled, perhaps, only by female roles of film noir, which was experiencing its "classic" era at the same historical moment.[5] Through their intersection of race, romance, and social transgression, they simultaneously confronted and were part of both the wildness *and* the taming of the American frontier.

This confrontation is particularly apparent in the case of the Latina or multiracial "working girl" character of the West. A mainstay of saloons, dancehalls, and brothels, the power wielded through her sexuality is overt, and directly available for social commentary, within and outside the text of the film. Fallen women of the frontier (or those of questionable morals) have a complex social role in cinematic

narratives. On the surface, they are dynamically juxtaposed against the valued female norm—the nurturer, the respectable sweetheart, wife, and mother and the school marm—the civilizers…keepers of the moral flame…controllers of male passions. On a deeper level, however, soiled doves embody the complexities of all women, and bear the weight of social awareness in ways that the normative Western female character of the classic era cannot. The Western prostitute is firmly situated in the economic realities of the West; displays a deep, nuanced understanding of human nature and social hierarchy; and typically has a heightened awareness of structures of power, both domestic and communal—a sadder but wiser girl, who fully understands the social space she inhabits, and manipulates it to the best of her abilities. She shares the label of "common" doled out to working-class folk by the gentry, and simultaneously is embraced and used as a scapegoat by her fellow commoners. She stands for the lack of justice and voice available to all women, and yet is considerably more powerful than the repressed female norm, because of her transgressive, outspoken nature.

She is also a woman in need of redemption, or who otherwise suffers destruction—the source for countless plot devices. After all, a soiled dove is still a dove underneath. And her redemption by a man situated within, or at least on the periphery of, the moral order is a critical reinforcement of social norms and values. In this, the classic Westerns and revisionist Westerns have much in common. Those who are repentant and redeemed—like Jane Russell's working girl, Rio McDonald, in *The Outlaw* (1943)—may be rewarded with some version of the normative lifestyle cherished by civilized society. At the film's conclusion, Rio's transformation was rewarded by romantic commitment from a man—Billy the Kid (Jack Buetel)—a significant normative resolution, even if that man was himself transgressive and existing on society's margins.

CAPTIVE BODIES, WILD HEARTS

What happens when romance across racial or ethnic boundaries is more about power, politics, or aggression than romantic or sexual passion? A mainstay of "Indian romance" literature with roots in the eighteenth and early nineteenth centuries, captivity narratives are well-represented in the Western genre, speaking more directly to fears of miscegenation than other narrative forms, in films such as *Broken Arrow* (1950), *The Searchers* (1956), *Little Big Man* (1970), *Dances with Wolves* (1990), and *The Last of the Mohicans* (1992)

(Wardrup 1997).[6] These films present a range of captivity narratives, with some featuring a male captive, and others, a female. The common thread that runs through all of these motion pictures, however, is a crossing of the racial frontier initiated by force, rather than by mutual desire. Their narratives are burdened, not only with social anxieties about the act of miscegenation, itself, but also about the longer-term effects it has—the production of mixed-race offspring and the cultural and psychological assimilation of white women or men by their Native American captors—resulting in the blurring of racial and cultural boundaries. This is particularly apparent during a rescue scene in John Ford's *The Searchers*, when a cavalry officer, taken aback by the state of captive white girls who appear insane and can no longer converse in English, exclaims, "It's hard to believe they're white" and receives the stoic reply "They're *not* white anymore."

While numerous films provide insight into interracial romance in the Western genre, *The Searchers* is, perhaps, the most familiar to audiences, and the most fully considered in scholarly literature on the genre. As Douglas Pye observes, miscegenation in *The Searchers* "can be imagined only as rape, and its results are madness, violence and death" (232). Despite Ford's refusal to allow the film to draw moral conclusions, interracial sex remains most closely associated with horror and brutality (Hui 195). Scenes repeatedly allude to violence and depravity indirectly—through close visual studies of the characters' discoveries of the (female) victims' remains—rather than grounding the scenes in the plights of the victims, themselves. The horrors suggested leave the rugged Ethan (John Wayne) speechless, and propel Brad (Harry Carey, Jr.) to the brink of insanity. As Hui observes, the relationship between the captive Debbie (Natalie Wood) and the Comanche Scar (Henry Brandon) is the least visible, yet the most dominant, in the film (199). Fully acculturated into Scar's tribe, Debbie resists rescue, and is nearly killed by Ethan for the transgressions she now represents.

Sex across racial boundaries receives very different portrayal when a male captive is the focus of a captivity narrative. This is due, in no small part to what Pye posits as gendered traditions of purity and pollution: " . . . sex between a white man and a Native American woman is unthreatening . . . while sexual contact between a white woman and a nonwhite man is an entirely different matter—tragic and demanding of vengeance" (227). Director Delmer Daves' film *Broken Arrow*—awarded a Golden Globe for "Best Film Promoting International Understanding"—featured a brief captivity narrative that set the stage

for interracial romance between Tom Jeffords (James Stewart) and the celluloid maiden Sonseeahray (Debra Paget). While the marriage ends in her death at the hand of marauding whites, Jeffords' bond with the Apache nation continues, with, as William Everson observes, "a few weak lines of dialogue insisting that her death was not in vain, because it had brought Indian and white closer than ever before" (281). Similarly, in Arthur Penn's *Little Big Man*, Jack Crabb (Dustin Hoffman) is captured in childhood, adopted, and raised by Cheyenne. Crabb displays characteristic revisionist sympathies for his Native American captors and a fluid racial identity, ultimately coupling with not only the Cheyenne woman Sunshine (Aimee Eccles) but with her widowed sisters, as well. He embraces the wilderness, a choice that his interracial romance, as Marubbio notes, makes easy (169). Looking back on his life, he recalls, "I reckon right then I come pretty close to turning pure Indian, and I would have spent the rest of my life with Sunshine and her sisters." While the interracial relationship between Crabb and Sunshine is sanctioned within the world of the narrative, the moral tension it creates between that world and the world of the audience is resolved with the death of both Sunshine and their mixed-race child at the hands of Custer's army. As Jacquelyn Kilpatrick observes, "Mixing emotions, mixing blood, and mixing identity have historically tended to provoke violence in Hollywood movies... it is an easier idea to deal with if it is presented as a tragic possibility..." (84).

George Seitz's 1936 adaptation of James Fenimore Cooper's *The Last of the Mohicans* (1826) circumvented the need for tragedy by removing interracial romance from the narrative, and portraying the tale's star-crossed lovers as white.[7] Over half a century later, however, director Michael Mann reintroduced Cooper's theme of forbidden love in his remake of the film, casting once again the attraction between Mohican brave Uncas (Eric Schweig) and Cora Munro (Madeline Stowe), the daughter of a white army general, as romance across the racial divide.

LOVE IN A TIME OF REVISION

As the genre entered its revisionist era, and portrayals of Native American, Latino/a, and white characters, alike, became increasingly resistant to facile, stereotypical definition, depictions of interracial and interethnic romance grew more complex, as well. Longheld notions of purity and pollution were interrogated, blind adherence to endogamy was challenged and mocked, and the consequences for violating romantic and sexual taboos began to lose force.

In 1966, Richard Brooks' adventure, *The Professionals*, called into question cherished assumptions about class and caste, and complicated the issue of love across racial and ethnic boundaries through a false captivity narrative. The wealthy Joseph W. Grant (Ralph Bellamy) engages the titular "professionals" (played by Lee Marvin, Burt Lancaster, Woody Strode, and Robert Ryan)—violent men for hire—to rescue his wife, Maria (Claudia Cardinale), who has been kidnapped by Mexican outlaw Jesus Raza (Jack Palance). The film's moral messages become more complex, however, as the narrative both challenges and reinforces mainstream notions of endogamy. Maria, Raza's longtime lover, is a co-conspirator in her own kidnapping, choosing an illicit affair with a "wild" and transgressive partner over her marriage to the affluent and "civilized" Grant. Her choice is a rejection of class, race, and social norms—a triple affront to society. As a woman of Mexican heritage, however, it is her relationship with Grant that is truly transgressive—violating taboos against love across racial and ethnic categories—and her false kidnapping is, in fact, a narrative of return. Although Grant's hired guns defy him at the film's conclusion, their actions defend more than "true love"—they defend the borders of the racial frontier.

Three years later, however, those borders are subject to a full-on assault by Tom Gries' controversial film *100 Rifles*. Burt Reynolds, Jim Brown, and Raquel Welch star as an unlikely trio—a half-Yaqui, half-white wanted for robbery, an African American deputy, and an Indian revolutionary—brought together in an adventure of larceny, passion, and political resistance in the border town of Nogales, Mexico. Yaqui Joe (Reynolds) robs an Arizona bank, in order to buy guns for the Indian resistance against a Mexican governor (Fernando Lamas) who, aided by the Germans, is bent on annihilating the Yaqui Indians. Lydecker (Brown), a US deputy, pursues the fleeing Indian across the border, and after experiencing the Mexican's savagery, aligns himself with the fugitive Yaqui. The pair is captured, but is soon freed by the overtly erotic rebel leader Sarita (Welch). Joining forces, the three defeat the governor and his troops. A true "wild" woman of the frontier, Sarita's character is consistent with Marubbio's sexualized maiden archetype—she is aggressive and daring, and exploits her sexuality to further her own interests and those of her people. While a minor (unnamed) female character—a sexualized Latina of questionable character, played by Soledad Miranda—displays more nudity in the film, Welch's Sarita is featured in a seductive public shower scene that has retained its erotic force, despite dramatic shifts in conventions for the display of sexuality on screen.

While the film's unvarnished sympathies for the Yaqui result in
Lydecker freeing Yaqui Joe to lead the resistance and returning
to the United States alone, it is the interracial romance between
African American Lydecker and Native American Sarita that sparked
controversy among critics and audiences, alike. Often credited with
being one of the first major Hollywood productions to feature an
interracial sex scene, *100 Rifles* explicitly "breach[ed] the sexual bar-
rier" between black men and white women, in spite of the liaison's
framing as African American and Mexican. "The fact that Raquel
Welch was supposed to be a Yaqui Indian did not alter the impact
of showing bodily contact between a black male and white female"
(Lenihan 51). In spite of the Western genre's numerous portrayals
of interracial romance between Native Americans or Latino/as and
whites, the scenes between Lydecker and Sarita were of particular
significance, specifically due to his status as an African American—
scenes that were explicitly prohibited just one year earlier. Unlike his
predecessors, as Guerrero observes, "Brown was able to...act in a
violent, assertive manner and express his sexuality openly and beyond
dominant cinema's sexual taboo" (79).

In the ensuing decades, many revisionist Westerns have addressed
the theme of interracial or interethnic romance, adding additional
depth and complexity to the genre's treatment of these once-
controversial liaisons. Carlos Cortes suggests that the demise of the
production code, concurrent with Civil Rights-era social changes—an
articulated interest in race relations, the growth of ethnic pride, and a
significant increase in "minority" moviegoers—led to significant shifts
in the conventions of portraying interracial romance across genres,
providing "enlightening glimpses into both new American realities
and the changing American psyche" (30–31). White men fell in love
with Native American, Latina, and Asian women in films such as
Jeremiah Johnson (1972), *Young Guns* (1988), and the 1992 remake
of *The Last of the Mohicans*—and those roles reverse in films such as
When the Legends Die (1972). In spite of these shifts, however, tra-
ditional conventions persist: Captivity narratives still drive the plots
of films such as *The Missing* (2003), love's ultimate failure to bridge
racially based cultural divides still frames the resolution of films such
as *Cheyenne Warrior* (1994), and in one of contemporary film indus-
try's more acclaimed epic Westerns, *Dances with Wolves*, the tension of
interracial marriage between John Dunbar (Kevin Costner) and Stands
with a Fist (Mary McDonnell) is circumvented by the fact that she is
culturally Sioux, but racially white.

THE FATE OF THE DUAL FRONTIER

In spite of these contradictory resolutions, interracial and interethnic romance in the cinematic West are inextricably linked with the figure of the "wild" women, and in particular, the transgressive "wild" woman—the *bandidas*, the working girls, the gunslingers, and the exotic racialized outsiders—who defy, rather than symbolize, mainstream social order, education, and morality. Physically and emotionally strong, unbound, sensual, and full of intensity and vitality, they present a clear and present danger to civilized society—at times through wantonness, violence, treachery, or rage; at others, through their introduction of possibility and difference.

These characters are not merely dangerous, however; they require thought. And often, our considerations of their roles and impacts on Western narratives are incomplete. Typically, their portrayals tell us more about social needs and fears of mainstream American society than they do about the women who challenged life on the geographic and racial frontiers. While their realities were complex and varied, their cinematic stories typically lapse into morality tales that reassure audiences of the essential "rightness" of existing social codes and moral structures. A careful look, though, reveals a testing of those codes and structures; an experimentation with ways of being; and a range of commentary about power, hierarchy, and the naturalization of gender roles just not available in the world of mainstream female characters. "Wild" women of the cinematic frontier often embody multiple oppositions to understandings of civilized life in the West, calling into question taken-for-granted notions of class and race, and subverting the limitations placed on women of their eras.

This, in turn, has significant implications for interracial romance in Western films. Native American, Latina, and mixed-race characters not only symbolize the freedom, independence, and wildness of the West—the very imaginings that informed literature and film, and inspired countless treks westward—but also most, male and female, actively engage with it. They *are* the romance of the Old West, offering their partners across the racial frontier a passion and agency not visible—or perhaps, available—in endogamous, "civilized" romances. Like the frontier, itself, the West's "wild" women—Louvette, Chihuahua, Sarita, Maria, and others—possess an allure that draws to them adventurers, wanderers, and dreamers—the brave and the foolhardy, alike—then, as on the frontier, that fascination is too often replaced by hardship and tragedy. Both the geographic and racial frontiers, by their very nature, invite taming, and, as they are,

the fire of the Old West—and that of exotic, interracial romance—is extinguished.

Or is it? In an era that has experienced a resurgence and hybridization of the Western genre, with the adaptations of Cormac McCarthy's *All the Pretty Horses* (2000) and *No Country For Old Men* (2007), and the production of Western (or Western-themed) films as diverse as *The Wild, Wild West* (1999), *From Dusk 'Til Dawn 3: The Hangman's Daughter* (2000), *Hidalgo* (2004), *Brokeback Mountain* (2005), *3:10 to Yuma* (2007), the animated *Rango* (2011), and *Cowboys and Aliens* (2011), the flame of the Western frontier appears to have been rekindled in territories such as steampunk, horror, fantasy, queer cinema, and science fiction. Marubbio notes that the female archetypes that populated the classic and revisionist Westerns have also migrated and reconfigured in other genres (such as the WB television series *Smallville*), and interracial romance has flourished in television series such as *ER* (NBC), *Grey's Anatomy* (ABC), and *Gilmore Girls* (WB) (228–229). Perhaps most significantly, though, John Favreau's science-fiction-Western hybrid *Cowboys and Aliens* has revitalized the exotic "wild" woman of the West, and revived the passion, danger, and ultimate tragedy of the frontier's classic interracial relationships. The aptly named Olivia Wilde (Ella Swenson) rides, shoots, and fights like a man, quickly captivating the film's antihero the amnesiac Jake Lonergan (Daniel Craig) with her boldness, mystery, and exotic beauty. She is an able gunfighter, an alluring temptress, an avenging angel, and a maiden in need of rescue—an archetypal Western "wild" woman—but she is also an alien. In classic Western fashion, their romance is destined to end tragically, with her death—affirming that even the Westerns of a new century continue to embrace the tropes of decades long since past.

Notes

1. *The North West Mounted Police* (1940).
2. Coined in 1864, the term emerged as part of a political hoax advocating racial "blending," that was intended to embarrass the Lincoln administration during the president's emancipation-based bid for reelection.
3. See also: Hodes (1997).
4. Well over 50 movies featuring romantic or sexual relationships between races were produced prior to the repeal of the production code, in addition to numerous Western genre films featuring relationships between white characters and those of Latino/a origin and "half breeds."

5. Film noir's "golden age" on film occurred 1941–1958, but on television, not until 1959–1965.
6. For more on early captivity romance literature, see Gregor (2010).
7. This is particularly interesting since Seitz's 1925 film *The Vanishing American* depicted interracial romance between a white man and Native American woman.

FILMOGRAPHY

100 Rifles. Dir. Tom Gries. Marvin Schwartz Productions, 1969.
3:10 to Yuma. Dir. James Mangold. Relativity Media, 2007.
All the Pretty Horses. Dir. Billy Bob Thornton. Columbia Pictures, 2000.
Ambush at Cimarron Pass. Dir. Jodie Copelan. 20th Century Fox, 1958.
Bandit Queen. Dir. William Berke. Lippert Pictures, 1950.
Brokeback Mountain. Dir. Ang Lee. River Road Entertainment, 2005.
Broken Arrow. Dir. Delmer Daves. 20th Century Fox, 1950.
Cheyenne Warrior. Dir. Mark Griffiths. Libra Pictures, 1994.
Cowboys and Aliens. Dir. John Favreau. Fairview Entertainment, 2011.
Dances with Wolves. Dir. Kevin Costner. Tig Productions, 1990.
Duel in the Sun. Dir. King Vidor. Selznick International Pictures, 1946.
From Dusk 'Til Dawn 3: The Hangman's Daughter. Dir. 2000.
Hidalgo. Dir. P. J. Pesce. A Band Apart Studios, 2004.
High Noon. Dir. Fred Zinneman. Stanley Kramer Productions, 1952.
Jeremiah Johnson. Dir. Sydney Pollack. Sanford Productions, 1972.
Last of the Mohicans, The. Dir. Michael Mann. Morgan Creek Productions, 1992.
Little Big Man. Dir. Arthur Penn. Cinema Center Films, 1970.
Missing, The. Dir. Ron Howard. Revolution Studios, 2003.
My Darling Clementine. Dir. John Ford. 20th Century Fox, 1946.
No Country For Old Men. Dir. Joel Coen and Ethan Coen. Miramax Films, 2007.
North West Mounted Police. Dir. Cecil B. DeMille. Paramount Pictures, 1940.
Outlaw, The. Dir. Howard Hughes. Howard Hughes Productions, 1943.

WORKS CITED

Aleiss, Angela. *Making the White Man's Indian: Native Americans and Hollywood Movies.* Westport, CT and London: Praeger, 2005.
Beltran, Mary and Camilla Fojas. *Mixed Race Hollywood.* New York: New York University Press, 2008.
Bobo, Jacqueline. *Black Women as Cultural Readers.* New York: Columbia University Press, 1995.
Berton, Pierre. *Hollywood's Canada: The Americanization of Our National Image.* Toronto: McClelland and Stewart Limited, 1975.

88 CYNTHIA J. MILLER

Cawelti, John. *Six-Gun Mystique*. Bowling Green, OH: Bowling Green Popular Press, 1971.

Chin, Gabriel and Hrishi Karthikeyan. "Preserving Racial Identity: Population Patterns and the Application of Anti-Miscegenation Statutes to Asian Americans 1910–1950." *Berkeley Asian Law Journal* 9.1 (2002): 1–39.

Cortes, Carlos. "Hollywood Interracial Love: Social Taboo as Screen Titillation." *Beyond the Stars: Studies in American Popular Film, Volume 2: Plot Conventions in American Film*. Paul Loukides and Linda K. Fuller, eds. Bowling Green, OH: Bowling Green State University Popular Press, 1991.

Courtney, Susan. *Hollywood Fantasies of Miscegenation: Spectacular Narratives of Gender and Race, 1903–1967*. Princeton, NJ: Princeton University Press, 2005.

Fenin, George and William Everson. *The Western: From Silents to the Seventies*. New York: Grossman Publishers, 1973.

Fuller, Karla Rae. *Hollywood Goes Oriental: CaucAsian Performance in American Film*. Detroit: Wayne State University Press, 2010.

Gaines, Jane M. *Fire and Desire: Mixed-Race Movies in the Silent Era*. Chicago: University of Chicago Press, 2001.

Gregor, Theresa. "From Captors to Captives: American Indian Responses to Popular American Narrative Forms." Unpublished dissertation, University of Southern California, 2010.

Grimstead, David. "Re-searching." *The Searchers: Essays and Reflections on John Ford's Classic Western*. Arthur M. Eckstein and Peter Lehman, eds. Detroit, MI: Wayne State University Press, 2004.

Guerrero, Ed. *Framing Blackness: The African American Image in Film*. Philadelphia: Temple University Press, 1993.

Hodes, Martha. *White Women, Black Men: Illicit Sex in the Nineteenth-Century South*. New Haven, CT: Yale University Press, 1997.

Hui, Arlene. "La Frontera Racial en The Searchers de John Ford." *Revista Complutense de Historia de America* 30 (2004): 187–207.

Jackson, Kevin. *The Language of Cinema*. New York: Routledge, 1998.

Kirkpatrick, Jacquelyn. "Keeping the Carcass in Motion: Adaptation and Transmutations of the National in The Last of the Mohicans." *Literature and Film: A Guide to the Theory and Practice of Film Adaptation*. Robert Stam, Alessandra Raengo, eds. Malden, MA and Oxford, UK: Blackwell Publishing, Ltd.

Lenihan, John. *Showdown: Confronting Modern America in the Western Film*. Urbana: University of Illinois Press, 1980.

Leonard, David J. *Screens Fade to Black*. Westport, CT: Praeger, 2006.

Lott, Eric. "Love and Theft: The Racial Unconscious of Blackface Minstrelsy." *Representations* 39 (1992): 23–50.

——. *Love and Theft: Blackface Minstrelsy and the American Working Class*. New York: Oxford University Press, 1993.

Lyons, Robert. *My Darling Clementine*. New Brunswick, NJ: Rutgers University Press, 1984.

Maltby, Richard. "A Better Sense of History: John Ford and the Indians." *The Book of Westerns*. Ian Cameron and Douglas Pye, eds. New York: Continuum, 34–49.

Mapp, Edward. *Blacks in American Films: Today and Yesterday*. Metuchen, NJ: Scarecrow Press, 1972.

Marchetti, Gina. *Romance and the Yellow Peril*. Berkeley, CA: University of California Press, 1994.

Marubbio, M. Elise. *Killing the Indian Maiden: Images of Native American Women in Film*. Lexington, KY: University Press of Kentucky, 2006.

Park, Robert. *Race and Culture*. Glencoe, IL: The Free Press, 1950.

Pye, Douglas. "Double Vision: Miscegenation and Points of View in The Searchers." *The Searchers: Essays and Reflections on John Ford's Classic Western*. Arthur M. Eckstein and Peter Lehman, eds. Detroit, MI: Wayne State University Press, 2004.

Simmons, Felly Nkweto. " 'She's Gotta Have It': The Representation of Black Female Sexuality on Film." *Feminist Review* 29 (Summer 1988): 10–22.

Stanfield, Peter. *Horse Opera: The Strange History of the 1930s Singing Cowboy*. Urbana and Chicago: University of Illinois Press, 2002.

Stephens, Gregory. "Romancing the Racial Frontier: Mediating Symbols in Cinematic Interracial Relationships." *Spectator* 16.1 (Fall/Winter 1995): 58–73.

Tucker, Linda G. *Lockstep and Dance: Images of Black Men in Popular Culture*. Jackson: University of Mississippi Press, 2007.

Wardrop, Stephanie. "Last of the Red Hot Mohicans: Miscegenation in the Popular American Romance." *MELUS* Vol. 22, No. 2, *Popular Literature and Film* (Summer 1997): 61–74.

CHAPTER 6

PALADIN PLAYS THE FIELD: 1950S TELEVISION, MASCULINITY, AND THE NEW EPISODIC SEXUALIZATION OF THE PRIVATE SPHERE

Erin Lee Mock

A silver knight emblem fills the screen. The camera dollies backward, first revealing the knight symbol as an adornment of a black leather gun holster, then pulling back farther to show the holster attached to an imposing black-clad male pelvis. The gun, a shiny black pistol, is removed by the anonymous man's hand from its holster, cocked, and pointed at the viewer. A voiceover begins:

I'd like you to take a look at this gun. The balance is excellent, this trigger responds to a pressure of one ounce. This gun was hand-crafted to my specifications and I rarely draw it unless I intend to use it.

After an establishing shot of the ritzy Carlton Hotel, with requisite street signs and bright lights placing us in San Francisco, the camera follows a Chinese bellman holding newspapers into the lobby, as a glamorous man in a slim white suit leads a beautiful, black-gowned, and bejeweled blond down the hotel staircase. They pause at the foot of the stairs, and she whispers with hand over mouth into his ear. He laughs heartily; she smiles at what she said, and the two part ways, the gentleman still chuckling to himself and the viewer. He buys a stack of

newspapers from the bellman and crosses the lobby to read them on
an opulent divan, stopping to look—and be looked at—seductively by
a sumptuously dressed young Mexican woman, after which they both
smile knowingly.

So begins "Three Bells to Perdido," the first episode of the hit
television program *Have Gun, Will Travel.* These first two minutes
of the show undoubtedly set the tone for six seasons of adventures
with debonair gentleman-gunfighter Paladin, when they aired during
the record-breaking television season of 1957. Paladin's character is
established: he is suave, a connoisseur, and a ladies' man.

TV historians argue that violence in the "adult Western" stems
from the inability to show sex on television then, but sexuality was not
absent in *Have Gun, Will Travel* (CBS, 1957–63). Its erotic under-
current, rendered through the boundaries of genre and medium, is
one of the program's defining elements. Its efforts to participate in a
cultural conversation in which both identities and space were increas-
ingly defined by heterosexual erotics set the show apart from the other
"adult Westerns." The evolution of the Western, with *Have Gun, Will
Travel* at the center, reflects and produces a change in the space tele-
vision could create: an erotic adult space, counter to a family-centered
domestic space.

The parameters of, and claims to, "the domestic," or the private
interior space, were being challenged by television and other media
in the 1950s. Television, unlike film, infiltrated the home, poten-
tially bringing "adult" issues into the family sphere. However, unlike
radio, television's visual component allowed sexuality to enter the pri-
vate sphere covertly. By limiting language, in favor of visual cues, the
knowing adult audience read the erotic content of the scenes, which
were assumed unreadable to children. In this way, television gradu-
ally moved from a juvenile-centered nightly family event, stopping
briefly on the "adult Western," which the parent and child watched
simultaneously while comprehending very different things, to separate
televisual spheres for children and adults, often divided temporally,
which unsettled 1950s orientations to the private sphere as primarily
a place for family interactions.

Paladin's erotic life also differs from the other male characters' on
TV at the time through its episodic quality. Westerns of the time fea-
tured romance, but the episodic mercenary's sexuality is inevitably,
necessarily, antiromantic. The unfolding romantic plot, the only erotic
plot available to television writers at the time, actually pushed the lim-
its of the episodic plot, verging on serial drama. But allowing the
frame of episode to fully contain the erotic plot unavoidably yields

a particular protagonist: the playboy. The viewer can only get a weekly one-night stand.

Through its episodic framing, *Have Gun, Will Travel* actually manages to evade the erotic tropes of its genre. However, Paladin's episodic sexuality is not without precedent. In fact, the show participated—with *Playboy* magazine and Ian Fleming's Bond novels—in the cultural construction of a new masculine model, using the tools of the televisual to push this model to its logical conclusion. *Playboy*'s vision of nonconformity included a revaluing of the private sphere. As Hugh Hefner puts it, "We don't mind telling you in advance—we plan spending most of our time inside. We like our apartment." Hefner appropriates the private sphere, developing a space of genteel machismo. The bachelor-pad intervenes into the concept of the private sphere, desentimentalizing and decollectivizing that space. The bachelor-pad, like the hotel, is a transient space, a space of occupation, not of ownership or stability. It is, in its own way, episodic. *Have Gun, Will Travel* is the ideal mediation of masculine ideals, one emerging, one waning. American male worldliness takes place in the apartment, as people watch the world on their television set. Paladin unites the tough guy with the man of leisure into an American amalgamation of masculine erotic power.

1950S TELEVISION AND THE MAKING OF THE ADULT WESTERN

After several years of steady incline, television viewership boomed in 1957, just as Paladin came to the small screen. By that year, "85% of all homes were watching some five hours a day," according to Erik Barnouw (198). During this period, 30 Westerns were on the air each week, with the Western genre dominating prime time on every network. As viewership grew and the industry responded by refining ideas about those viewers, the television Western became a far broader category.

Gary Yoggy, the foremost historian of the television Western, defines the TV Western genre in his comprehensive *Riding the Video Range: The Rise and Fall of the Western on Television*:

Television shows modeled after the old B (for "budget") Westerns that were such an important part of the Saturday matinees of the forties became a sensation on television in the fifties. The "good guys" never shot first and rarely killed the "bad guys."...Their stories about the winning of the West with

examples of justice prevailing were both culturally and politically compatible with an America caught up in the East-West confrontation of the Cold War. They offered a simplistic and direct solution to virtually every problem and adults, as well as children, could appreciate that. (5)

Here, it is important to notice that both Barnouw and Yoggy unquestioningly posit the television viewer as both multiple and simultaneous: as family. Barnouw uses "homes," rather than individuals, as the unit of viewer measurement, and Yoggy makes sure to include "adults as well as children," explicating for his 1990s readers what would have been the 1950s assumption: that children were watching television with their parents, parents with their children, and that the viewing of television was a family affair. It is precisely this "everybody in front of the TV together" approach to the television medium that is being broken down in the subgenre referred to as the "adult Western."

The television Western that Yoggy describes in the quote above—the juvenile Western epitomized by *Hopalong Cassidy* and *The Lone Ranger*—was being overtaken by the adult Western in the mid-1950s, starting with *Gunsmoke* in 1955. *Gunsmoke*'s pilot episode, tellingly referred to in previews as "*Gunsmoke: The Premier*," was introduced by Western film star John Wayne, who told us that the show was "honest, it's adult, it's realistic." Part of this "adult Western" phenomenon is mythical, or seems so to the twenty-first-century viewer—the morals and situations were rarely *that* complex, the violence was rarely *that* graphic, and the good guys and bad guys were generally distinguishable, at least by 10 minutes into the episode. But the experience of watching episodes of *Hopalong Cassidy* and *Gunsmoke* back to back reveals significant differences; the pretense of difference, that is, the self-conscious striving toward the "authenticity" and complexities of theatrical Westerns like *High Noon* and *Shane*, while typically unsuccessful, is perhaps the most evident distinction between the two shows, as representatives of their respective subgenres. The introduction of *Gunsmoke: The Premier* by iconic Western film actor John Wayne not only authorizes the genre just in terms of its historical or psychological accuracy but he also addresses television's participation in a greater culture as a serious artistic medium, openly addressing issues historical and psychological, alongside film and other art and media. Wayne, via his stamp of quality on the project, and simply by being there on television to do the stamping, gives the serious filmgoer permission to take television—at least *good quality* television—seriously.[1]

Ralph Brauer sees the shift in tone from the "juvenile Western" to the "adult Western" as symbolized by the shift from the "Western of the horse" to the "Western of the gun" in *The Horse, The Gun, and The Piece of Property: Changing Images of the TV Western*. To clarify, the intimate relationship between the Western hero and his horse— who is the Lone Ranger without Silver?—which involved a juvenile audience in a sort of harmless camaraderie, is seen to give way to an intimate connection with one's weapon.[2] In *Have Gun, Will Travel*, an exemplar of this shift, Paladin is unattached to any particular horse, though he's an accomplished equestrian. However, his gun, which he wears on his person and actually shoots-to-kill in most episodes (unlike the Lone Ranger and Hopalong Cassidy), is a particular gun, "hand-crafted to [his] specifications." When this gun is taken from him in the course of an episode, which is often part of the action, Paladin must retrieve it by the episode's conclusion. Paladin frequently loses the horse on which he rode into town, but feels no urgency to reclaim it: horses are interchangeable.

Brauer argues that a preponderance of violence (figured, in his thesis, by the instrument of violence—the gun—itself) in the so-called "adult Western" was required because television could not portray sex, but, as the pilot episode substantiates, an erotic undercurrent, rendered through the boundaries of genre and medium, is one of the defining elements of *Have Gun, Will Travel*, as the opening of the pilot episode substantiates. Arguably, its emphasis on the erotic underpinnings of a national identity, and its effort to participate in a cultural conversation in which both identities and space were increasingly defined by nationalism and heterosexual erotics, set *Have Gun, Will Travel* apart from the other "adult Westerns" that dominated the prime-time set at the same time. As Martin Grams, Jr., and Les Rayburn declare in their passionate "Introduction" to *The Have Gun, Will Travel Companion*, "If *Gunsmoke* can be considered the first 'adult Western,' then it can be said with certainty that *Have Gun, Will Travel* perfected [the genre]" (8). The changing of the Western, with *Have Gun, Will Travel* as our example, reflects the changing of what television could do and the space TV created: an erotic space, directly counter to a juvenile-centered, safe, domestic space.[3]

As Spigel puts it, "in the postwar era, the increasingly blurred boundary between public and private worlds was considered to be a central dilemma—one that posed a threat to the sentimental ideals of family life and privacy itself" (*Welcome to the Dreamhouse* 1). Television, unlike film, entered the home, though it most often

entered welcome. However, unlike radio, the broadcast medium that
previously occupied the private sphere, it was partly visual. The visual
allowed sexuality, though not sex, to enter the private sphere covertly
in a new way. By limiting language, in favor of visual cues, the knowing
adult audience was given the chance to read the erotic content of the
scenes, while the assumed unknowing child was unable to articulate
that which she could not read.

In the scene described at this chapter's opening, Paladin descends
the stairs with an anonymous blond who whispers something the
viewer can't hear. The nature of their interaction suggests that
the content of her remark is sexual, or at least heavily flirtatious.
Within moments, another woman is "making eyes" at Paladin, and
he returns her look. The adult viewer could hardly miss the sexual
connotations of Paladin's interactions with both women, but chil-
dren could be given permission to see what, adults reasoned, they
could not understand. In this way, television as a medium grad-
ually made its way from being a juvenile-centered nightly family
event to the "adult Western," which the parent and child watched

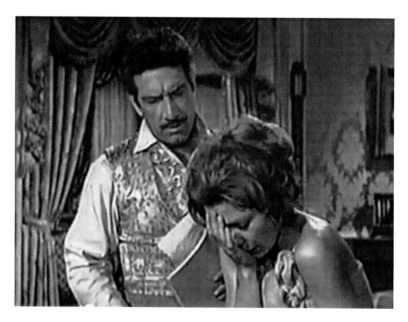

Figure 6.1 Paladin (Richard Boone) comforts Ella West (Norma Creane) in
Episode 1, Season 1 of *Have Gun, Will Travel* (1957).
Source: Courtesy of Colombia Broadcasting System.

simultaneously while comprehending very different things, before developing into completely separate, often temporally divided, tele-visual spheres for children and adults. The "adult Western," which unsettled 1950s orientations to the private sphere, remains a point of serious controversy and political contention, as these divisions are never easy to regulate, occurring as they do in the private sphere.[4]

What makes the erotic life of Paladin so markedly different from that of other leading men in television Westerns, even so-called "adult Westerns," is its episodic quality. Other television Westerns of the time featured romance—Marshall Matt Dillon and Miss Kitty of *Gunsmoke* were the Sam and Diane of their era, so to speak—but the episodic mercenary's sexuality is inevitably, necessarily, antiromantic. In sum, *Have Gun, Will Travel* manages to evade the erotic tropes of the tele-vision "adult Western." However, it should be noted that Paladin's episodic male sexuality is not without precedent, and that the show is participating in a broader cultural construction of a new masculine model and uses the tools of the televisual to push this model to its logical conclusion.

THE MAKING OF THE EPISODIC EROTIC: PALADIN IN THE AGE OF BOND AND *PLAYBOY*

Ian Fleming's first Bond novel, *Casino Royale*, came out in the UK in 1953 and was reprinted for American readers under the unfortu-nate title *You Asked for It* in 1955. In *Casino Royale*, Bond gets his heart broken by a female double agent, Vesper Lynd (181). When she kills herself, he reports to his superiors, "The bitch is dead now." By the next novel, *Live and Let Die*, cold hard Bond is hooking up with sexy Solitaire, the Afro-Caribbean fortune-teller. Their relation-ship is facilely assumed to end at the close of the novel. In fact, the reader is not meant to feel the relationship should or will continue. One of the most marked characteristics of the Bond series is the series of Bond girls, never repeating, with whom Bond is connected over the course of one novel (or film), then another.[5] The relationships between Bond and the women he encounters are explicitly sexual, only mildly if at all "romantic" (with minor exceptions, usually on the part of the woman).[6]

Fleming's Bond was part of Cold War spy fad that had transatlantic prevalence. Michael Kackman, in *Citizen Spy: Television, Espionage, and Cold War Culture*, accounts for the rise of the spy program on

American television, a phenomenon which "negotiated two of the period's most contentious sites of cultural struggle—gender and Cold War politics" (xxxiii). Unlike Bond, the popular American TV spy hero, like Herbert Philbrick of *I Led 3 Lives* or Mel Hunter in *World of Giants*, is duly anchored: he is married with children and an "organization man." (When these shows were based on real people, the idyllic family life of the show was often in stark contrast to the broken homes of reality.)

In 1954, an episode of *Climax!*, an anthology show that ran on CBS (the same network that ran *Have Gun*), featured Bond in a television adaptation of *Casino Royale*. It starred American actor Barry Nelson as American secret agent "Jimmy Bond" and was, in fact, the first screen adaptation of a Bond novel. The reconfiguration of Bond into an American spy is important, not only politically but culturally, and in the history of broadcasting, as 1955 marked the start of commercial television in Britain. Emphasizing Americanness was important both in staking claim to television as the American art form and in selling the American product. As the Americanized "Jimmy Bond" on *Climax!* shows us, Americans were set on developing a national-worldly hero, the ultimate American who could navigate the foreign landscape with aplomb. Keats-quoting, Westpoint-educated, well-traveled, equestrian, rough-knuckled, gunslinging playboy Paladin was that merged hero. Distinguishing Britishness from Americanness abroad was politically complicated during the Cold War, but the Western landscape and the gunfighter type (as opposed to the nationally ambiguous, though certainly anti-Communist, spy) overlaid a set of American mythological tropes on top of the Britishness (however compromised) of James Bond. Paladin is the next logical step after Jimmy Bond.

Having used the word "playboy" repeatedly to describe Paladin, the obvious connection to another significant 1950s cultural milestone must be acknowledged: *Playboy* magazine's first issue came out in December 1953; by 1956, its sales had passed the one million mark. Barbara Ehrenreich locates the magazine at the center of an impulse against a notion of "conformity" for middle-class American men in the 1950s, saying that "[f]rom the beginning, *Playboy* loved women...and hated wives" (*Hearts of Men*, 42). The *Playboy* male's relationship to women, and to heterosexual desire, then, was figured as episodic; the wife—the serial character—trapped her husband into lifelong conformity.[7] Like Paladin in his episodic masculine sexual exploits, the *Playboy* reader is expected to meet, and be done with,

a new woman monthly, and to supposed to have nothing but fun doing it.

According to Ehrenreich, "autonomy" and "freedom" came to replace "isolation" and "uprootedness" as descriptive terms for bachelorhood, in an era that seemed to prize marriage and monogamy. The identification of masculinity as unrootedness in the 1950s becomes an identification of masculinity with the playboy. The mercenary, as opposed to the spy, is not only unmarried but professionally unfettered. He's the opposite of the organization man. But unlike the *noir* antihero whose isolation is shored up by his sexual chemistry with one (often fatal) woman, Paladin plays the field and he does so lightly and easily.[8]

In contrast to *Maverick*, an adult Western comedy that came out the same season as *Have Gun*, the only thing that *Have Gun* and Paladin do not take seriously is his sex life. While both *Maverick* and *Have Gun* incorporated a fair amount of eroticized content that was generally absent in the genre until that point, the use of sexuality in the two programs, and the effect this sexuality had on the programs' other components, differed greatly, as did the messages these brief sexual narratives gave the viewer about their beloved protagonists. The overtly serious moral, ethical, and political tone of the rest of *Have Gun, Will Travel* makes sex and sexuality the show's sometimes awkward comic relief.[9] The amusement that underlies every episode of, and nearly every happening within the episodes of, *Maverick*, places sexuality in line with everything else to be joked about. In *Maverick*, the brothers' sexual and romantic exploits generally served to portray them as incompetent, lazy, careless, gullible, and cowardly, unable to adequately manage a connection to the opposite sex; often this incompetence underwrote the episodic rhythm of their sexual contacts. To hear Bret Maverick himself tell it: "...my old pappy used to say, 'Son, stay clear of weddings because one of them is liable to be your own'"; this echoed other of "old pappy's" advice, like: "...a man does what he has to do—if he can't get out of it." Bret's comically voracious sexual appetite was often his downfall, as Neil Summers puts it in *TV Westerns*: "Most of the time it was the female that got them into this trouble" (42). Paladin's affairs, in stark contrast with Bret's, tended to underscore his image as the unshakable master of his ever-changing domain. Paladin's constantly revolving cast of lady friends, in this way, mimicked his absurd linguistic abilities: whatever language was needed on the job, he could speak it fluently, even vernacularly if the situation demanded it, though we'd

usually never heard him speak it before, nor would we hear him speak it again; if there was a beautiful woman in the area worth pursuing, he could woo her, with incomparable suavity and keen perception, for the length of his—or, more rarely, her—stay, but never longer.

Though nearly any episode of *Have Gun, Will Travel* could lend support to the thesis of this article, "The Colonel and the Lady," written by Michael Fessier for the show's first season, perhaps best illustrates the interaction between Paladin's erotic life, the cultural reconstructions of masculinity alive in the late 1950s, and the limits and possibilities of episodic television.

Paladin is lured to Sacramento by a classified ad placed by Colonel H.P. Lathrop in the *Sacramento Bee*. Paladin's task is to track down a woman named Gloria Morgan from the town of Lone Star, Nevada. Paladin is greeted at the door to Lathrop's mansion by a buxom young maid in a tight-fitting uniform. He flatters the maid by requesting her name—it is clear that the Colonel's guests rarely care to find out—and she replies "Tuolumme O'Toole," explaining that her "mother was Cherokee and [her] father an Irish railroad worker." After finding out the details of this mission from Colonel Lathrop, Paladin retires upstairs to his opulently furnished room, only to find Tuolumme waiting for him:

> *Paladin*: Well, Tuolumme O'Toole, this is indeed a pleasure.
> *Tuolumme*: I didn't come here to give you pleasure.

After the sexual tension has been duly established, Tuolumme begs Paladin not to go to Lone Star:

> *Tuolumme*: The country's full of bandits, and wild Indians, and grizzly bears.
> *Paladin*: You're beautiful, Tuolumme, and you're such a bad liar.
> *Tuolumme*: I didn't think I could scare you.
> *Paladin*: Well then, why did you try?

As Tuolumme continues to beg him not to go, Paladin begins to leisurely walk the room, lighting candles, letting the match burn extremely close to his fingertips. When Tuolumme brandishes a knife, telling Paladin, "I'll kill you and you better believe me." Paladin replies, casually, "Well, I believe you'd try," then deflates her aggression, by grabbing her hand holding the knife with his left hand, and her neck with his right, kissing her outlandishly. He then ushers her

toward the door, giving her a little spank, as she crosses the threshold, "Goodnight, Tuolumme!" he says, closing the door behind him and laughing to himself.

The music in that scene, as in the opening scene, was composed by Bernard Herrman, who famously worked with Hitchcock on *Vertigo* and Orson Welles on *Citizen Kane*. In this choice of music, we see that part of the move toward "adult" television was a posture of improved "quality" and a usurpation of cinematic techniques and strategies: better music, better props, better acting.[10] Paladin modeled for the viewer this appreciation of "the finer things in life" within the show, as well. The very first moments we spend with Paladin are in aestheticized, mutual appreciation of his gun, a gun "hand-crafted to [his] specifications," which tells us he knows of whereof he speaks, that he has tried many weapons and had made for himself the amalgamation of their best components. Paladin's choice to carry the gun in a decorative holster emblazoned with a symbol of aristocratic leisure activity announces it as an aesthetic, rather than a strictly utilitarian, object. As we watch him walk through the hotel lobby, he moves from the refined flirtatious aristocratic beauty of the black-gowned blond to the seductive, knowing smile of the Mexican woman in the lower-cut gown, the assertion being that both are desirable. Tuolumme's mix of Cherokee and Irish ancestry, both less than highly valued stock in the American 1870s, in no way diminishes Paladin's sexual attraction to her; after all, because of her ethnic background or despite it, Tuolumme is beautiful. Like Bond's liaison with the Afro-Caribbean Solitaire of *Live or Let Die*, Paladin's appreciation of brandy in the hotel and whiskey on the frontier, with equal sensitivity, is an Americanized echo of Bond's "martini—shaken, not stirred." As David Lancaster says of Bond:

> . . . the joy of swank is crucial to the series' success; Bond beguiles us with the notion that individual style is more potent than missiles and secret hideaways. With one flick of an elegantly turned cuff, evil crumbles to dust.
>
> ("Hero as Globetrotter," 83)

Appreciation of the television medium, the American medium, and appreciation of the Western—the American genre—side by side with film and music, then, becomes a sort of nationalistic worldliness, a heroic and an American way of incorporating a refined aestheticism. A dearly held democratic principle of American-ness—this American eclecticism—that is, the ability to appreciate the *best* of the high and

low, in local, national, and global arenas, is exemplified here through both form and character.

The limits of episode construct the erotic narrative in a way that is so familiar to the twenty-first-century viewer as to be almost invisible. The connection between Paladin and Tuolumme O'Toole is real, even fraught, but unsatisfying in the age of the serial drama. In order to limit Tuolumme's importance to within the 24-minute boundaries, condescension is laid over lust. Tuolumme is completely ineffectual. With the considerable advantages of a literal secret weapon and a cache of secret information, she is still unable to thwart, harm, or affect Paladin. All she is able to do, as Paladin says twice in the scene, is "try."

When the episode ends, Paladin not only shows no jealousy whatsoever that Tuolumme is in a relationship with "little Pablo's big brother" but he happily sends her off to her boyfriend, expressing mild regret at their kiss. What he regrets is that he, for whom the kiss meant little, stole Tuolumme's first kiss from the man to whom it "belonged," a man to whom it would have meant "the world." His uproarious laughter at her as the scene, and episode, ends—and it is, at least partly, at her—shows that, to Paladin as well as presumably to the viewer, Tuolumme's part in the program was, overall, meant for mildly comic and sexy relief from the violence, sadism, greed, and ethical confusion of the frontier, which occupies the other half of the episode. Her fumbling play at this violence actually makes her more attractive, as it separates her even further from the wilds of the West, and reveals her incapacity for exactly what makes Paladin Paladin. Tuolumme makes no discernible impact that would have to be sustained in Paladin's character into another episode. The pure episodic hero would be tainted by emotional impact.

In the episode, "A Matter of Ethics," Paladin, strangely, does not have an affair with "Amy Bender," played by Angie Dickinson, despite all the regular viewer's expectations. Similarly, though Ella West, played by Norma Crane, makes clear that she is wildly attracted to him, she does not get a sexual encounter with Paladin in the episode named after her. That these women are violent—Amy is the leader of a lynch mob and Ella is the performing gunslinger—and products of the frontier negates their sexual desirability. That both characters are played by known actresses, with established screen presences, seems important in contrast with actresses like Faye Michael Nuell, who portrayed Tuolumme O'Toole, and whose resume reveals her as the ultimate episodic sexual conquest: "Working Girl," "Gypsy Woman," "Woman at Juschi's," and other such one-episode roles. Unlike in the Bond series, the erotic allure of the villainess is not fully explored;

despite some of Paladin's girls' attempts to go bad, there's always a lady of good feminine heart and refinement beneath the surface every woman he beds.

THE MAKING OF THE EROTIC DOMESTIC

Martin Nussbaum tried, in 1959, to determine what made the adult Western so popular:

> What then are these recurring ideas or elements that influence and produce "the adult Western" and that make it so enjoyable to all segments of our society? First, the Western contains the spirit of foreign adventure, of new and exciting places.... Coupled with this spirit of foreign adventure is the inherent romance of the West.... To the average city dweller, confined to a neighborhood of row houses, a stretch of prairie or mountain range extending as far as the eye can see offers a transcending exhilaration.

The allure of travel, dramatized equally in the spy program but fundamental to the appeal of the Western, is effectively played upon by placing Paladin in a new location in almost every episode (though several interesting episodes leave Paladin in San Francisco, usually encountering the "wilds" of an ethnic subculture), enforcing the episodic boundaries of his sexual contacts. In *Have Gun, Will Travel*, travel offers the lure of sampling the best of everything, including women, of course. In contrast to the other popular adult Westerns, like *Gunsmoke, The Rifleman*, and *Maverick*, the location is unstable. In contrast to Westerns that featured travel, like *Wagon Train* or *Rawhide*, relationships are as unstable as location. Though many episodes begin at the Carlton Hotel, just as many do not, with the audience showing up inside a stagecoach, not knowing the direction, or an undefined saloon, or riding into an unknown town. Surprisingly though, there is very little emphasis on Western landscape; we tend often to move from interior to interior, even while traveling from San Francisco to the frontier. Surely, this was related to budgetary limits of location shooting, but its effect is in keeping with the times. As Hugh Hefner put it:

> Most of today's magazines for men spend all their time out-of-doors— thrashing through thorny thickets or splashing about it fast-flowing streams, but we don't mind telling you in advance—we plan spending most of our time inside. We like our apartment.
>
> (*Playboy*, 1)

Desentimentalizing and destabilizing the private space, the bachelor-pad appropriates and redefines the domestic in the terms of genteel machismo.[11] The apartment, specifically the bachelor-pad, is similar to the hotel in that it is a transient space, a space of occupation, not of ownership or stability. It is, in its own way, also episodic. With this in mind, *Have Gun, Will Travel* is the ideal mediation of the new and old masculine ideals. Through television, the wilds of travel, of the frontier, and of physicality are brought into the private sphere, which is therefore newly masculinized and made physical. American male worldliness takes place in the apartment, watching the world on television. Paladin unites the tough guy with the man of leisure into an American amalgamation of masculine erotic power. Combining these qualities, Paladin is both an enactment of the American aesthetic of eclecticism, discussed earlier in this chapter, and is himself an embodiment of the impulse. The viewer also takes part: Ehrenreich's comment on the descriptions of bachelorhood shifting from "unrootedness" to "autonomous" fits nicely aside James Clifford's consideration of travel: "negatively viewed as transience, superficiality, tourism, exile, and rootlessness... positively conceived as exploration, research, escape, transforming encounter" ("Traveling Cultures," 105). The hotel room and the bachelor-pad align in their mediation of public and private relationships and in their introduction of performative "taste" into the private sphere.

We enjoy mixing up cocktails and an *hors d'oeuvre* or two, putting a little mood music on the phonograph and inviting in a female acquaintance for a quiet discussion of Picasso, Nietzsche, jazz, sex.
 ("The Playboy Philosophy, *Playboy*, 41)

As Ehrenreich parses Hefner's message: "Women would be welcome only after men had conquered the indoors, but only as guests—maybe overnight guests—but never as wives" (*Hearts of Men*, 44).

The image of two well-dressed people enjoying the comforts of a well-appointed room, swilling cocktails, and discussing aesthetics is one replayed, without the phonograph (though sometimes with the piano) throughout *Have Gun, Will Travel*, and most always the show features a woman viewer whom we have not only not seen before but also will never see again.[12] Aesthetic appreciation is figured here as an appropriate gateway to sexual appreciation; the erotics of this Americanized aestheticism are set out in the lineup of words such as "Picasso, Nietzsche, jazz, *sex*" (emphasis mine).

In Hefner's "philosophy" above, some complex reformations of the private sphere, and of masculinity, are being asserted. First, the man who is "mixing up of cocktails and an *hors d'oeuvre* or two" is not afraid of the feminized element of the private sphere, even as he may be reclaiming it, taking on "women's labor" in service of erotic potential—*he* serves *her*, as Paladin always does. Second, the use of the word "acquaintance" to describe the woman is in marked contrast to the domestic model of the private sphere, wherein everyone is family. Introducing the near-stranger into the private sphere is also a way of introducing travel, in a sense, into the home. The navigation of the unknown "territory" can take place both in and out of doors, through physical motion or through relationship, and the ever-new woman can never successfully "stake her claim" to the domestic territory.

CONCLUSION: THE EPISODIC EROTIC AND THE MAKING OF A STAR

Casting Richard Boone would seem to keep Paladin's erotic power in check. Though tall and built, he was referred to, by colleagues on the show and in the press, as "the ugliest actor in Hollywood." The show's creators expected, therefore, an audience almost exclusively of men, in comparison to the mixed-gender viewership of other adult Westerns like *Gunsmoke, Maverick*, and *Cheyenne*, with more conventionally attractive actors such as James Arness, James Garner, and Clint Walker. Even the fact that a television show, an entry into the private sphere, could be worthwhile when focused toward a single-gendered audience signals that profound shift in the way that television and the private sphere were being conceptualized.

It was precisely this episodic male sexuality and this new masculine erotic blend of the American tough guy and the worldly aesthete embodied by Paladin (and contrasted with all three: Matt Dillon, Bret Maverick, and Cheyenne Bodie) that made Richard Boone the recipient of more fan mail than any male television star up to that point. Repetition of same-ness as a principle of the episodic, the unchanging character with the unchanging close-up, also facilitated desirability through a familiarizing moderation of his features. This same-ness in the portrayal of his mate choice—the fact that she was always new—also proclaimed him, from the very first episode, to be desirable, undermining any contrary viewer reaction. The heterosexual female audience actually gained entry to Paladin through his episodic mate choices; not only might "you" be next but, by not being the his last acquaintance, you were safe from the violence and hardship

that entailed in being a traveling gunfighter's partner. Also, fancying one's self as the object of Paladin's desire was self-flattering; only the best is good enough for Paladin, as he is a connoisseur of everything he consumes. The threat of his disappearance was assuaged by the woman's own sense of sexual desirability. The gunfighter's erotic potency was both mediated by and attained through strategic use of episodic boundaries.

Notes

1. The notion that television shows could vary in quality, not just popularity—whether journalism or drama—is a fairly new one in the mid-1950s. This shift is tied to a calculated resituation of the medium as a place of artistry, not just commerce. I see Wayne's brief entry into television as a defining moment for the medium, not just the TV Western or the "adult Western" genre.

2. Brauer attempts to make a connection between the horse and the racial other, which seems to ignore the obvious: the solitary hero—Paladin— can connect with the controllable gun, not the uncontrollable living thing, whether horse or woman. Close connection to the uncontrollable or emotional would undermine his effectiveness as an ethical freelance gunfighter, which is, to use Paladin's words, "the life I've chosen for myself."

3. Many scholars of television history would take issue with my seemingly strict divisions of public versus private space before, and at the beginning of, the first American television boom (see McCarthy). That television was viewed only within the home and that the home was strictly "private," family, and noncommercial are certainly overstatements, but overstatements I find suggestive of several cultural currents, particularly the valorization of the middle class in the Cold War era, by both politicians and culture makers, which seems crucial to the type of masculinity that, I argue, the television programs in this chapter construct.

4. Clearly, significant elements of this multigenerational "family" approach to television sexuality remain today in a great many network programs, especially early prime-time sitcoms.

5. The character of "Natasha" in the James Bond series, like the character of "The Lady Doctor" in *Have Gun*, represents the only disruption to this norm.

6. In the "James Bond Renaissance" that accompanied the 2004 Penguin reissues of the Bond series, a great deal of scholarly attention was focused on the differing representations of the "Bond girl," from a feminist perspective, or as a way of critiquing the feminized racial

characterizations throughout the series, in print and on film. See
Jenkins, Linder, Comentale, Watt, Willman, Chapman.

7. The relationship to Brauer's hypothesis and my extension of it is clear:
the gun—as an extension of the gunfighter's body—in the "adult
Western" constitutes the only safe serialized "character," indistinguish-
able as it is from the protagonist himself.

8. Discussion of the noir antihero, as he is figured specifically in the
1950s, must include Blake Edwards's *Richard Diamond, P.I.* and *Peter
Gunn*, as well as Mickey Spillane's Mike Hammer character, all of
whose relationships with multiple women vary in many aspects from
both the 1930s hardboiled P.I.'s or the "episodic" sexual contacts
pointed to in this chapter. Certainly, the spy genre and the "adult
Western" are operating in a cultural conversation that includes this
genre as well.

9. Paladin's moral code, adopted from a "juvenile Western" tem-
plate, and its relation to the Western film renaissance; the drastic
shifts embodied in and accomplished through the administrations of
Eisenhower and Kennedy, respectively; and other cultural norms of
visuality and notions of space (especially the distinctions between
the rural, the urban, and the suburban) warrants a chapter of
its own.

10. A similar move was made in fashioning popular radio show *Richard
Diamond, P.I.* for television, with a score by Frank De Vol, arranger for
the studio recordings of well-known singers, including Nat King Cole,
Ella Fitzgerald, and Sarah Vaughan. The role of music in fashioning
television as an art form, rather than strictly an entertainment form,
should not be underestimated.

11. What Baudrillard calls a "private telematics" wherein "each person sees
himself at the controls of a hypothetical machine" in the television era
can also account for the focus on the gun, particularly in the opening
of each episode, which I haven't opportunity to address in detail here.

12. The mediation of public and private boundaries in the case of the hotel
has an added dimension—the public space of the hotel lobby, which
also plays a major part in the way Paladin's sexuality is encoded visually
in *Have Gun*.

FILMOGRAPHY

"Matt Gets It." *Gunsmoke*. Dir. Charles Marquis Warren. CBS. 10 Sept. 1955.
"Three Bells to Perdido." *Have Gun, Will Travel*. Dir. Andrew V. McLaglen.
CBS. 14 Sept. 1957.
"The Colonel and the Lady." *Have Gun, Will Travel*. Dir. Andrew
V. McLaglen. CBS. 23 Nov. 1957.

BIBLIOGRAPHY

Arp, Robert and Kevin S. Decker. " 'The Fatal Kiss': Bond, Ethics, and the Objectification of Women." *James Bond and Philosophy*. Ed. James B. South and Jacob M. Held. Peru, IL: Caru Press, 2006.

Barnouw, Erik. *Tube of Plenty: The Evolution of American Television*. 2nd ed. New York: Oxford University Press, 1990.

Baudrillard, Jean. "The Ecstasy of Communication." *The Anti-Aesthetic: Essays on Postmodern Culture*. Ed. Hal Foster. New York: The New Press, 1998.

Boddy, William. *Fifties Television: The Industry and Its Critics*. Urbana-Champaign: University of Illinois Press, 1992.

Brauer, Ralph. *The Horse, The Gun, The Piece of Property: Changing Images of the TV Western*. Bowling Green, OH: Bowling Green University Popular Press, 1975.

Britton, Wesley. *Beyond Bond: Spies in Fiction and Film*. London: Praeger Publishers, 2005.

Brooks, Tim and Earle Marsh. *The Complete Directory to Prime Time Network TV Shows: 1946–Present*. New York: Ballantine, 1979.

Chapman, James. *License to Thrill: A Cultural History of the James Bond Film*. New York: Columbia University Press, 2000.

Comentale, Edward P., Stephen Watt, and Skip Willman. *Ian Fleming & James Bond: The Cultural Politics of 007*. Indianapolis: Indiana University Press, 2005.

Ehrenreich, Barbara. *The Hearts of Men: American Dreams and the Flight from Commitment*. New York: Anchor Books, 1983.

Fleming, Ian. *Casino Royale*. New York: The New American Library, 1953.

——. *Live and Let Die*. New York: The New American Library, 1954.

——. *To Russia with Love*. New York: The New American Library, 1957.

——. *Her Majesty's Secret Service*. New York: The New American Library, 1958.

Hilmes, Michele. *The Television History Book*. London: British Film Institute, 2004.

Gunsmoke: The Premier Episode. NBC. 10 Sept. 1955.

"Three Bells to Perdido," "The Colonel and the Lady." By Sam Rolfe and Herb Meadow. *Have Gun, Will Travel*. CBS. 14 Sept. 1957.

Hefner, Hugh. "Editor's Note." *Playboy*. December (1953): 1.

Grams Jr., Martin and Les Rayburn. *The Have Gun, Will Travel Companion*. Arlington, VA: self-published, 2000.

Jenkins, Tricia. "James Bond's 'Pussy' and Anglo-American Cold War Sexuality." *Journal of American Culture*, 28:3 (2005): 309–317.

Kackman, Michael. *Citizen Spy: Television, Espionage, and Cold War Culture*. Minneapolis: University of Minnesota Press, 2005.

Lancaster, David. "Hero as Globetrotter: A Review of The James Bond Phenomenon: A Critical Reader." *Film and History*, 34:1, (2004): 82–83.

Linder, Christopher. *The James Bond Phenomenon: A Critical Reader.* Manchester: Manchester University Press, 2003.

MacDonald, J. Fred. *Who Shot the Sheriff? The Rise and Fall of the Television Western.* New York: Praeger, 1987.

McCarthy, Anna. " 'The Front Row Is Reserved for Scotch Drinkers' : Early Television's Tavern Audience." *Cinema Journal,* 34:4 (1995): 31–49.

——. *Ambient Television: Visual Culture and Public Space.* Durham: Duke University Press, 2001.

Newcomb, Horace. *Television: The Critical View.* New York: Oxford University Press, 2006.

Spigel, Lynn. *Make Room for TV: Television and the Family Ideal in Postwar America.* Chicago: University of Chicago Press, 1992.

——. *Welcome to the Dreamhouse: Popular Media and Postwar Suburbs.* Durham, NC: Duke University Press, 2001.

Summers, Neil. *The First Official TV Western Book.* Omaha, NE: self-published, 1987.

Thomson, Irene Taviss. "Individualism and Conformity in the 1950s vs. the 1980s." *Sociological Forum,* 7:3 (1992): 497–516.

West, Richard. *Television Westerns: Major and Minor Series, 1946–1978.* Jefferson City, North Carolina: McFarland, 1987.

Williams, Raymond. *Raymond Williams on Television: Selected Writings.* New York: Routledge, 1989.

Yoggy, Gary A. *Riding the Video Range: The Rise and Fall of the Western on Television.* Jefferson, North Carolina: McFarland, 1994.

CHAPTER 7

REVERSE TRANSVESTISM AND THE CLASSIC HERO: *THE BALLAD OF LITTLE JO* AND THE ARCHETYPAL WESTERN (FE)MALE

Vincent Piturro

> *The Western's narrative structure and motifs are seen to derive less from any real world than from the economic and artistic imperatives of Hollywood, each film finding its plausibility and terms of reference in the audience's previous experience of the genre.*
>
> —Edward Buscombe, *The BFI Companion*

The Western has always been in repair. *Stagecoach*, the classic of the classic Westerns, was a film that struggled to get made. Most studios did not want the project: David Selznick dismissed it as "just another Western," and Daryl Zanuck (Fox Studios) refused to even read the script. John Ford and partner Merian C. Cooper shopped it all over Hollywood, finally securing financing with Walter Wanger at United Artists (Buscombe 16). Ford pitched the film as a "classic Western with classic characters" (14) implicitly nodding to the low opinion of Westerns in the late 1930s—when the genre was all ready well established as a low-budget, highly formulaic stable of

conventions. This film *was* different from earlier Westerns, however, because it boasted an ensemble cast that included a female with top billing (Claire Trevor as Dallas), a Z-list actor in his first major role (John Wayne as The Kid), and it delayed the big action sequence until the end of the picture. Those two central characters—an outlaw on the run and a prostitute—comprise the love relationship in the film, both riding off into the night together at the end of the film. In short, *Stagecoach,* as many films to follow would be, was a revisionist Western.

Stagecoach also departed from audience expectations. In his commentary on the film, Jim Kitses acknowledges that *Stagecoach* "crystallized and refreshed the language of the genre" (DVD Commentary). The Western would travel a well-documented albeit rocky road thereafter: from king of Hollywood (1940s and early 1950s) to genre in decline (late 1950s) to new life (in the 1960s) to the violent action film (1960s and 1970s) to rejuvenation and resurrection (late 1980s and early 1990s) and now back to life support (late 1990s into the new millennium). Along the way, the Western continually remade itself. *High Noon* (1952) would read as an allegory for the HUAC (House Un-American Activities Committee) era, leading John Wayne to famously call it "un-American" (Lewis 212); *Shane* highlighted the brutality of the Western genre and the impact on the victims of that violence; *The Searchers* illustrated the racist, sadistic, and narrow-minded ethnocentrism of many Western protagonists; and the Anthony Mann Westerns displayed the psychological fragility of his characters. In addition, the European invasion and the post-Code Westerns of the 1960s and 1970s helped to further redefine the genre. This (perhaps oversimplified) progression highlights the dynamic nature of the Western film history: there were never really any essential characteristics of the Western, and it remains a constantly evolving style with varying degrees of success.

So when a film such as Maggie Greenwald's *The Ballad of Little Jo* (1992) enters the realm and is critically dismissed as "revisionist" (Gorbman 190) or (worse!) "feminist" (Lusted 259–60), the conversation disregards the inherent Western-ness of the film. Such labeling denies the classic elements of the Western, not the least of which are the dual-love story and search for identity. Westerns also use violence as a means of keeping order, maintaining a reverence for the Western setting, and incorporating the search for identity and the love story. These staples are entrenched in *Stagecoach* and *The Ballad of Little Jo* as well. Both films have helped to define the genre while simultaneously revising it.

To situate *The Ballad of Little Jo* into the larger context of the classic Western first requires identifying the characteristics of the classic Western. For Richard Slotkin, a "regeneration through violence" (5) has been a central characteristic of the classic Western. For Jim Kitses, the aesthetic of the West was an important characteristic: the openness, the possibility, and the coexistence of beauty and violence were paramount aesthetic concerns. Kitses also saw class warfare and the search for identity as essential thematic concerns (*Stagecoach* DVD commentary). Other critics such as Jane Tomkins have noted the genre's focus on the discourse of masculinity; further, according to Steven Neale, the genre "privileges and celebrates the body of the male" (55–62). One constant throughout the genre has been the centrality of the male protagonist and the subservient nature of the female characters—roles for women constituted either wife or whore, both of which are clearly defined in *Stagecoach*. The love stories present in the films depicted varying degrees of gunslinger with the refined Eastern woman (*My Darling Clementine*), the loner desired by all (*Shane*), or the occasional reticent wife (*High Noon*) who finally submits. Granting females top billing in a Western was rare, with the exception of a series of films in the late 1960s. Typically, the Western's mythology of the West was very phallocentric. The industry was male-dominated in the first half of the twentieth century, something *The Ballad of Little Jo* would seek to change. While still incorporating the genre expectations that preceded it, Greenwald's film doesn't challenge the aesthetic or even the structure of the Western; rather, it *adds to* the project of revision that has been such a salient characteristic of the Western as a genre. The story of Josephine Monaghan, an Eastern socialite who is excommunicated from her family and subsequently reinvents herself as a man in the West, also has dual-love stories: her love affair with the West, and her love affair with a man. The expectations are intact, but the story changes.

The film was met with a negative reaction when it was released, however. One of the reasons for the negativity, posits Tania Modleski, is the film's attempt to force a "reverse transvestism" on the audience; in other words, the male viewer is sutured into the perspective of the female protagonist. Compounding this notion is the fact that Jo dresses as a male. Modleski argues that this anomaly incites a "fear that the phallus may not be in the usual place: hence the lack or 'incompleteness' experienced by some of the male reviewers...." (524). Ruby Rich criticized the film for not focusing on lesbian desire, and still others criticized it for not dealing more with the "gay issue" (Modleski, "Our Heroes" 4). Modleski also highlights still another

line of criticism extrapolated from the wealth of discourse on female transvestism—such as that of Mary Ann Doane or Laura Mulvey—where such theorists identified genre (in general, but herein applied to Westerns) as simply reinforcing conservative notions of a woman's place. But even Mulvey allowed that the female spectator "never wholly gave herself up to it" ("A Woman's Gotta Do..." 538–39). Modleski ultimately asserts that *The Ballad of Little Jo* differs from the classic Western, comparing it to Sam Peckinpah's *Ride the High Country* (1962). Tracing the history of the Western, however, finds *The Ballad of Little Jo* actually *following* from, rather than *differing* from, the line of classic Westerns drawn directly back to *Stagecoach*. The argument here is *The Ballad of Little Jo* actually preserves the Western conventions while changing them, and central to that project is the love story: a dual-love story set against the backdrop of the West and including a search for personal identity.

Josephine Monaghan, the female protagonist in *The Ballad of Little Jo*, is introduced carrying a parasol and wearing a long, flowing dress as she walks westward. The image of a woman walking alone in the West is not typical stock footage in the Western, and that's precisely why it's so shocking, and dangerous. She is immediately noticed by two passing soldiers, and a traveling merchant engages her for sales help. After Jo makes a sale to a particularly wary female buyer, the merchant gives her a portion of the profits. This is the first money she's ever made, she tells him with pride and wonder. As night falls and they sit by the fire, Jo reads Hawthorne's *The Scarlet Letter* to the merchant. Josephine seems to be a smart, independent female who is beginning to make her way in the world. From the perspective of the late twentieth-century/early twenty-first-century viewer, she is an admirable character. But this is the Wild West, and she is swiftly punished for her independence.

The merchant makes a deal with the soldiers, "sells" her, and is killed for his part. A chase ensues as the men attempt to abduct her. Able to shed her attackers, Jo seeks refuge in a river and hides under cover of darkness. When she finds a small store the next day, she is told that men had indeed been looking for their "sister," and (as she tries on men's clothes) she is told by the female shopkeeper that it is against the law to wear the clothes of the opposite sex. She looks into the mirror as she holds up the clothes to her body. As she does so, her face is framed by a separate smaller mirror apart from the larger, full-body mirror. At once, she is disconnected and disembodied. This image is one that will become the leitmotif of the film—a face disconnected from its body, a body covered by clothes that hide its secret, and

a face that will both show and hide its pain. Her identity is in turmoil. She precedes to brutally scar her face with a knife, an action that is both functional and symbolic: it functions to brand her as a male (no woman would bear such a scar), and it also serves her own scarlet "A," an echo of Hester Prynne's scar of shame in *The Scarlet Letter*. It simultaneously announces her as a man as it marks her past as a woman. The sequence also serves as exposition, intercut with the story of her journey to this particular point in the film: she bore an illegitimate child with a photographer back East and was subsequently banished by her family. The film now scans Josephine's memories and how she was seduced by the photographer through the use of her own image in pictures—the same way that a viewer is seduced by the images on the screen. Then the film cuts back to Josephine undressing in front of the mirror. Jo is now regenerated through violence, in Slotkin's schema, and Jo's new identity as the Western hero takes shape.

The next scene solidifies Kitses' notion of the Western as Jo rides into a small mining town. The hardscrabble settlement in the middle of the wilderness serves to highlight the plight of westward expansion—it is both beautiful and cruel, full of opportunity and full of danger. Taming such a place is crucial to the idea of American exceptionalism and American expansionism. The first men Jo encounters eye her suspiciously and remark on her scar, a gender coding that the men cannot see past (concretizing the notion of Jo as a man). As Jo eats in the saloon, copying the mannerisms of the men around her, she begins to take on the persona of the solitary male figure so prevalent in the Western. Still more suspicion arises when Jo is stopped and asked if she is a "dude." Frank Badger (Bo Hopkins) is one of the characters introduced here and does the interrogating. The term "dude" certainly has homosexual undertones, as some critics have noted (Ebert), but the men use it as a derogatory term to define a substandard type of male in the West—Easterners who presumably (according to the male residents of the mining town) can't endure the difficult conditions in the West. Such men are harassed and driven out of town, symbolized by the rows of socks on the wall. Because Jo has the correct type of socks and makes a stand against the men, she is accepted into the town fraternity as a male. If someone acts like a man in the West, he or she is a man.

THE BALLAD OF LITTLE JO (1993)

Ensconced in the town boarding house and working as a mining prospector, Jo begins the business of becoming not just a man but

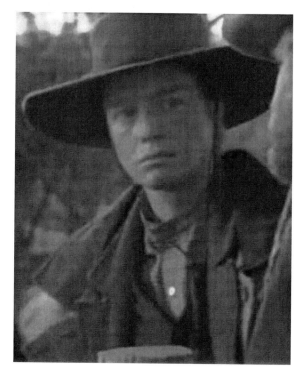

Figure 7.1 Joe Monaghan (Suzy Amis) is told that he is "quite peculiar" in *The Ballad of Little Jo* (1993).
Source: Courtesy of Joco and Polygram Filmed Entertainment.

also a true Westerner—a Westerner in the sense of being a hardworking, independent loner attempting to conquer the land. The images of this type of figure are common to the genre: from Wayne's Kid in *Stagecoach* to Jimmy Stewart's young lawyer in *The Man Who Shot Liberty Valance*, this hardworking, principled character represents the American Dream and the American myth propagated by the Western. The foundation of the West would be built by such characters, and Jo follows in that line. She does not fare well as a prospector, Percy Corcoran (Ian McKellen) offers his advice and help to Jo. He informs Jo of an opening at the livery, and because Jo had shown great skill and care with her horse, Percy believes Jo would make a good hand. Two important pieces of information emerge from this encounter: First, Jo is singled out as being responsible, fastidious, and hardworking; second, the repressed homosexuality of Percy is implied and he is

coded as such because of his attraction to Jo, his domesticity, and his aloofness. Both aspects of the initial meeting have important plot and genre implications. Jo becomes admired and respected for her work, independence, and skill—qualities that serve her well in the film and allow her to continue with the charade (because nobody would ever believe a woman would have such qualities). At the same time, Jo becomes the embodiment of the Western hero from so many films— the smart, strong, independent, hardworking figures who become the leaders and saviors of the various towns they populate. The homosexuality of Percy also has dual implications: Percy's repressed urges eventually lead him to act out violently against two separate women in the film—the traveling prostitute as well as Jo herself (after Percy reads a letter and discovers Jo's secret). Percy's actions will lead to his banishment from the town. On the genre level, Percy highlights the implicit homoeroticism of many Westerns throughout the history of the genre—from the mutual admiration of Wyatt Earp (Henry Fonda) and Doc Holliday (Victor Mature) in *My Darling Clementine* to the more overt longing showed by Charlie Prince (Ben Foster) for Ben Wade (Russell Crowe) in the 2007 remake of *3:10 to Yuma*. Through Percy, *The Ballad of Little Jo* suggests that one possible underlying reason for violence in the Western is this repressed sexuality in the middle of a male-centered West.

Percy's violent and bloody attack on the prostitute also serves as an important plot point: Jo realizes she is not suitably equipped for life in the West and takes action to change herself. Once again, her identity is regenerated through violence: she offers herself for a winter shepherding job working for Frank Badger. Yvonne Parker sees this move as an act of weakness: "Jo . . . is haunted by the threat of discovery. This threat leads to isolation, for example, with Jo taking the job of shepherding, the loneliness of which would drive other men crazy" (205). The decision is not one of weakness, but one of regeneration and a continuing search for identity. As in the earlier sequence with the soldiers, Jo sees that she must become self-sufficient and stronger, able to defend herself and be respected. The mise-en-scène parallels the mood in this scene: it is cold, hard, and lonely, and the violence is omnipresent. Jo decides to transform into a tougher, self-reliant Westerner because of it.

Badger is skeptical that Jo can handle the loneliness, the rough winter weather, and the dangerous surroundings; however, Jo is able to convince him. Frank agrees to Jo's proposal and Jo is off to the wilderness for the winter montage. It is here that Jo becomes a real Western hero: solitary, self-sufficient, durable, thrifty, and, most

importantly, good with a gun. The famous (clichéd, even) scene of shooting cans as target practice not only portrays the method by which Jo practices her gunslinging but also reminds viewers of many other Western coming-of-gun montage sequences (Shane teaching the boy to shoot in *Shane*; Wayne's J.B. Brooks teaching little Gillom in *The Shootist*). After some time in the mountains, Jo is able to kill the predator wolves, use their fur for a coat, and keep the herd intact throughout the winter. Her successful stint and personality overhaul into a hard-as-nails gunslinger will solidify her elevated status in the town. In addition to the plot considerations, the sequence also fulfills Kitses' notion of the Western aesthetic (where the landscape of the West serves as a barometer of character) as central to the genre discussion. Jo battles the environment and succeeds—she tames the West and paves the way for future settlement.

Jo's transformation into the classic Western hero also highlights the limited range of women's roles in previous Westerns. The breadth of women's roles in *The Ballad of Little Jo* are portrayed through the characters of Mary (Heather Graham), Ruth Badger (Carrie Snodgrass), and the prostitute brought into town in a carnival-like atmosphere. The prostitute is normally a stock character from the Western central casting office, except in this film in which she is an angelic mute who is then brutally attacked and slashed by Percy. The fact that she is mute speaks to the lack of voice for women in that period; the fact that she is slashed speaks to the violence so often inflicted (gratuitous, unpunished, senseless) on women in that era/on film. The slashing also references the earlier, self-inflicted violence on Jo herself. Additionally, the men who are not slashing the prostitute are cheating on their wives with little discretion—a fact not lost on Jo as she interrogates Frank in the wake of the carnage.

The character of Mary represented what was probably a large percentage of the female population in the West: She is a beautiful young woman, she works at the local saloon until a suitable mate comes through town and proposes her, and she is married. Once married, she is *gone*—taken away by her husband to become a housewife and mother and never to be seen or heard from again. The fact that she simply disappears from the narrative midway through the film speaks to how women would disappear into oblivion once they were married and began to serve their husbands. The other prominent female character is Frank Badger's wife, Ruth. Her most prominent scene entails employing various forms of home remedies to Tianman, Jo's eventual lover. In the absence of modern medical care, the women turn to using natural remedies that may or may not work—homespun

medicine that speaks both to lack of education and vocation of the women but also to the inventiveness of women living in such primitive conditions. Ruth also embodies Mary's future—she materializes only when necessary and she returns to her obsolescence just as quickly as she appeared. The only other woman we see in the film is the Eastern banker's wife, who arrives with her husband at Jo's farm to entice Jo into selling. Modleski cites this scene as typical of the Western and in the process validates Jo as a Western hero:

> Toward the end of the film Jo must make the kind of decision that most Western heroes face: whether to embrace the way of life associated with the East, with domesticity and civilization, or to remain apart from the forces encroaching on the wilderness and to live out her life as a rugged individualist.
> ("A Woman's Gotta Do . . . " 534–535)

As Jo watches the wife nag her son and sit uncomfortably in a ridiculously formal dress in the middle of the Wild West, Jo understands her own role in society and how she does not wish to return to the repressive situation of women, particularly in the East. The contradictory nature of women's place in society is evident here: in the "gentile" and lawful society of the East, the women have limited and defined roles as well—perhaps even more than women of the West. At least in the West, a woman could help a sick man from time to time and work on the farm as needed. Jo is able to overcome the obstacles and find peace, identity, and love, on her own terms, in the West. Jo chooses the life of the rugged individualist, as many a Western hero before her chose.

Jo's return from her mountain journey solidifies her first love affair in the film: her love for the West. As mutually beneficial partners, Jo has learned to live, commune, and nurture the West; in return, the West has given her the ability to live free and independent. The mise-en-scène is particularly instructive after her return: during the sequences with Percy inside his house, the camera focuses on the interior aspects of the Western mining town—the pans, the pots, the crude silverware, and plates. These practical items also serve as symbols of enclosure and domesticity: once Percy discovers the truth about Jo, he attacks Jo amidst these symbols. The film reinforces this idea as it cuts back and forth from the pots and pans to the attack. The repression inherent in the "normal" scope of female activity in Western film surrounds the violence. But as Jo pulls a gun on Percy and then forces Percy out of town, Jo becomes forever associated with

the outdoors, the wilderness, and the harsh conditions of the mining town rather than the symbols of domesticity. Jo now becomes an active character associated with the typical symbols of maleness in the West, a condition that is a direct result of her love affair with the West beginning with her stay in the mountains while she was tending the sheep. The idea of Jo's transformation due to this love is made explicit at Mary's wedding: Jo is the first one to pull out a gun and shoot the cans attached to the wagon. The other men of the town follow. Once again, Jo experiences a regeneration through violence: the violence of Percy's attack led to her transformation.

As a respected, full-fledged member of the town now, Jo is able to exert her will at various points. The key scene is when she meets her next love, Tianman. Tianman has been caught by the town's men and they threaten to hang him as Jo gallops by. Jo protests and eventually wins the stand-off. The result is that Frank forces Jo to take Tianman as a cook/servant in exchange for sparing Tianman's life. The undertone here is poignant: Frank is still unsure of Jo's sexuality, and perhaps sees Jo as a homosexual or even asexual being. Frank's caring feelings for Jo cause him to look out for Jo's best interest, and Frank realizes that Jo and Tianman would be suitable companions for each other:

Frank: "It's too lonely out there, you need company."

Jo: "I don't want company."

Frank: "You'll go crazy out there; I've seen it happen to men. And that worries me."

Jo: "Who asked you to worry about me?"

Frank: "I can't help it."

This exchange highlights the strange, and close, bond shared by the two. It is at once paternalistic but it borders on the mutual admiration typically shared by successful peers. Frank and Jo need each other in a way that neither can fully understand, and if they could understand, would never admit.

Jo's initial encounters with Tianman in her home are terse and brusque. Tianman cooks for Jo and Jo berates him for not having dinner ready on time. Jo makes Tianman sleep outside. She tells Tianman to put everything back to where it was because she likes her privacy. The next day, however, as she walks her horse out of the barn, Jo sees Tianman bathing in the pond nearby, shirtless, and she pauses to look.

Jo turns away quickly but turns immediately back and gazes upon Tianman. The reverse transvestism of the film now becomes overt as Jo, the male who is actually female, gazes upon the male body. Male viewers are forced into the female perspective as so many female viewers in the history of cinema have been forced into the perspective of the male viewer. As Laura Mulvey argued, the cinematic apparatus in the Classical Hollywood Cinema era was controlled by the male, and the scope of the woman's body was fetishized by the camera for the pleasure of the male (711–722). *The Ballad of Little Jo* reverses this dynamic, and therefore, the male gaze becomes the female gaze. Jo has earned that power: through her transformation into the Western hero and her love affair with the West, she now holds the power of the gaze and it is the shape of the *male* body that is objectified. Through the cinematic apparatus now appropriated by a female, male viewers are sutured into a reverse transvestism that is complicated by the fact that the typical Western hero is a female.

That night, as Jo cleans her gun, she begins to hum a tune, and her very feminine voice now becomes prominent. Tianman pretends not to notice but Jo bristles as she realizes what she's been doing. Jo yells at Tianman to get out, and he sleeps in the pouring rain that night. The next day they build a shelter for Tianman, and as Jo is about to fall from a ladder, Tianman grabs Jo's leg. Tianman turns away, embarrassed, and says, "You are no *Mister* Jo." The moment of realization is a relief for both and significant on several levels. First, Tianman obviously discerns the truth about Jo because of his proximity to her; second, on the narrative level it highlights the emotional distance between the many characters, and yet once someone finally gets close to Jo, he finds out Jo's secret almost immediately.

More importantly, perhaps, is that the emasculation and feminization of Tianman allows him to see the gender differences more clearly. Frank and the other men of the town were not able to see the truth in Jo because they never "got close to her" and because they were unable to imagine any other possibilities for a woman other than being a wife or whore—other options simply didn't exist in their world. The men's myopic vision can be extended to the film-going audience (and critics): as previously discussed, the film was dismissed as "revisionist" or "feminist" because the only possibility for a Western was a male protagonist—other options simply didn't exist and were therefore never allowed/considered. If the hero of this film is the archetypal Western character who is regenerated through violence; who is able to tame/coexist with the land; who

is the strong, silent type; who imposes his or her will; who engages in a search for identity; and who finds love in the West, then the oversimplified labels float away. Jo is the archetypal (fe)male Western hero(ine).

Jo and Tianman's love affair takes off quickly and fervently: They make love, they smoke opium, and they lie in bed and talk. Jo, who has never taken a drink while the men drink whiskey with wild abandon, relishes the opium and lovemaking as much as the Western hero loves his whiskey and women. Again, the reverse transvestism forces the male viewer to identify with Jo and her desires, which are different from the male hero in substance but with no inherent material difference. Jo gets his/her man, imbibes in her preferred substance, and finds pleasure in her actions. She now has the "fun" Frank told her she was missing. They live out their days together, presumably growing old and happy together.

The coda is as much comedy as it is mythmaking and truth-making all wrapped into one. The coroner examines the body and uncovers—literally—the truth about Jo. Frank, Ruth, and a few others gather round the body in astonishment. The women laugh as the men are stunned. The women realize that Jo was able to pull one over on the men, and they are envious and amused—by both Jo's actions and the reactions of the males (Frank is furious and ransacks her house). Jo's body is then propped up on a horse by the townspeople as a photographer captures the moment. The photographer—played by Director Maggie Greenwald—adds a poetic touch to the proceedings, highlighting the rare occasion of a woman in the West who managed to fool everyone and live independently, but it also highlights the importance of a woman bringing that story to the rest of the world (as Greenwald brings the story to us). The woman in charge of the cinematic apparatus, holding the power of the gaze, adds to the authenticity and builds upon the reverse transvestism of the film, as noted earlier. The reflexivity indicts the audience, and we are forced to examine the limitations of our own viewpoints and definitions of what makes a Western and a Western hero. Preserved as a myth, Jo is certainly one of those heroes.

The classic Western, the reverse transvestism, the role of the woman in the Western, and the dual-love story are all packaged by *The Ballad of Little Jo* as it forces us to look at the classic Western hero through a new lens. The film was part of a larger project of expanding the Western in the late 1980s and early 1990s—*Dances with Wolves, Unforgiven, Tombstone, Wyatt Earp, Geronimo: An American Legend* all revived the Western and rescued it from life support. Much like

these other films, *The Ballad of Little Jo* would add to the wonderful and rich tradition of the genre going directly back to *Stagecoach*, without obliterating it.

FILMOGRAPHY

3:10 to Yuma. Dir. James Mangold. Lionsgate, 2007. DVD.
Dances with Wolves. Dir. Kevin Costner. Tig Productions and Majestic Films International, 1990. DVD.
Geronimo: An American Legend. Dir. Walter Hill. Columbia Pictures, 1993. DVD.
High Noon. Dir. Fred Zinnemann. Stanley Kramer Productions, 1953. DVD.
My Darling Clementine. Dir. John Ford. Twentieth Century Fox, 1946. DVD.
Ride the High Country. Dir. Sam Peckinpah. MGM, 1962. DVD.
Shane. Dir. George Stevens. Paramount, 1953. DVD.
Stagecoach. Dir. John Ford. Walter Wanger Productions, 1939. DVD.
The Ballad of Little Jo. Dir. Maggie Greenwald. Joco and PolyGram, 1993. DVD.
The Man Who Shot Liberty Valance. Dir. John Ford. Paramount, 1962. DVD.
The Searchers. Dir. John Ford. Warner Brothers, 1956. DVD.
Tombstone. Dir. George P. Cosmatos. Cinergi Pictures Entertainment, 1993. DVD.
Unforgiven. Dir. Clint Eastwood. Warner Brothers, 1992. DVD.
Wyatt Earp. Dir. Lawrence Kasdan. Warner Brothers, 1994. DVD.

BIBLIOGRAPHY

Brower, Sue. "'They'd Kill Us if They Knew': Transgression and the Western." *Journal of Film and Video* 62.4 (Winter 2010). 47–57.
Buscombe, Edward. *Stagecoach*. London: BFI. 1992.
Ebert, Roger. "The Ballad of Little Jo." *Chicago Sun Times*. 10 September, 1993. Online.
Gorbman, Claudia. "drums along the l.a. river: scoring the Indian." *Westerns: Films Through History*. NY: Routledge, 2001. 177–195.
Kitses, Jim. *Stagecoach* DVD Commentary. Dir. John Ford. Walter Wanger Productions, 1939. DVD.
Lewis, Richard Warren. "The John Wayne Interview (re-print)." *Playboy*. January, 1989: 205–278.
Lusted, David. *The Western*. London and New York: Pearson. 2003.
Modleski, Tania. "A Woman's Gotta Do . . . What a Man's Gotta Do? Cross-Dressing in the Western." *Signs: Journal of Women in Culture and Society* 22.3 (1997) JSTOR. Web. 29 Nov. 2010.

———. "Our Heroes Have Sometimes Been Cowgirls." *Film Quarterly* 29.2 (1995–1996) JSTOR. Web. 29 Nov. 2010.

Mulvey, Laura. "Visual Pleasure and Narrative Cinema." *Film Theory and Criticism*. 7th ed. Ed. Leo Braudy and Marshall Cohen. New York: Oxford UP, 2009. 711–722.

Neale, Steven. *Genre*. London: BFI. 1980.

Parker, Yvonne. "Cowgirl Tales." *Genre, Gender, Race, and World Cinema*. Ed. Codell, Julie F. Malden, MA: Blackwell. 2007.

Slotkin, Richard. *Regeneration Through Violence*. Middletown, CT: Wesleyan UP. 1973.

Tomkins, Jane. *West of Everything: The Inner Life of Westerns*. New York: Oxford UP. 1992.

CHAPTER 8

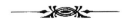

THE MELANCHOLY COUPLE IN *WINCHESTER '73*

Peter Falconer

A moment toward the end of *Winchester '73* (Anthony Mann, 1950) succinctly expresses the suitability of Lin McAdam (James Stewart) and Lola Manners (Shelley Winters) as an eventual couple. Lin is about to confront the maniacal bandit Waco Johnny Dean (Dan Duryea) in a saloon in the town of Tascosa. Lola has just warned Lin not to "quarrel" with Dean, and she grabs his arm and stops him for a moment before he can get away. What the audience might expect to follow would be Lola pleading more forcefully with Lin not to risk his life tangling with a psychopath. Instead, however, she offers tactical guidance: "Lin, watch his left hand." Lin recognizes Lola's gesture with a very slight smile.

This brief exchange shows that the two characters understand the situation, and their relation to it, in similar ways. The economy with which this understanding is communicated between them suggests that it forms part of a much wider shared conception of how the world works. The movie offers this worldview as a basis for the emerging romantic relationship between Lin and Lola. This relationship is not clearly established until they embrace at the end of the film (and even this affirmation is hardly emphatic), but the audience has been subtly prepared for it. The type of attitude or perspective that the two char- acters have in common can be described as melancholy. It is useful and interesting to think about Lin and Lola in terms of melancholy; this

is relevant not only to their construction as a couple but also to the movie's broader engagement with its genre and its audience.

In his influential article on the Western genre, Robert Warshow argues that the "melancholy" that he ascribes to the figure of the Western hero "comes from the 'simple' recognition that life is unavoidably serious" (1954, 107). Many Westerns ask for a similar recognition from their audiences. Jane Tompkins claims, "One of the hallmarks of the genre is an almost desperate earnestness" (1992, 11), an insistence on the painful seriousness of physical existence. It is this tone that gives the action in many Westerns its significance, and, in order to recognize this, an audience must first be persuaded to accept the seriousness of the world that an individual Western depicts.

A common strategy is to portray the world as inherently violent. This allows the violence of the hero to emerge as a natural response to the conditions in which he finds himself. It becomes part of what connects the character to the setting, making him the "right" man for his milieu. Warshow makes reference to the classic, almost clichéd scenario (dating back at least as far as Wister's *The Virginian*,[1] and the source of the expectations surrounding Lola's behavior in the example above) in which the heroine unsuccessfully objects to the hero's pursuit of violence:

If there is a woman he loves, she is usually unable to understand his motives; she is against killing and being killed, and he finds it impossible to explain to her that there is no point in being "against" these things: they belong to the world.

(1954, 107)

Warshow's contention that death and violence "belong to the world" of the genre is a premise that Westerns often ask their audiences to accept. In the fictional worlds of many Westerns, violence is inevitable. It can be controlled or confronted, but it cannot be escaped.

The Westerns of Anthony Mann develop this tendency within the genre. The West that Mann presents is a tragic one, characterized by fatalism, cruel irony, and inevitable violent reckoning. As critics like Jim Kitses (1969, 77) have pointed out, Mann's movies are strongly influenced by classical and Shakespearean tragedy. Mann's approach is exemplified in another scene from *Winchester '73*. A cavalry unit has survived an Indian attack with the help of Lin McAdam and his friend High-Spade Frankie Wilson (Millard Mitchell). After the Indians have been repelled, the film dissolves to a shot of Lin's rifle— the commemorative "one in a thousand" Winchester referred to in the

film's title, which was stolen from him after he won it in a shooting competition and which he is trying to get back—lying in the dust. The rifle has since been passed from owner to owner, the most recent being the Sioux chief, Young Bear (Rock Hudson), whom Lin shot while defending the camp. The camera tilts up from the gun and pans across the bodies and discarded weapons around it, arriving at a long shot of Lin and High-Spade preparing to leave. Before he departs, Lin advises Sergeant Wilkes (Jay C. Flippen) to collect the guns that the Indians have dropped: "No use leaving all those repeating rifles lying out there to rust." Shortly afterwards, as the two men ride away, the camera returns to the Winchester. Oblivious to its presence, Lin and High-Spade ride right past the rifle, nearly trampling it. In the very next shot, the gun is found by the young cavalryman Doan (Tony Curtis). Wilkes judges that it is "too good for an officer," and decides to give it to Lin, but he is already too far away to hear the sergeant's call. Instead, Wilkes gives it to Steve Miller (Charles Drake), Lola's fiancé (Lola is also in the camp), who also helped the soldiers fight off the Sioux, but who has been shown to be susceptible to moments of cowardice.

The scene is constructed to emphasize the sense of tragic irony. Twice the camera moves between Lin and the Winchester, linking them in the same shot. This reminds the audience how unknowingly close he is to his lost gun. The dialogue also ensures that the irony is as explicit as it can be. When Doan finds the gun, Wilkes observes that it was dropped by Young Bear, who was killed by Lin with what the sergeant calls a "real pretty shot." Wilkes goes on to note that the nameplate on the Winchester, which Lin did not have time to have engraved, is blank, but he still concludes that it "rightfully belongs" to Lin (presumably because he shot Young Bear). Similarly, Wilkes' remark when he gives the gun to Steve, "I wish it was a Congressional Medal for bravery—you earned it," emphasizes his unawareness of Steve's cowardly side. All of these moments are emphatically ironic— they rely on the audience knowing something that the characters do not know. However, the overall effect is less to demonstrate the characters' ignorance than it is to indicate the persistent cruelty of the world they inhabit. Coming straight after the successful defense of the camp, these ironic moments in the scene undermine any sense of victory, or even resolution. The violence through which Lin's Winchester keeps moving seems doomed to repeat itself.

Such a world would appear to be no place for a romantic couple. It will become apparent how much of Lola's part of the narrative is taken up with the destruction of her dream of settling down in

a conventional fashion. For Lin and Lola to form a credible couple, then, the film has to find a way to establish a connection between them in terms appropriate to its world. This connection is achieved through their mutual melancholy. At this point, it is worth clarifying what this description is intended to evoke. The word "melancholy," as it is used here, refers fairly generally to a mood or a feeling of sadness (as distinct from the more specific medical and psychoanalytical associations that the word "melancholia" has acquired). In the context of this general usage, however, there are a number of other cultural and historical connotations to melancholy that can also be drawn upon. One of these is an association with history, or with age. Naomi Schor remarks, "Melancholy is an old affect," and points out that it was already considered to be old by the nineteenth century (1996, 1). It is a mood that seems to come out of antiquity, making it well suited to the primal, fatalistic world of *Winchester '73*. A related point is the recurring association between melancholy and greatness or distinction. This tradition extends back to the followers of Aristotle and has developed in part out of observations concerning the supposed "sorrows of mythical heroes, such as Hercules, Ajax and Bellerophon" (Sullivan, 2008, 884).

The distinction conventionally associated with the melancholy individual often takes the form of wisdom or privileged insight. One of the many definitions of melancholy offered by Klibansky, Panofsky, and Saxl in their extensive historical account of the subject is an "awareness of life's menace and sufferings" (1964, 245). Melancholy has been frequently portrayed as giving its sufferers superior perception and understanding of the harsher and more threatening aspects of reality. This, above all, is what makes Lin and Lola a melancholy couple. The connection that gradually develops between them as the film progresses is rooted in their shared understanding of the cruelty and violence of the world around them. The extent of this understanding also brings the two characters epistemically closer to the audience. This helps to establish them as individuals deserving sympathy, and encourages viewers to regard their melancholy as an appropriate attitude. Lin and Lola do not generally know as much as the audience does, but it is repeatedly suggested that they know more than most of the other characters.

The scene following the Sioux attack demonstrates the extent to which the film emphasizes distinctions of this kind. A clearer sense of their importance can be gained by looking at a moment that occurred shortly before the attack in *Winchester '73* alongside its close equivalent in the next Western that Mann made with James Stewart, *Bend*

of the River (1952). In both scenes, the hero and the heroine are in a camp surrounded by Indians. Both involve the recognition or mis-recognition of the bird and animal calls with which the Indians signal one another (this convention is familiar enough that viewers rarely expect the calls to actually come from animals or birds). In *Winchester '73*, Lin tries to pretend to Lola that the calls come from genuine wildlife, rather than the Sioux who are preparing to attack. "Pretty, aren't they?," he says, "Sometimes they sing all night." Lola, how-ever, is fully aware of the situation and refuses such false comfort and says, "I know what they are."

In *Bend of the River*, the exchange is taken in a contrasting direc-tion. Laura Baile (Julia Adams) comments on what she thinks are the sounds of "night-birds." Glyn McLyntock (Stewart) indulges her misapprehension to avoid frightening her, identifying the "birds" as "redwing orioles" and giving the phrase a knowing emphasis to prompt Emerson Cole (Arthur Kennedy) to play along. This, how-ever, makes the situation increasingly awkward, as Laura is licensed to continue her naïve enjoyment of the sounds: "They're sort of plain-tive. I hope they nest near our farm." These lines are delivered in a medium close-up of Laura sitting on a wagon at the edge of the camp. It is shot with a long lens, so that she is isolated in the fore-ground from the other settlers at the campfire behind her, who are flat and out of focus. Her isolation in the shot emphasizes both her vulnerability and the personal nature of her reaction to the sounds, which provoke her into wistful musing. Glyn quickly changes the sub-ject, urging Laura to go over by the fire and wash a shirt for him, presumably to maneuver her toward the center of the camp where she will be less exposed. The first sign that the small Shoshone raiding party has started its attack, however, is when Laura, despite her more sheltered position, gets hit in the shoulder by an arrow.

The two scenes dramatize different levels of comprehension of the world and its violence (with the melancholy implied by greater aware-ness of this), and the effect that this has on the relationships between the characters. In *Winchester '73*, the scene forms part of the pro-cess of suggesting the similarities in outlook between Lin and Lola. In *Bend of the River*, it is the two men, who will emerge first as friends and then later as enemies, who are connected in this way. The scene contrasts Laura's limited awareness of the possibilities of violence and danger with the fuller understanding shared by McLyntock and Cole. This can be seen in the editing, which alternates between the medium close-up of Laura and a two-shot of the two men, and in the mul-tiple levels of meaning in the conversation. There are effectively two

conversations going on at once—one between Laura and the men on the nominal topic of birds and another between Glyn and Cole on the real topic of the nearby Indians. Laura's obliviousness to the immediate threat generates an ironic tension between what the characters say and the situation they actually face. It is this quality that Cole seems to be responding to when he laughs at McLyntock's remark about not wanting the "redwing orioles" for neighbors.

Laura's romantic ruminations on what she thinks are birds follow soon after a discussion between Glyn and Jeremy Baile (Jay C. Flippen), Laura's father. Jeremy questions Glyn's plan to take the settlers on a detour around the mountain that looms in the background. He asks McLyntock about the mile-high hills around it: "Just one mile? Is that too bad?" Glyn tells him, "A lot of people had the same idea. Most of them are still up there under the snow." Both Laura and Jeremy's remarks reflect a view of the natural world as essentially benign, as consisting of things that enrich their environment (like birdsong) or provide them with opportunities to reach their destination more directly (like mountains). This perspective forms a part of a broader understanding of the settlers' impulses and aspirations. Their aim is to establish an idealized community of their own in the wilderness, from which violence can be excluded. Glyn sees the danger in the world that the settlers miss to see. Jim Kitses refers to the "*pathetic* relationship between man and environment" (1969, 71— original emphasis), which is often a feature of Mann's Westerns, with the harshness of the landscape reflecting the violence of the characters within it. Glyn and Cole are attuned to their environment in this way—their common background as Missouri-Kansas border raiders (another thing that the settlers are, at this stage, unaware of) gives them an experiential understanding of violence.

The violence of the Shoshone attack on the camp seems to emerge impersonally out of its surroundings. The Indians themselves remain unseen until Glyn and Cole go out after them, and their initial presence is indicated by natural-sounding noises. The arrow hits Laura suddenly and seemingly from out of nowhere. The settlers respond by firing wildly into the dark, as if trying to fight back at the night around them. The representation of the attack in this way is an example of the common strategy of portraying Indians less as people than as a malevolent manifestation of the environment, what Tompkins likens to "a particularly dangerous form of local wildlife" (1992, 8). As ideologically dubious as this convention undoubtedly is, it is a part of the generic context through which this scene can be understood and connected to the broader logic that the film establishes for its world (and that can also be seen in *Winchester '73*). Because that is what

the arrow that hits Laura is—an announcement of the violence of the world. The irony that it should be Laura that the first arrow hits is used to draw attention to her ignorance of this violence and its potential consequences.

This portrayal of the world as inescapably violent indicates a melancholy perspective, especially when contrasted with the utopian ambitions of the settlers. They seem to defy or deny forces that, as Douglas Pye notes, could easily erupt again (1996, 172). This context of fatalistic melancholy is more explicit in *Winchester '73*. The earlier film frames its equivalent to the "night-birds" scene in terms of the shared melancholy of Lin and Lola. The characters' melancholy comes from their knowledge and experience of violence. It is this connection that makes them credible as an eventual couple. Some critics have found the pairing of the characters to be unconvincing. Pye, for example, groups the film's final generation of its couple with that in another Mann Western:

> In *The Far Country* and *Winchester '73*, James Stewart is left respectively with the characters played by Corinne Calvet and Shelley Winters. In neither case has a relationship developed that seems a likely basis for the marriage that the end seems to indicate.
>
> (1996, 172)

Fairlamb argues that Lola functions as a convenient means "to reassert [Lin's] masculinity and unequivocal heterosexuality" (1998, 22) at the end of the movie. He also argues that

> ... there is little doubt throughout that McAdam's treatment of her is inspired by the Western chivalric code and that the gun—with all it represents—is the real object of desire
>
> (1998, 22)

Leaving aside the psychoanalytical assumptions implied by Fairlamb, it is still true that Lin's retrieval of the gun—stolen from him by his own brother, Dutch Henry Brown (Stephen McNally), who also murdered their father—is the film's main narrative resolution. The title of the movie makes this focus clear enough. However, the production of a romantic couple can still be a significant element without necessarily being the most prominent strand to the story.[2] The development of Lin and Lola as a potential couple may not take up much of the movie, but it is done with a subtle insistence through moments of slowly increasing mutual understanding and brief but direct connection.

These moments characteristically involve Lola appreciating Lin's consideration and Lin admiring Lola's fortitude. Both of these traits

are displayed in the film in circumstances that relate to their wider sense of melancholy. Fairlamb is right to describe Lin's behavior in terms of chivalry, insofar as his courteous gestures toward Lola are primarily important *as gestures*, that is, for what they exemplify rather than what they achieve. They are tangible manifestations of kindness and comfort in a harsh world, which give them a poignant value. But rather than simply embodying an impersonal code of conduct, his actions toward her are given very specific significance by their context.

Lin first meets Lola when she is being forced to leave Dodge City by its marshal, the famous Wyatt Earp (Will Geer). As a saloon girl, she is judged to be bad for the image of the town over the centennial weekend. Lin steps in on her behalf, addressing her as "ma'am" and being curt and aggressive with Earp (the first real hint the movie gives of Lin's capacity for violence). However, he does not follow his aggression up with action, nor does he prevent Lola's expulsion from Dodge City. Nonetheless, his intervention is still appreciated. Lola leans out of the window of the stagecoach she has been bundled onto and says, "Thanks, anyway." Lin responds with a nod and a tip of his hat. In that brief exchange, the two characters acknowledge both the futility of the situation and the value of the gesture in spite of this futility. It is the first suggestion of the mutual melancholy that the film subsequently develops.

A similar point could be made about Lin giving Lola his saddle to sleep on after they meet again in the besieged cavalry encampment. Here, the wider context for the gesture comes from both the seemingly impossible situation they face, where they are outnumbered and surrounded, and the difference between Lin's actions and those of Steve Miller. Steve had ridden away in panic when first confronted with the Indians, leaving Lola behind; although he came back to guide her into the camp, the memory of his initial cowardice still hangs over them, expressed throughout this part of the film via a series of anguished and disappointed looks. Lin, by contrast, acknowledges the extent of the danger they are in but still goes out of his way to help Lola. Offering her the saddle does not improve their chances of survival (although, of course, they do manage to fight off the Indians), but the small kindness stands in stark contrast to the desperate circumstances. Again, it is the fact that both characters recognize and accept the bad situation that they find themselves in that gives the gesture its significance.

This is why Lin's attempt to comfort Lola by lying about the bird calls, another of his chivalrous gestures, is not received in the same way. The previous two examples involved a mutual acknowledgment

and acceptance of the violence that governs the film's world, whether in the form of marauding Indians or the less obvious threat of Wyatt Earp, whose folksy good humor belies his strict control of Dodge City and enduring power to inspire fear. By trying to delude Lola about the bird calls, Lin is attempting to take the whole burden of dealing with the violence onto himself. Lola knows too much to allow this to happen. The directness with which she rejects the fantasy of the bird calls seems to surprise Lin—for a moment, he does not know what to say—and prompts him to answer truthfully when she asks if he is afraid. In this respect, her response establishes the two characters as equals.

One of the great strengths of Shelley Winters at this stage in her career was her ability to evoke both youth and experience at the same time. David Thomson describes her persona as "either voluptuous or drab" (2003, 943), but at her best she combines the two, resulting in characters that possess a kind of tarnished vitality. This quality makes Lola, with her awareness of violence and experience of betrayal, an appropriate counterpart to Lin. Both characters are given insight into the way things work, but this is portrayed as a melancholy burden—in the world the film creates, their wisdom affords them no serenity (consider Laura's blissfully oblivious contemplation in *Bend of the River*). Their knowledge of violence makes them visibly weary—both Winters' and Stewart's performances emphasize this effect (Stewart was 42

Figure 8.1 Lola (Shelly Winters) tells Lin (James Stewart) that she understands what the last bullet is for in *Winchester '73* (1950).

Source: Courtesy of Universal National Pictures.

when the film was first released, and although still gangly and boyish in appearance, he was starting to show signs of age).

The characters' melancholy insight also enables them to communicate with each other as frankly as the Motion Picture Production Code would allow. Just before the Indians attack, Lin gives Lola his pistol, "Just in case you, uh . . ." When she insists that she knows how to use it, Lin looks at her gravely. She picks up his implication and says, with an apologetic half-smile, "I understand about the last one." The convention, in Indian attacks, of saving the last bullet for the white woman, to spare her the possibility of rape, is another problematic but familiar trope in Westerns. As Kim Newman puts it, "The threat of red lust to white womanly virtue is a spectre that stalks the genre from Fenimore Cooper onwards" (1990, 64). In this instance, though, the significant point is that Lola knows this convention. Again, her understanding is explicitly aligned with that of the audience. Lola's level of awareness might be compared with that of Lucy Mallory (Louise Platt) during the Apache attack in *Stagecoach* (John Ford, 1939). Mrs. Mallory is tearfully praying, her eyes pointed up and to the right, as the gun held by Major Hatfield (John Carradine) creeps into the shot from the left. Before he can pull the trigger, Hatfield is shot by an Indian, and Mrs. Mallory remains apparently unaware of how close she came to being killed. The understanding of violence that Lola is shown to have allows her character to challenge a number of conventional expectations concerning heroines in Westerns.

Expectations of this kind have resulted in critics downplaying or dismissing the couple in *Winchester '73*, and particularly Lola's part in it. Jacques Rancière claims that the heroes in Mann's Westerns have "no interest in [the heroine] or in starting a family" (2006, 77). With more specific reference to *Winchester '73*, Rancière also argues that

. . . nobody can imagine James Stewart savouring the tranquillity of work done, the Winchester hanging on the wall, Shelley Winters in an apron, and a bunch of children with his same blue eyes.

(2006, 75)

This is a fair and justifiable assertion, inasmuch as the film offers nothing in its world that might seem to be able to support or sustain this type of settled life. However, it does not necessarily follow that because happy, secure domesticity seems like a remote prospect in this context, the film has no interest in Lola, or her relationship with Lin can have no other significance. This assumption proceeds from an overly simplistic equation of Western heroines with settlement and

the home. It is true to say that female characters in a large number of Westerns do carry these sorts of associations, but it is dangerous to assume this automatically and without regard to the details of the particular movie.

In the case of *Winchester '73*, the film provides plenty of information on which to base a more specific understanding of Lola's relation to domesticity. The second time Lola appears in the movie, after she has been run out of Dodge City, she seems to be on the brink of settling down. She and Steve are traveling to their new home, looking happy and contented. Lola is almost childlike in her affections—she clings onto Steve's arm and asks him if their ranch is "a pretty place"; later she puts her head on his shoulder. But even at this stage, all is not right. Before they settle down together, Steve has a suspicious-sounding "deal" that he needs to attend to with "some fellas." The problem, it seems, is that the money they are settling down with was earned by Lola, by playing piano in Dodge City. As Steve puts it, "That's what I mean—you got the money. Now I've got to get some." For Steve, settling down involves taking up the more traditional role of provider and redressing the perceived imbalance in his relationship with Lola. For Lola, by contrast, ideas of domesticity and independence are bound up together. Later, when talking to Lin in the cavalry camp, she stresses the importance of having a home of her "very own." Although her dreams (and the girlish enthusiasm with which they are sometimes expressed) are still fairly conventional, these early assertions of her personal and financial independence already show signs of a departure from orthodox critical conceptions of heroines in Westerns.

As the film progresses, Lola's domestic aspirations, and any attendant notions of conventional courtship and romance, are, if not entirely destroyed, at least profoundly debased. First, Steve temporarily abandons her when the Sioux attack. Subsequently, Lola is subjected to nightmarish inversions of domesticity and then of romance. When she and Steve arrive at the Jameson place, where they had been planning to settle, the future of their relationship is uncertain. It is not yet clear whether Lola's trust and affection for Steve will be able to recover from the damage done by his cowardly actions. At this stage, though, domesticity still has its appeal for Lola. This is most apparent in her tender and maternal reaction to the Jameson children (the family have yet to move out). Before any of this can develop further, however, Waco Johnny Dean and his gang arrive at the house, pursued by a posse. Dean's invasion of the domestic environment strips it of any comforting or optimistic associations. He turns the trappings of domesticity into a cruel joke, bullying Steve by

forcing him to make coffee, suggesting that he "put an apron on," tripping him over, and ordering him to clean up the mess. Steve is finally goaded into going for his gun, and Dean shoots him dead. The Jameson children's toys can be seen on the floor behind Steve as he dies. The end of the scene provides an even more emphatic image of violated domesticity. Marshal Noonan (Ray Teal) and his men try to force the gang out by setting the house on fire, but Dean escapes with Lola as a human shield. As they ride away, the only ordinary family home in the film can be seen in long shot, burning.

Waco Johnny Dean keeps Lola with him, forcing her into what Kitses calls "a grotesque love relationship" (1969, 59). In the scenes that follow, Dean tells Dutch Henry Brown and his gang that Lola is "crazy" about him, sits her on his knee, and repeatedly smiles and simpers at her. His horrific parody of affection, combined with the coercive force that prevents her from leaving, creates a disturbing sense of sexual menace. In the world of *Winchester '73*, this is what Lola's dreams of settling down with Steve become.

Lola's bitter experience of domesticity is another element that links her to Lin. Her remarks in the cavalry camp about having a place of her "very own" come at the start of a larger conversation with Lin about homes. Lin tells Lola that he once had a home "like that" with his father, but that his father was killed. Retrospectively, it becomes clear that this conversation establishes a kind of symmetry between the trajectories of the two characters. Lin is coming from a destroyed home, while Lola is heading toward one.

Another way that the film establishes Lin and Lola as a complementary pair is through their association with particular objects. If Lin's emblematic object is the titular gun, Lola's is a bullet. Without making too much of this correspondence, the film uses these objects to subtly establish a logic of part and counterpart. Lola saves the last bullet in Lin's six-gun after the Sioux attack, not as an emergency contingency, but as a keepsake. When Lola returns the gun, he asks if she can keep it saying, "You just never know when a girl might need a bullet." This phrase conveys both practicality and sentiment. It hints at both the likelihood of future violence (as the world has not changed) and at a continuing bond between her and Lin. The bullet becomes a significant object for Lola. It stands for both the continuing threat of violence and the possibility of survival, and her connection to Lin and its limited prospects for development (when Lola takes the bullet, Lin is still obsessively focused on retrieving the Winchester and avenging his father's death, while she is confronting the possibility of having chosen the wrong man to settle down with).

In this respect, too, the portrayal of the couple can be said to be melancholy. The other side to the traditional association of melancholy with insight is the sense that what appears to be a greater sensitivity to the surrounding world is often more a desire to invest it with meaning, that is, to give every object a symbolic significance. It is striking how often melancholy has been connected to an interest in material objects and what they might mean. Siegfried Kracauer suggests that a melancholy perspective not only "makes elegiac objects seem attractive" but also "favours self-estrangement, which on its part entails identification with all kinds of objects" (1960, 17). The idea that the sadness and alienation of melancholy might result in a greater attention to and affinity with things (as opposed to people) is still a resonant one. Walter Benjamin explains this tendency by arguing that, if melancholy entails despair at the apparent lack of permanence and continuity in the world, it also inspires its sufferers to seek these qualities in objects: "The persistence which is expressed in the intention of mourning, is born of its loyalty to the world of things" (1928, 157). In its complex emotional resonance in a harsh and turbulent world, Lola's bullet is an exemplary melancholy object.

When Steve has been killed and Waco Johnny Dean has taken Lola away with him, she takes comfort in the bullet. She stands on the porch of the run-down shack where Dean has met up with Dutch Henry Brown and his gang, tossing the bullet up in the air and catching it much like George Raft flipping a coin, feeling its weight and shape as it lands back into her hand. The film emphasizes the material character of objects—Kitses describes Mann's style as "distinctively physical" (1969, 33). The gun at the center of the narrative is often photographed in depth and at a diagonal, in such a way as to display its three-dimensional shape and the play of light on its surfaces. The bullet is smaller and more personal, but some sense of its physical substance is still important, because it gives Lola something solid and concrete to cling onto, to connect her tribulations to something permanent and meaningful. Like her bullet, Lola acknowledges the violence of the world but manages to endure despite this acknowledgment.

Thus, when Lin and Lola are united at the end of the movie, his mission fulfilled and her succession of wrong men dispensed with, it is in the most positive way that the logic of the movie will allow—as survivors. To bring them together more emphatically—with a kiss, say—would be inappropriate, not only because of the tone of the whole film but also because of the risk of drawing too obvious a parallel between Lola and the Winchester (both having been passed

from man to man until they end up with Lin). The movie has shown too much respect to Lola's weary wisdom to finally reduce her to an object. Instead, Lin and Lola embrace one another with exhausted relief, and the final shot shows the scuffs and scratches on the once-pristine stock and still-blank nameplate of the recovered Winchester '73, permanently marked by violence. The affirmation of the couple at the end of the movie is presented with a suitable tinge of melancholy.

The particular representation of the romantic couple seen in *Winchester '73* is articulated through the conventions of the Western genre. Many critics, including Rancière (2006, 73) and Tim Pulleine (1993, 312), have described the film as a kind of compendium of characteristic Western tropes and images. This can be seen in the structure of the movie—the succession of different Western characters and settings facilitated by the passage of the rifle—and in individual moments, such as the shooting competition in Dodge City, which includes a panorama of incidental characters embodying familiar "types" from the genre (farmer, fur trapper, grizzled old man, mustachioed dandy, etc.). The film has its own distinct style and perspective, but these are created by the careful arrangement and inflection of generic elements. Many of the moments that contribute to the creation of Lin and Lola as a couple exemplify this approach. Comprehending the significance of the bird calls around the cavalry camp or of Lola's bullet depends on recognizing them as Western motifs, with their own history of accumulated associations. Academic work on Westerns has not always recognized the versatility of such conventions. If aspects of *Winchester '73* seem surprising to contemporary critics, it is perhaps because the conception of what is possible in a Western has grown too narrow. Thinking about the movie and its couple in melancholy terms provides an opportunity to appreciate the diversity and scope of the Western genre at the time of its greatest popularity and proliferation.

NOTES

1. See Slotkin (1992), 180–182.
2. See, for example, Bordwell, Staiger, and Thompson (1988), 16–18.

FILMOGRAPHY

Bend of the River. Dir. Anthony Mann. Universal, USA, 1952. DVD.
Stagecoach. Dir. John Ford, Walter Wanger Productions, USA, 1939. DVD.
The Far Country. Dir. Anthony Mann, Universal, USA, 1954. DVD.
Winchester '73. Anthony Mann, Universal, USA, 1950. DVD.

BIBLIOGRAPHY

Benjamin, Walter. *The Origin of German Tragic Drama*. Originally published 1928, version cited, London: Verso, 1998.

Bordwell, David, Staiger, Janet, and Thompson, Kristin. *The Classical Hollywood Cinema: Film Style and Mode of Production to 1960*. London: Routledge, 1988.

Buscombe, Edward, ed. *The BFI Companion to the Western*. London: BFI, 1993.

Cameron, Ian and Pye, Douglas, eds. *The Movie Book of the Western*. London: Studio Vista, 1996.

Fairlamb, Brian, " 'One in a Thousand': Western Stars, Heroes and their Guns." *CineAction* 46 (June 1998): 18–25.

Kitses, Jim. *Horizons West: Anthony Mann, Budd Boetticher, Sam Peckinpah: studies of Authorship Within the Western*. London: BFI/Thames and Hudson, 1969.

Klibansky, Raymond, Panofsky, Erwin, and Saxl, Fritz. *Saturn and Melancholy: Studies in the History of Natural Philosophy, Religion and Art*. London: Nelson, 1964.

Kracauer, Siegfried. *Theory of Film: The Redemption of Physical Reality*. Oxford: Oxford University Press, 1960.

Newman, Kim. *Wild West Movies, or How the West Was Found, Won, Lost, Lied About, Filmed and Forgotten*. London: Bloomsbury, 1990.

Pulleine, Tim. "Winchester '73." In *The BFI Companion to the Western*. Ed. Buscombe. London: BFI, 1993: 312.

Pye, Douglas. "The Collapse of Fantasy: Masculinity in the Westerns of Anthony Mann." In *The Movie Book of the Western*. Ed. Cameron and Pye. London: Studio Vista, 1996: 167–73.

Rancière, Jacques. *Film Fables*. Trans. Emiliano Battista. New York: Berg, 2006.

Schor, Naomi. *One Hundred Years of Melancholy: The Zaharoff Lecture for 1996*. Oxford: Oxford University Press, 1996.

Slotkin, Richard. *Gunfighter Nation: The Myth of the Frontier in Twentieth-Century America*. Norman: University of Oklahoma Press, 1992.

Sullivan, Erin. "The Art of Medicine: Melancholy, Medicine and the Arts." *The Lancet* 372 (September 13, 2008): 884–885.

Thomson, David. *The New Biographical Dictionary of Film*, Fourth Edition. London: Little, Brown, 2003.

Tompkins, Jane. *West of Everything: The Inner Life of Westerns*. Oxford: Oxford University Press, 1992.

Warshow, Robert. *The Immediate Experience: Movies, Comics, Theatre and other aspects of Popular Culture*. Originally published 1962, version cited. Cambridge MA: Harvard University Press, 2001.

——. "Movie Chronicle: The Westerner." Originally published 1954, version cited in Warshow, *The Immediate Experience*. Cambridge, MA: Harvard University Press, 2001: 105–124.

CHAPTER 9

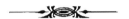

OUTLAWS, BUDDIES, AND LOVERS: THE SEXUAL POLITICS OF *CALAMITY JANE* AND *BUTCH CASSIDY AND THE SUNDANCE KID*

Frances Pheasant-Kelly

Initially, *Calamity Jane* (David Butler, 1953) and *Butch Cassidy and the Sundance Kid* (George Hill, 1969) seem to have little in common, except as variations of the Western genre. One is a lighthearted musical Western that results in the heterosexual marriage of its two protagonists, while the other tells the story of two outlaws on the run and their eventual demise. However, there are connections between them, not only in their musical content (both achieved acclaim for their musical scores) but also in the homosocial and homoerotic undertones that pervade both films. While such relationships are always discernible in Hollywood cinema, there has been a failure to explore them fully until the release of *Brokeback Mountain* (Ang Lee) in 2005. Indeed, at the time of *Calamity Jane's* release in 1953, the Hays Production Code (1934) explicitly forbade the representation of "sexual perversion or inference to it" (Bordwell and Thompson 216). Nevertheless, while not directly depicting homosexuality, *Calamity Jane* contains multiple instances of cross-dressing, and a potential development of lesbian relationship between Katie Brown (Allyn McLerie) and Calamity Jane (Doris Day). Ultimately, though, the film culminates in a heterosexual relationship between Calamity and Wild Bill Hickok (Howard Keel)

and their eventual marriage, one of the most usual outcomes of classic Hollywood narratives, especially where a woman needs to be "tamed." Various other strategies also serve to recoup the characters' heterosexuality, while the use of comedy frequently signals the film's potentially homoerotic encounters.

By 1961, the Motion Picture Association of America (MPAA) had relaxed its enforcement of the Hays Production Code, eventually phasing it out completely by 1968. Even so, homosexuality on screen was still a taboo subject and while *Butch Cassidy and the Sundance Kid*, released in 1969, was subject to less stringent censorship, the two male "buddy" protagonists effectively "share" a girlfriend (Katherine Ross), thereby similarly negating any implication of homoeroticism. Richard Dyer's analysis of representation in relation to the buddy film, and his study of gay types, as well as Steve Neale's account of masculinity as spectacle provide theoretical ways to illuminate the representation of homosocial and homoerotic relationships within the two films and their implications for heterosexual love. The films' musical content as relevant to heterosexual desire and spectacle, as well as their respective years of production in relation to censorship issues are further germane to such analysis.

CALAMITY JANE

Calamity Jane is a musical-Western hybrid that capitalizes not only on the vocal capabilities of Doris Day and Howard Keel but also on their respective archetypal gender and star attributes. Toward the end of the film, Doris Day transforms into an idealized image of femininity, possessing both the platinum-blond hair associated with Hollywood stardom and the innocent smile of the "girl next door," while Howard Keel's physical stature and deep voice conform to conventions of the Western's classic masculinity. Initially, though, Day's character, Calamity Jane, presents as a masculinized female protagonist who cross-dresses in buckskins and cracks a bull whip, her figure behavior (physical expression) excessive and parodic in relation to concepts of classic masculinity. The film focuses on her apparent tomboy attributes, and follows her transformation to idealized heterosexual femininity (and eventual marriage), this "make-over" (Jeffers McDonald, *Carrying Concealed Weapons* 179) effectively structuring the narrative.

Essentially, Calamity's mannish costume and excessively masculine figure behavior carry connotations of the "butch female," which Richard Dyer defines as a form of gay representation. Dyer identifies

four gay types: the "in-between" categories of mannish dyke and effeminate queen; the "macho man," who has an excess of masculinity and often wears tight clothing, with "the conscious deployment of signs of masculinity" (38). Third, he describes the "sad young man," who is "soft [and] has not yet achieved assertive masculine hardness" (42). Finally, he discusses the "lesbian feminist," images of which "deploy a rhetoric of the natural" (44). Arguably, Calamity falls into the category of the "in-between" as a female who has distinctly masculine qualities and who seems to take an "unnatural" interest in looking at other women—especially when one considers the film's lesbian undertones and instances of cross-dressing by other characters. Ultimately, however, such representations do not undercut the film's recuperation of heterosexuality, which it achieves through various visual and narrative strategies in order to cohere to the production code values of the time.

The film's narrative unfolds in the remote Dakota town of Deadwood where Golden Garter theater owner Henry Miller (Paul Harvey) advertises for a female actress to perform in his saloon. When the actress, supposedly Miss Frances Fryer, arrives at Deadwood, "she" turns out to be Mr. Francis Fryer (Dick Wesson) in the film's first example of gender confusion. In his desperation for a female performer, Miller coerces Fryer into cross-dressing as a woman, but when the men in the audience realize the ploy, they respond angrily. The plot centers on Calamity Jane's promise to them to bring back famous actress Adelaid Adams (Gail Robbins) from Chicago as compensation. The men in the isolated town of Deadwood only know of Adelaid Adams from photographs of her printed on cigarette cards, one of which the viewer sees in close-up. It reveals a semiclad female, an image of stereotypical feminine desirability that recurs later in various other formats and is important to the film in several respects. Narratively, it allows both Calamity and the men in the theater to be duped by Katie Brown's masquerade as Adelaid Adams, since they wear the same costume. Visually, its version of womanhood is antithetical to Calamity's masculinized appearance and provides a recurring example of constructed femininity to which Calamity must aspire. Most obviously, the image signals heterosexual desire, the politics of which are fundamental to the narrative.

The next scene thus unfolds in Chicago, where Calamity searches for Adelaid Adams. Her interest in other women becomes obvious as she looks curiously at them in the street—evident from a medium close-up of her staring open-mouthed before an eye-line match cuts to a close-up of a bustle on the back of one of the women's dresses.

The film implies that Calamity is unfamiliar with the minutiae of feminine finery, arguably as a means of disguising lesbian desire. She then accidently walks into another woman who turns her head admiringly and winks at Calamity, seeming to regard her as either a man or a lesbian.

Calamity locates the Lyceum theater where Adelaid Adams is performing. However, unbeknownst to Calamity, Adelaid has donated her costumes to her maid, Katie Brown, as a gift. Calamity knocks on her dressing room and asks Katie to perform at Deadwood's Golden Garter in the belief that she is Adams. This scene provides another potentially homoerotic moment. While Calamity opens the door of the dressing room, she finds Katie dressed in a skimpy strapless stage outfit (the same one worn by Adams in the picture that appears on the cigarette cards). Approaching Katie with apparent fascination, Calamity exclaims, "Gosh almighty, you're the prettiest thing I ever seen. Never known a woman could look like that. Say how do you hold that dress up there anyways" and then proceeds to peer down the top of Katie's costume. Katie in turn mistakes Calamity for a man, and is astounded when she realizes her error, saying to Calamity, "you're . . . you're a woman?" "You thought I was a man?" replies Calamity and laughs before saying, "come to think of it, that ain't so funny." Katie takes up Calamity's offer, and on their arrival in Deadwood, she attracts the attention of both Bill Hickok and Lieutenant Gilmartin (Philip Carey), with whom Calamity is in love. By the film's end, Bill Hickok, although initially entranced by Katie too, marries Calamity while Katie marries the lieutenant.

Examples of identity and gender confusion thus insistently pervade the film, with multiple examples of transvestitism: initially, Mr. Francis Fryer becomes Miss Frances Fryer, and Katie Brown masquerades as Adelaid Adams, while later, Bill Hickok dresses as a Sioux squaw nursing "her" papoose. These episodes of cross-dressing often invite homoerotic attention from other characters. Indeed, according to Brett Farmer, the musical has a tendency for sexual subversion. He argues that, "the musical number frequently offers images and sequences that can be read as homosexual or, at the very least, homoerotic" (81). Highlighting *Calamity Jane*, he notes, "[t]hese spectacular moments of gender transgression all point to a profound undercurrent of sexual subversion at play in the musical number" (82).

However, the film continually destabilizes these potentially transgressive instances to circumvent the Production Code values, even though they likely broaden audience appeal. Certainly, Jackie

Stacey's study of female spectatorship specifically comments on the implicit homoerotic interest of female viewers at the time of the film's release (138). Since effeminacy in men and butchness in women are ways to signify homosexuality, the film's narrative works to reclaim its protagonists' heterosexual status by reestablishing stereotypical representations of gender. This occurs generally through repeated idealized images of femininity (the cigarette cards featuring Adelaid Adams, and her performance in Chicago, as well as a life-size painting of Katie Brown). These images feature women dressed in frilly, feminized costume, an aspect central to stereotypical constructions of femininity. Indeed, costume constitutes a significant aspect of Calamity's transformation, with Jeffers McDonald (*Hollywood Catwalk*) interpreting the change in Calamity's appearance wholly in terms of dress.

A second way in which the film mitigates its homoerotic undercurrents is through frequent verbal references to heterosexual desire between the protagonists, especially by Calamity, who constantly professes her love for Lieutenant Gilmartin. More significantly, and predictably, the film culminates in a double (heterosexual) marriage.

Therefore, although Calamity initially dresses as a man, the film's narrative returns her eventually to hetero-normative femininity, visually through costume and narratively through marriage. The reclaiming of heterosexuality through depictions of stereotypical femininity also occurs in less obvious ways. While some scholarly analyses locate this recuperation in certain types of camera shot (Wills), or particular aspects of the mise-en-scène (Jeffers McDonald, *Hollywood Catwalk*), there is, in fact, a broader range of factors to consider. These include Doris Day's star image, her parodic performance of masculinity, gendered modes of *diegetic* spectatorship, specific aspects of cinematography and lighting, and finally, the use of comedy.

Indeed, the film's episodes of sexual subversion are inevitably humorous, an aspect that arises from performance as excessive and artificial, and incongruities between star image and role, in particular, those pertaining to Doris Day. In examining Day's career, Dennis Bingham outlines various stages in the development of her star image, ranging from her "tomboy" and "girl-next-door" personae associated with the Warner Brothers musicals to her later roles as "career woman." In fact, while Day topped box office ratings for a series of romantic comedies, and is currently sixth in all-time box office ratings,[1] her image has remained primarily one of being "perpetually virginal" (Bingham 3). Moreover, though her earlier association with the "tomboy" is relevant to *Calamity Jane's* depiction of her as a cross-dresser, her transformation within the *diegesis* to a paradoxical

figure of desirable femininity and "a version of blond perfection" (Bingham 6) merely serves to heighten the parodic nature of her "butch female" performance.

A contemporary review of the film similarly notes the disparity between the role of Calamity Jane and Day's star persona, stating that "Doris Day works very, very hard at being Calamity and is hardly realistic at all" (Variety Staff). In her study of costume, Jeffers McDonald sees this incongruity as essential to the narrative, arguing that "the film is unique among its Western peers by centering the narrative on ideas of transgression and transformation, and that what Day wears in the role of Calam is precisely the point" (*Carrying Concealed Weapons* 179).

Connected to this potential deviation from Day's star image is the musical genre's tendency to excess, mediated through certain types of performance and camera angle, for example, "the crotch shot" (Wills), which is discussed below further. Here, the excess associated with performance of numbers in the musical (Farmer 80), and which temporarily arrests the narrative flow, coincides with the excess of Calamity Jane's performance of masculinity. This combined excessiveness (of musical numbers *and* masculinity) further heightens the artifice of her transvestitism and the improbability of her as a butch lesbian. Although Farmer refers to the "brash butchness" of Day's character (82), the film's overall narrative trajectory seems to promote traditional images of femininity for postwar audiences.

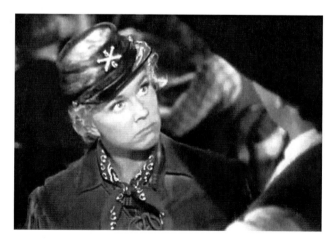

Figure 9.1 Calamity Jane (Doris Day) disagrees with Bill Hickok (Howard Keel) in *Calamity Jane* (1953).
Source: Courtesy of Warner Bros. Pictures.

Ostensibly, the fact that Calamity performs masculinity to excess does not masculinize her but merely highlights her *lack* of masculinity. Her parodic display is apparent, for example, in the opening scenes, where she slaps her thighs in a pronounced way; adjusts her cap in an overly masculine, exaggerated gesture; and emphatically tucks her thumbs into her belt. At the same time, she appears center frame (a viewpoint often associated with depictions of women), and in an early pairing with Bill Hickok, they stand face to face, clearly high-lighting her considerably smaller stature. Attention is also drawn to her as female (and implicitly feminine) through dialogue—Bill Hickok says to her that if she "dolled up a bit, I gotta hunch you'd be a pass-able pretty gal." He also describes her as "having the emotions of a woman" and tells her, "You're a fake Calam, you dress, talk, ride and shoot like a man, but you think like a female." Therefore, while performing masculinity, she clearly retains some feminine attributes. In contrast, the real men of the film are mostly inactive, and, at times, are passive victims, while the Sioux tribe flee when Calamity rides into their midst to rescue Lieutenant Gilmartin single-handedly. (Here, even Gilmartin seems to have accepted his fate without resis-tance, and when Calamity rescues him, the ropes binding him appear to come undone quite easily). In general, men seem solely preoccu-pied with watching "women" perform femininity, either within the framing confines of the theater stage or within the containing images of the cigarette cards. Their inactivity contrasts with, and thereby emphasizes, Calamity's excessive figure behavior. Later in the film, Calamity also stages femininity to excess, the cinematic spectacle shift-ing from her physicality and shooting skills to displays of beauty and womanliness.

While Nadine Wills too notes that "*Calamity Jane* deals overtly with gender as performance," her argument rests on the prevalence of certain visual strategies common to the musical, identifying what she terms "the crotch shot" as a "particular kind of gender spec-tacle" (121). Wills argues, "[T]hese performances of femininity are most clearly constructed through the convention of the crotch shot (moments where attention is drawn to the female genital area) instead of heterosexual embrace" (121). She examines such scenes across a wide range of Hollywood musicals made in the Hollywood studio sys-tem between 1933 and 1957, and includes *Calamity Jane* as part of this enterprise. However, different to other musicals, which generally feature femininity as excess, Wills notes the use of the crotch shot in *Calamity Jane* to situate Calamity as female "despite all appearances to the contrary" (134). She defines two types of crotch shot—the

"posed" crotch shot and the "accidental" crotch shot—the "former being much more obvious than the latter even though both are equally contrived" (Wills 126). In relation to *Calamity Jane*, she notes the predominance of the accidental crotch shot. For example, in the opening Golden Garter sequence, Wills describes how initially, Calamity reclines on the bar with a gun holster lying across her leg, which she then repositions to reveal an "accidental" crotch shot. This scenario is replayed a number of times. Wills concludes that in *Calamity Jane*, "the crotch shot is a sign of gender authenticity even as femininity is constructed as performance" (137). As she further notes, "it is only when a woman begins to perform her sexuality as a certain type of femininity that she can become the '110 per cent woman'" (Wills 135).

A third means by which the film reclaims heterosexuality through gender associations emerges in the way the framing of Calamity coheres to conventional feminist models of spectatorship (Mulvey). Such instances arise in Calamity's execution of dance routines where the other male characters watch her in action. She is also center of the film audience's attention, and thereby, on the surface, epitomizes psychoanalytic strategies that position the woman as object of the gaze. However, this gaze at times is ambivalent, for in the early part of the film, she is continually active within the frame. Thus, while Calamity *is* object of the male gaze, her constant energetic activity within the frame resists the passive objectification normally connected with feminist theories of spectatorship. Rather, she occupies an ambiguous subject position. Bingham too notes Day as "a peculiar figure in this [feminist] debate" (6). This ambivalence further surfaces when, paradoxically, she stands in as male spectator, watching Adelaid Adams perform in Chicago.

Adams first appears in the conventional close-ups that Mulvey associates with Hollywood's representation of feminine beauty. She is then visible in extreme long shot from where Calamity (surrounded by male spectators) is watching, thereby again resisting gender boundaries in respect of classic Hollywood spectatorship. Adams here accentuates femininity as performance, smiling at the audience, and then her smile immediately and obviously disappearing as soon as she is backstage.

Related to these aspects of spectatorship, the cinematography too assumes gendered tendencies. In line with Steve Neale's discussion of masculinity as spectacle, we see Calamity mostly in long shot or extreme long shot initially (apart from the opening stagecoach scene), which encourages a focus on her physicality. Neale describes how certain genres associated with men similarly involve action, and that

potentially voyeuristic and therefore feminizing looks are diverted in a number of ways. Vast landscapes and cityscapes, or even acts of violence, serve to deflect attention away from the objectification of the male body. Alternatively, other characters may mediate the look of the spectator indirectly (Neale 18). These effects serve to counteract potential homoeroticization of the male body.

However, in *Calamity Jane*, a curious conflation of gendered looks, framing, and action materializes. As noted earlier, while Calamity is active in the frame, and thus performing masculinity, she appears in long shot, surrounded by male characters who also watch her closely. All other characters are motionless, allowing emphasis on her performance of song and dance routines. Moreover, while many of these movements are "masculine" in their strong, direct, energetic, and unflowing execution, several correspond to those typically found in the dance routines of female performers and are dependent on male physical assistance. For example, a shot in the *Windy City* sequence shows her being pulled up by two men to the floor above in the Golden Garter theater. Another shot in the same sequence sees her dive headlong into the arms of a group of men, and directly address the camera. Indeed, there are several occasions where she acknowledges the spectator thereby also resisting an objectifying spectatorial gaze (another occasion arises when she persuades Katie to travel from Chicago—she turns to face the camera saying, "I've got a feeling someone's being hustled here"). Thus, in the early scenes, the framing and content of her performance infer both feminine and masculine qualities, and contrasts, for example, with the framing of Adelaid Adams in the Lyceum theater scene that was noted earlier. Katie Brown, the film's only other significant female, is also seen in close-up, allowing emphasis on her facial appearance. However, as Calamity's transformation progresses, the framing of her changes too. As she becomes more feminine and heterosexualized, she appears increasingly in medium close-up and close-up, enabling an emphasis on qualities associated with beauty and stardom (especially her blond hair). This difference in camerawork first becomes evident on the way to the ball—here she is noticeably less physically active and is framed in medium close-up (although the spectator is unaware at this point that she is dressed elaborately beneath "Custer's old coat"). Later, in the sequence in which she reveals to Bill her love for Danny Gilmartin, the camera frames her again in medium close-up, before zooming in closer as the two eventually kiss. Subsequently, when singing *Secret Love*, there is less focus on physical activity, with attention centering on her facial appearance, once more visible in close-up. The

song, *Secret Love*, won the Academy Award for Best Original Song,[2] its reception perhaps reflecting polarized postwar responses to Day's cross-dressing and heteronormalizing makeover (putting women back in their "rightful" place *and* being liberating).

Closely tied to the increasing use of close-up are changes to Calamity's makeup, hairstyle, costume, and lighting. While in the earlier scenes, she wears her hair in a rough ponytail and appears to wear little or no makeup, the later close-ups reveal her styled hair and made-up face. In respect of lighting, even in the early stages of the film, she appears illuminated by a soft three-point system that enhances the blondness of her hair, thus indirectly capitalizing on the aspects of her star image that carry connotations of both innocence and glamour. Calamity's transformation is most striking in the sequence where Katie and Calamity go back to Calamity's shack. As they drive off in a carriage together, Katie's feminized figure behavior and costume of blue velvet contrast with Calamity's dirty buckskins, masculinized appearance, and apparently unmade-up face. "Calamity has the idea that we should live together and chaperone each other," Katie tells Bill Hickok, her comment carrying further homoerotic connotations. However, Katie subsequently transforms both Calamity's home and Calamity herself, feminizing both. Jeffers McDonald argues that this transformation emerges predominantly through costume: "*Calamity Jane* uses the costume transformations of its protagonist to signal assumptions about appropriate goals and desires for women" (*Hollywood Catwalk* 141). She sees the transformation as one of maturation and, quoting Canby, "a variation on the ugly duckling to beautiful swan theme" (Canby in Jeffers McDonald 166). Consequently, Calamity wears long gowns rather than her buckskins, this transformation reaching its apotheosis at the ball. Here, the men compete for Calamity's attentions, while, at first, Bill Hickok fails to recognize her.

A final aspect that allows the film to recoup heterosexual love as the norm emerges through humor. Scenes in which Calamity masquerades as masculine closely interweave with her as object of ridicule. Until she conforms to the conventions of typical womanhood through changing her dress and behavior, becoming the (empty) image of femininity that is evident on the cigarette card pictures and painting of Katie Brown, and confessing a desire for children and marriage, her male peers do not take her seriously. For example, in the opening Golden Garter scene, she stands at the bar, orders a drink before putting her foot onto the footrest, misses it, and falls over (legs astride). In another example, she recounts a story about being chased by the

Sioux, and tells the men in the bar that "there must have been a hundred of them," while behind her back, a man raises his hand and puts up five fingers. In performing masculinity, she is therefore a source of humor.

The other two cross-dressers of the film, Bill Hickok and Francis Fryer, become sources of ridicule too. Having vowed that he would dress up as a Sioux squaw if Calamity succeeded in bringing back Adelaid Adams, we see Bill Hickok dressed in Sioux garb carrying a papoose. "Ain't he gorgeous," shouts one character as the men in the bar laugh at him. Hickok draws his gun in retaliation, thereby signaling his masculinity through a typical phallic signifier. Subsequently, he reasserts his masculinity in a scene that also reestablishes his heterosexuality. Here, he sings to a life-size painting of Katie—about love. The music to the song, titled *My Heart Is Higher than a Hawk, Deeper than a Well*, literally lowers on the word "deeper," thus enabling Keel to utilize his deep voice as an added signifier of masculinity.

The scenes associated with Francis Fryer's cross-dressing generate further humor and have implications of same-sex desire. While Fryer is clearly male, the men in the audience appear to believe the ploy and respond to him as if he is female, inviting him to sit on their knee. Initially Fryer performs femininity to excess—for example, as he steps onto the stage, he tentatively extends one leg out from behind the curtain in a consciously provocative manner. However, he lapses into his "real" gender and incorporates obvious masculine actions during his performance of femininity, the juxtaposition of these gendered qualities providing points of absurdity, both for the characters and for the spectator. Fryer's outraged reactions to the heterosexual behavior of the men in the bar reconstitute it as homoerotic and he responds by physically picking up one of his "admirers." The sequence's key comedic moment occurs when a trombonist accidentally removes Fryer's wig with his trombone, the wig moving back and forth humorously as the trombonist plays on.

As noted earlier, the most obvious contribution to the recuperation of heterosexuality is the frequent reference to heterosexual desire between the protagonists, resulting in their eventual marriage. While throughout the film, Calamity professes her longing for Lieutenant Gilmartin, when Katie and Gilmartin become a couple, Hickok and Calamity suddenly decide that they love each other too. The double marriage at the end of the film thus contains aberrant transvestite behavior and upholds the Production Code values concerning heterosexuality.

BUTCH CASSIDY AND THE SUNDANCE KID

Butch Cassidy and the Sundance Kid is a Western that, like *Calamity Jane*, loosely reflects fact. Visually, it is very different, incorporating sepia-tinted imagery to signify its historicity, and its settings tending to be the typically panoramic landscapes of the Western. Its plot centers on two outlaws who plan to rob the "Pacific Union Flyer" train, first on its outward journey, and then again on its return, with the premise that the second robbery will be unanticipated. However, following the second robbery, an armed posse arrives, and the two protagonists end up fleeing, eventually ending up in Bolivia. Here, though they attempt to "go straight" they eventually return to a life of crime as outlaws, and are gunned down in the film's final frame. As well as differing visually, its narrative trajectory is therefore pessimistic in comparison to *Calamity Jane*. Nonetheless, the two films have commonalities in the way that heterosexual relationships feature as a way of countering homoerotic possibilities, in the case of *Butch Cassidy and the Sundance Kid*, between the two male protagonists.

As a film that features two male stars (Paul Newman and Robert Redford), and privileges male homosocial bonds above heterosexual ones, *Butch Cassidy and the Sundance Kid* conforms to the buddy movie template. Neither character displays the signifiers of homosexual stereotypes. Rather, their relationship conforms to one of close friendship. However, it was one of several late 1960s and 1970s Hollywood films, whose narrative signaled the decline of masculinity (Benshoff 281), perhaps reflecting failures and losses in the Vietnam War. Sally Robinson also calls attention to this "crisis in masculinity," claiming that "from the late sixties to the present, dominant masculinity appears to have suffered one crisis after another" (5). She further notes that "white masculinity most fully represents itself as victimized by inhabiting a wounded body" (Robinson 6).

According to Benshoff and Griffin, these buddy movies of the 1960s "often wistfully recreated earlier eras where 'men were real men' and/or pessimistically suggested that American culture was coming undone because American masculinity itself was in decline" (281). They go on to say that "the fact that the heroes of many of these films often die in the final reel is one indication of this pessimism" (281). While they acknowledge that the 1960s' resurgence of the buddy film also arose out of the growth of feminism, they note that such films still need a female character to confirm the buddies' heterosexual status, and deny any possibility of homoeroticism.

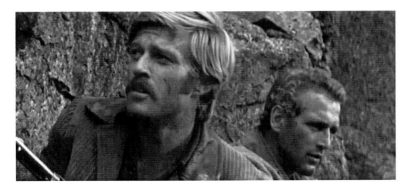

Figure 9.2 Sundance (Robert Redford) and Butch Cassidy (Paul Newman) discuss whether or not to jump off a cliff and into a river in *Butch Cassidy and the Sundance Kid* (1969).
Source: Courtesy of the Twentieth Century Fox Film Corporation.

Indeed, the token female (and/or homosexual) is one of the defining characteristics of the buddy film. Related to his analysis of *Papillon* (Franklin Schaffner, 1973), Richard Dyer identifies a number of further typical features, including, "a male-male relationship that [is] composed of humour, tacit understanding, and, usually, equality of toughness between men" (103). He notes that this relationship is "constructed by a disavowal of the very thing that would appear to bind the men together—love" (Dyer 103). Dyer further comments that "for the most part, [*Papillon*] acknowledges that what it is treating is a love relationship. It does this partly by signifying the relationship in small but emotionally loaded details" (103).

While much of the protagonists' interaction depends on humor in *Butch Cassidy and the Sundance Kid*, there are instances where it follows a similar pattern to *Papillon*, and looks between the two men are equally emotionally charged. One example occurs midway through the film after Butch and Sundance, in their newly acquired "straight" status as payroll protection guards, gun down a group of bandits who are stealing the payload. Just as they are about to shoot them, Butch reveals to Sundance that he has never killed anyone before. The bandits, however, draw their guns first, and Butch and Sundance have no option but to retaliate. The subsequent sequence explores their feelings of regret, particularly those of Butch, about the massacre, depending solely on cinematography and setting to convey this. In the first part of the sequence, Sundance occupies the foreground of the frame, and Butch is in the background, both looking toward the bandits' bodies, the profiles of the two men mirroring each other

almost identically. The scene occurs in slow motion, the dust and smoke slowly swirling in the wind. This scene is lengthy and adds no narrative information other than to illustrate the unspoken emotional connection between the two men. In the following scene, Butch is visible in a sharply focused close-up occupying the foreground of the frame while Sundance is now in the background, appearing out of focus. Again, the profiles of the two men are similar, and are in an almost identical position to the previous scene. The persistent lack of dialogue and the cinematographic repetition convey their somber mood. While Sundance remains out of focus, he turns his head to look at Butch, this small but deliberate action signifying Sundance's consciousness of his partner's feelings. Both scenes thus exemplify "silent communication as a means for not articulating or confronting feelings" (Dyer 103). Cynthia Fuchs too discusses the buddy movie, identifying several tensions arising in such a combination. She suggests that "the buddy movie typically collapses intra-masculine differences by effecting an uncomfortable sameness, a transgression of bound-aries between self and other, inside and outside, legitimate and illicit" (Fuchs 194). Arguably, the mirroring of Butch and Sundance (who are otherwise depicted as opposites) within these two scenes reflects the collapse of this intramasculine difference. Moreover, there are many other occasions where the cinematography implies their emotional closeness. For example, the camera often frames them together in close-up even in conversation when shot-reverse-shot might be the more usual convention.

Dyer notes that a "further feature of the buddy movie's representa-tion of male-male relationships is its explicit denial of homosexuality" (104). It usually achieves this by the inclusion of a token female or homosexual character. In *Butch Cassidy*, women crop up regularly in these roles, contributing little to the narrative but frequently occu-pying extended screen time. This is important to the buddy film, especially one of that period, since although the Production Code was no longer viable, the portrayal of explicit homosexuality was still taboo. While homosexuals have always featured in American cin-ema, they were regularly portrayed through demeaning or derogatory stereotypes. In his study of masculinity as spectacle, Steve Neale notes how "male homosexuality is constantly present as an undercurrent, as a potentially troubling aspect of many films and genres, but one that is dealt with obliquely, symptomatically, and that has to be repressed" (19). In this case, the film circumvents such possibilities in the way that the two men effectively share a girlfriend. Like *Papillon*, the film establishes their heterosexuality early on, firstly by their hideout in a

brothel and secondly, through two extended consecutive sequences that illustrate in detail their respective (heterosexual) relationships to female character Etta Place (Katherine Ross). While conventionally women in the buddy film often "have no function other to signal the men's heterosexuality" (Dyer 104), Etta has some import to the narrative in that she accompanies them to Bolivia and assists in the bank robberies there.

Dyer notes that in the case of *Papillon*, some critics construe the inclusion of a woman/homosexual as a disavowal of the sexuality of the central relationship. As Dyer points out, "this conflates love and sexuality too readily" and does not allow for the "possibility of non-sexual love" (104). In *Butch Cassidy and the Sundance Kid*, the episodes featuring "token" women begin after the two men have committed the first robbery, when they take refuge in a nearby brothel. Sitting on a balcony, they watch the local sheriff trying to organize a posse for their capture. Butch then goes inside, where he sits observing a group of women. Then, as he returns to the balcony, one of the women from the brothel approaches him from behind and embraces him. The camera cuts to a medium close-up, the woman now kissing Butch and standing (literally) between Butch and Sundance. Sundance then announces that he too will "get saddled up and go looking for a woman."

The following scene reveals the female character, Etta Place, undressing in a semidarkened room, unaware that someone else is in the room. As she starts suddenly, the camera cuts to reveal, in close-up, Sundance sitting in the shadows. "Keep going, teacher lady," he tells Etta, the spectator likely to interpret this as a potential rape, particularly as Sundance is toying with his gun. The scene unfolds slowly, close-ups revealing Etta unfastening each button of her clothing. Throughout the sequence, the camera intercuts between close-ups of Sundance's face half in shadow as he watches Etta, and long shots of her in part shadow. "Let down your hair and shake your head," he instructs her, before cocking the trigger of his gun in a display of phallic signification. The slow pace and sexualizing of the scene through the long shots of the partially clad Etta, and close-ups that indicate Sundance's voyeuristic desire, thus further allow an emphasis on its heterosexual nature.

These two scenes are unnecessary to the narrative yet provide both characters with heterosexual alibis. The ensuing scene is also lengthy and is one in which Butch Cassidy essentially shares Sundance's girlfriend. Waking up to the sound of Butch cycling past the window, Etta goes outside in her nightgown. She sits on the handlebars of his

bicycle, and as they cycle away, the music for which the film is famous, titled *Raindrops Keep Falling on My Head*, provides a romantic musical interlude. The film assumes a different visual style here, featuring fast tracking shots of the two in medium close-up, illuminated and often backlit by sunlight, images of them intercutting with close-ups of backlit foliage. The dialogue of the film is omitted, the overall effect creating a romantic, naturalized scene that seems disconnected from the Western genre, much like the *Secret Love* scene of *Calamity Jane*. It also serves an analogous function, ostensibly emphasizing the heterosexuality of its protagonists. Like *Secret Love*, *Raindrops Keep Falling on My Head* achieved the Academy Award for Best Original Song. Here, it specifically facilitates a display of heterosexuality between Etta and Butch. The sequence centers wholly on their interaction, the omission of dialogue emphasizing their facial expressions and physical responses to each other. A close-up of Etta's face with her hair backlit also has romantic connotations. As the two walk back to the house, Butch places his arm around her shoulder, before a cut to an extreme long shot reveals the two walking across a sunlit field. Arriving back at the house, he kisses her on the cheek and she asks him, "Do you ever wonder if I'd have met you first that we'd have been the ones to get involved?" "What are you doing?" Sundance asks Butch as he sees the two kiss. "Stealing your woman," replies Butch. The film thus makes clear its reasons for the inclusion of this extended scene. It has no narrative input, the sequence occupying four minutes of screen time, and merely functioning as reassurance for the spectator that the men's relationship is homosocial rather than homoerotic.

While *Calamity Jane*'s recuperation of heterosexuality depends in part on a restoration of conventional femininity, the characters of Butch and Sundance correspondingly draw on the signifiers of masculinity. Typically, these include displays of gunmanship. In the opening card-game scene, one of the cardplayers accuses Sundance of cheating. The scene ends with one of the film's characteristic close-ups of Butch and Sundance before cutting to long shot of the three men, enabling a display of Sundance's dexterity as he shoots the cardplayer's gun out of its holster. He then progressively maneuvers the gun along the floor by firing at it. The sequence unfolds quickly with rapid editing, indicating his reaction speed, and close-ups of the gun as it bounces over the floor, further accentuating his skills. Indeed, the film continually highlights his gunmanship. Additionally, in line with Neale's commentary on masculinity, the film frequently situates the two men in vast open spaces, and, while a narrative necessity, mostly finds them on horseback. These scenes intercut between panoramic

and extreme long shots (to show them traversing vast landscapes) and close-ups (to emphasize their friendship)—they thus engage in masculinizing activities throughout the film. While their loyalty to each other often remains unspoken, the film mediates their friendship mostly through humorous dialogue.

In fact, although Karen Hollinger suggests that in *Butch Cassidy* "the buddies develop an unspoken loyalty, but very little intimacy or emotional commitment" (112–113), there are instances where they clearly articulate a commitment to each other through humor. For example, in the early scenes when Logan (Ted Cassidy) challenges Butch to a knife fight, Butch goes over to Sundance saying, "Maybe there's a way to make a profit in this, bet on Logan" to which Sundance replies, "I would, but who'd bet on you." "Listen, I don't mean to be a sore loser, but when it's done, if I'm dead, kill him," Butch says to Sundance. "Love to," responds Sundance, thereby indicating his commitment to their friendship. These humorous moments mostly emerge when the two are under threat, providing ways of communicating anxiety to each other without appearing afraid (thus avoiding compromises to their masculinity). The use of humor to mitigate fear and mediate friendship occurs in a number of scenes. It is apparent as the pursuit of the two men gets underway and they try to elude their pursuers. Butch comments to Sundance, "I think we lost 'em. D'you think we lost 'em?" to which Sundance replies, "No." "Neither do I," says Butch.

Another tense but humorous scene occurs when they try to rob their first bank in Bolivia. They have to learn Spanish first, but at the crucial moment of rounding up the bank staff, Butch forgets his lines. He pulls out a crumpled crib sheet and reads out the handwritten prompts, while Sundance holds the staff at gunpoint. Butch reads out the first command from the handwritten list, obviously an instruction to raise their hands above their heads as Sundance replies, "They got 'em up!" Butch proceeds to read the next command in Spanish. "Skip on down," Sundance tells Butch angrily. Butch does indeed "skip down." "They're against the wall already!" shouts Sundance, the robbery thus becoming farcical.

The final shoot out of *Butch Cassidy* provides some of the film's most humorous dialogue and while it departs from *Papillon* in the deaths of the two men, which draws on a last stand mythology, it has some similarities. Dyer notes in respect of the escape scene at the end of *Papillon* that there is "more time spent on the lovingly cantankerous relationship between Papillon and Dega than on the escape" (107). Similarly, although Butch and Sundance are about to

die, and are suffering, the film expends more time on their bickering and discussion than on their imminent demise.

The final sequence begins as the two men ride into a Bolivian village, a parallel tracking shot suggesting that a hidden observer is watching them. They take cover as they come under fire. "We're gonna run out unless we can get to that mule and get some more," says Butch, referring to their dwindling ammunition. "I'll go," says Sundance. "This is no time for bravery. I'll let ya," Butch replies. As they run out to retrieve their ammunition, they are both shot, but even when injured, the humorous banter continues between them. "Is that what you call giving cover?" asks Butch, to which Sundance responds "is that what you call running?" The two men talk about to which country they will go next and other irrelevances, before running out with their guns blazing. The camera freeze-frames to the sound of gunfire as they race out, inevitably to their deaths, the final frame becoming sepia toned as it "freezes" the two outlaws in history. Fuchs describes the last scene of *Butch Cassidy* as a "final image of disastrous ejaculatory excess [that] exemplifies the paradox of the buddy formula" (195) explaining this paradox to entail the opposing poles of homophobia and homosexuality. This scene, she suggests, "demonstrates by unsubtle metaphor the incongruous nature of the buddy politic. Too much and never enough, the final catharsis becomes untenable" (Fuchs 195).

Clearly, the film's precautions regarding its sexual politics suggest the complexity of representing same-sex relationships. Even though the film's release occurred in the post Production Code era, representations of homosexuality were still taboo. That taboo remained unbroken until recent decades, when it was addressed in mainstream films such as *Philadelphia* (Jonathan Demme, 1993) and subsequently, and more explicitly, in *Brokeback Mountain* (Ang Lee, 2005).

SUMMARY

Both *Calamity Jane* and *Butch Cassidy and the Sundance Kid* are based loosely on fact. *Calamity Jane* features a cross-dressing woman, for whom heterosexual love proves transformative, "saving" her from masculinity to become a "real" woman. Conversely, *Butch Cassidy* features two male outlaw protagonists bound together in a quest for survival. Images of heterosexual desire abound in the two films, and arguably function to mitigate their homoerotic possibilities. In the case of *Calamity Jane*, this circumvents the lesbian tendencies of the protagonist in line with the restrictions of the Hays Production

Code. While progressive for women in films of the time in address-
ing issues of gender and sexuality, likely a marketing bid for broader
audiences within the confines of the Production Code, *Calamity Jane*
therefore ultimately conforms to the standardized Hollywood ten-
dency for heteronormative sexuality and marriage. On the surface,
the film ostensibly contains Calamity's masculine tendencies, changing
her from the butch female into a conventional portrayal of femininity.
While it thus limits any lesbian or homosexual possibilities, it also ren-
ders the other characters in these instances of cross-dressing sources of
humor and ridicule. In *Butch Cassidy and the Sundance Kid*, attention
to heterosexual relationships similarly alleviates potential homosexual
implications—for while not subject to Production Code values, homo-
sexual representation was still problematic for Hollywood at the time
of the film's production.

NOTES

1. See http://www.quigleypublishing.com/MPalmanac/Top10/Top10_
 lists.html.
2. See http://www.oscars.org/awards/academyaward [Accessed
 01/09/11].

FILMOGRAPHY

Brokeback Mountain (2005) Directed by Ang Lee. USA/Canada.
Butch Cassidy and the Sundance Kid (1969) Directed by George Hill. USA.
Calamity Jane (1953) Directed by David Butler. USA.
Papillon (1973) Directed by Franklin Schaffner. USA/France.
Philadelphia (1993) Directed by Jonathan Demme. USA.

BIBLIOGRAPHY

Anon. Quigley Almanac. [Accessed on 17/09/11]. Available at http://www.
 quigleypublishing.com/MPalmanac/Top10/Top10_lists.html (no date
 available).
Benshoff, Harry and Sean Griffin. *America on Film: Representing Race, Class,
 Gender, and Sexuality at the Movies.* Oxford and Malden: Wiley-Blackwell,
 2009.
Bingham, Dennis. " 'Before She Was a Virgin': Doris Day and the Decline
 of Female Film Comedy in the 1950s and 1960s", *Cinema Journal*, 45. 3
 (2005): 3–31.
Bordwell, David and Kristin Thompson. *Film History: An Introduction.*
 London and New York: McGraw-Hill, 2003.

Dyer, Richard. *The Matter of Images: Essays on Representation*. London and New York: Routledge, 2002.

Farmer, Brett. "Queer Negotiations of the Hollywood Musical". *Queer Cinema: the Film Reader*. Eds. Harry Benshoff and Sean Griffin. London and New York: Routledge, 2004: 75–88.

Fuchs, Cynthia. "The Buddy Politic". *Screening the Male: Exploring Masculinities in Hollywood Cinema*. Eds. Steve Cohan and Ina Rae Hark. London and New York: Routledge, 1993: 194–210.

Hollinger, Karen. *In the Company of Women: Contemporary Female Friendship Films*. Minneapolis: University of Minnesota Press, 1998.

Jeffers McDonald, Tamar. "Carrying Concealed Weapons: Gendered Makeover in 'Calamity Jane' ". *Journal of Popular Film and Television*, 34. 4 (2007): 179–186.

Jeffers McDonald, Tamar. *Hollywood Catwalk: Exploring Costume and Transformation in American Film*. London and New York: I.B.Tauris, 2010.

Mulvey, Laura. "Visual Pleasure and Narrative cinema". *Screen*, 16. 3 (1975): 6–18.

Neale, Steve. "Masculinity as Spectacle". *Screening the Male: Exploring Masculinities in Hollywood Cinema*. Eds. Steve Cohan and Ina Rae Hark. London and New York: Routledge, 1993. 9–20.

Stacey, Jackie. *Star Gazing: Hollywood Cinema and Female Spectatorship*. London and New York: Routledge, 1994.

Variety Staff. "Review of Calamity Jane". *Variety*. 31 Dec 1952. [Accessed on 14/08/11]. Available at http://www.variety.com/review/ VE1117789651.

Wills, Nadine. " '110 per cent woman': the Crotch Shot in the Hollywood Musical". *Screen*, 42. 2 (2001): 121–141.

CHAPTER 10

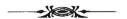

HORSE POWER: EQUINE ALLIANCES IN THE WESTERN

Stella M. Hockenhull

Partway through David Miller's Western *Lonely Are the Brave* (1962), Jack W. Burns (Kirk Douglas) rides into the distant hills, watched by his best friend's wife, Jerry Bondi (Gena Rowlands). Jerry's husband is in prison, and, based on a mutual attraction, she and Jack are tempted to begin a love affair. However, Jack, now being pursued by the sheriff, departs the Bondi homestead to find refuge in the hills. What appears as a straightforward, albeit modern-day, Western is complicated by the relationship that Jack has with his young horse, Whisky. Throughout the film, Jack speaks with pride and affection about his recent equine acquisition; he pats and strokes her, talks to her, and complains about her behavior, which he fondly refers to as her "wifely" qualities. Ultimately, he chooses to take her with him on a dangerous journey, rather than remain at the Bondi homestead and woo his friend's wife.

With some exceptions, the archetypal cowboy in the Western is the quintessential hero. He is physically powerful, competent, and experienced in the ways of the land, and living in the wild, contentedly and at home with nature. Above all he is either an icon of masculinity "possessing a robust, virile heterosexuality [where] the privileged coupling is normally between brave men and beautiful, strong women" (Freedman 18) or a private sufferer, who possesses the ability to rebuff female company and live a life of self-denial. However, more recent scholarly activity has revealed the subtext of male bonding in the

Western and, in the case of *Brokeback Mountain* (Lee 2005), homo-sexuality. As Roger Horrocks argues, frequently the persona of the tough cowboy is destabilized by a subtext, for example, "male love, male suffering and a defiance of bourgeois values" (56). If "the holy marriage of males has particular resonance to the cowboy and his side-kick" (Horrocks 65), then, arguably, there is also a subtext in existence in the guise of the cowboy's relationship with his horse. Whereas het-erosexual romance is the common goal of the classic Hollywood film, in the Western the cowboy must move on, which he nearly always does with his trusty steed. Thus, the relationship between man and horse is both a central tenet of the genre, and also forms a subtext to destabilize traditional codes of masculinity. Indeed, if the horse forms an essential part of the genre's iconography, it is also indispensible as a friend and partner to the cowboy, and the object and prioritization of his affections. Where women are frequently represented as subor-dinate or marginal figures, typically the horse nearly always holds an important place in his heart. If the Western uses women as a façade behind which male bonding takes place, then it manipulates the rela-tionship between man and woman offering it as a smokescreen for emotional attachment between the cowboy and his mount.

Nonetheless, the hero of the Western, who is variously a cattle rancher, sheriff, or gunfighter, is personified by the personal charac-teristics of firmness and determination, and as heterosexual. These qualities have long been associated with the Western hero, particu-larly with stars such as John Wayne. Yet, as Freedman points out, heterosexuality can never be fully masculine either. To act on het-erosexual desire necessarily removes a man from the sphere of pure masculinity, shackling him to the feminine. For a man to want and to actively seek a woman is to confess that masculinity is incomplete, and he thereby places himself—even if only in one specific department in life—under womanly power (19).

Freedman notes that while John Wayne's various personae in the Western do not suggest same-sex relationships, he is not embroiled with women either. In many Westerns, this subtext of effeminacy and suppression of desire finds relevance in the relationship between man and horse.

As noted, the one constant theme in the Western is the relationship between the cowboy and his mount. While the animal is important as a component of the iconography of the Western, providing the films with action, and operating as a mode of transport, it also affords friendship and support for its rider. In most Western films, the horse is a constant companion to its rider, enabling him to traverse the land

or waiting patiently for its master, tied to a fencing post or outside a saloon bar. Generally, the animal is not referred to or named by its owner, unless there is an allusion to its value or pedigree. Indeed, for the most part, its significance lies in its indiscernible contribution both to the safety of its rider and as his sole traveling companion.

Just as horses have played an important part in the Western, and the special relationship between horse and rider has been a regular feature, so the animal serves to distinguish the worthy hero/cowboy from the unscrupulous. As Hintz suggests, "In many movies the way a man treated his horse was used to define his character. The good guys treated their horses with kindness, the bad guys were mean to their mounts" (21). Not only does the horse raise the status of cowboy from an ordinary human, elevating him to considerate hero, but he demonstrates a love for his animal through his power to tame its free spirit. *Lonely Are the Brave* is one of the number of examples that examines the relationship between horse and its rider in the Western, noting this affinity as a destabilizing subversion of traditional codes of masculinity.

As noted, Jack in *Lonely Are the Brave* holds deep affection for his horse, and this is demonstrated throughout. The film opens with a wide expanse of empty prairie, before the camera pans to the left to reveal a close-up of a cowboy boot, and then its owner, the reclining figure of Jack smoking a cigarette. The man sits up slowly and glances upwards, tilting his hat, as a point-of-view shot from his perspective shows three jet planes leaving a trail across the sky. Glancing to his right, the camera focuses on a horse standing quietly by a rock. "It's time we took off too," Jack declares to the animal, and the two remain in frame for some seconds. "What do you think Whisky?" Jack asks of the horse as he places her bridle over her head, praising and stroking her, whereby, in return, the mare whinnies back. Here Miller sets up a number of themes that are played out in the ensuing narrative. The jet planes symbolize modernity and a changing way of life, whereas Jack and his horse remain set in the past, a situation that creates harmony between the two as, later in the film, the wilderness calls to their primitive instincts to ensure survival. The contrast between homestead/civilization and mountains recurs throughout the film to indicate Jack's position in relation to society. As Horrocks suggests, the Western also symbolically restores to men something they have lost—not simply being able to live in nature and its own beauty but being able to live in *their own nature*, their own beauty. The snow-covered hills, the immense plains, the "pretty country" that men gaze at in wonderment—surely these are symbols of something internal to

men, that has been cut out of them. Let me call it simply enough their own sensuousness. There is a utopian vision here, a recovery of lost harmony with nature (73).

The rapport between man and horse is reciprocal. Just as Jack loves the animal, so the mare responds lovingly toward him. When he places a saddlecloth on her back, she wrenches it off as though teasing him. He converses with her using terms of endearment, describing her as "real cute" and affirming "that's a baby," while shaking his head affectionately. Later, when he is escaping from the sheriff, he stops to drink from a pool of water as Whisky nudges him forwards so that she too may join in. Her beauty is displayed for spectator contemplation when he mounts her, and she rears upwards, her flaxen mane and tail trailing behind her.

Following Jack and Jerry's reunion, he sets off to the nearest town in order to find a bar and get drunk. His reasoning is that by getting involved in a fight he will go to jail, an act that will enable him to locate Jerry's husband Paul (Michael Kane), and assist his escape. However, his concern for his horse takes priority and, before he departs, he takes a pail of water for Whisky. Rather than focus on Jerry, the camera is directed at all three in the frame together, with Jerry positioned obstructively between man and horse. However, Jack directs his attention toward the animal rather than his female companion and, although Jerry begs him not to go, he aims his reassurances at Whisky, telling her, "Good girl Whisky, I'll be back real soon." Characteristic of the female homesteader, Jerry has presented herself as an obstacle to "her man's determination to fight. She is for peace and against war" (Horrocks: 62). Ironically, it is Whisky's agility and guile that aids him, enabling Jack to escape and fight his pursuers.

That Jack will not remain with Jerry is never in question. It is not only that she is married to his friend but also that he has a greater allegiance with the wilderness, a point he verbally expresses when he states, "I didn't want a house, I didn't want pots and pans. I didn't want anything but you." However, as he says these words, he glances out toward the prairie longingly and gathers his reins in his hand. At this point, the horse is nearly obliterated from view by Jack's figure, whereas Jerry stands to his left, set apart by a pillar that forms the wooden structure of the homestead; this forms a visual barrier between the two people. He kisses her good-bye, but then mounts his horse and, seen from her point of view, rides away to be engulfed by the landscape, his figure becoming a speck on the horizon. Jack is returning to the land where he feels at ease and safe, and his only companion must be his horse. It is the animal that links the man to nature

and the beauty of the wilderness, rather than his female counterpart. As Horrocks argues,

[t]he western . . . presents action set in landscape; it is utterly sensuous. Above all it celebrates beauty—I doubt if there is a more beautiful film genre, constantly dwelling on the shape of the land, the mountain, the river, the desert, within which stylized choreographed male violence is depicted. (153)

Jack's concern for his mount, and in turn his traditional way of life, materializes at the end of the film. The last 15 minutes shows the figures of man and horse as they outwit authority. Refusing to be abandoned by her owner, Whisky is loyal and determined. She whinnies and attempts to escape when he tries to leave her, eventually insisting on accompanying him on rough and near-impassable terrain: a landscape only accessible by horse. Subsequent to the fatal accident that causes Whisky's death, the camera focuses on Jack's bewildered face as his eyes dart about in confusion accompanied by the pitiful noises of the injured animal. The man remains agitated until the sound of a gunshot followed by silence suggests that Whisky has been put out of her misery, and his face appears calm. His gritted teeth and nervous glance relax in relief. The loss of Jack's horse suggests his loss of identity and, although he has been exonerated by the sheriff, for him there is no future western Eden, no typical "utopian strain . . . a land full of milk and honey" (Horrocks 60): there continues only the restrictions of an industrialized contemporary landscape.

The theme of progress and mechanization as opposed to nature and wilderness is prominent throughout. Man and horse must negotiate a busy main road on the way to visit the Bondi homestead, and, later in the film, the sheriff and his men pursue Jack and Whisky in a variety of vehicles including helicopters and all terrain motors, rather than on horseback. For a short period toward the end of the film, Jack outwits man and machinery. He scrambles up steep hillsides, dragging his horse behind him. Ultimately, Whisky meets her demise when struck by a truck on a busy stretch of road, and the final shot consists of Jack's Stetson floating in a puddle of water on a stretch of tarmac to the sound of motor horns blowing. This image, along with the death of the horse, symbolizes the loss of a way of life in America.

The horse in George Steven's seminal film, *Shane* (1953), plays a more passive role in its relationship with man, functioning to ennoble its rider, surrounding him with a sense of mystery and allure. Shane arrives alone and unannounced at the Starrett ranch on horseback, and leaves exactly the same way at the end of the film. Although he never

appears unkind to his mount, he does not talk to it or demonstrate any affection toward it. However, although their relationship is never fully articulated, the only constant in his solitary life is his horse. As Gabriel Miller observes, the man is "first seen through Joey's eyes as an ideal-ized figure in buckskin, astride a horse" (34) as, from a distance, the camera observes man and beast emerge mysteriously from the prairies where "the glowing chestnut of Shane's horse is an inseparable part of the impact" (cited in Hintz 12). Shane's only union is with his horse and this adds a mythic aura to his presence, raising his status to that of an inscrutable free spirit. He retains this mystery throughout, and neither the characters in the film nor the spectator is privileged to any further information about him.

Shane has a different relationship with each member of the Starrett family. The young boy Joey (Brandon de Wilde) romanticizes the man; from his point of view, the spectator is privileged to various scenes of Shane's masculinity and prowess. As befitting for a cowboy, he shoots accurately, demonstrating expertise with a gun; he displays proficiency in fist fighting, again a spectacle witnessed by Joey; and he is strong and robust, a physical attribute revealed when he and Joe axe a tree stump out of the ground. Shane prefers the companionship of the homestead owner, Joe Starrett (Van Heflin), to female com-pany, and he and Joe are constant companions, as they undertake a variety of activities together, such as planting vegetables, traveling to town, and discussing the problems faced from the evil Ryker family who want to oust Joe from his homestead. However, it is the rela-tionship with Joe's wife that forms the complication in the ménage à trois. There is clearly an attraction between Shane and Marian Starrett (Jean Arthur), an emotion exhibited through frequent exchanges of looks between the two. At the end of the film, Shane has the choice of remaining at the homestead, where the spectator is led to believe that a romantic situation might develop, or riding away on his horse. Shane chooses his former life despite Joey's protestations of "Mother wants you to stay." The opening sequences of the film are repeated at the end, as Shane rejects the security of the homestead and returns to the liberty of the wild. Seen from Joey's point of view, he rides away toward the mountains, and he and his mount become specks on the horizon. Shane has chosen a solitary existence accompanied by his horse, rather than a life with the family and Marian, a decision exem-plified by the final shots of the film. Shane is a gunfighter, yet requires peace, which is arguably a feminine trait, an attribute of femininity. As Buscombe notes, "[W]hen Shane's attraction to Marian, the wife of his friend Joe Starrett, threatens their friendship Shane buries his feelings for her and rides off alone" (35).

Wendy Chapman Peek in her analysis on John Ford's 1948 film, *Fort Apache*, notes that there are two competing lines of affiliation in the film. These, she suggests, are "vertical and horizontal. Vertical affiliations are characterized by the military hierarchy: horizontal affiliations are marked by camaraderie across divides of class, gender, race, ethnicity, age and history" (216).

Arguably, in *Shane*, the cowboy establishes a "horizontal" affiliation with his horse. Peek suggests that it is the horizontal relationships that "lead to success, whereas male hierarchies based on vertical relations lead to failure" (216). In this respect, Shane's relationship with his horse, and in turn the wilderness, also accounts for his achievements, and the final sequences make the connection between the hero and his horse. It is his own unison with nature that enables the Starrett household to continue in peace. If Shane typifies the Western hero, he demonstrates the qualities of the cowboy who remains alone and single because, as Freedman suggests, "only by refusing to stoop to entanglement with the feminine can he maintain the supremely confident and self-sufficient masculinity that he exemplifies..." (22). Shane chooses nature over home and women, and retains his freedom, a condition enabled by his mount.

Peek, in her work on masculinity and the Western, argues that a number of films in the genre include central protagonists who display effeminate characteristics. Indeed, weakness, particularly in the case of affection for a woman or a horse, becomes a measure of masculinity. However, Peek suggests that the ultimate goal of the hero is success, and frequently he can only attain this through, what might be perceived as, the acquisition of feminine traits. As she purports, masculine and feminine do not need to be

contradictory and become complementary. Viewed diachronically, to be at one time dominant and at another deferential is not a contradiction but a strategy, one that several prominent Western protagonists use to achieve their goals... They realize their goals precisely because they incorporate behaviour marked as feminine into their strategy. (208)

For Peek, some elements marked by commentators as feminine are also masculine constituents. Ultimately, whether the hero displays qualities that are stereotypically masculine, feminine, or both, of greatest value is the measure of success. Thus, to take Peek's arguments to a conclusion, affection for the horse does not interrogate masculinity, and the hero's ability is tested through these horizontal attachments.

Throughout the Hughes and Hawks film, *The Outlaw*, released in 1946, two men fight over a horse. The tough cowboy and outlaw,

Billie the Kid (Jack Beutel), is not afraid to show his affection for his horse named Red. The boy has stolen the animal from Doc Holliday (Walter Huston), another likeable scoundrel in the film, and, at one point, Holliday attempts to reclaim it from his young counterpart. Under the pretence of retiring for the evening, Holliday returns to the animal's stable after dark in an attempt to retrieve his horse, but his comrade, Billie, detects his charade. Leading the animal from its stall, Holliday pats its neck affectionately before turning around to encounter Billie surveying the scene. To justify his presence, Holliday explains that he is "just saying goodnight to the little horse." Billie suggests he return the animal to the stall, and, seen in medium shot, Holliday turns again to stroke the animal's neck. At this point, the camera frames the two together; illuminated by a soft light, Holliday's face is close to the horse's head and his hand caresses him, leaving little doubt that he has great affection for the animal. However, when Billie asks, "What no kiss?," Holliday replies, "No, he don't like mush," suggesting that the lack of fondness is not on his part, but that of the horse. Following this "romantic interlude" and, in an attempt to protect his recent acquisition, Billie beds down with Red, speaking affectionately to him as he prepares a makeshift area to sleep. Buscombe points out that "the women in Westerns are merely a smokescreen; the real emotional action is between the men" (34). But here the "emotional action" is between man and horse.

That the two men are in competition over the horse is not in debate. Throughout the film, Holliday and Billie the Kid discuss Red, who is described using terminology similar to that normally used to illustrate a love interest. Indeed, at the very outset of the film Holliday informs his old friend, Sheriff Pat Garrett (Thomas Mitchell), that his horse has been stolen. He immediately displays his affection for the animal, describing it as a little strawberry roan, "cutest little fellow you ever saw. Mean as mean, but I dote on him like he was pure rock candy." The color roan suggests stereotypically blond characteristics although, as Hintz suggests, "roans were not commonly ridden by the hero" (74).

Following information that his stolen horse is tied up in the street outside, Holliday leaves Garratt to go in search of the beast. What follows is an extraordinary reunion that, using classic Hollywood techniques, is constructed as a romantic encounter traditionally mobilized between two people. Aided by a jaunty piece of folk music, and seen at a distance amidst the flurry of the town's activities, Holliday walks along the dusty street. The camera then cuts to a medium shot of the man, his face breaking into a broad smile as the music

alters, ultimately building to a crescendo of orchestral sounds. To aid the romantic reunion, the camera cuts from his point of view to a shot of the horse, face turned toward his owner's direction. Holliday builds up his speed, and the camera withdraws to an overhead shot of the two placed center frame as the animal whinnies in pleasure and paws the ground. Holliday moves to the beast's head and lovingly strokes his face. At this point, and at numerous points throughout the film, the two are shown softly lit, facing one another, and in the frame together. As Horrocks points out, "[t]he looking is crucial— in many westerns, men continually stare at each other, held in each other's gaze with a passionate intensity quite different from their regard for women" (152). Here, Holliday exchanges such a look with his horse.

Both Holliday and Billie the Kid possess a deep affection for the horse, and, frequently throughout the film, the encounters between the three are accompanied by soft romantic music to enhance specta-tor emotion and understanding. At one point, following a discussion about a form of greeting, the two men stand either sides of the animal. On the mention of shaking hands, the horse lifts his leg as though to commune with the two men who fight over him, this scenario oper-ating to bring the three together as a team. Thus, the horse functions to progress the narrative. At one point in the film, Holliday briefly reclaims his horse, providing a wild black stallion for Billie to ride instead. The animal rears and shies away from the boy, initially refus-ing to be ridden. However, in a display of masculinity, Billie mounts the aggressive beast and the two gallop away. *The Outlaw* demon-strates the cowboy's mastery over the horse through both masculine and feminine techniques. As Peek suggests, "in post-war Westerns of the 1940s and 1950s, competence involves the mastery of a variety of skills, some marked as masculine, others as feminine" (209). The teaching of tricks to his mount suggests a feminine side to Holliday, whereas Billie's success in the film is wrought from domination, in this case the oppression of the uncontrollable beast.

The animal in *The Outlaw* also reciprocates the cowboy's love. As the two men escape Garratt, Billie is shot, although, despite his wounds, he and Holliday manage to get away on horseback. Prior to this, Billie falls from the horse into a river and the camera frames Red at a distance, the animal stopped in his tracks and returning to his rider. Gripping the boy's clothing, Red pulls him to the safety of the bank, an event which does not go unnoticed by his rider, whose last words before losing consciousness are "did you see what that little horse did—pulling me out like that?"

The love triangle between Billie, Red, and Holliday is also mirrored in the relationship between the two men and Rio (Jane Russell). Rio is Holliday's girlfriend seeking vengeance on Billie, who killed her brother in a brawl over a woman. She is asked by Holliday to care for Billie when he is wounded, and subsequently falls in love with him, and, in one of the number of sequences that enraged the censors (resulting in a three-year delay on the film's release), she climbs into bed with Billie to "deflect his fever." Meanwhile, Holliday's love for his horse knows no bounds. He has escaped over the border, with Garratt and his men in pursuit. To protect his horse, which is drenched in sweat and unable to continue, he dismounts and takes aim at the posse, thus endangering himself on behalf of the welfare of his animal. Similarly, Billie's first concern when he recovers from his coma is the well-being of his horse. He questions Rio closely, asking how the animal is and whether she has been caring for it during his illness.

While the horse is represented as a loyal servant to his master, the women in the film are presented as duplicitous and vain. After initially trying to kill Billie, and having been raped by him, Rio tends to the injured man and is attracted to him, thus being unfaithful to Holliday. Not only does she prevent Billie from getting out of bed, although he has recovered from his bullet wound, thus attempting to control him, she also covertly marries him when he is ill and unable to comprehend what is happening. Although the wedding is not witnessed by the spectator, a close-up shot of her hand wearing Billie's now-missing ring on her own wedding finger, suggests that, as Rio requested, a wedding ceremony has taken place. Holliday is dismayed to find that the coupling has occurred, but, even on this discovery, he lists his horse first in the list of "thefts" that have taken place. Likewise, when Billie realizes that Holliday has reclaimed the animal, and he has the girl, he offers his rival a choice between Red and Rio, at which his wife comments angrily, "You mean you would trade me for a horse?" Both Rio and Red have saved Billie's life, yet, in a conversation where Rio stands between the two men, they both argue over the ownership of the animal, until eventually Billie pays Rio for her services, and he and Holliday leave the homestead. As Leslie Fiedler points out, "[t]he very end of the pure love of male for male is to outwit woman, that is, to keep her from trapping the male through marriage into civilization and Christianity" (in Horrocks 57). If Billie and Holliday collectively outwit Rio, then their shared love of Red suggests that their goal is avoidance of heterosexual marriage, and a desire for wilderness and nature.

Throughout the film, women are represented as treacherous and disloyal. Not only does Rio have a relationship with Billie while she is still Holliday's girlfriend, she also advises Sheriff Garratt of the duo's whereabouts and puts sand in their water carriers. Similarly duplicitous, Aunt Guadalupe (Mimi Aguglia), a housekeeper to Rio, initially dislikes Billie because of the previous crime he committed: the murder of Julio, Rio's brother. However, within a few minutes, he charms her, calling her pet names, and she flirts with him and attempts to disguise the fact that he and Rio share the same room. Whereas the horse offers escape and wilderness to the men, women are presented as "a problem by the makers of Westerns—daughters to be disciplined, hoydens, harridans and whores to be avoided, mothers to be feared as they doggedly brush the porch or cook up beans" (Buscombe 30).

Their love toward the horse cements the relationship between Billie and Holliday, who become constant companions while continually sparring with one another, and, in this respect, the film displays homoerotic undertones, particularly through their mutual dislike of women. Toward the end of the film, Holliday and Billie overcome their differences and prepare to leave together, even amicably deciding who will ride Red. However, at this point another ménage à trois develops. Garratt has irked Holliday by riding Red as they flee to safety from a group of Indians. As the two outlaws begin to leave together, Garratt becomes angry, and reveals a deep-rooted jealousy of the two men's relationship.

At the end of the film, following the death of Holliday, Billie is seen, center frame, saddling his horse. Similar orchestral music used between Holliday and the horse earlier accompanies his actions, implying a gentle quality to his character and inviting empathy from the spectator. In the last few sequences, Billie, Rio, and Red are seen in close-up, as Billie mounts his horse ready to leave. At the end of the film, he has gained both animal and the girl. She mounts behind him, and the motif of a triangular relationship is reintroduced as the couple ride off into the distance. Both Holliday and Billie chose the horse first, and the spectator is left under no illusion that, in certain circumstances, this will be Billie's future decision. Faced with a choice over Red and Rio, Red will win each time. Peek suggests that "[a]lthough women do threaten men in the Western, serving as sources of critical judgment, sexual distraction, or emasculation (these three usually working together as a triple-headed demon), these gender conflicts are played out in the confines of a genre that virtually guarantees male success" (210). However, in *The Outlaw* it is not Rio who poses

the threat, but Red. The animal is at the center of attention for both Holliday and Billie, and both select him over Rio. Indeed, the horse brings out the feminine side in both men, threatening to undermine their masculinity, although, as Peek points out, some critics believe that the "genre makes an *absolute* and value-laden division between the masculine and feminine spheres. While it links masculinity with activity, mobility, adventure, emotional restraint and public power, it associates femininity with passivity, softness, romance and domestic containment" (210). However, Peek acknowledges that there is a tension between the two, and arguably, the horse brings out the feminine side of the cowboy.

Nowhere is the cowboy's love for the horse more apparent than in Sydney Pollack's romantic adventure, *The Electric Horseman* (1979). It is the central protagonist Norman "Sonny" Steel's (Robert Redford) job to ride rodeo horses, which he does with great success. A montage of shots opens the film that features a variety of equine events, the sequence comprising Sonny riding horses and steers, cheer leaders, cheering crowds, and trophies in abundance. Clearly, this alludes to the man's glory days that have disintegrated into drunken bouts; his work now involves guest appearances for a well-known cereal company to advertise its product. The cereal company has introduced a famous and very valuable racehorse as a promotion exercise and Sonny must ride this horse. The first encounter between man and horse occurs when Sonny is asked to appear onstage in Caesar's Palace, Las Vegas. It is in Vegas that the man frequently makes his guest appearances, clad in gaudy illuminated cowboy attire, and it is here that he becomes so drunk that he regularly falls off his horse. When Sonny first encounters the animal named Rising Star he stops in his tracks. He has just arrived at Caesar's Palace and is to ride the racehorse onstage to advertise a commercial product. From his point of view, the horse is seen standing at the fence in a makeshift corral, and he expresses concern that the animal is being retained unsuitably in a parking lot. Eventually, Sonny exchanges the glitz and vulgar fake of Vegas for the natural open prairie, as befitting for a cowboy. He rides Rising Star onto the stage at an inopportune moment and, dressed in an array of flashing lights that are strapped to his body (hence the film's title), he rides out through the casino and metaphorically into the sunset. The sound of hooves clattering on the tarmac herald the disappearance of Sonny and Rising Star, made more apparent as the lights on his costume dim, and then disappear, enabling him to blend in with his surroundings and eventually merge with the distant landscape.

Sonny has helped the horse to escape, but the stallion is heavily drugged with tranquilizers, pain killers, and steroids. He obtains a horsebox and changes his clothes from the garish flashing lights' costume to a traditional rancher's attire. As he drives along, Rising Star leans forwards and, in close-up, the two appear side by side, Sonny stroking the horse's face. He tends to the animal's wounds and obtains herbs to steam the drugs out of his system, talking to him throughout and referring to him in familiar terms as "son." Later in the film, Sonny bandages the animal's leg, obtaining ice from a frozen river to effect a healing process.

If Sonny and the horse form a relationship, then the heterosexual love interest arrives in the guise of the television reporter Alice "Hallie" Martin (Jane Fonda). Hallie is interested in obtaining a story from this strange drunkard who has stolen a horse, and she pursues him into the wilds to acquire an interview. Just as Rio figures as an interloper between Billie, Holliday, and Red, so Hallie is initially an outsider to the relationship between man and horse, although eventually she serves as a source of critical judgment and sexual distraction for Sonny. When she catches up with him in the mountains, they argue and he leads Rising Star away. The three appear together in the frame and, just as Jerry is marginalized in the relationship between Jack and Whisky in *Lonely Are the Brave*, so Hallie is placed on the periphery, walking to the rear of Sonny and the horse. Similarly, just as Billie mistreats Rio in *The Outlaw*, so Sonny is violent toward Hallie, slashing the tires of her vehicle to prevent her from following him, and wrestling her to the ground while slapping her face. Later, when they reunite in order that she can interview him to clear his name, Hallie falls to the ground, believing her leg to be broken. Sonny returns to help her, but, while still retaining contact with the horse, he collects her luggage rather than helping the woman to her feet. This scene is in stark contrast to the previous sequence, which demonstrates Sonny's care for the animal in comparison to his misogynistic behavior toward Hallie.

Rather than Rising Star providing a means of transport for his rider, as is the tradition of the Western, Sonny offers mobility to the horse. Throughout the film, Sonny and Rising Star are seen in the horsebox together. The horse peers over his shoulder and Sonny talks to him, and when Hallie arrives to interview him, he stands behind the beast, resting his hand on his withers, stroking him, while describing him in affectionate and admiring terms suggesting that "He has more heart, more drive and more soul than most people you will ever know." Partway through the film, the roles reverse, however. In order

to return Rising Star to the wild, a situation that is analogous with Sonny's own situation, he must escape a police road blockade. He removes the animal from the trailer and gallops across country, relying on the horse's speed and integrity to escape. Just as Jack and his horse Whisky in *Lonely Are the Brave* confront modernity and progress, desiring a return to a simpler existence, so Sonny and Rising Star confront mechanization in a contemporary world. Cornered by police motorbikes, and encountering farm machinery, they achieve an escape through terrain impassable to human-made vehicles. The animal's prowess and the rider's guile assure their escape and, from an overhead shot, man and horse are seen galloping along a promontory toward a sunlit river. At the end of the sequence, he is reunited with Hallie, and dismounts the horse, leading him to a tree. However, rather than engaging in conversation with the television reporter, he tends to the tired animal, stroking his neck and campaigning for natural healing products while simultaneously stating, "I owe you one buddy."

In Peek's terms, if Sonny's unheroic attitude, and hence masculinity, is called into question through a combination of his drunkenness, his Vegas dress attire, and his fondness for the horse, then this does not detract from recognition of his manliness. His former wife, Charlotta Steel (Valerie Perrine), clearly still loves him and refuses to go to his room because "she knows what will happen." Suggestively, she informs Hallie that he is not a thief, but he has the ability to "take your breath away"—a comment derided later by Sonny, who states, "that's not hard to do, she is all breath anyway." Similarly, Sonny is concerned that the use of steroids on the stallion will make him sterile, a comment that suggests that the animal will not be able to enjoy sex. As the interview between Hallie and Sonny finishes, Sonny's prime concern is for the horse. He throws a rug over its back and stands protectively against its side. His compliment to Hallie is that she has stamina, likening her qualities to those of the racehorse.

Because she is implicated in the chain of events, Hallie is forced to go on the run with Sonny. She enters the cab alongside the cowboy and, from behind the partition curtain Rising Star leans forward to nibble her arm. Clearly unused to horses, she jumps, and the animal forms a barrier between the couple. She redeems herself later when, after the police chase, she enquires whether the horse is OK. At this point, she is seated on a rock facing Sonny and his horse. He doctors the animal's bleeding leg and she watches this from a distance. Sonny is more concerned over his horse than with his female companion, who he has placed in danger through his own actions.

Even when the couple sits down to dinner, he leaves the table while they are still eating and goes outside to check the horse. From a distance, the camera frames the horse eating, with Sonny walking toward him, yet Hallie remains framed in the doorway, separated from the union formed between the cowboy and his horse. Sonny's preferential treatment toward the horse knows no bounds. When the couple decides to leave the horsebox and travel on foot, he places a light load on the horse's back, just as Hallie emerges from the trailer laden with luggage. However, Sonny refuses to overload Rising Star, and she is forced to carry her load, shadowing the man and beast across the mountains. Similarly, when Hallie and Sonny begin an emotional relationship with one another, his first thought following their coupling is his horse. She tries to offer him a makeshift breakfast by the campfire, but instead he rejects her offer and moves to tend to Rising Star's injured leg. Sonny's acceptance of Hallie arrives when he offers her to ride the horse rather than walk alongside, a position that she adopts for the remainder of the journey until they arrive at the destination where the horse is to be released into the wild. Sonny stands alongside Rising Star as a group of mares advance toward them and Hallie kisses the animal on the nose, a gesture permitted by Sonny who asks the animal whether he wants to say good-bye to the lady. He then releases the horse, who gallops off into the distance.

In a similar way to Jack, Holliday, and Billie, Sonny is an outlaw. He has chosen the horse above human relationships and, ultimately, he and Hallie do not form a connection. Archetypal of the Western narrative, she is representative of female characteristics requiring safety, domesticity, and gradual progress. The man often revolts against this and craves violence, danger, and abrupt changes in fortune. In this sense woman in the Western often represents bourgeois values, which are resisted by the drifters, cowboys, and gunfighters, who romantically hold out for another way of life, an impossible one, a purely mythic world that rejects family and property values (Horrocks 63). Instead of wanting domesticity, Sonny is shown walking down the road toward the mountains, and the place where the animal now resides.

Whether it is a contemporary or traditional example from the Western, the horse operates as a significant element in the genre. It functions as a vehicle to enable mobility; it symbolizes freedom through its links with the wilderness and nature, and it advances the notion of masculinity in that it aids its rider in success. Through these links with nature, the cowboy is restored a utopian vision, a recovery

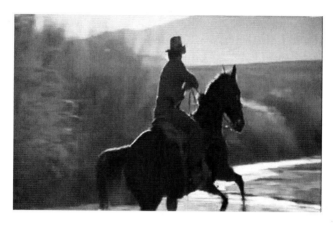

Figure 10.1 Sonny (Robert Redford) and Rising Star ride off into the sunset at the conclusion of *The Electric Horseman* (1979).
Source: Courtesy of Universal Pictures.

of lost harmony. As in many films of the genre, frequently, the cowboy/hero is unable to commit to women, yet he is passionate about his mount, investing the animal with female attributes and traits. Conversely, the cowboy's love for his horse might be perceived as a form of emasculation, representing feminine traits and a "holy marriage," not between male and female, but between man and horse.

FILMOGRAPHY

The Electric Horseman. Dir. Robert Redford. DVD Columbia Pictures and Universal Pictures, 2004.
The Horse Whisperer. Dir. Robert Redford. DVD Buena Vista Home Entertainment, 2001.
Lonely are the Brave. Dir. David Miller. DVD Universal Studios, 2009.
The Outlaw. Dir. Howard Hughes. DVD Elstree Hill Entertainment, 2003.
Shane. Dir. George Stevens. DVD Paramount Home Entertainment, 2003.

BIBLIOGRAPHY

Buscombe, E. "Man to Man." *Sight and Sound* 16.1 (2006): 34–37.
Clarke, R. "Lonesome Cowboys." *Sight and Sound* 16.1 (2006): 28–33.
Freedman, C. "Post-Heterosexuality: John Wayne and the Construction of American Masculinity." *Film International* 5.1 (2007):16–31.
Hintz, H.F. *Horses in the Movies* A.S. Barnes and Co., 1979.
Horrocks, R. *Masculinity in Crisis: Myths, Fantasies and Realities*. London, Macmillan, 1994.

Horrocks, R. *Male Myths and Icons: Masculinity in Popular Culture.* Macmillan, 1995.

Neale, S. (ed.) *Genre and Contemporary Hollywood.* London, Bfi Publishing, 2002.

Peek, W. C. "The Romance of Competence: Rethinking Masculinity in the Western." *Journal of Popular Film and Television* 30.4 (2003): 206–219.

CHAPTER 11

A French Unsettlement of the Frontier: Love and the Threatened American Dream in *Heaven's Gate* (1980)

Lara Cox

Michael Cimino's *Heaven's Gate* (1980) occupies an infamous place in the canon of Western films. The film retells the story of the Johnson County War of 1892 in Wyoming, in which Anglo-American ranch owners systematically eradicated, with the aid of a "death list," European immigrants who had been caught or accused of cattle rustling. Overbudget at an estimated 44 million dollars and overtime at two and a half hours long, critics have typically considered the film in terms of its commercial shortcomings. For instance, Michael Coyne considers the "quasi-Marxist" specificities of the film as failing to fit with the expectations either of the "moviegoers who enjoyed Westerns" or "those who would be ideologically responsive to such a theme" in different filmic genres (185). While there has been a critical tendency to dismiss the film as a failure based on a conflation of its economic and aesthetic determinants, the unconventional love triangle between henchman Nate Champion (Christopher Walken), prostitute Ella Watson (Isabelle Huppert), and sheriff Jim Averill (Kris Kristofferson) points to the need to reinvestigate *Heaven's Gate* for what it does to subvert the precepts of the Western genre and the political value that this might hold. This love triangle, coded

as a battle between two American men and one French woman, stands resolutely outside of the amorous conventions of the Western genre. In particular, Ella's role in both the triadic relationship and the near-completed heterosexual, monogamous denouement of the film may be re-read along philosophical lines. When one considers the similarities between the aesthetic codes of the erotic maelstrom in *Heaven's Gate* and the contemporary "theory wars" occurring in American academia between domestic philosophical traditions and an insurrectionary "French theory," a pathway for *Heaven's Gate* is indicated. In short, this film challenges the dominant ideologies of the Western by amorously assaulting two of its touchstones: liberalism and dialectical materialism.

THE LOVE TRIANGLE AND THE WESTERN

James Lindroth maps a normative configuration of heterosexual development, the Freudian Oedipus complex, onto the love triangle of *Heaven's Gate*. In this schema, Jim Averill—the "father"—and Nate Champion—the "son"—both vie for the attention of Ella Watson as the "mother" (228). This reading permits Lindroth to couch the film's love triangle in a rhetoric that corresponds to the Western's conventional codes of masculine honor and feminine subordination. As he argues, "when the mother is threatened—the Association has compiled a death list and Ella is on it—both father and son as twin heroes come to her aid" (229). Lindroth's Oedipal interpretation of the love triangle serves to bolster his conviction that "self-sacrifice, loyalty, compassion, and dedication to woman as mediatrix of transforming grace" constitute the film's signature values (224).

Yet, Lindroth's Freudian reading misses several key aspects of the love triangle of *Heaven's Gate* that refuse to coalesce with the generic codes of the Western. Love triangles, although not particularly uncommon in the Western (for instance, *Bucking Broadway* (John Ford, 1917), *Big Stakes* (Clifford S Elfelt, 1922), *Calamity Jane* (David Butler, 1953), and *Dust* (Milcho Manchevski, 2001)), typically set the stage for a reduction of the triadic interchange to the heterosexual, monogamous ideal. The Western's love triangle, according to David Lusted, typically threatens the much-prized heterosexual couple "develop[ed] through courtship" at the center of the genre. The plots of such films, Lusted argues, systematically work through the triangular threat and "conclude in the couple's partnership, classically signified in a final embrace" (149).

The love triangle of *Heaven's Gate* rejects the codes of heterosexual propriety through courtship and marriage—and thus the normative Oedipal struggle and resolution suggested by Lindroth—in various ways: first a prostitute (Ella), who refuses to abandon her brothel for love, is placed at the apex of the triangle; second, this character reprimands one of her lovers, Nate Champion, for his insinuations of marriage ("that sounded dangerously close to a proposal"); and third, the brutal, sanguinary death of Ella immediately precedes her implied marriage to her other lover, Jim Averill. Depending on the version of the film—since Cimino found himself obliged to re-release *Heaven's Gate* in 1981 in an abridged form for the purposes of commercial viability—Ella's death leaves Jim either alone (in the 1981 shortened version) or with an anonymous American love (in the 1980 uncut version). Regardless of which ending is watched, however, the implications of the hero's isolated and mournful survival are palpable. As Lindroth concedes, "it is clear that he will never recover from the loss of Ella" (229). The ending is therefore a far cry from another generic convention of the Western: the triumphant lone cowboy riding into the sunset in films such as *Shane* (George Stevens, 1953) and *True Grit* (Henry Hathaway, 1969).

While Virginia Wright Wexman pinpoints that prioritization of economic advantage over emotional fulfillment is a key impetus for the Western's typical resolution of the love triangle, a final reduction to a "dynastic model of marriage" cannot be found in *Heaven's Gate*. In such films as *Ride the High Country* (Sam Peckinpah, 1962), "the marriage relationship [is understood] not in terms of individual emotional fulfillment but as an economic partnership, the object of which is to make use of land to build a patrimony for future generations" (81). Radically diverging from this, the love triangle of *Heaven's Gate* dissolves the binary opposition between the emotional and economic. The motive behind Ella's decision to have sex with Nate and Jim remains undefined. Inexplicably, the prostitute charges the impecunious Nate for the privilege of having sex with her. (*Nate*: "I thought you were getting to like me." *Ella*: "I do. But I like money.") Meanwhile, she bestows her affections upon the well-to-do Averill free of charge, his cannot be attributed to a difference in emotional intensity that Ella feels for Jim, as she asks at one point, with explicit reference to her relationship with Nate: "Can't a woman love two men?"

In addition, the Champion–Watson–Averill relationship falls outside of another guise of love triangle identified by Wexman in Westerns such as *The Desperados* (Henry Levin, 1969) and *Butch*

Cassidy and the Sundance Kid (George Roy Hill, 1969). Here, the "competition of two men over a woman [...] is never resolved as the men begin to know each other and find that the shared values created by their allegiance to the same male-oriented life-style constitute a stronger tie than their desire for the woman" (85). Related to this, critics such as Paul Willemen, Robin Wood, and Stephen Neale have rooted out a transgressive homoeroticism undergirding the Western (brought famously to the fore by *Brokeback Mountain* (Ang Lee, 2005). Yet, these oppositional modes of masculinity cannot be detected in *Heaven's Gate* even though the triadic relationship is, like the homoerotic paradigm, never itself "fixed" in heteronormative satiety. Ending with only the survival of Jim Averill, the film kills off the two other members of the love triangle. The cohort of rich Anglo-American landowners of the Stock Growers' Association burn Nate alive in his wood cabin, while Ella is shot dead in her (implied) wedding clothes by the same lynch mob.

Falling outside of all of these patterns, the love triangle of *Heaven's Gate* stands out for its ambiguity, for the refusal of its own resolution in the heterosexual or homosocial couple or in the triumphant monadic hero. The autonomy of the heroine, Ella (Huppert), is notable for its role in contesting the collapse of this love triangle into the genre's normative patterns. As such, Lindroth's circumscription of the prostitute as an object of exchange between the two men— as "mediatrix of transforming grace"—seems insufficient. In order to understand the ideological challenges presented by this love relation and Huppert's role in it, therefore, a new paradigm is required.

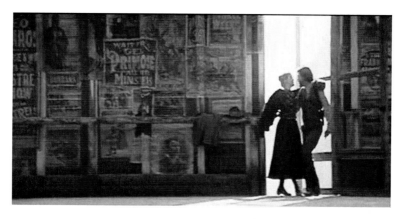

Figure 11.1 Ella Watson (Isabelle Huppert) and James Averill (Kris Kristofferson) dance in *Heaven's Gate* (1980).
Source: Courtesy of Partisan Productions.

THE NIHILISM OF *HEAVEN'S GATE*

Steve Bach—senior executive of the studio (United Artists) bankrupted by the disastrous reception of *Heaven's Gate*—argues that *Heaven's Gate* is characterized by the destruction of social values. According to this critic, the film's failure was caused by its "pervasive nihilism" from the "advertising slogan—'What one lives in life are the things that fade'—to its climactic and violent reworking of history" (416–417). At the heart of Bach's critique is Isabelle Huppert's casting in the role of the prostitute, Ella Watson, who, he argues, was too "French," "young," and "contemporary" to portray the real-life Canadian-born "frontierswoman in nineteenth-century western American" (191).

Taking Bach's comments on the film's nihilism and Ella's ill-fitting Frenchness together, it is possible to conceptualize an insurrectionary force in *Heaven's Gate* that acquires French philosophical dimensions. In its apparent eschewal of social values, *Heaven's Gate* occludes the Manichaeism—the binary opposition between "good" and "bad"— that underwrites much of the Western genre (Simmon 125). The film's moral ambiguity bears an analogous logic to that of "French theory." While Bach's comment on the film's omission of the "respect for human life" suggests the importance of rational *humanist* values in the Western genre (417), *Heaven's Gate* strikes up a closer relationship with the *antihumanism* or "French Nietzscheanism"— recalling its "pervasive nihilism"—of critical thinking crystallizing in the late 1960s in France (Descombes 188). With the political failures of the Paris riots of 1968, the thought of French theorists such as Foucault, Deleuze and Guattari, Lacan, Derrida, and Baudrillard brought into contention the fixity of social values and ideologies, by instead placing primacy on the complexities and vicissitudes of subjective desire.

Rather than agreeing wholesale with Bach's outright condemnation of *Heaven's Gate* as morally indeterminate, it is fruitful to read the film's "pervasive nihilism" through the lens of the Nietzschean logic of "French theory." In this light, Bach's claims of a nihilistic undercurrent help to re-position the film as unsettling the totalizing ideological values of the Western in place of a critical assumption that it engages in a complete evacuation of ethical and political worth. The ambiguous, unresolved love triangle and bitter failure of Jim Averill to find happiness on the frontier are more in tune with the concepts of French theory than with the reification of humanism that Bach believed would have dictated the success of *Heaven's Gate* in the Western genre. The year of release of the second shortened version of

Heaven's Gate, 1981, was also the year in which, as feminist literary critic Jane Gallop observes, French theory was being read, taught, and disseminated with particular fervor in English and literary departments throughout the United States (3). Cimino or his production team may not have self-consciously engaged this body of thought in the making of *Heaven's Gate*, but nevertheless it is possible to locate an unconscious aesthetic transfiguration of the imported ideas of French theory within the *diegesis*. Relevant to this, it is important to bear in mind both the high degree of American receptivity toward French philosophical radicalism during the early 1980s and the fact that *Heaven's Gate* found itself a victim of a troubled time for the Western genre and its espousal of the American ideal in the aftermath of Vietnam and Watergate (Greene 34).[1]

The following analysis, therefore, underscores the ways in which Huppert's Ella sets in motion a French disruption of the American idealism of the Western. In order to begin, a consideration of Julian Bourg's following description of French theory as a point of departure is very useful:

In broad brushstrokes, a number of family resemblances within th[e] field [of French theory] can be identified: a concern about the opacity of language, suspicions about the unified self, doubts about historical progress, valorizations of desire, and anxieties about power. The buzzwords of French theory which gathered around these topics—terms such as discourse, difference, the other, decent ring, absence and interdeterminacy—were set against categories such as universalism, origins, representation, and metanarratives. (11)

Two of the principles of French theory laid out by Bourg—"suspicions about the unified self" and "doubts about historical progress"—are illustrated in Ella's assault on two ideological cornerstones of the Western genre: Anglo-American liberalism and a dialectical materialist view of history. Ella's disruption of these two ideologies is, as shall be seen, played out in her operations within both the love triangle and the film's final attempts to assent to heterosexual coupledom in her implied marriage to Jim. In these ways, Huppert's function as cipher for French theory in *Heaven's Gate* enriches his viewer's understanding of the amorous conventions of the Western and the extent to which this film departs from them.

FRENCH SUSPICIONS ABOUT THE UNIFIED SELF

Pivotal to the French assault on and deconstruction of the American idealism of the Western in *Heaven's Gate* is the film's opening

sequence. A graduation ceremony for the all-male class of 1870 hails the start of the film and effectively provides a backdrop for the celebration of the dominant normative values of the genre. This introductory American portentousness precedes destruction and disillusionment that characterize the remainder of the film as described by Bach in his allusions to the "pervasive nihilism" of *Heaven's Gate*. At the end of the sequence, Jim recalls 20 years on, in a wistful voiceover: "In that lovely place, on that perfect day, I dreamed I could do anything. I met a marvelous girl, I had good friends and a good family, but when I was young the world seemed unfair to me." Jim's self-proclaimed conviction in his freedom to do anything or be anyone in his life encapsulates the autonomous and rational subject of American liberalism that lies at the heart of the Western genre. We see the genre's integration of liberalism, as a doctrine that places primacy on the individual's rights and freedom, in the autonomous cowboy figure. Jim Kitses' descriptions of the Western frontier as a site of "freedom," "self-knowledge," "integrity," "self-interest," and "equality" gesture toward the embedded nature of liberal ideology in the genre (65–66).[2]

In effect, Jim's statement regarding his self-professed autonomy glosses the function of the title sequence as a crucible of liberal ideology. At the center of this, the liberal ideal of autonomous masculine identity is privileged ("I dreamed I could do anything"). However, this touchstone is contingent upon a secure social order ("I had good friends and a good family") and the heterosexual, monogamous bond ("I met a marvelous girl"). Taken together these three elements—individual autonomy, the unified social network, and heterosexual coupledom—combine to give a cohesive sense of American nationhood. Shots of the central heterosexual couple, Jim and a nameless American woman, intersperse themselves throughout this sequence, thereby serving as bulwark for the liberal benchmark of the free individual, and, concomitantly, a free nation composed of autonomous subjects. Initially, Jim constitutes part of the graduation procession while the American woman forms a member of the all-female, coquettish audience. One whispers to the other, "I think he's looking." As the dean invokes the united nation under the banner of patriotism—"three cheers for our dear old country!"—the couple cast chaste and furtive glances at one another, thereby recalling the rules of heteronormative courtship in the Western genre described by Lusted. Out in the courtyard, the graduation party begins an exquisitely ordered waltz. High-angled shots, which in the Western typically denote a rationalistic "master all of I survey" as Wexman observes

(78), depict the circularity and symmetry of the dance party as it stands in for the unified American nation. The waltz sequence is shot through with an aesthetic emphasis on the heterosexual couple, as a series of medium shots reveal Jim and his waltzing partner moving in synchronicity and expressing their mutual attraction for one another. (*Averill*: "God you're beautiful." *American Woman*: "So are you.") Finally, the women move to the building overlooking the courtyard while the male graduates playfully fight in the central space below. The spatial marginalization of the women and strict delineation between robust male activity and coy female passivity visually bring into relief the heterosexism and misogyny that subtend the exclusively masculine version of liberalism privileged by the Western genre. The camera cuts continuously between Jim below and the American muse framed by the window above, imbuing the scene with a sense of complementary coupledom, a sense of heterosexual "wholeness." Her smile is sweet and demure and invites Jim's gaze. Her idealization becomes more pronounced as day turns to night and candlelight softly illumines her face.

Almost immediately, however, these rules of liberalism in *Heaven's Gate* are ruptured. Ella Watson's (Huppert) entry into the film alters the coordinates of the gender-based stratification of the liberal space of this first sequence. Her character sets in motion a two-fold disruption of the principles laid out in the first sequence of *Heaven's Gate*: First, she occupies a central role in destabilizing the masculine liberalism of the opening sequence through her interactions with Nate and Jim; and second, her paradoxical show of feminine autonomy and inconsistency thoroughly negates the possibility of her reshaping the American masculine liberalism as a feminine counterpart. This paradoxical specificity of her subversion of American liberalism strikingly resembles the nonrational subject of French theory.

To turn to the first mode in which Ella overturns the coordinates of the opening sequence, her destabilization of masculine liberalism hinges upon her flouting of the feminine subordination. While the marginalized female muse assured Jim's autonomy in the first sequence, Ella reigns supreme in her first encounters with her two lovers. Like the American woman, the French prostitute is framed twice by a window at the moment of first encountering her love interests, Nate and Jim. Unlike the American, however, Ella refuses feminine obliteration. When meeting Nate for the first time in the film, she peers through the window of her brothel. Clad in deeper, more overtly sexualized colors than the pale shades of the American woman's outfit in the first sequence, the camera frames the back of Ella's head

as she looks through the window, thereby implying to the viewer autonomy of perspective on the part of this character. Combined with this, Ella remains emotionless; her face is inscrutable. The blankness of her gaze sutures Huppert's performance as Ella to her wider star-text from *Madame Bovary* (Claude Chabrol, 1991) to *The Piano Teacher* (Michael Haneke, 2001). Serge Toubiana describes Huppert's inscrutability as "the art of displacement," which in its impenetrability, refuses voyeurism and "always emerges the winner" (37). Huppert's trademark enigmatic defiance is conferred upon her role as Ella, as when Nate enters her brothel, she coolly reminds him—with the same steely look—that: "you pay in advance here, cash or cattle." The couple proceeds to the kitchen, at which point Ella starts to clean her gun, emphasizing an aesthetic reversal of the gendered binaries initially set up in the film's first sequence that had placed primacy on masculine liberal autonomy. Ella is her own custodian of the law.

In her first meeting with Jim, the camera also frames Ella at the window. All that the viewer sees, on this occasion, are her eyes as she peers briefly through the top window before opening the door to the sheriff. Her overt emotion and delight at seeing Jim are notable. As in her initial greeting of Nate, she refuses to be idealized by the camera, whereas her American predecessor invited this by means of her protracted stay at the window in soft candlelight. Ella, in contrast to the American muse, ducks quickly out of sight in her encounter with Jim, thereby hindering of the fetishized gaze on the part of either the viewer or Jim.

However, Ella's absolute dominance over these two men is by no means assured. Consequently, turning to the second way in which she subverts the ideological coordinates of the film's first scene, this ambiguity is what situates her character not as a new unified heroine of Anglo-American liberalism but as akin to the never selfsame "subject" of French theory. Jean-Philippe Mathy notes the opposition between an Anglo-American "culture of liberalism" and "commonsense" and the "abstruse skepticism" and philosophical suspicion of liberal ideologies ingrained in French theory (340–341). Internal conceptual differences notwithstanding, the "subject" (individual) devised by the luminaries of French theory tends to operate at the juncture between limit and possibility. This complicates and potentially hinders the rational and rightful claim to freedom of the subject of American liberalism. However, it also paves the way for new, perpetually self-differentiating, nonrational ways of expressing subjective autonomy. French theorists troubled the notion of stable identity, positing it instead as inherently contradictory, inconsistent, and unpredictable.

French theory's assaults on the so-called "Selfsame" subject—the latter could be likened to the autonomous, stable individual conceived by Anglo-American liberalism—include Jacques Lacan's undermining of the stable ego in his idea of the "split subject" at the mercy of the perpetual machinations of language; Gilles Deleuze and Félix Guattari's "nomadic" subject who operates according to a "rhizomatic" and rootless trajectory of desire; and Jean-François Lyotard's liquidation of identity at the hands of libidinal multiplicity in *The Libidinal Economy* (Descombes 188).

Ella's oscillation between submission and control with both Jim and Nate echoes this complex, never self-contained subject of French theory. We saw that the autonomous subject of Anglo-American liberalism borne out in the opening sequence adheres to rationalist and unified tenets of subjectivity, a fact corroborated by Jim's syllogistic computation of friends, family, a partner, and his own freedom. By contrast, Ella's expressions of freedom are complex and often illogical as she either switches between domination and subordination or implies a paradoxical combination of the two. In a sudden shift of power in their first encounter in the film, Nate reprimands Ella for demanding stolen cattle from the impoverished European immigrant clients who darken her doors. He towers over her, and she implores him to stay the night with an affectionate kiss on his hand. He then moves out of shot, and the viewer is left with a frame of Ella's beseeching, apologetic eyes. Similarly, after having been informed by Averill that a birthday gift awaits her outside, Ella wraps her naked body in a sheet and runs out to the courtyard where she sees a brand new horse and carriage. While at this moment the camera encircles her barely covered body freezing her to the spot in passive capitulation, she delightedly articulates her subjective freedom: "I feel like I finally got somewhere." Her agency is concretized in the following scene, as she takes the reins of her new carriage and rides wildly through the local town of Sweetwater with a cautious but ultimately powerless Jim at her side.

In a similar moment in which the prostitute's agency is derived from ambiguity and limits, later in the film a distraught Ella is rejected by Jim, owing to her refusal to choose him over Nate. Yet, this is also the moment in which Ella decides to fight the Stock Growers' Association. Her mettle and valor gain thematic ascendancy over any humiliation borne in Jim's rejection of her. Fleeing the scene on horseback, Ella leaves Jim framed by the camera in a stock-still and impotent position in the window in an ironic reference to the mute American woman of the first scene. In a gendered reversal of

the opening sequence, the camera gradually tracks out from his posi-tion at the window and, in this gesture, momentarily deprives him of autonomy as a result.

While Ella's "messy" form of French freedom may no longer guar-antee the subject's sovereignty, it does grant a forever-potentiated guise of self-autonomy. This is an important conceptual difference when applied to *Heaven's Gate*, because Jim's absolute liberal dom-inance over femininity in the first sequence is supplanted by a complex form of individual liberty that at once enables Ella to gain a voice and does not summarily preclude masculine autonomy as the prosti-tute's ambivalent interactions with Nate and Jim confirm. Ella thus imbues the film with a pluralism that had been denied in the gradua-tion sequence. Even when brutally raped by the scabrous henchmen of the Stock Growers' Association, she does not capitulate to her res-cuer Jim and his calls for a monogamous relationship. Instead, she decides to go to Nate. This is not before, however, declaring her love for Jim while invoking her oft-repeated impenetrable and defi-ant gaze. Lindroth is keen to read Ella's role in this series of actions as an object of exchange between the two men: "in the rape scene, Kristofferson is the first figure of retributive justice to appear, but he is followed within moments by Walken as symbolic son" (229). Nevertheless, his demotion of Ella's agency in this reading is chal-lenged by her defiant question to Jim in the midst of these actions: "Can't a woman love two men?" Ella's constant, unresolved struggle between self-annihilation and self-affirmation, between limits and pos-sibility, thus echo French theory's destabilization of the self-contained, reductively and abstractly "free" individual of American liberalism. Therefore, she supplants the Western's premise of self-made, unified masculinity established in the first sequence of *Heaven's Gate* with a French mode of subjectivity that is never selfsame or consistent.

DOUBTS ABOUT HISTORICAL PROGRESS

Steve Bach argues that one of the reasons *Heaven's Gate* was doomed to commercial failure as a Western was its implementation of an ill-judged "climactic and violent reworking of history." After the battle scene in which the Stock Growers' Association and (mostly butchered) emigrant masses of Sweetwater come to blows, the camera leaps for-ward to the turn of the century and, in the 1981 re-released version, depicts Jim Averill alone on a steamboat. In order to understand why *Heaven's Gate* "failed" in this "climactic and violent reworking of his-tory," it is necessary to turn once again to the ideological conventions

of the Western. Whilst critics' observations of the melodramatic undertones and "mythic past" would seem to self-consciously sever the Western genre from any notion of historicity, or claim to historical authenticity (Coyne 6; Schatz 46), it is self-evident that the Western serves a purpose in shoring up an idealized version of the American past. In his reflections of why the Western has occupied an indomitable, anachronistic plinth in Hollywood's history, Michael Coyne suggests that suturing past struggles—the birth pains of a nation—to present-day American glory constitutes a mainstay of the genre:

> There is considerable irony in a prosperous, technologically sophisticated society forging an idealized self-image from a spartan past; but it was partly a reminder of American fortitude and, in the spirit of predestination, a justification for present opulence. Furthermore, if life in America failed to match its promise, Westerns implied past and—often but not always—future greatness. (3)

In exploring these cross-overs between past struggles and "future greatness," Coyne gestures toward the assimilation of a dialectical materialist view of history into the Western genre. Based on Hegel's philosophy of the battling forces in the interdependent master–slave dialectic, philosophers from Marx and Engels to Sartre and Merleau-Ponty subscribed to the view that history rationally works toward its own future perfection. Although it constitutes the stage upon which an opposition between power and revolt continually plays itself out, history inexorably triumphs in dialectical synthesis in this line of argument. Coyne's invocations of linearity, futurity, past struggles, and future victory in the Western expose the dialectical convictions underpinning the genre. When we consider the erotic conventions of the Western (described above), it may be easily discerned that the heterosexual couple—in those films that stage a final reduction of the love triangle to the dynastic model of marriage—is coopted into this dialectical ironing-out of and final victory for history.

However, the finale of *Heaven's Gate* is not one that invites thoughts of "future greatness" or historical perfection. The end scene exits the timeframe and space of the frontier and enters twentieth-century modernity; it does not depict, in the midst of this, the Western genre's conventional fin de siècle nostalgia. As Wexman observes, the end of the nineteenth century is typically lauded in the Western film as "a time in when the country was united under a single value system that, at least in theory, viewed all people as equal. Slavery had been

dispensed with" (72). By contrast, at the end of *Heaven's Gate* the camera continually loops back to past iniquities, thereby suturing Jim's melancholy turn-of-the-twentieth-century existence to the Johnson County War atrocities. The assent to the idealized heterosexual couple, which would mark the culmination of the totalizing dialectical march of history in the genre, is also refuted. Indeed, it could be argued that the film hints at this posthistorical utopian heterosexual coupledom in order to subvert it. As Jim moves from the deck to the interior, the camera flashes back to the implied aftermath of the battle. Jim and Ella (dressed in white) prepare to leave the town. The couple descend the stairs and are momentarily framed, arm-in-arm, in the doorway. Ella is shot dead suddenly by a member of the Stock Growers' Association. As Jim clutches the dead prostitute in his arms, the camera flashes forward again to 1900 and his elegiac subsistence on his boat. Ella's voice returns as a spectral presence as twentieth-century Jim looks on mournfully. The refusal to banish Ella's demise in this vision of the film's posthistorical—insofar as postbattle—future effectively denies this Western a place in the genre's prototypical dialectical shoring up of a triumphant modernity. The invocations of Ella in the end scene bring into effect a fragmentation of the linear and synthesizing narrative of history and the heteronormative ideal by which the latter is often secured.

Huppert's Ella thus plays a key role in subverting the dialectical assumptions of the Western. As such, her function as the incarnation of "French theory" can be identified once again. The imperative dialectical flow of history was profoundly ruptured as a concept in post-1968 French theory. The ascendancy of totalizing ideologies such as Nazism and Stalinism legitimated in the name of history, in addition to the ultimate failure of the leftist revolt of May 1968 to overthrow the ailing Fifth Republic, brought the dialectical materialist argument into disrepute in this body of thought (Bourg 241).[3] French theory's constellation of skeptics of the transcendent march of history includes: Foucault and his connection of the authors of history to hegemony and power, and his genealogical dissolution of historical "truth" into disparate narratives; Lacan and his notion of the "Real," which stands outside of language, interrupting attempts to linguistically systematize knowledge, including that relating to history; the "New Philosophers" including Bernard-Henri Lévy, Maurice Clavel, and André Glucksmann, who disturbed the idea that history's trajectory ultimately paves the way for emancipation (Bourg 241); and, perhaps most well known of all, the French postmodernists' assaults on the linear march of modernity. Jean Baudrillard

theorized the ascendancy of the endless proliferation of "simulacra"—signs without a discernible point of origin—in contemporary Western society, as technology and media modulate the latter. As such, he posits that "whereas so many generations, and particularly the last, lived in the march of history, in the euphoric or catastrophic expectation of a revolution—today one has the impression that history has retreated, leaving behind it an indifferent nebula, traversed by currents, but emptied of references" (43). Similarly, postmodern pioneer Jean-François Lyotard pinpoints a social change occurring in the latter half of the twentieth century that saw the demise of belief in the "grand narratives" (such as Fascism and Communism) of history.

 Not only can it be affirmed that Ella imbues the end scene with a sense of pessimism that flatly refutes the linear laws of history in a manner akin to that of French theory but also has her death brought into relief the implicitly normative coordinates of dialectical resolution by at once banishing the chances of the union of the heterosexual couple and the corresponding triumph of history. In this way, she encapsulates an "antinomian" and "antinormative" spirit of French theory that, according to Bourg, targeted "the marxisant [dialectical materialist] 'laws of history'" (7). Whereas her negotiations of the love triangle privileged an inconsistent French femininity at the same time as discrediting masculine liberalism, Ella's role in the end scene serves to stage a confrontation with the sanctity of the heterosexual couple in the Western genre. The denial of the heterosexist resolution in Ella's death leaves a regretful, destabilized Jim and the history of a nation torn apart—literally disaggregated to the extent that it is reduced to one man—by the legacy of past atrocities.

CONCLUSION

Isabelle Huppert's role as prostitute Ella Watson, as the central love interest of *Heaven's Gate*, serves as a cipher for an insurrectionary philosophical force of "French theory" in the Western genre in two ways. In her inconsistent and ambivalent interactions with Nate and Jim, Huppert's Ella embodies the unstable and inconsistent subject of French theory, grappling with both the limits of her subjectivity and the (albeit complex) forms of agency therein. Her subjective instability subverts a rationalist, reductive Anglo-American liberalism underpinning the Western. In her refusal to grant a "satisfying" denouement in heterosexual coupledom and spectral presence at the end of the film, Huppert's Ella undermines the dialectical materialist march of history and the heteronormativity upon which it relies. She thus impresses

upon the viewer a notion that sits uncomfortably with the Western's nostalgic return to the birth narrative of America: that the travails of history have come at a great and unjustifiable cost. In sum, Ella Watson throws into relief the ideological assumptions of the Western, the role of heteronormative love in the shoring up of these ideologies, and an erotic path of resistance in *Heaven's Gate* that departs from the subversive homosexual subtext identified by Willeman and colleagues.

Huppert's function as an oppositional cipher of French theory also lays the ground for the critical recuperation of *Heaven's Gate* in the canon of Western films. In a rare acknowledgment of the worth of this film, Westerns critic Patrick McGee suggestively states that "the final unveiling or apocalypse of the Western [in *Heaven's Gate*] [is] itself [...] a theory of the political meaning of subjectivity" (McGee 218). In McGee's opinion, *Heaven's Gate* turns the function of the Western on its head. It does not shore up an idealized American identity. On the contrary, it brings to light the violence and cruelty that the history of the Western frontier entailed. In short, McGee posits that "the failure of *Heaven's Gate* lies in its articulation of the truth about [the Western movie] tradition" (216).

While this reading focuses on apocalyptic endings and the politics that are permitted by the destruction of the Western, its analysis helps to pinpoint and clarify the role of *Heaven's Gate* in terms of a historical understanding of its deconstructive creation of postapocalyptic *new beginnings* for the genre. It is imperative to remember that French theory has been met with a warm reception in academic and nonacademic arenas of American culture.[4] As Sylvère Lotringer and Sande Cohen note, "French thought became American theory, freeing up, like faultlines, the interstices among belief, judgment, facts and principles. The first thing to say about French theory in America is that it provides new senses of art, philosophy, and science 'outside' reigning American ideas and writing" (1).

The revitalization meted out by French theory in the United States can be applied productively to an understanding of the transformative role of *Heaven's Gate* in the late twentieth-century history of the Western. As Kitses describes:

After a dormant period stretching back over much of the previous decade to Michael Cimino's blockbuster failure, *Heaven's Gate* (1980), [Costner's] epic tale of a cavalryman taking on Indian identity [in *Dances with Wolves*] generated the last post-modern cycle of substantial and interesting Westerns. After Costner, a number of the films that followed—*Geronimo: An American*

Legend (1993), *Posse, The Ballad of Little Jo, The Quick and the Dead*—reversed the genre's traditional focus on the white male as the embodiment of America's Manifest Destiny. (5)

In short, the impetus for the 1990s ideological reinvigoration of the Western genre may be traced further back to the subversive abyss created by *Heaven's Gate*, for this film grapples with a "French theoretical" complexification of the genre's prevailing reductionist views of subjectivity and history, and its pluralism can be seen as a precursor to the more critically and commercially successful revisionist "postmodern" Westerns referred to by Kitses. In short, whilst *Heaven's Gate* was undeniably a "blockbuster failure," its French theoretical challenges to the amorous codes of the Western demonstrate that this film should not as a corollary recede into oblivion in critical accounts.

NOTES

1. For the integration or "blackboxing" of French theory in American culture, see Alison M. Gingeras.
2. See also: Stephen J. Mexal.
3. This epistemological shift has animated French theory's fiercest opponents to dismiss this body of thought as dehistoricizing and defeatist (Appleby, Hunt, and Jacob 215).
4. François Cusset historically locates the birth of French theory in the United States in a conference in 1966 at John Hopkins University that united such wildly divergent French theorists as Derrida, Barthes, and Lacan in one room.

FILMOGRAPHY

Big Stakes. Dir. Clifford S Elfelt. Metropolitan Pictures Corporation of California, 1922.

Brokeback Mountain. Dir. Ang Lee. Focus Features, 2006. DVD.

Bucking Broadway. Dir. John Ford. Universal Film Manufacturing Company, 1917.

Butch Cassidy and the Sundance Kid. Dir. George Roy Hill. Twentieth Century Fox, 1969.

Calamity Jane. Dir. David Butler. Warner Home Videos, 2007. VHS.

Dust. Dir. Milcho Manchevski. Lion Gate Films *et al.*, 2001.

Heaven's Gate. Dir. Michael Cimino. Twentieth Century Fox Home Entertainment, 2001. DVD.

Heaven's Gate. Dir. Michael Cimino. Twentieth Century Fox Home Entertainment, 2007. DVD.

Madame Bovary. Dir. Claude Chabrol. Warner Home Video, 1991. VHS.
Ride the High Country. Dir. Sam Peckinpah. Metro-Goldwyn-Mayer, 1962.
Shane. Dir. George Stevens. Paramount Pictures Corporation, 1953.
The Desperados. Dir. Henry Levin. Columbia Pictures Corporation, 1969.
The Piano Teacher. Dir. Michael Haneke. Artificial Eye, 2002. DVD
True Grit. Dir. Henry Hathaway. Paramount Pictures, 1969.

WORKS CITED

Appleby, J., Lynn Hunt, and Margaret Jacob. *Telling the Truth About History*. New York: Norton, 1994.

Bach, Steve. *Dream and Disaster in the Making of Heaven's Gate*. London: Faber, 1986.

Baudrillard, Jean. *Simulacra and Simulation*. Trans. Sheila Faria Glaser. Ann Arbor: University of Michigan Press, 1994.

Bourg, Julian. *From Revolution to Ethics: May 1968 and Contemporary French Thought*. Montreal: McGill-Queen's UP, 2007.

Coyne, Michael. *The Crowded Prairie: American National Identity in the Hollywood Western*. London: I. B. Tauris & Co, 1997.

Cusset, François. *French Theory: How Foucault, Derrida, & Co. Transformed the Intellectual Life of the United States*. Trans. Jeff Fort. Minneapolis: University of Minnesota Press, 2008.

Descombes, Vincent. *Modern French Philosophy*. Trans. L Scott-Fox and J M Harding. Cambridge: Cambridge UP, 1980.

Gallop, Jane. *Around 1981: Academic Feminist Literary Theory*. New York: Routledge, 1992.

Gingeras, Alison M. "Disappearing Acts: The French Theory Effect in the Art World." *French Theory in America*. Ed. S. Lotringer and S. Cohen. New York: Routledge, 2001. 259–270.

Green, Naomi. "Coppola, Cimino: The Operatics of History." *Film Quarterly* 38.2 (1984–1985): 28–37.

Kitses, Jim. *Horizons West: Directing the Western from John Ford to Clint Eastwood*. London: BFI Publishing, 2004.

Lindroth, James. "From Natty to Cymbeline: Literary Figures and Allusions in Cimino's *Heaven's Gate*." *Literature/Film Quarterly* 17.4 (1989): 224–230.

Lotringer, Sylvère and Sande Cohen. "Introduction: A Few Theses on French Theory in America." *French theory in America*. Ed. S. Lotringer and S. Cohen. New York: Routledge, 2001.

Lusted, David. *The Western*. Harlow: Longman, 2003.

Mathy, Jean-Philippe. "The Resistance to French Theory in the United States: A Cross-cultural Inquiry." *French Historical Studies* 19.2 (1995): 331–347.

Mexal, Stephen J. "Two Ways to Yuma: Locke, Liberalism and Western Masculinity in *3: 10* and *Yuma*." *The Philosophy of the Western*. Ed. Jennifer L. McMahon and Steve Csaki, 2010. 69–88.

McGee, Paul. *From Shane to Kill Bill: Re-thinking the Western.* Malden: Blackwell Publishing, 2007.

Neale, Stephen. "Masculinity as Spectacle: Reflections on Men and Mainstream Cinema." *Screen* 24.6 (1983): 2–16.

Schatz, Thomas. *Hollywood Genres: Formulas, Filmmaking, and the Studio System.* Philadelphia: Temple UP, 1981.

Simmon, Scott. *The Invention of the Western Film: A Cultural History of the Genre's First Half- Century.* Cambridge: Cambridge UP, 2003.

Toubiana, Serge. "Foreword." *Isabelle Huppert: The Woman of Many Faces,* Ed. R. Chammah and J. Fouchet. New York: Harry N. Abrams, 2005. 9–14.

Willeman, Paul. "Anthony Mann: Looking at the Male." *Framework* 15–17 (1981): 16–20.

Wexman, Virginia Wright. *Creating the Couple: Love, Marriage and Hollywood Performance.* Princeton: Princeton UP, 1993.

Wood, Robin. *From Hollywood from Vietnam to Reagan.* New York: Columbia UP, 1986.

CHAPTER 12

MIDNIGHT COWBOY: A LOVE STORY

Zhenya Kiperman

John Schlesinger's *Midnight Cowboy* (1969), the only X-rated film in history to win the Best Picture Oscar, is one of the most unusual love stories ever filmed. The picture also offers a keen assessment of the 1969 status of the Western genre, putting an ironic twist on some of its key idioms. This ironic reevaluation begins with the opening shot—a little boy riding a toy pony in front of the huge white screen of a drive-in cinema to the forceful sounds of the galloping horses and gunfire from his imagination. The image suggests that the once-glorious idea of American manhood of the Westerns by 1969 may have remained such only in a child's mind. The film's protagonist is indeed a man-child, a naïve Texan dishwasher Joe Buck (Jon Voight), about to head off to New York to try his luck as a hustler offering sexual services to rich women. Joe's West-to-East route is also a subversion of the classic Western itinerary, which had always been westward, away from the greedy and corrupt urban East. Joe dresses like a cowboy, talks like a cowboy, and thinks of himself as a cowboy, riding—albeit on a bus—into a new town. Once in town, Joe himself gets hustled by about everyone he meets, including a sickly street-smart conman Ratso Rizzo (Dustin Hoffman). Their unlikely friendship eventually develops into the first and only meaningful relationship of their lives, even more intimate than the male bonding in the Western world of John Ford and Howard Hawks. Ratso invites Joe to share his "rent-free" apartment in an abandoned building. For several months

they live there together without heat or electricity, Ratso trying to manage Joe's hustling operation, Joe trying to take care of his ailing friend. They become each other's surrogate family, not unlike the odd companions of Ford's *Stagecoach* (1939), united by random chance and bonding together to survive. Joe's crushed dream of making a fortune in New York is now pushed out by Ratso's dream about going to sunny Florida, where Ratso would recover from his sickness and their hustling business would prosper. With the approaching winter, Ratso's health deteriorates rapidly. Desperate to save his friend, Joe commits a violent crime to get the money for their trip. On the bus to Florida, Ratso dies in Joe's hands. This heartbreaking finale is reminiscent of John Ford's sentiment that Peter Bogdanovich called "glory in defeat" (Giannetti, 155). Their dreams get crushed and Ratso dies, but this friendship and this death transform Joe Buck forever. He leaves us not as a sexually troubled man-child playing a cowboy, but a grown man mourning the loss of his only friend.

According to *Midnight Cowboy's* producer Jerome Hellman, approaching the material as a love story was central to the project. He recalls his conversations with director John Schlesinger and screenwriter Waldo Salt during the development period:

What we talked about primarily was Joe's need for love and connection, and Ratso's need to make a connection. We shared a view that *Midnight Cowboy* was a love story. The only way that it would work, in terms of our intent, would be for that to be thematically something we would always be aware of. The peculiarities of the characters and the peculiarities of the context in which they connect don't make it any less a love story. They were both totally disconnected people who had never had a mutually inter-dependent relationship anywhere in their lives. Ratso was an exploiter and Joe dreamed of being an exploiter but in reality their need for each other was so great that they fused. And so we had a love story.

(Hellman, 94)

This approach was thematically faithful to James Leo Herlihy's novel *Midnight Cowboy* on which the film was based. Herlihy's name is rarely mentioned in association with the celebrated film version of his creation. Although brilliant and daring for its time, the novel has been out of print since 1965 and today is virtually forgotten. But reading it now gives the impression of very contemporary vibrancy, humor, and tenderness. Herlihy shows a rare gift of seeing human beauty in dark and ugly places, and genuine understanding and compassion for the lost and fallen. Much of the film's strength is owed to its

literary source, beginning with the psychological depth and authenticity of its unique characters—the foundation for Jon Voight and Dustin Hoffman's extraordinary performances. Joe's lonely talks with himself in the mirror came from the novel, as well as his vividly cinematic fantasies, which screenwriter Waldo Salt called "flash-presents,"[1] because they mixed the images from Joe's past with his present daydreams. Many unforgettable lines of the film also came from Herlihy pages, for example. a woman's famous response to Joe's pickup question about the Statue of Liberty's location: "It's up in Central Park takin' a leak. If you hurry, you'll make the supper show" (Herlihy, 111).

The central theme in *Midnight Cowboy* is Joe's yearning for love and family. That's what he feels while saying good-bye to his middle-aged coworker before hopping on a bus to New York: "Papa," his eyes said, "I am going now to seek my fortune and have come to ask your blessing" (Herlihy, 19). Of course, this black dishwasher was not Joe's father. Not only had he never seen his father but he has never understood which of the three blondes that had raised him up to the age of seven was his actual mother. After that he was brought up by his grandmother Sally, who never had any time for him either. So his lonely personality was largely shaped by the lack of and longing for the parental love. In his imagination Joe had a succession of fathers, including a man named Woodsy Niles, the only one of his grandma's many boyfriends who "paid him any more than a counterfeit token of attention" (23). At some point,

Jesus replaced Woodsy Niles in Joe's affection. He was taught by a young lady with warm, humorous, kindly eyes that Jesus loved him. There was always a painting on an easel in front of the class; it depicted Jesus walking with a boy child. You could see only the back of the boy's head, but Joe felt that he himself was that child. (25)

Joe's longing for love and affection is gratified only in his imagination. He has no friendship or relationship of any kind until adolescence when he experiences his first, brief and intense love affair—with 15-year-old Anastasia (Annie) Pratt.

Annie Pratt is a nymphomaniac who had slept with about every boy in town, but she convinces Joe that he is the best of them all. In the film she appears in Joe's many flashbacks, and her words "You're the best, Joe, you're the only one, you're the best of them" that continuously resonates in his memory gives a clear indication from where his idea to make lovemaking into a career came. What is emphasized in

the book, however, is that the core of Joe's feeling for Annie is not so much desire as compassion. Soon after the beginning of their affair, Joe is rejected by the other boys for his preferred status with her. He begins to avoid her, trying to break up. Annie, on the contrary, uses any pretext to see him again. One day she comes to his house to offer him a raffle ticket. Joe says that he does not want it.

The girl knew what he was saying no to, and without actually moving, her face strained toward him, her eyes watery and deeply troubled, and she said: "Are you sure?"He nodded. Anastasia quickly turned and walked down the steps and up the path toward the sidewalk...and then he noticed how sorry her back was, how sad and lonesome the backs of her knees looked, and then he heard himself saying "Umh" fairly loud. When she turned to him again, Joe said, "I don't know if I got any change," and the tilt of her eyebrows pulled at his heart. (38)

Joe feels for Annie so strongly because her loneliness mirrors his own. His real precious gift is not for physical love, as Annie has convinced him, but for love in his heart—the instinctive compassionate under-standing of another person's pains and vulnerabilities. That's what he sees in the first older woman that he tries to pick up in New York:

She smiled and Joe was touched suddenly by the very special beauty of a lady at the far, far end of her youth—old age just under the surface of her skin, but not yet emerged, not yet—and by the still-young blue of eyes that were more deeply sympathetic than truly young eyes could ever be. (108)

That's what he feels while observing how Ratso, using both of his hands, puts his bad leg under the table during their first meeting in a bar:

For Joe this was a precarious moment: the awareness that his new friend was in pain, probably lived in a constant state of pain, threatened to wreck entirely this brilliant hour they'd been having....the knowledge that there was nothing he could do to right the bad leg, induced in Joe an anger that was fierce. (124)

As it turns out, at this moment Ratso's thoughts and feelings about his new friend are not that sentimental. After learning about Joe's professional aspirations, for 20 dollars Ratso sends him to the best pimp in town. Mr. O'Daniel, however, is no pimp, but a crazy Evan-gelist in one of the funniest scenes of the book and the film. After Ratso's deceit dawns on him, Joe flees, running through the streets of

Manhattan, seeking Ratso and revenge. Like always in times of stress, he has a fantasy. This time it is about finding Ratso and choking him to death with his bare hands.

Joe's trusting, caring disposition gets in the way of his professional ambitions. Yet he makes every effort to think and act as a hustler. One of the first things he does in his New York hotel room is to hang on the wall the poster of Paul Newman as Hud Bannon in Martin Ritt's *Hud*. Significantly, of all the cowboy heroes of the screen he chooses Hud, who had challenged the Western values six years before *Midnight Cowboy*. Like Hud, Joe perceives masculinity as a mere performance, both artistic (his cowboy act) and sexual. Inspired by Hud, Joe is trying to build a manly façade without the foundation of honor and integrity— the subversion of Western ideals condemned in the famous words of Hud's father (Melvyn Douglas) to his son:

You don't care about people, Hud! You don't give a damn about 'em ... Oh, you got all that charm going for you, and it makes the youngsters want to be like you. That's the shame of it, cause you don't value nothin', you don't respect nothin', you keep no check on your appetites at all. You live just for yourself—and that makes you not fit to live with ...

But unlike Hud, Joe does care about people. And unlike Hud, and through his friendship with Ratso, in the end he finally drops the act and becomes a man.

After Ratso cons Joe out of 20 dollars, they do not meet again for several weeks during which Joe runs out of money, gets kicked out of his hotel, and has a dreadful experience providing oral sex to a college student who appears to have no money to pay for the service. But when, after all these troubles, Joe suddenly runs into Ratso again, his instant reaction is not rage, but joy:

... Joe, having wandered homeless and a stranger for three weeks, a long time by the clocks of limbo, was thrilled to see a face that was known to him. His whole being stopped short, accustoming itself to this keen, unexpected pleasure, and it took more than a moment to remember that Ratso Rizzo was an enemy. (155)

Ratso's immediate reaction is very different: "Seeing Joe, Ratso closed his eyes quickly and remained as motionless as a person praying for invisibility" (155). But in the film the unexpected joy of recognition is mutual—in Waldo Salt's script it is described as "one almost subliminal flash of each revealing something like pleasure at finding a long-lost friend ..." (Salt, 64).

This humane moment quickly gives way to the more expected Joe's rage and Ratso's fear:

RATSO. Don't hit me, I'm a cripple.

JOE. Oh, I ain't gonna hit you, I'm gonna strangle you to death . . .

But all he actually does is search Ratso for money, find 64 cents, and not take them. That is when Ratso invites the homeless Joe to stay with him. In the film, chasing Joe out of the cafeteria, Ratso cries out with sudden sincerity of desperation, "I'm inviting you, goddammit!" And Joe accepts. At Ratso's place, Joe has second thoughts about his decision, but one glance at Ratso eliminates his doubts: "Looking at him now, Joe saw nothing more frightening than a puny crippled kid sitting on a pile of old blankets on the floor of a tenement flat afraid of being left alone" (160).

And thus begins a new chapter in the lives of two outcasts who found each other in the big unfriendly world, two orphans who became brothers. For both of them the alliance starts out of desperate loneliness. Here is how Joe's new state of mind is described in the novel:

. . . He was happy.

For the first time in his life he felt himself released from the necessity of grin-ning and posturing and yearning for the attention of others. Nowadays he had, in the person of Ratso Rizzo, someone who needed his presence in an urgent, almost frantic way that was a balm to something in him that had long been exposed and enflamed and itching to be soothed. (164–165)

But what starts out of the basic selfish impulse not to be alone and to use each other's strengths—Ratso's street-smarts and Joe's handsome-ness and physical stamina—in their daily fight for survival gradually develops into a relationship of mutual care and concern.

They share conversations. These talks are primarily Ratso's expert monologues about everything in life, from the survival techniques in New York to the generosities of the land of Florida where they should go one day. They share food and money. They agree that they both lack the necessary skills or motivation for any legitimate work, so they get their money and food through shoplifting, pickpocketing, and other forms of theft.

Even with Ratso's "management," Joe's efforts to hustle rich ladies continue to fail. Ratso questions the sex appeal of Joe's cowboy act. He says that Joe is out of touch, that the cowboy look doesn't work

for ladies any more, and that it is "strictly for fags." The offended Joe is momentarily speechless, but then blurts out, "John Wayne! Are you gonna tell me, he is a fag?!" Now it is Ratso's turn to be speechless; there is no counterargument for "John Wayne." Thus, in the course of Voight and Hoffman's inspired improvisation, the iconic status of Wayne's Western hero is reaffirmed. On the night of the 1970 Academy Awards, it was reaffirmed again when the 63-year-old Wayne finally won his leading actor Oscar for *True Grit*, taking the statuette from both Hoffman and Voight, who were nominated in the same category for *Midnight Cowboy*.

At some point in the film, Ratso steals for Joe the invitation for a high-class male escort from one Miss Beecham of the Barclay Hotel for Women. As Joe enters the hotel's lobby, Ratso, waiting across the street, is having his own dream about their wonderful life in Florida that would begin from Joe's success in the hotel. This dream in which, among other happy changes, Ratso loses his limp and is running along the ocean faster than Joe is as movingly childish as Joe's fantasies; for all his street-smarts, deep-down Ratso is as naïve as his friend. And as all of Joe's dreams, Ratso's fantasy gets crushed by reality: he sees Joe giving Miss Beecham a pat on her behind right in the lobby, and then getting slapped by her and thrown out by two bellboys. Ratso promptly limps across the street to help Joe get on his feet and away from the approaching police car.

As the weather gets colder and Ratso's cough worsens, Joe gets more anxious to find a way to help. In the film, Joe donates his blood at a blood bank and brings home almost ten dollars. He does not tell Ratso where he got the money, but urges him to take it and "buy yourself some medicine before you die on my damn hands . . ." It turns out that Ratso also has something for his friend: while Joe was away giving blood, Ratso has stolen for him a large sheepskin coat.

One day when they are sitting in a café, a strange couple walks in and invites Joe to a party, while ignoring Ratso. Although pleased with the special attention, Joe assures the hurt Ratso that he will not go without him. On the way to the party, Joe notices that Ratso is out of breath, his face and hair wet with perspiration. On an impulse, Joe rubs Ratso's head with his shirt. Twenty-nine years after making the film Director John Schlesinger still remembered this moment as one of the most compassionate in the film:

There's one moment that I find very dear, that the actors just did, which is very moving and touching and physical, which is the moment when Joe lifts his shirt to mop Dustin's head and he puts the head on the naked flesh.

That was something they did, not something I suggested, and it's a very, very beautiful moment that I've always thanked the actors for.

(Schlesinger, 206)

While giving the well-deserved credit to the actors whose specific choices made this moment particularly moving, we should not forget that the moment itself came from the novel:

Joe said, "You better dry your hair some."

Ratso made a swipe at it with his bare hands.

Joe took out his own shirt tails. "Come here. Gimme y'fuckin' head."

Ratso growled, "No." But Joe was louder. "Come here!"

Ratso bent forward and offered his head to be dried. Joe rubbed it with his shirt tails. (180)

In the novel, an even stronger revelation of how much they mean to each other comes in the same scene in the form of a sudden grim premonition. After they are done with Ratso's hair, Ratso asks Joe about his appearance, and Joe gives him a careful look:

Some vague, awful thing had come into evidence between them, hovering in the air between them like a skeleton dancing on threads, something grim and secret that filled Joe with terror, making him feel locked out and alone and in peril. (181)

This is the vision of Ratso's eminent death, which both try to shake off as soon as they can. Only people with the deepest psychological and emotional connection to one another are capable of such intuitions.

In the film, the death forewarning appears more as Ratso's intuition than Joe's. In the cafeteria, right before Joe gets invited to the party, Ratso provokes a conversation about afterlife and mentions the possibility of a spirit going into another body. Joe responds with a joke, "I hope I don't come back in *your* body." But for Rasto it is a serious matter. "Maybe you gotta think about those things for a while," he says, probing Joe with his sad sickly eyes. In his contemplations about death, Ratso reveals more of a Western sensibility than "cowboy" Joe who dismisses the topic is his juvenile way. For Ratso, like a real Westerner, thoughts about death are ever present, for death itself is never far away. As *Once Upon a Time in the West's* Cheyenne (Jason Robards) says about another outlaw, Harmonica: "People like that

have something inside, something to do with *death*." Ratso certainly has this quality. At some point he even takes Joe to the cemetery to visit his father's grave. As they stand near the tombstone, Ratso is reminiscing about his father:

RATSO. He was even dumber than you. He couldn't even write his own name. 'X', that's what it oughta say on that goddamn headstone. One big lousy 'X'! Just like our dump: condemned by order of City Hall.

JOE. *(after a pause, sadly)* My Grandma, Sally Buck . . . she died without lettin' me know.

And we realize that we are looking at two little orphans whose only blessing in life was finding each other.

Ratso is getting weaker every day. Joe finally scores with a rich woman and brings home aspirin and new socks for his friend, but these are of little help: Ratso tells Joe that he cannot walk any more. In their frantic search for a solution, the trip to Florida occurs to them as the only possibility. Joe runs out to find the money for the bus fare. Determined to save his friend, he does what he dreads most—he offers himself to strangers on the street. He is picked up by an extravagant older man who introduces himself as Towny and takes Joe to his hotel room. While Towny is in his bedroom talking on the phone, Joe is in the bathroom rehearsing his speech, as usual, in front of the mirror.

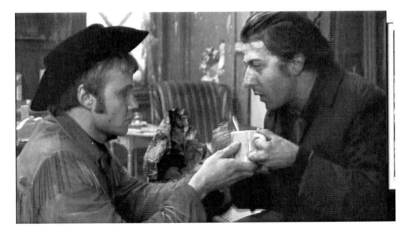

Figure 12.1 Ratso (Dustin Hoffman) tells Joe (John Voight), "I don't think I can walk anymore" in *Midnight Cowboy* (1969).
Source: Courtesy of Florin Productions and Jerome Hellman Productions.

In this rehearsal, he refers to Ratso as his "sick kid" whom he needs to get South as quickly as possible. What follows is no sex, but a brief ugly struggle for Towny's wallet, during which his false teeth fall out of his mouth. In a masochistic fit, Towny provokes Joe to hurt him more, and, on a sudden impulse, Joe shoves the phone receiver into the man's toothless mouth.

After getting the money for the trip at such a horrible price, Joe drags Ratso to the bus. On their way to Florida, Joe confesses to his friend that he is planning to quit hustling and find a real job. In the novel he explains thus:

"My whole point is, working, I'm gonna be able to look out for you, too. Not just me. Okay?"

. . . Joe was astonished at the thing he had just said to Ratso, promising to take care of him, even more astonished to realize that he meant it.

And so now here he was with this burden on his hands, responsible for the care of another person, a sickly, crippled person at that. But oddly enough, he liked the feeling it gave him. It was a curious kind of burden under which he felt lighter instead of heavier, and warm. (242)

So we witness two extreme sides to Joe's transformation, inspired by his feeling for his friend. For Ratso he commits a violent crime, possibly a murder, of which he has never been capable before. And out of his new sense of responsibility for Ratso comes the realization that he has to quit hustling and start working.

There are two significant moments when the bus stops briefly on the way to Miami. Joe runs out to buy summer clothes for himself and Ratso. He walks out of the store not dressed as a cowboy (for the first time in the film), but in a simple shirt and pants, and stuffs his entire cowboy outfit into a garbage bin. Right after that he has a small exchange with a pretty waitress at a sandwich stand and—again for the first time in the film—he talks to a woman without his usual manly bravado or sexual suggestiveness, but naturally. Thus the Western masculinity performance is dropped and a real man is born.

The emotional power of the film's final scene defies any commentary. One last quote from the last pages of the novel should show, once again, how much of this heartbreaking scene and this timeless film was inspired by James Herlihy's extraordinary talent. This is what Joe feels while changing Ratso into the dry clothes at the back seat of the bus and looking at his small helpless body covered in bruises from his many falls in the last several days:

He was like a plucked chicken, one who'd spent his life getting the worst of barnyard scraps and had finally cocked up his heels and quit. This history was written all over his body, and Joe read it well and with a feeling for the sacredness of it. For a moment he saw in his mind a motion picture of himself wrapping this naked, badly damaged human child in the blanket, taking him up gently and holding him rock-a-bye and git-along-little-doggie in his lap for the rest of the trip. (247)

Ratso dies before they reach Florida. Joe closes his eyes and puts his arm around him. This final image of the film—Joe holding his dead friend for the last few miles to their destination—is also conveyed in the last paragraph of the novel.

Joe's sad and meaningful final gestures—closing Ratso's eyes and embracing him for his last trip—complete the transformation of Joe's character. He is not any more a confused boy living the illusion of manhood, but a grieving grown man who just lost his only friend. The power and purity of this friendship transcends the gloom and misery of their lives and redeems everything they did wrong along the way. And it is this friendship that makes the film version of *Midnight Cowboy* one of the most unusual but also one of the most moving and lasting love stories in the history of cinema.

NOTES

This chapter, in a less developed form, was initially presented at the 2010 Film & History Conference "Representations of Love in Film and Television" in Milwaukee, Wisconsin, on November 13, 2010.

1. Hellman, 205.

FILMOGRAPHY

Hud. Dir. Martin Ritt. Paramount. 1963.
Midnight Cowboy. Dir. John Schlesinger. Florin Productions, 1969.
Once Upon a Time in the West. Dir. Sergio Leone. Rafran Cinematografica/ San Marco. 1968

WORKS CITED

Giannetti, Louis, and Scott Eyman. *Flashback: A Brief History of Film*. 5th ed. New Jersey: Prentice Hall, 2006.
Hellman, Jerome. Producing Midnight Cowboy. Interview with Annie Nocenti. Scenario. *The Magazine of Screenwriting Art*. Vol. 3, No. 4: 93–206.

ZHENYA KIPERMAN

Herlihy, James Leo. *Midnight Cowboy.* New York: Simon and Schuster, 1965.

Salt, Waldo. Screenplay of Midnight Cowboy. Scenario. *The Magazine of Screenwriting Art.* Vol. 3, No. 4: 47–87.

Schlesinger, John. Directing Midnight Cowboy. Interview with Annie Nocenti. Scenario. *The Magazine of Screenwriting Art.* Vol. 3, No. 4: 98–206.

CHAPTER 13

GERMAN SADDLE PALS AND THE ABSENCE OF LOVE IN THE KARL MAY WESTERNS

Robert Spindler

The whole history of the European Western film is divided into three parts, the first of which are the German Karl May film adaptations, the second the Italo-Westerns proper, and the third the Italian Western parodies. While all the films that come under these categories have coincidental parallels in their portrayals of heterosexual love, the focus of this chapter will be the Karl May film adaptations. Karl May (1842–1912), a German author of adventure novels predominantly set in the American West, is deemed the most widely read German author.[1] When film production mogul Horst Wendlandt adapted May's *Treasure of Silver Lake* for film in 1962, he met the demand of traumatized postwar Germany[2] and spawned one of the most successful German film series to date. Sixteen films were to follow until 1968, ten of which Westerns, and while their faithfulness to the literary originals would gradually diminish,[3] the success formula of May's novels would always be kept up: a white Westerner of German nationality or descent ("Old Shatterhand," "Old Firehand," or "Old Surehand," nicknamed so for their fighting or shooting skills) teams up with Apache chief Winnetou to fight injustice throughout the West in a Native American–European alliance. Side characters may be involved in a secondary love plot, and even title characters may happen to enjoy brief liaisons. However, the focal point of the action

is the male–male relationship. Male–female love relationships involving one of the title characters are never consummated. While this is not much of a surprise in films generically belonging to the ever-masculine Western, there are reasons for these phenomena that must be sought outside the influence of the American Western, and instead in the independent cultural history of Europe.

The work of Karl May and its peculiarities have had a tremendous cultural influence in the German-speaking world that is often unknown of or underestimated outside Europe. Many generations of German youths have closely associated the myth of the American frontier with the characters of May's adventure novels, first and foremost Apache chief Winnetou and "Teutonic warrior," Old Shatterhand.[4] Hans argues that May's Native Americans are the first a German is confronted with, and, despite the outrageous historical inaccuracies in their portrayals, better known than any other fictional or historical Native American personality.[5] For the German audience, the omnipotent adventurer Old Shatterhand and the noble savage Winston have become the cowboy–Indian couple per se, while their obvious literary models, Leather stocking and Chingachgook (which strongly influenced May[6]), and similar precursors to May's characters never caught on in a comparable manner.[7] Although repetitive, the May stories, which are typically set in uncivilized territory, follow a formula that grants a maximum reading experience for young readers. Fast-paced sequences of action and violence interchange with the embarrassing adventures of comedic side characters, lessons on survival in the West, and "ethnological information" about Native Americans. All of these are supported by Christian preaching of morality, by which the author continuously reinforces his mission of peace between Native Americans and Whites. Winnetou and Old Shatterhand turn up wherever this peace is endangered and combat injustice, whichever side commits it.[8]

What is missing in most of May's novels, however, are significant female characters, and, consequently, romantic love plots. In her revealing study on May's literary characters, Oel-Willenborg suggests three predominant categories of female characters that are to be found (only marginally, of course) in the "America" stories:[9] the innocent victims, the lovers of bad guys, and the sluttish Latinas—all portrayed in a very consistent, black-and-white manner. Interestingly, those of the most positive first category occasionally have masculine features about them; they are sometimes mistaken for men, or dress or behave like them (by sitting in the saddle male fashion, for example). The occasional lovers of the bad guys are voluptuous and feminine,

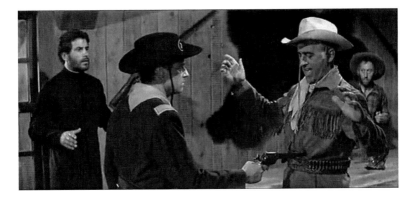

Figure 13.1 Old Surehand (Stewart Granger) meets the cavalry in *Among Vultures* (1964).
Source: Courtesy of Atlantis Films.

but, as can be expected, vain and untrustworthy. The third group of female characters, the Mexicans are harmless, stupid, and clumsy (an example of not only the misogynist but also the racist tendencies of May's writing).[10] In addition, the characteristics of the male heroes of the stories make a romantic union with a woman unlikely from the outset. The heroes (besides Winnetou and Old Shatterhand, the *Westmänner*, "Men of the West" Old Firehand, and Old Surehand have been mentioned; Sam Hawkens is the most prominent of the comedic heroes) all live by a sort of "unwritten code" that stipulates poverty and chastity.[11] The character descriptions also suggest that they have all surpassed the average age of marriage (Old Firehand is the only one who has been married once but his wife is dead long since).[12] In the first part of the *Winnetou*-trilogy, however (together with *Treasure of Silver Lake* the most popular among the more than 70 volumes May authored[13]), two of the most prominent heroes, Old Shatterhand and Sam Hawkens, are "in danger" of getting married. May wrote this book relatively late, later than the stories that where combined for the volumes *Winnetou II* and *III*. It is a "prequel" to all the other novels set in the West, as it tells the story of how Old Shatterhand comes to America for the first time and meets Winnetou. May's intention was obviously to answer some of the questions readers had asked themselves while reading his work in the years before—for example, where did he learn to shoot and ride so well, how did he get to know Winnetou, and why his heroes have no apparent interest in women. In *Winnetou I*, Winnetou's sister Nscho-Tschi, a Great Plains Pocahontas, falls for Old Shatterhand. He is attracted to her,

but reluctant to commit to a union with her unless she visits a school to be "civilized" and learn white customs. She is on her best way to be civilized when she is killed by the bad guys. Only then is Shatterhand ready to admit that he was in love with her. Less tragically but equally hopelessly ends the liaison with another Native American woman with whom Shatterhand's sidekick Sam Hawkens is about to indulge in: when his beloved discovers that he is wearing a wig to cover up his bare skull, once having survived a scalping by Indians, she shrieks and runs off, never to return. I-narrator Shatterhand's final comment is that it was unthinkable that Sam could ever be a husband.[14] By telling these stories in the late-composed prequel to all of his Western novels, May does away with any hopes of his reader for future love stories involving the title heroes: a comedic character like Sam Hawkens is too clumsy to be a lover, and the attractive hero Old Shatterhand is traumatized by the death of Nscho-Tschi. And, if Old Shatterhand even needs convincing to marry the noble and beautiful Nscho-Tschi, who does not at last bear great resemblance to her *Übermensch*-brother Winnetou, how could he ever find a woman in the West who is good enough for him? So, no further romantic interests involving the principal heroes are introduced in the other Winnetou books.[15]

Indeed it is unthinkable to have Old Shatterhand marry in one of the books, as it could mean the immediate end of his adventures. In this respect, Old Shatterhand resembles Superman (or any other serial superhero), whose status quo must be preserved to leave the possibilities for infinite future adventures open: "If Superman married Lois Lane, it would of course be another step toward his death, as it would lay down another irreversible premise [...]."[16] The comparison of Old Shatterhand with a superhero is not arbitrary, by the way. He is practically unfailing in any skill a Westerner should have; he rides, shoots, hunts, and traps better than anyone surrounding him; and his superhuman physical strength has given him the nickname "Shatterhand," being able to knock out any opponent by a single blow to the temple. Even his horse and weapons are the best. And so, like Superman, the declared bachelor does not give in to erotic temptations. Umberto Eco explains the reason for these heroes' vows of chastity, the "parcifalism," as he calls it:

If we have to look for a structural reason for this narrative fact, we cannot but go back to our preceding observations: the "parsifalism" of Superman is one of the conditions that prevents his slowly "consuming" himself, and it protects him from the events, and therefore from the passing of time, connected with erotic ventures.[17]

As long as the hero remains a bachelor, the episodes of his adventures are unspecified in time and can multiply infinitely. A marriage would be an event that not only brings a (traditionally) irreversible change to the hero's life but also brings new responsibilities for the hero, making it more difficult for him to concentrate on his "calling": fighting crime in the case of Superman, preserving peace between Native Americans and Whites in the case of Old Shatterhand.[18]

Equivalents of the Superman comics' Lois Lane character, who provides continuous but unfulfilled romantic potential for the principal masculine hero, are missing in May's novels; instead one finds a great emphasis on male friendship. Oel-Willenborg observes that almost two-thirds of May's numerous "men of the West" characters (exclusively male) live together in couples. They are usually "funny couples," two contrasting comedic characters resembling an old married couple, who might appear almost out of nowhere in the middle of the Great Plains, albeit never in singularity. The following dialogue between Dick Hammerdull and Pit Holbers in *Old Surehand II*, for example, is typical:

Dick: "What would you do, if you came to realize all of a sudden that you are a disguised daughter of Eve?"

Pit: "I would marry you, right off the bat."[19]

Others, who do not live in constant "partnership," still have their male counterpart they team up with for occasional adventures. Once again, Old Shatterhand overshadows all the other Westerners here, as his best friend and male counterpart, Winnetou, not only is the noblest, most skillful, and handsomest of all but also, since their friendship, is exemplary, harmonious, and tender. When meeting again in the West after having been long separated, their welcome greeting is a long rite of exchanged caresses, starting physically with hugs and kisses and ending verbally with kitschy pseudo-Indian metaphors of affection:

Winnetou: "My brother Shatterhand comes like the dew into the calyx of the thirsty flower..."

Old Shatterhand: "My brother Winnetou is dear to my heart as the ray of sun to the sick, dear to my soul as the child to the mother who bears it."[20]

The relationship of Old Shatterhand and Winnetou as May portrays it, seen by Oel-Willenborg as the depiction of an elevated and supposedly exemplary male friendship,[21] has provided impetus for theories

that May was homosexual. Dealing with an author who drew many
parallels between his personal life and his literary work, at times claim-
ing that the stories of Old Shatterhand (whose real first name in
the novels is also Karl) are actual facts and happened to him the
way they are written in the novels,[22] scholars have debated whether
Old Shatterhand's friendship with Winnetou is an expression of the
author's latent homosexuality. The most vehement supporter of this
theory is Arno Schmidt, whose *Sitara und der Weg dorthin* is a half-
satirical work that aims to point out the supposedly vast number and
great frequency of subliminal, especially homo- but also heterosexual
allusions throughout May's work.[23] However, Schmidt is not content
with the more obvious homoerotic tendencies apparent in dialogues
like that given above. In a polemic and derogatory manner, he goes so
far as to read shapes of genitalia into May's descriptions of landscapes
and sexual acts into scenes of horse riding. Without doubt, Schmidt's
Sitara has had some influence in strengthening the popular belief that
Karl May was homosexual and that his alter ego Old Shatterhand's
affectionate relationship with Winnetou is a (subconscious) expres-
sion of unfulfilled sexual desires of the author.[24] Presently, though,
the prevailing opinion among Karl May scholars is that the author
was not homosexual (perhaps bisexual), following a study by Heinz
Stolte and Gerhard Klußmeier.[25] In *Arno Schmidt & Karl May: Eine
notwendige Klarstellung* they expose the invalidity of Arno Schmidt's
Sitara by pointing to inaccuracies in his reproductions of text pas-
sages, his manipulation of the reader by clipping and combining text
passages, his ignorance of May's biography, and contradictions within
his text. Reacting to a claim by Schmidt that May "indulged in homo-
delights"[26] over many years of his life, they argue that no strong male
relationship in the course of May's life is indicated,[27] but numerous
bonds with women are documented, including romances and short
liaisons, an affair with a married woman, girlfriends, and two wives,
the first of whom he married only after a three-year relationship.[28]
Another argument of Schmidt for May's sublime homoeroticism in his
works is that there is no small number of transvestites among May's
literary characters. This position is refuted by Stolte and Klußmeier
by maintaining that there is only one character in the whole of the
author's writing for whom this description is remotely fitting, which is
Tante Droll ("Auntie Droll"), a man of the West whose shabby over-
sized clothes give him an effeminate appearance.[29] But Tante Droll
does not dress up as a woman deliberately, and thus is a "transvestite"
only by accident and carelessness. His actions are always in con-
trast to his outer appearance and reaffirm his masculinity whenever

another character doubts it. Stolte and Klußmeier seem to forget, however, that the quite prominent character of Kolma Puschi, in *Old Surehand II*, whom all believe to be a male hermit, is in fact a woman disguising as a man, while awaiting an opportunity to revenge her murdered family. A thorough author-oriented reading of the character of Kolma Puschi, who deliberately hides the fact that she is a woman, would perhaps give much more reason to theorize about transsexual fantasies of May than Schmidt's dubious analysis of Tante Droll. Schmidt's approach might have been fruitful if he had generally studied his subject in less polemical and populist, but more scholarly manner. But then, May's sexual orientation and the question of how much it influenced his writing remain matters of debate.

The fact remains that the principal heroes of May's most popular works are never involved in a consummated heterosexual love plot and that female characters and romantic love—if present at all—are always secondary, and to the greatest extent this is true of the film versions of May's novels as well. When Horst Wendlandt adapted *Treasure of Silver Lake* for the screen in 1962, he created a recipe for success by going for action and straightness instead of psychological undertones, to meet the demands of the German postwar generation.[30] The producer, who would never read a full Karl May novel himself, understood that a one-on-one adaptation of May's voluminous novels was impossible. His philosophy was that 400 pages of a 600-page novel have to be left away—a film must follow certain laws and for an adaptation it is sufficient to take the characters from the book and develop a film plot from them.[31] As a consequence, some of the Karl May films differ substantially from their literary models, with newly invented figures and plot lines, less omnipotent heroes, and—most interestingly—notable female characters, either absent or insignificant in the originals.[32] Sometimes they are self-assured elderly ladies who put a damper on the heroes' masculine omnipotence by offering a life-saving plan, like Mrs. Butler (Marianne Hoppe) in *Treasure of Silver Lake* (unthinkable in an original May novel), and sometimes they provide romantic potential for the films. Also in *Treasure of Silver Lake*, the very first adaptation,[33] a love plot develops between the characters Fred Engel (Götz George) and Ellen Patterson (Karin Dor). Not only is this love plot absent in the novel but also the prerequisites for it have been manipulated in the film adaptation: both the originally 16-year-old Fred and the 13-year-old Ellen of the novel are full-grown adults in the movie. Although producer Wendlandt lured Götz George to star in *Treasure of Silver Lake* by telling him that neither Winnetou nor Old Shatterhand but he will be the title hero and

although Fred Engel does indeed have a great amount of screen time, the romance with Ellen is a subplot and viewers considered Winnetou and Old Shatterhand (who are not involved in love plots in the film) the principal heroes.[34] But the recipe of *Treasure* has been copied for another, similar Karl May film, *Among Vultures* (1964), again starring Götz George as a courting young settler. Here the voluptuous Elke Sommer plays the emancipated markswoman One Gun Annie, reminiscent of the historical Annie Oakley of Buffalo Bill's Wild West Show. The character, whose presence in the film enlivens "Karl May's misogynist vision of the West" as Christopher Frayling puts it,[35] is not based on any figure in the works of Karl May, but serves as the girlfriend of George's Martin Baumann, who is again apparently older than the 16-year-old youth of the original story. The producers went one step further for the film *Winnetou und das Halbblut Apanatschi* (1966), filmed from an original script not even based on any work by Karl May. Once again, it features a secondary love plot involving a character played by Götz George, Jeff, who wants to marry the half-breed Apanatschi (also a newly invented female figure not present in Karl May's works). Thus it is remarkable how the films add romantic potential and female characters to May's West. Still, the women and love plots are secondary.

The film adaptation of the only Karl May novel that features at least something of a romantic love plot featuring Old Shatterhand, *Winnetou I* (and the climax of the series according to Hatzig[36]), is relatively faithful to its literary model in this respect. The Old Shatterhand of the film is arguably a bit more of a charmer than the one of the novel. When he encounters the femme fatale girlfriend of bad guy Santer, Belle (another female film character with no direct literary basis, but obviously belonging to May's second category of female characters, the lovers of bad guys), and she introduces herself seductively to the attractive Shatterhand—"I am Belle,"—he coolly replies, "And that in the true sense of the word," and walks past. But in the episode involving Winnetou's sister Nscho Tschi, the hero is much that of the literary model, as the sequence of events is largely the same as in the novel. Old Shatterhand reacts like a gentleman to Nscho Tschi's advances, but explains he loves his homeland and plans to return to it, implying that a bond between them is impossible. A fraternizing kiss on the forehead is all the love Nscho Tschi gets from the German adventurer. Toward the end, however, at the event of Nscho Tschi's death, Shatterhand reveals to his now "blood-brother"[37] Winnetou that he loved her as well and will never forget her. As they ride off into the sunset, Winnetou concludes, "We are

alone now, brother," and to supporters of the latent homosexuality theory this might sound almost like an expression of relief. In fact, as in the novel, the relationship between Winnetou and Old Shatterhand is given much more emphasis than that of Old Shatterhand and Nscho Tschi. In one sequence, Old Shatterhand is severely wounded and abducted by the Apaches who believe he is an enemy at that time, and Winnetou's sister is given the task of making him well again so he will be able to endure death at the stake. When Shatterhand awakens from a fever and beholds Nscho Tschi for the first time, he is rather bemused at the sight of the pretty young girl preparing to feed him. In contrast to that, when he saw Winnetou for the first time, the camera lingered on his face for an additional moment in which his faint smile expressed admiration and awe at the impressive and well-groomed appearance of the Apache warrior. And while Nscho Tschi enters no official bond with Shatterhand whatsoever, Winnetou and the German become "blood-brothers" in the course of the film (see above) and have a lot more screen time together. In a crucial discussion of war maneuvers between the two, Nscho Tschi serves merely as a cupbearer, entering and leaving the scene uncommented. Frayling even reduces the Nscho Tschi–Shatterhand romance to a means to "link together (jigsaw-fashion) a series of very lively action sequences."[38] The filmmakers have certainly created a memorable character by their portrayal of Nscho Tschi in *Winnetou I*, and her storyline is maintained from the original novel while many others have been cut, but the romance between her and Shatterhand is clearly secondary to the developing friendship between the latter and Winnetou.

With this focus on the relationship between two men, some of the Karl May Westerns seem to take their place among the "buddy" film genre, which Konigsberg defines as films that feature "the friendship of two males as the major relationship. [...] Such films extol the virtues of male comradeship and relegate male-female relationships to a subsidiary position."[39] However, there are clear differences between the Karl May films and prototypical American buddy film as it gained popularity in the late 1960s and the 1970s. Gates theorizes about the latter that they were motivated by an anti-feminist stance:

To punish women for their desire for equality, the buddy film pushes them out of the center of the narrative and replaces the traditional central romantic relationship between a man and a woman with a buddy relationship between two men. By making both protagonists men, the central issue of the film becomes the growth and development of their friendship. Women as potential love interests are thus eliminated from the narrative space.[40]

While this applies to another category of European Westerns, the
Italo-Westerns, which are characterized by misogynist elements on
more than one occasion, it would not do justice to the Karl May
films to call them antifeminist. As film adaptations of original nov-
els, they even tend to break with faithfulness to the books in order
to enlarge the roles of female characters, introduce new ones (like
the emancipated characters of Mrs. Butler in *Treasure of Silver Lake*
or One Gun Annie in *Among Vultures*), or at least maintain those
story lines in which women are involved (see above). That the films
still concentrate on masculine protagonists and male relationships
could rather be explained by the fact that they adapt novels that were
written in imitation of American adventure literature and frontier his-
tory, where friendship between two men was oftentimes considered a
bond exceeding, for example, marriage in longevity and incorruptibil-
ity.[41] From Cooper's Leatherstocking tales to the dime novel boom
around 1900 when "historical" male friendships like Butch Cassidy
and Sundance Kid, Wyatt Earp and Doc Holiday, or Pat Garret and
Billy the Kid were celebrated, the Western genre had frequently been
associated with male bonding.[42] Actually, in some of May's earlier
romantic adventure writings, often set in Germany, like "Die Rose
von Ernstthal", the element of male comradeship is not present at
all; here the hero is on his own and the story centers around a love
plot between him and a local girl. May's Middle East adventure sto-
ries, second in popularity to the America stories, are also characterized
by a strong male friendship: that of I-narrator Kara ben Nemsi[43] and
his clumsy guide Hadschi Halef Omar. Although their relationship
is often described in affectionate words, however, it is not compa-
rable to that of Old Shatterhand and Winnetou, who are on equal
terms in skill and personality, whereas Hadschi (comparable to Sam
Hawkens in the America stories and played by the same actor, Ralf
Wolter, in the film versions) is more of a comical sidekick to Kara ben
Nemsi. The character of Winnetou and the intensity of the friend-
ship between himself and Old Shatterhand are singular in May's work,
and consequently only featured in the Western novels. Whether May
was only emulating the Leatherstocking tales and thus created a simi-
lar Native American–white settler couple, or whether he thought the
wild West context most appropriate for a dominating male friendship
theme he was interested in for whatever reason, remains to be seen.
In fact, the focus on male comradeship in May's America stories is
strongly present, while the film adaptations rather tend to soften this
focus instead of picking up on it in a cinematic and sociocultural con-
text to create antifeminist buddy films. In addition to that, the Karl

May films are different from the prototypical "buddy" film in that they concentrate more on the similarities of the two men, the mutual understanding between the two protagonists, instead of presenting them as the "odd match." Winnetou and Old Shatterhand hardly ever disagree, and seem to be able to read each other's thoughts. There is also a continuous outward display of respect—not, as with more typical film buddies, only in extreme situations. However, it is not always Old Shatterhand who teams up with Winnetou in the films (as in the books), but on one occasion it is the trapper Old Firehand (Rod Cameron),[44] and in three films Winnetou roams the West with Old Surehand (Stewart Granger) at his side.[45] Granger, who was recruited by German producers to have an "American Western Star" on board (and was, in fact, over the hill at that time), was very unpopular on the set of the Karl May films he starred in: apparently the haughty actor resisted instructions by the director and did things his way to "teach the Germans the Western."[46] Interestingly, the behavior of Surehand in the films is very different from that of Shatterhand (and, not to mention, different from the Surehand of May's books), and the relationship of Winnetou and Old Surehand resembles that of a typical buddy film slightly more, probably owing to Granger's American influence: the filmic Old Surehand is an ironic joker, ready to point out that he is in the right and his companions are in the wrong. Of course it must be mentioned that not all of the Karl May Westerns foreground the relationship between Winnetou and a white counterpart to such an extent as to match Konigsberg's definition of a buddy film. Especially the *Winnetou*-trilogy, *Winnetou I, II,* and *III,* make the friendship between Old Shatterhand and Winnetou their central theme, starting with their first encounter in *Winnetou I* and ending with Winnetou's death in *Winnetou III*. In films outside this cycle, however, the Winnetou–white settler couple is sometimes only one element in a large repertoire of figures enmeshed in an action-packed adventure story. Thus, most Karl May films do feature some key elements of the buddy film, but none are prototypical examples of the genre.[47]

For many Europeans, the "cowboy–Indian" couple Old Shatterhand and Winnetou epitomizes a fantasy of male comradeship in the wild West. Women and romantic heterosexual love play only a marginal role in this fantastic vision of nineteenth-century America. So, the principal protagonists of May's novels are never involved in a consummated heterosexual love plot, while male–male friendships are always a central element. Some have tried to explain this fact by arguing that May was homosexual, but the debate remains controversial. That May's

heroes like Winnetou and Old Shatterhand never marry is more plausibly explained by Eco's argument that such an irreversible change to a serial "superhero's" life would mean the immediate end of his adventures. The emphasis on male bonding, especially in May's America stories is not unlikely to be connected to the context and tradition of American frontier literature, which influenced May and put a great focus on male friendship ever since. The Horst Wendlandt-produced Karl May film adaptation series, starting with *Treasure of Silver Lake* in 1964, made some effort to step away from May's ultramasculine vision of the West and introduced, amplified, or at least maintained female characters and heterosexual love plots. However, these remain secondary besides the central male–male relationship between Winnetou and a white settler (Old Shatterhand, Old Firehand, or Old Surehand). The Karl May films thus bear some features of the buddy film, but not enough to be considered prototypical.

NOTES

1. Dieter Sudhoff and Hartmut Vollmer, Introduction in *Karl Mays Winnetou*. Ed. by Sudhoff and Vollmer (Oldenburg: Igel, 2007), 9–25, 9. For sales figures, see: Birgit Hans, "Karl May und das Indianerbild der Deutschen" (Neanderthal Museum, Mettmann. n.d.), 5, and Christopher Frayling, *Spaghetti Westerns: Cowboys and Europeans from Karl May to Sergio Leone* (London: Tauris, 2006), 105.

2. Heger notes: "After the ethical catastrophe of National socialism, the young West-German republic painfully yearned for recuperation of their international reputation. A fairy-tale hero of the kind of the noble Karly May hero Old Shatterhand came in handy at this post-traumatic state, to show the world what the true German was really like: proactive, self-sacrificing, and helpful" (*Nach der ethischen Katastrophe des Nationalsozialismus sehnte sich die junge westdeutsche Republik schmerzlich nach der Wiederherstellung ihrer internationalen Reputation. Ein märchenhafter Held vom Schlage des noblen Karl-May-Helden Old Shatterhand kam in diesem posttraumatischen Stadium gerade recht, um der Welt zu zeigen, wie der wahre Deutsche wirklich war: tatkräftig zupackend, aufopferungsvoll und hilfsbereit.*) Christian Heger, *Die rechte und die linke Hand der Parodie: Bud Spencer, Terence Hill und ihre Filme* (Marburg: Schüren, 2009), 17.

3. Hansotto Hatzig, "Verfilmungen" in *Karl-May-Handbuch*. Ed. Gert Ueding. 2nd ed. (Würzburg: Königshausen, 2001), 528.

4. Old Shatterhand is also the author's alter ego, and many stories are told from his perspective.

5. Hans, 4, 13.

6. Hans, 7.
7. Frayling, 105.
8. Thomas Klein, "Der Schatz im Silbersee" in *Filmgenres: Western*. Ed. Bernd Kiefer and Norbert Grob. (Stuttgart: Reclam, 2003), 258–261, 259.
9. The largest part of May's novels are set in North America, but there is also a group of novels set in the Middle East and a smaller number set in various other places around the world.
10. Gertrud Oel-Willenborg, *Von deutschen Helden: Eine Inhaltsanalyse der Karl-May-Romane* (Weinheim: Beltz, 1973), 49–50.
11. Oel-Willenborg, 53, 65.
12. Oel-Willenborg, 66.
13. Oel-Willenborg, 16.
14. Oel-Willenborg, 67.
15. Frayling, 111–2.
16. Umberto Eco, *The Role of the Reader: Explorations in the Semiotics of Texts* (Bloomington: Indiana UP, 1979), 114–5.
17. Eco, 115.
18. There is one exception in May's late work, which is known for its increasing symbolism, extravagance, and encoding. In *Winnetous Erben* (Winnetou's Heirs) Old Shatterhand is accompanied on his last trip to America after Winnetou's death by his wife Klara, with whom Karl May was married in real life at the time of writing.
19. Dick: *"Was willst du dagegen machen, wenn du plötzlich zu der Erkenntnis kommst, daß du ein heimlich verkleidetes Frauenzimmer bist?"* Pit: *"Ich würde dich augenblicklich heiraten"* Oel-Willenborg, 35.
20. Winnetou: *"Mein Bruder Shatterhand kommt wie der Tau in den Kelch der dürstenden Blume..."* Old Shatterhand: *"Mein Bruder Winnetou ist meinem Herzen ersehnt wie der Sonnenstrahl dem Kranken und meiner Seele teuer wie das Kind der Mutter, die es geboren hat"* Oel-Willenborg, 67–8.
21. Oel-Willenborg, 67–8.
22. Klaus Walther, *Karl May* (München: DTV, 2002), 101–6.
23. Arno Schmidt, *Sitara und der Weg dorthin: Eine Studie über Wesen, Werk und Wirkung Karl Mays* (Karlsruhe: Fischer, 1963).
24. Bernd-Ulrich Hergemöller, *Mann für Mann, Biographisches Lexikon zur Geschichte von Freundesliebe und männlicher Sexualität im deutschen Sprachraum* (Hamburg: Männerschwarm, 1998), 497. That this popular belief is still dominant in the German-speaking world was demonstrated in 2001, when German TV comedian Michael "Bully" Herbig directed and starred in the feature film *Der Schuh des Manitu* (The Shoe of Manitou), a spoof of the Karl May Western film adaptations of the 1960s. It relies for much of its jokes on deliberate homosexual undertones and on the exaggerated effeminate behavior of one of its male title characters. Apparently, the public got the

joke: the film was one of the highest-grossing German film production since 1945.

25. Heinz Stolte and Gerhard Klußmeier, *Arno Schmidt & Karl May: Eine notwendige Klarstellung* (Hamburg: Hansa, 1973).

26. "[...] *der dann viele Jahre lang Homo-Wonnen genossen hatte*" Schmidt 191.

27. Except for his later friendship to Sascha Schneider, interestingly an openly homosexual painter who designed book covers for some of May's works.

28. Stolte and Klußmeier, 45–6.

29. Stolte and Klußmeier, 36.

30. Joe Hembus, *Das Western-Lexikon: 1567 Filme von 1894 bis heute*, Ed. Benjamin Hembus (München: Heyne, 1995), 739.

31. Dona Kujacinski, *Horst Wendlandt: Der Mann, der Winnetou & Edgar Wallace, Bud Spencer & Terence Hill, Otto & Loriot ins Kino brachte* (Berlin: Schwarzkopf, 2006), 130.

32. Oel-Willenborg, 148–9. Some of the films are not based on stories by May at all but simply borrow the principal characters. See Hatzig.

33. There had been earlier Karl May film adaptations, which, however, shall be disregarded here for their lack of quality, prominence, and influence. See Hatzig.

34. *Auf den Spuren Winnetous*. Dir. Axel Klawuhn. Kabel 1. 1 November 2004.

35. Frayling, 113.

36. Hatzig, 528.

37. Karl May repeatedly presents this rite as a common Native American custom to seal a deep, everlasting friendship: two people cut their skin and dissolve a few drops of blood in a cup of water. Then each drinks this blood-cocktail of the other. In the film adaptation of *Winnetou I*, the ritual is simplified. Winnetou and Old Shatterhand simply press the cut on their forearm against that of the other. Hans points out that she discussed the rite with several American and Native American scholars, experts in Native American studies, but none ever heard of such an adoption rite before (13).

38. Frayling, 113.

39. Ira Konigsberg, *The Complete Film Dictionary* (2nd ed. New York: Penguin, 1997), 41.

40. Philippa Gates, "Always a Partner in Crime: Black Masculinity in the Hollywood Detective Film" *Journal of Popular Film and Television* 32 (Spring 2004): 20–29, 22.

41. Heger, 48.

42. Heger, 48.

43. Kara ben Nemsi, translated as "Karl, son of Germans," is May's second alter ego and, as some hints in the novels indicate, actually identical with Old Shatterhand.

44. *Winnetou und sein Freund Old Firehand* (1966).
45. *Among Vultures* (1964), *Der Ölprinz* (1965), and *Old Surehand* (1965).
46. *Auf den Spuren Winnetous.*
47. In contrast to that, plenty of later European Westerns, like Sergio Leone's *Dollar*-trilogy, and especially the Bud Spencer-Terence Hill Spaghetti Western send-ups, are buddy films par excellence.

FILMOGRAPHY

Among Vultures [Unter Geiern]. Dir. Alfred Vohrer. Rialto, 1964.
Old Surehand. Dir. Alfred Vohrer. Rialto, 1965.
Ölprinz, Der. Dir. Harald Philipp. Rialto, 1965.
Schuh des Manitu, Der. Dir. Michael Herbig. Constantin, 2001.
Treasure of Silver Lake [Der Schatz im Silbersee]. Dir. Harald Reinl. Rialto, 1962.
Winnetou I. Dir. Harald Reinl. Rialto, 1963.
Winnetou II. Dir. Harald Reinl. Rialto, 1964.
Winnetou III. Dir. Harald Reinl. Rialto, 1965.
Winnetou und das Halbblut Apanatschi. Dir. Harald Philipp. Rialto, 1966.
Winnetou und sein Freund Old Firehand. Dir. Alfred Vohrer. Rialto, 1966.

BIBLIOGRAPHY

Auf den Spuren Winnetous. Dir. Axel Klawuhn. Kabel 1. 1 November 2004.
Birgit Hans, Birgit. "Karl May und das Indianerbild der Deutschen." Neanderthal Museum, Mettmann. n.d.
Eco, Umberto. *The Role of the Reader: Explorations in the Semiotics of Texts.* Bloomington: Indiana UP, 1979: 114–115.
Frayling, Christopher. *Spaghetti Westerns: Cowboys and Europeans from Karl May to Sergio Leone.* London: Tauris, 2006.
Gates, Philippa. "Always a Partner in Crime: Black Masculinity in the Hollywood Detective Film" *Journal of Popular Film and Television* 32 (Spring 2004): 20–29.
Hatzig, Hansotto. "Verfilmungen." *Karl-May-Handbuch.* Ed. Gert Ueding. 2nd ed. Würzburg: Königshausen, 2001: 528.
Heger, Christian. *Die rechte und die linke Hand der Parodie: Bud Spencer, Terence Hill und ihre Filme.* Marburg: Schüren, 2009.
Hembus, Joe. *Das Western-Lexikon: 1567 Filme von 1894 bis heute.* Ed. Benjamin Hembus. München: Heyne, 1995.
Hergemöller, Bernd-Ulrich. *Mann für Mann: Biographisches Lexikon zur Geschichte von Freundesliebe und männlicher Sexualität im deutschen Sprachraum.* Hamburg: Männerschwarm, 1998.
Klein, Thomas. "Der Schatz im Silbersee." *Filmgenres: Western.* Ed. Bernd Kiefer and Norbert Grob. Stuttgart: Reclam, 2003: 258–261.

Konigsberg, Ira. *The Complete Film Dictionary.* 2nd ed. New York: Penguin, 1997.

Kujacinski, Dona. *Horst Wendlandt: Der Mann, der Winnetou & Edgar Wallace, Bud Spencer & Terence Hill, Otto & Loriot ins Kino brachte.* Berlin: Schwarzkopf, 2006.

Oel-Willenborg, Gertrud. *Von deutschen Helden: Eine Inhaltsanalyse der Karl-May-Romane.* Weinheim: Beltz, 1973.

Schmidt, Arno. *Sitara und der Weg dorthin: Eine Studie über Wesen, Werk und Wirkung Karl Mays.* Karlsruhe: Fischer, 1963.

Stolte, Heinz, and Gerhard Klußmeier. *Arno Schmidt & Karl May: Eine notwendige Klarstellung.* Hamburg: Hansa, 1973.

Sudhoff, Dieter, and Hartmut Vollmer. Introduction. Karl Mays "Winnetou". Ed. by Sudhoff and Vollmer. Oldenburg: Igel, 2007: 9–25.

Walther, Klaus. *Karl May.* München: DTV, 2002: 101–106.

"WHEN YOU SIDE WITH A MAN, YOU STAY WITH HIM!"—*PHILIA* AND THE MILITARY MIND IN SAM PECKINPAH'S *THE WILD BUNCH* (1969)

Sue Matheson

Today, *The Wild Bunch* is generally considered to be one of the number of movies in the late 1960s and early 1970s that recontextualized the Vietnam conflict.[1] Generally considered "the most graphically violent Western ever made and one of the most violent movies of all time" (Murray, *Peckinpah*), *The Wild Bunch* became the subject of heated controversy among its reviewers and the public after its release—its notoriety due to an extraordinarily high body count and sinew-ripping slow motion. As New Yorker critic Pauline Kael has commented about the public outrage elicited by the opening and closing scenes of *The Wild Bunch*, "All they saw was the violence" (quoted in Murray, *Peckinpah*). This public reaction roughly divided the movie's viewers into two camps less than a year after the Tet Offensive, when "the issues of violence in American society and American foreign policy had become central to virtually every national forum of public opinion," and at a time when the American public "stood at the end of a decade of political assassinations whose magnitude was unprecedented in [its] history, and [was] deeply mired in a genocidal

war in Vietnam" (Cook). David Cook points out that for many critics, in 1969,

The Wild Bunch seemed to be an allegory of our involvement in Vietnam, where outlaws, mercenaries, and federal troops fought to produce the largest civilian "body count" since World War II. Others saw the film more generally as a comment on the level and nature of violence in American life. But nearly everyone saw that it bore some relationship to the major social issues of the times, and, depending on how one felt about *those issues,* one's reaction to the film was enthusiastically positive or vehemently negative—both mistaken responses to a work whose prevailing tenor is moral ambiguity from start to finish.

Roger Ebert remembers his own response when attending a screening of *The Wild Bunch.* When a reviewer from *Reader's Digest* stood up and asked why this movie was ever made, Ebert also "stood up and called it a masterpiece"; he says, "I felt then, and now, that *The Wild Bunch* is one of the great defining moments of modern movies."

Critical reaction to *The Wild Bunch* (1969) has been just as volatile. Roy Armes' reaction to the director's unflinching treatment of the material, for example, is decidedly negative, noting that while *The Wild Bunch* is about "...a collection of stupid brutish men [for director Sam Peckinpah].... Casting his film in the Western mould...comes automatically to endow them with a spurious glamour.... The violence too that Peckinpah intends to be horrifying as well as strangely fascinating becomes infused with a false romanticism in the context of the Western" (106). Michael Sragow, on the other hand, finds *The Wild Bunch* "irreducible." It is a movie that "demands that you establish an original relation to it." "What struck me, and shook me," Sragow says, "[w]asn't that specific. It had to do with the size of the characters and the gnarly individualism of the storytelling; the tonal blend of effrontery, tenderness, and Rabelaisian gusto; the unprecedented combination of gusto; the unprecedented combination of virtuosity and heartbreaking passion"; Peckinpah, he claims, gave himself over to "the gamiest possible example of an aesthetically worn out and socially disreputable genre [and...] came up with a piece of art whose power couldn't be shrugged off or explained away" (Sragow 116). In *Gunfighter Nation: The Myth of the Frontier in Twentieth-Century America,* Richard Slotkin lauds this film, viewing *The Wild Bunch* as " the Moby-Dick of Westerns: a sprawling epic whose powerful poetic and ideological resonance derives from its deliberate combination of strong adventure-narrative with compendious reference to history and the traditions of American

mythology—particularly those of the Western." Peckinpah's critique of American myth-ideology, Slotkin says, takes the form of a countermyth, which mirrors and exposes the structure of the original. *The Wild Bunch*, he argues, "unites the themes and conventions of the Mexican Western and the Cult of the Outlaw in a single story, thus bringing together the populist mythology of the outlaw story, its concern with the problem of domestic justice, and the counterinsurgency mystique of the gunfighters-in-Mexico, which reflects on America's role in world affairs" (594).

The public, the reviewers, and the critics, notwithstanding, Peckinpah himself insists that *The Wild Bunch* is just "a simple story about bad men in changing times." "*The Wild Bunch* is simply what happens when killers go to Mexico," he says in a 1969 interview with Stephen Farber; "The strange thing is you feel a great sense of loss when these killers reach the end of the line" (42). This sense of loss that has been noted by many critics has remained the subject of what continues to be a passionate debate. Leonard Engels suggests that this is a reaction to the loss of "the glory and grandeur that was once the myth of the American West" (30). Michael Sragow suggests that this reaction is triggered by the Bunch's "glorious group sacrifice" (116). Logically, however, how could the deaths of five grungy killers involved in the Mexican War in 1913 become the transcendent, almost cathartic, experience that has been noted by many of the movie's viewers and reviewers? One would think that the demise of thieves and murderers would elicit little sympathy, even a certain relief, from the audience. Clearly, the viewers' strong visceral reaction to Pike's "Battle on the Bloody Porch" has little if anything to do with logic. In his "Introduction" *to Doing It Right: The Best Criticism on Sam Peckinpah's The Wild Bunch*, Michael Bliss reminds his reader that the topography of *The Wild Bunch* is preeminently emotional: "[i]nitially, one should realize that, predominantly, *The Wild Bunch* is a love story," Bliss says, noting that in part, *The Wild Bunch* evokes "love for the camaraderie of men on a shared mission" (xv). Painstakingly developed throughout the narrative, this camaraderie, an expression of the experience of manly or brotherly love belonging to a "centuries-old tradition of strong non-sexual male friendship" (Richards 117), sparks the berserk behavior of Pike and the men at the movie's end. It is what McKubin T. Owens would recognize as being "the glue of the military ethos . . . what the Greeks called *philia*—friendship, comradeship, or brotherly love."

When examining Peckinpah's use of *philia* in *The Wild Bunch*, it is important to recognize that Pike and his men's introduction as

cavalrymen (c 1913) during the film's opening is much more than a clever disguise designed to mislead the audience as well as the towns-folk and thwart the railway men in San Rafael. In a 1969 interview with Joe Medjuck for *Take One*, Peckinpah comments that *The Wild Bunch* is about the military ethos being "a way of life" (24). "I tried to make a movie about heavies [not heroes]," he says. "It's been so much a part of my life that it seems strange for me to be talking about it. I don't know except that I know those people very well. They are vio-lent people. And we're dealing in terms of violence and what violence comes down to" (25; 24).

As Jonathan Shay notes, an army, ancient or modern, is a social construction defined by shared expectations and values. Some of these are embodied in formal regulations, defined authority, written orders, ranks, incentives, punishments, and formal task and occupational def-initions. Others circulate as traditions, archetypal stories of things to be emulated or shunned, and accepted truth about what is praisewor-thy and what is culpable. All together, these form a moral world that most of the participants most of the time regard as legitimate, "nat-ural," and personally binding (6). Like army regulars, the Bunch is also a social construction, made up of Pike (William Holden), Dutch (Ernest Borgnine), Angel (Jamie Sanchez), Tector (Ben Johnson), Lyle (Warren Oates), and Freddie Sykes (Edmond O'Brien) and defined by shared expectations and values. Like an army's coherence and legitimacy, the binding nature and legitimacy of its values rest on the existence of *philia* or manly love within the unit. Peckinpah carefully reveals the presence of *philia* via a series of confrontations between members of the Bunch and their leader. The first occurs when the Tector and Lyle Gorch question Pike's decision to give Freddie Sykes and Angel equal shares of the loot because it "ain't fair." Pike's answer calls into question their loyalty to the group as a whole: "If you two boys don't like equal shares, why in the hell don't you just take all of it?" When Lyle realizes that the rest of the Bunch agree with Pike, he drops his challenge. Clearly the unit's cohesion is of paramount importance to every member of the group, even the Gorches.

As Owens points out, the efficacy of *philia* on which the cohe-sion of a military unit depends rests upon fairness and the absence of favoritism. For the members of the Bunch, as for those in the mili-tary, fairness is crucial. Equal shares are the coin of the realm. Later, after the group rolls down a sand dune, the Gorches, who have lost their tempers, suggest getting rid of the old man, Freddie, who is responsible for the accident. Once again, *philia* prevents the disin-tegration of the group. Pike reminds the men of their duty to their

comrade, saying, "We're not gonna get rid of anybody! We're gonna stick together, just like it used to be! When you side with a man, you stay with him! And if you can't do that, you're like some animal, you're finished! We're finished! All of us!" It is *philia* that enables these men to be superior to animals—it is what allows them to transcend their "natural" condition and function as men. Here it should be noted that as a code, *philia* pertains only to those within that group; the civilians, railway men, soldiers, prostitutes, villagers, and bounty hunters in *The Wild Bunch* are neither bound by its regulations nor awarded its privileges. Thus, Deke Thornton has promised to cooperate with Harrington and the men with whom he rides, but, because there is no *philia* functioning within that group, he cannot be considered *philos* (or a comrade). As Pike points out, Thornton has given his word, but Dutch immediately draws Pike's attention to an important distinction: "That ain't what counts!" he says, "It's who you give it to!" Having given his word to a railroad, Thornton himself recognizes his own debased condition: after telling his posse that they are "egg-suckin', chicken stealing gutter trash," he adds, "We're after men, and I wish to God I was with them."

When one considers the nature of *philia*, it becomes evident that the closeness in relationships between Pike and his men, that is, love itself, as Michael Bliss points out in his "Introduction" to *Doing It Right: The Best Criticism on Sam Peckinpah's The Wild Bunch*, is the force that drives the action of Peckinpah's narrative. As Shay says, men fight mainly for their comrades; this has become conventional wisdom even among civilians. In combat situations the soldier's social horizon shrinks to include the members of his unit (Shay 23). *Philia*, the soldier's feeling of loyalty for one another, is the result, not the cause, of comradeship. Comrades are loyal to each other spontaneously and without any need for reasons. As Owens points out, *philia* is the source of the unit cohesion which most research has shown to be critical to battlefield success. "Survival and success in combat often require soldiers to virtually read one another's minds, reflexively covering each other with as much care as they cover themselves and going to one another's aid with little thought for safety . . . such cohesion within an airborne reconnaissance unit has been summed up as: 'You grew like a hand'" (Shay 61–62). A prime example of such closeness in *The Wild Bunch* is evident during the train robbery. As the script notes, "There are no words. Everyone knows his job." Throughout this sequence, Angel saves Dutch's life. Deemed by Nick Redman, Paul Seydor, Garner Simmons, and David Weddle in the commentary of the original director's cut of *The Wild Bunch* to be the conscience of the outlaws'

unit, Angel proves to be what Shay would consider to be the group's special comrade: the caretaker of his comrades and his village. Angel, an embodiment of the principle of brotherly love, is the member of the Bunch who shoots the soldiers who fire at Dutch when he stumbles and falls, and then pulls Dutch to safety from between the train cars without thinking of his own safety.

As Shay notes, the difficulty of finding the right word in English for the Greek term, *philia*, occurs because of the differences between ancient Greek and modern American culture. Friendship is too "bland" a term for the closeness of the emotional topography that *philia* engenders, and, the word, "love," in modern American English, carries with it emotional and sexual connotations not found within the experience of *philia* (Shay 40). Thus Peckinpah ensures throughout *The Wild Bunch* that the homosocial bonding of Pike and his men contrasts sharply with the homosexual overtones found in the relationships of Harrington's bounty hunters, in particular that of Coffer (Strother Martin) and T.C. (L.Q. Jones). In the movie's opening scenes, on top of the bank, Coffer's coital relationship with his rifle barrel as he waits for the order to begin shooting at the Bunch disintegrates into jealousy and competition when he and his partner quarrel over the corpses of the men they have shot. Claiming to have killed all three bandits, Coffer quells T.C.'s assertions otherwise, by screaming a racial slur, "Liar! Liar! Black liar!" Contrasting sharply with this scene, one finds the horseplay that occurs between the members of the Bunch is good-humored and cooperative—with their heterosexuality been established early in the movie, Pike's men's relationships are homosocial. Content to share women and alcohol, these men display no jealousy as their property is divided equally among them. Here there is no competition—not even for the favors of a woman. At Angel's village, for example, Pike gives the woman who sits beside him to Dutch when his friend wants to dance. Freddie announces to Pike that he's going to steal Dutch's girl as Dutch leads the woman to the dance floor—and when he cuts in during the dance, Dutch is unperturbed by the interruption and gives his partner to his rival immediately.

Philia not only exists as close friendships found between comrades-in-arms; it also includes "many relationships that would not be classified as friendships. The love of mother and child is a paradigmatic case of *philia*; indeed, all close family relations including the relation of husband and wife are so characterized... The ancient Greeks, perhaps because their societies were so highly militarized (that is every male citizen was also a soldier), simply assumed the centrality of

philia" (Shay 41). With this in mind, *philia* is the force that also binds Angel to his community and the members of that extended family to one another. Later in *The Wild Bunch*, Peckinpah establishes and emphasizes the highly militarized nature of the Mexican peasants. Surprised by the men of Angel's village, Old Freddie Sykes points out that the Bunch have been out-maneuvered because "they [the village men] been fightin' Apaches a thousand years." Even Dutch Engstrom is impressed by the discipline and skill evidenced by the actions of Angel's relatives: "those fellas," he says, "[k]now how to handle themselves!"

In modern English, the kin relationship of brothers seems to be the most accessible and commonly spoken symbol of the bond between combat soldiers who are closest comrades (Shay 40). In combat, men learned to care passionately for the well-being of another individual person. Here it should be noted that this passion of care is only partly captured by the term "brotherly love" for in combat men also become mothers to one another (Shay 49). Not surprisingly then, Sykes mothers the others in the Bunch, serving them coffee even though Dutch complains that his coffee is so bad that Freddie has taken up killing with it instead of his guns. At first, membership in the Bunch means acknowledging one's own kinship with and caring for one's comrades to the exclusion of any other community. Sykes instructs Angel, "Listen boy, you ride with us, your village don't count. If it does, you don't go along."

In *The Wild Bunch*, however, *philia* is deemed a desirable condition not only because it enables one's survival in combat but also because it is the means by which one's humanity is realized and expressed. As Pike points out to the Bunch, without the bond of kinship, one is no better than some animal. Thus, Peckinpah's lyrical use of a filtered golden light and transcendent treatment of the green world via low-angle shots of the horsemen riding out of an avenue created by the trees as the band of brothers leave the village signals to the viewer the elevated and elevating nature of the *philia* found between family members and in Angel's community. Having come to care for those in Angel's village, the Bunch transcends its own insular condition, just as caring for others in the Bunch enable Pike and his men to transcend their individual conditions. Unlike *philia*, *eros* is sexual in nature and therefore an individual and exclusive state of being in *The Wild Bunch*. As such, *eros* entails a descent on the part of the individual. Angel's love relationship with Theresa, for example, signals his (and the Bunch's) ruin. A *puta* (prostitute)— that is Teresa, Mapache's lover—embodies the lowest form of *eros*

possible. Such *eros* encourages the disintegration of the community via Angel's jealousy and hatred of his sexual competitor. As Owens points out, *eros* manifests itself as sexual competition, protectiveness, and favoritism, all of which undermine military order, discipline, and morale. Aptly, Mapache's unit, whose soldiers are recruited by the lure of money and the promise of *eros* (the erotic pleasures offered by "muchachas bonitos"), is no better than a rabble. In the state of *eros*, every man thinks only of himself. The resulting construction, a selfish and immoral world, is, at its base, antisocial. As Paul Seydor points out, Mapache's headquarters is like Sodom and Gomorrah. Commenting on the depravity of Mapache and his drunken lieutenants, Seydor notes in the film's commentary, "The only thing you can do is destroy it. Just raze it. There is no fixing this." Given the depths to which those involved in *eros* sink, it is entirely appropriate then that Pike snaps out the word "bitch" when shot in the back by a whore: a professional practitioner of *eros*, the woman is by definition not only an adherent of the lowest, most debased form of love but also antisocial and therefore no better than an animal. Fittingly, another animal image associated with prostitutes, the image of the tethered bird that appears in the bordello in Aqua Verde, also alludes to the pathetic and debased condition of the prostitutes and their customers. Leaving the bordello and the young prostitutes behind, Pike and his men choose the transcendent experience of *philia* over the squalid situation, produced by the *eros*, which they have just experienced.

Paradoxically then, as odd as it may seem, the massacre at the movie's end is an ancient and culturally sanctioned act of love. Here it should be noted that ancient Greek culture explicitly approved of revenge killing—it was a kinsman's duty not merely a permitted act—and also approved of receiving monetary compensation (*poine*, which may be translated as blood-price or indemnity) instead of taking revenge (Shay 81). Thus, when Mapache slits Angel's throat, the Bunch's grief and guilt over their betrayal and subsequent loss of their brother and special comrade, exacerbated by the general's refusal of Pike's offer of half of his take as a *weyr-gilt*, is transformed into a killing rage. As Shay notes, bereavement is preeminent among the triggers of the berserk state (81). The emergence of rage out of intense grief is a biological universal, Shay says (54–55), and, because Pike's unit has become "like a hand," the rage that is produced is communal. As Shay points out, *The Iliad* climaxes with Achilles' beastlike and godlike rampage over the death of Patroclus (124). Similarly, *The Wild Bunch* climaxes with a rampage at the Bloody Porch: the Bunch's massacre at Mapache's headquarters. As Paul Seydor notes in "The

Wild Bunch as Epic," the parallels that exist between *The Iliad* and *The Wild Bunch* are not coincidental: "Peckinpah," he says, "knew his Aristotle's *Poetics* cold" (*Western Film* 345; in Simons and Merrill 10). "The spectacle of Angel being dragged behind Mapache's automobile is not unlike the spectacle of Hecktor being dragged behind the chariot." Seydor points out in "The Wild Bunch as Epic," "Angel himself, in his relationship to Pike and in the function he serves in the plot, suggest Patroclus, Achilles' young friend whose death in battle inspires the older man to take up arms once again on behalf of his countrymen. In both cases—Achilles' and Pike's—the immediate impulse is for revenge" (125).

Also well acquainted with Homer, Peckinpah, in a 1972 interview with William Murray for *Playboy*, reveals that his interest in and references to the Greek classics in his movies is not historical: "The facts about the siege of Troy, of the duel between Hector and Achilles and all the rest of it, are a hell of a lot less interesting than what Homer makes of it all. And the mere facts tend to obscure the truth anyway" (109). Always, Peckinpah's storytelling is firmly rooted in the psychology of his characters. In a 1976 interview with Anthony Macklin, Peckinpah, "very interested in the human heart," reveals that his business "is to understand." He tells Macklin, "I think if you're going to be a filmmaker, first you really have to get your feet wet in living and loving and being hurt. Then you say, 'Now maybe I can make a story out of it and understand'" (151). "[H]aving been a marine," Peckinpah's intimate knowledge of the military mind is both personal and profound: of the Bunch, he says, "I know those cats" (24).

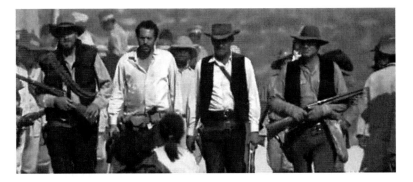

Figure 14.1 Tector (Ben Johnson), Lyle (Warren Oates), Pike (William Holden), and Dutch (Ernest Borgnine) walk to the Bloody Porch to rescue Angel (Jamie Sànches) in *The Wild Bunch* (1969).
Source: Courtesy of Warner Brothers/Seven Arts.

The berserk state of the Bunch, illustrated during the massacre at the Bloody Porch, is what Shay would consider to be the most important and distinctive element of combat trauma. Leaving the bordello and walking to Mapache's headquarters evidences the regrouping of the Bunch as a unit. Having regained its cohesion, this action, like the action during the train robbery, is accomplished without words. Everything that has gone before—the Bunch's detachment from what Shay would recognize as moral and social restraints by their and the railroad's prior betrayals of "what's right," their grief and guilt at the death of the special comrade in their group, and their sense of being already dead and deserving to be dead because of their betrayal of their companion who "played his string out right to the end"—all converge on and create the berserk state that erupts when Mapache slits Angel's throat (75). As Shay points out, at some deep cultural and psychological level, spilling enemy blood is an effort to bring the dead back to life: During berserk rage, the friend is constantly alive; letting go of the rage lets him die. In addition to reviving the dead, revenge denies helplessness, keeps faith with the dead, and affirms that there is still justice in the world, even if this is manifested only in the survivor's random vengeance (89–90).

The physiology of extreme stress can be applied to berserking— thus the berserker's experience of hyperarousal and hyperalertness is conveyed to the audience by Peckinpah's extreme slow motion and ultra-graphic violence. Like the *aristeiai* (berserk episodes) in *The Iliad*, the Bloody Porch sequence is actually of very brief duration. The intensely violent and graphic images of blood spurting and splattering often encapsulated in frames lasting no more than two seconds resonate in the viewer's memory, making the slow-motion action seem even slower and more static than it really is. Shay's insight that the berserk state is ruinous, leading to the soldier's maiming or death in battle, could not be more true in this case (98); the Bunch die one after another. But, because of *philia*, their massacre cannot be mistaken for anything other than an act of love. As Garner Simmons notes in the film's commentary, Dutch's crying out as he runs to his dying friend expresses "love and admiration and despair." In the end, Pike, Dutch, Angel, Tector, and Lyle may lie dead, but as the movie's curtain call suggests, their spirit is regenerated—not by the violence of the massacre but by the camaraderie that their laughter suggests.

At the movie's end, *philia* also enables Thornton and Sykes, former enemies, to ride off to fight again as friends. As before, the cohesion of individuals into a fighting unit is paramount, sweeping aside all other considerations. Sykes saying to Thornton: "Well, me and the

boys here, we got some work to do. Want to come along? It ain't like it used to be, but it'll do" is followed by the social and personal transcendence that such an opportunity to be among men again offers Thornton—underlined for the viewers by the rising perspective of Peckinpah's final crane shot. At this point in the movie's commentary, Paul Seydor says, "It goes to laughter. This is how he [Peckinpah] wants us to remember them." Peckinpah's final shots of the Bunch reintroduce the outlaws, riding from the green, Edenic world of Angel's village like heroes in filtered golden light and acknowledging and accepting the adulation and accolades of the grateful villagers, to end the film. In the film's commentary, Nick Redman notes, "This is how the individual passes into legend" and becomes "a campfire story." Peckinpah leaves his audiences with the images of men on horseback, his "heavies," riding to their deaths, transformed and immortalized on screen in the end as warrior-heroes being presented as larger than life by the camera's low angle shots. When one considers Peckinpah's presentation of the Bunch leaving the village in terms of the movie's release date, it is impossible not to agree with Jim Kitses' comment that in *The Wild Bunch*, the "historical moment of the film is 'crucial' "; as Kitses points out, if *Ride the High Country* is an elegy on American individualism; if *Major Dundee* inquires into national identity; [then] in *The Wild Bunch* it is the male *group* that is Peckinpah's subject" (76). Kitses argues that what dooms the group finally in spite of the trust and affection of the men for one another is not only the fact that they cannot change but also their inability to sustain their ideal of a disciplined unit. A careful examination of *philia*, however, suggests that the force that unifies the group and sets off the berserk state at the movie's end is also their salvation. *The Wild Bunch*, however bloody and graphic its carnage, however immature and moronic its members, is an expression of male passionate caring. Illustrating the camaraderie of combat culture experienced by Hector and Achilles *and* the American Soldiers who fought and died at Hamburger Hill, *The Wild Bunch* is an enduring statement about the complex nature of love. In final analysis, the deep visceral reaction that this movie's audiences continue to experience and record marks this subject as relevant an experience for Americans during the Iraq crisis as it was for the movie's viewers in 1969 or for Homer's audiences in the fifth century BC. Throughout history it does seem that the more things change the more they remain the same—*philia* has been and still is alive and well and living wherever men fight wars. What reduced Peckinpah to tears during the filming of this movie and paradoxically continues to elevate five grungy killers in a fictional tale about Mexico in 1913 to

the status of folk heroes on movie and television screens during the late twentieth and first part of the twenty-first centuries is the fact that today we, like Pike and Dutch and Peckinpah himself, would not have had it any other way.

NOTE

1. General comments and popular reviews from Internet sources reflect divided audience response to *The Wild Bunch*. For example, see *BookRags'* claim that "[e]arlier Westerns had good guys and bad guys as clearly demarcated as the sides in World War II, but *The Wild Bunch* came out during the Vietnam War, and it better reflected that war in both its complexity and carnage; *amc Movie Guide* notes that "[r]eleased in the late '60s discord over Vietnam, in the wake of the controversial *Bonnie and Clyde* (1967) and the brutal "spaghetti westerns" of Sergio Leone, *The Wild Bunch* polarized critics and audiences over its ferocious bloodshed. One side hailed it as a classic appropriately pitched to the violence and nihilism of the times, while the other reviled it as depraved; Tim Dirks in *Filmsite* regards Peckinpah's "revolutionary film" as a precursor to urban crime thrillers and inner-city gunfighting of the 1970s and later, and was often interpreted as an allegory about the Vietnam War.

FILMOGRAPHY

The Wild Bunch (1969). Dir. Sam Peckinpah. Burbank, California: Warner Home Video, 1997. DVD.

WORKS CITED

Armes, Roy. "Peckinpah and the changing west" *London magazine* 9 (Mar 1970): 101–06.

Bliss, Michael. "Introduction." *Doing It Right: The Best Criticism on Sam Peckinpah's The Wild Bunch*. Ed. Michael Bliss. Carbondale and Edwardsville: Southern Illinois University Press, 1994: xv–xxiii.

——. "The Conclusion of *The Wild Bunch*." *Doing It Right: The Best Criticism on Sam Peckinpah's The Wild Bunch*. Ed. Michael Bliss. Carbondale and Edwardsville: Southern Illinois University Press, 1994: 158–68.

Cook, David. "*The Wild Bunch*." *film reference*. Accessed 3 August 2010. <http://www.filmreference.com/Films-Vi-Wi/The-Wild-Bunch.html.>

Dirks, Tim. "Sam Peckinpah." AMC Filmsite. Accessed 3 August 2010. <http://www.filmsite.org/westernfilms5.html.>

Ebert, Roger. 29 September 2002. "*The Wild Bunch* (1969)." *RogerEbert.com Chicago Sun Times*. Accessed 3 August 2011. <http://

rogerebert.suntimes.com/apps/pbcs.dll/article?AID=20020929/
REVIEWS08/209290304/1023.>

Engel, Leon. "Sam Peckinpah's Heroes: Natty Bumpo and The Myuth of the Rugged Individual Still Reign."

Farber, Stephen. "Peckinpah's Return." *Sam Peckinpah: Interviews.* Ed. Peter Brunette. Jackson, Mississippi: University Press of Mississippi, 2008: 29–45.

Kitses, Jim. "*The Wild Bunch.*" "The Wild Bunch as Epic." *Doing It Right: The Best Criticism on Sam Peckinpah's The Wild Bunch.* Ed. Michael Bliss. Carbondale and Edwardsville: Southern Illinois University Press, 1994: 74–79.

Macklin, F. Anthony, "Mort Sahl Called Me a 1939 American." *Sam Peckinpah: Interviews.* Ed. Peter Brunette. Jackson, Mississippi: University Press of Mississippi, 2008: 145–57.

Medjuck, Joe. "Sam Peckinpah Lets It All Hang Out." *Sam Peckinpah: Interviews.* Ed. Peter Brunette. Jackson, Mississippi: University Press of Mississippi, 2008: 19–28.

Murray, Gabrielle. "Sam Peckinpah," *senses of cinema* 20. Accessed 2 April 2011. <http://archive.sensesofcinema.com/contents/directors/02/peckinpah.html.> Cited parenthetically as *Peckinpah*.

Murray, William. "Playboy Interview: Sam Peckinpah." *Sam Peckinpah: Interviews.* Ed. Peter Brunette. Jackson, Mississippi: University Press of Mississippi, 2008: 96–120.

Owens, McKubin T. 2000. "Military Ethos and the Politics of 'Don't Ask, Don't Tell.'" *On Principle* 8.1. Accessed 8 July 2010. <http://www.ashbrook.org/publicat/onprin/v8n1/owens.html.>

Richards, Jeffrey. " 'Passing the love of women': manly love and Victorian society."

Seydor, Paul. "The Wild Bunch as Epic." *Doing It Right: The Best Criticism on Sam Peckinpah's The Wild Bunch.* Ed. Michael Bliss. Carbondale and Edwardsville: Southern Illinois University Press, 1994: 115–38.

——. *Peckinpah: The Western Films.* Urbana, Illinois: University of Illinois Press, 1980. Cited parenthetically as *Western Films*.

Shay, Johnathan. *Achilles in Vietnam: Combat Trauma and the Undoing of Character.* New York: Touchstone, 1994.

Simons, John L. and Merrill, Robert. *Peckinpah's Tragic Westerns: A Critical Study.* Jefferson, North Carolina: McFarland & Company, Inc, 2011.

Slotkin, Richard. *Gunfighter Nation: The Myth of the Frontier in Twentieth-Century America.* Norman, Oklahoma: University of Oklahoma Press, 1998.

"The Wild Bunch." *BookRags.* Accessed 5 August 2010. <the-wild-bunch-sjpc-05/.>

"The Wild Bunch overview." amc Movie Guide. Accessed 4 August 2010. <http://movies.amctv.com/movie/54529/Wild-Bunch/overview.>

NOTES ON CONTRIBUTORS

Lara Cox is a Lectrice at Université de Jules Verne Picardie. Her doctoral research focused on the Theatre of the Absurd and aimed to reinvigorate critical considerations of this theatrical genre with the aid of French postmodern and psychoanalytic theory. Her wider research interests include French visual cultures, French theory (in particular, considerations of this body of thought as an Anglo-American phenomenon), and star culture.

Debra B. Cutshaw is a part-time Adjunct Lecturer in English at Western Nevada College. Since retiring as a prison caseworker in 2007, she has helped inmates with GEDs, besides presenting Black literature symposiums at Carson City prisons. Debbie has recently finished a chick lit novel, a Shakespearean time travel screenplay, and a Theresienstadt screenplay.

Andrea Gazzaniga is an Assistant Professor at Northern Kentucky University. When she is not working in the area of Victorian literature, she specializes in film and women writers.

Pete Falconer is a Lecturer in film studies at the University of Bristol. His main research interests lie in the forms and genres of popular cinema. He completed his PhD in 2011 and has published work on Westerns, horror movies, and film adaptation.

Stella Hockenhull is a Senior Lecturer in film studies at the University of Wolverhampton, UK. Her first degree, Bachelor of Arts (Hons.), in *History of Design and the Visual Arts* was followed by a Master of Arts degree in *Screen Studies* at Manchester University. She gained her PhD in 2006 titled *Neo-Romantic Landscapes: An Aesthetic Approach to the Films of Powell and Pressburger*—published 2008. She has researched extensively on British Cinema, which is evidenced in her latest book titled *Aesthetics and Neo-Romanticism in Film: Landscapes in Contemporary British Cinema* (2012). Currently, she is researching the role of horses in film.

Zhenya Kiperman is a Professor of film at Drexel University, where he teaches film production and cinema studies courses. He is also an award-winning filmmaker and founder of *Kiperfilms* (www.kiperfilms.com). Mr. Kiperman holds a Master's degree in filmmaking from Columbia University and has taught at

NYU, New School, Fordham, and St. John's universities. He is the author of numerous essays on film and literature published in the United States, Europe, and Russia, and the editor and one of the authors of the textbook *European Cinema: The Defining Figures, Movements, Films,* published in 2012.

Helen M. Lewis teaches English and humanities at Western Iowa Tech Community College, Sioux City, Iowa. She earned her BA from Wilkes College, and MA and ABD in English Literature from the University of Maryland, College Park. Using the Chautauqua method of presenting living history, she has portrayed Jane Addams since 1999, from Oklahoma to North Dakota, with Grace Abbott as a more recent addition. Since 2002, she has served as Area Chair of Westerns and the West for the Popular Culture Association/American Culture Association.

Sue Matheson is an Associate Professor at the University College of the North in Manitoba, Canada. She specializes in American popular culture and film, Children's Literature, and American and Canadian Literature.

Cynthia J. Miller is a cultural anthropologist, specializing in popular culture and visual media. Her writing has appeared in a wide range of journals and anthologies, including *Post Script, The Journal of Popular Film and Television,* and *Film & History.* She is the editor of the forthcoming *Too Bold for the Box Office: A Study in Mockumentary* (Wayne State UP), and *Cadets, Rangers, and Junior Space Men: Televised "Rocketman" Series of the 1950s and Their Fans,* coedited with A. Bowdoin Van Riper (Palgrave-MacMillan). Cynthia is also the series editor for Scarecrow Press's Film and History book series.

Erin Lee Mock is a PhD Candidate at the City University of New York Graduate Center. Her dissertation explores postwar masculinity across a variety of media and a related article appears in *Film and History.* Another article on television history is forthcoming in *Camera Obscura.*

Andrew Patrick Nelson is an Instructor of film studies at the University of Calgary. He holds a PhD from the University of Exeter.

Frances Pheasant-Kelly is MA Award Leader and a Senior Lecturer in film studies at the University of Wolverhampton, UK. Her research areas include abjection and space, which form the basis for her book *Abject Spaces in American Cinema: Institutional Settings, Identity, and Psychoanalysis in Film,* I.B Tauris (2011). Her other main research area is 9/11 with publications including a forthcoming book *Fantasy Film Post 9/11* (Palgrave Macmillan). Recent publications include "Authenticating the Reel: Realism, Simulation and Trauma in United 93" in Bragard, V., C. Dony, and W. Rosenberg (eds.) *Portraying 9/11: Essays on Representations of 9/11 in Comic Books, Literature, Film and Theatre,* McFarland Press (2011); "Ghosts of Ground Zero"

in P. Hammond (ed.) *Screens of Terror* (2011); and "The Ecstasy of Chaos: Mediations of 9/11, Terrorism and Traumatic Memory in *The Dark Knight,*" *Journal of War and Culture Studies* (2011).

Vincent Piturro is an Assistant Professor of cinema studies at Metropolitan State College of Denver. He teaches courses on film history, Westerns, science fiction, European cinema, and global cinema. He holds a PhD in Comparative Literature from the University of Colorado.

Robert Spindler was born in Germany in 1984 and moved to Austria in 1988, where he lives today. He has studied English and American Studies at Innsbruck University, Austria, finishing his thesis on *Recent Westerns: Deconstruction and Nostalgia in Contemporary Western Film* in 2008. He is currently doing research on the Sir Gawain character in modern literature and film.

INDEX

Printed in the United States of America